# DAVID GILL

## DESIGNING ART

# DAVID GILL

## DESIGNING ART

VENDOME

NEW YORK • LONDON

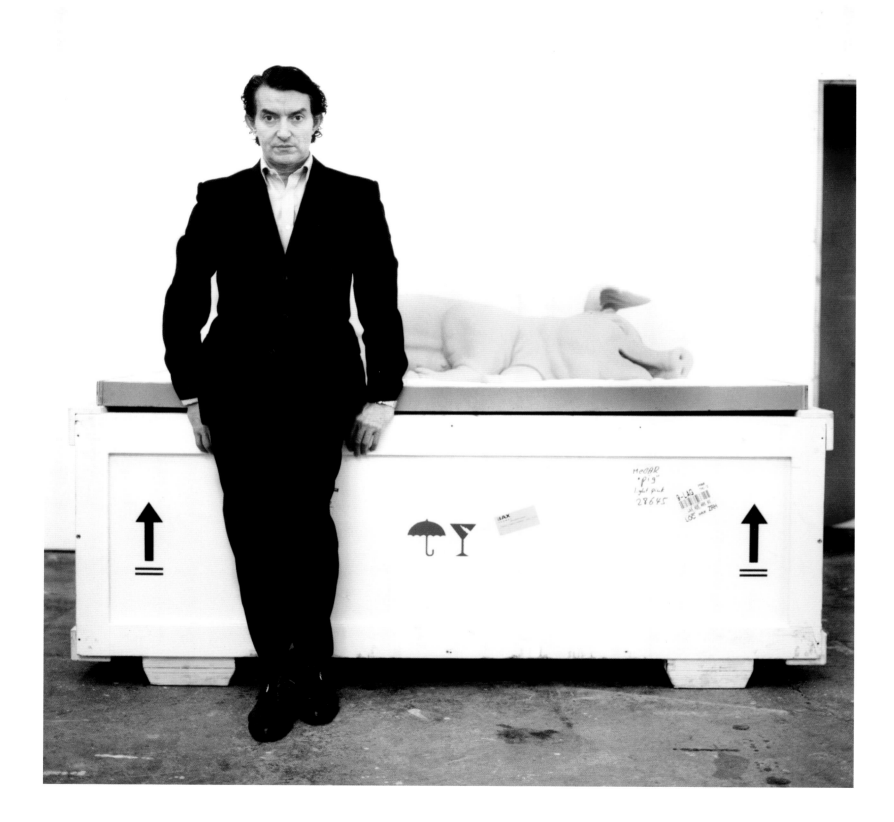

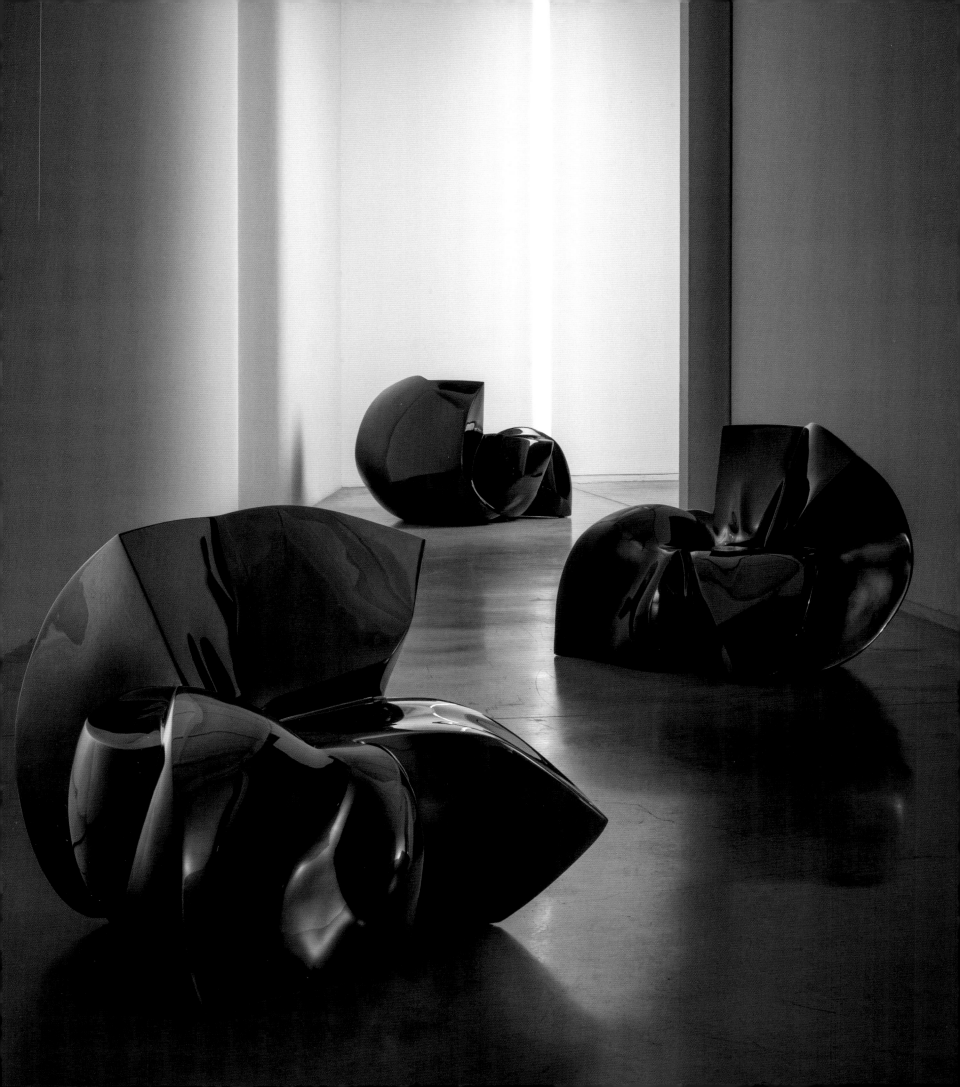

# DAVID GILL
# DESIGN ENTREPRENEUR

There are few people in the world who have the true gift of imagination, even fewer who are capable of using it to create, and fewer still who can do so in such a way that it changes another's aesthetic appreciation of the world. David Gill is one of these incredible people.

I first met David in the autumn of 1991, after he was featured in *The World of Interiors* magazine which drew me to a Garouste & Bonetti exhibition at the Fulham Road Gallery. We had lunch together after viewing the Aldo Mondino show David staged at Leighton House in the spring of 1992, and I have spent the subsequent years learning from and responding to the genius of a man who leaves an indelible impression on all who meet him.

Every artist and designer who has worked closely with David would say the same about him: that his mentoring and support have been invaluable to the development of their art and career. David manages to push both the boundaries and the buttons of artists, which results in some of their most profound and beautiful work. And that is what makes this book, *David Gill: Designing Art,* so important. It documents the instrumental influence David has had on the growth of the luxury design market, and illuminates his pioneering actions which took the decorative arts of the 1980s and reinvented it into the contemporary "design-art" global market that exists today.

Though the terminology has been updated to suit our modern interpretation and definition of what constitutes interior design, what has remained consistent since the 1980s is David's committed vision and philosophy. He demands the exceptional from his collaborators, and will only show work he fully believes in. His eye for detail ensures the quality of a finished piece begins with the design process, and is matched at every stage of production, through the choice of materials to the manufacturing process. Contemporary design and materials allow for greater possibilities, but David's objective has always been the same: the exquisite.

What David possesses is a beautiful, unique talent. But it comes at a cost. Whilst his ability to recognise and create something special seems instinctive, it is upheld by an impassioned pursuit for perfection which torments him daily. It's this beautiful conflict which sets him apart from others in his field. Friends and collectors look to him for his expert observations, and he expects everyone involved in the process to be as invested as he is in the outcome.

As the Artistic Director of David Gill Gallery, and an interior and furniture designer in my own right, as well as David's life partner, it would be fair to assume I have some special insight into the formula behind his alchemy. However, his brilliance is as much of an enigma to me as anyone else who marvels at his Midas touch. If I ask him to explain his thought process, I always receive the same reply: "Lateral thinking, Francis. Lateral thinking."

*David Gill: Designing Art*, is perhaps the best opportunity for us all to understand the inimitability of the collector, the creator and the curator, David Gill.

Francis Sultana

OPPOSITE: King Bonk Chairs, 2008, Fredrikson Stallard.

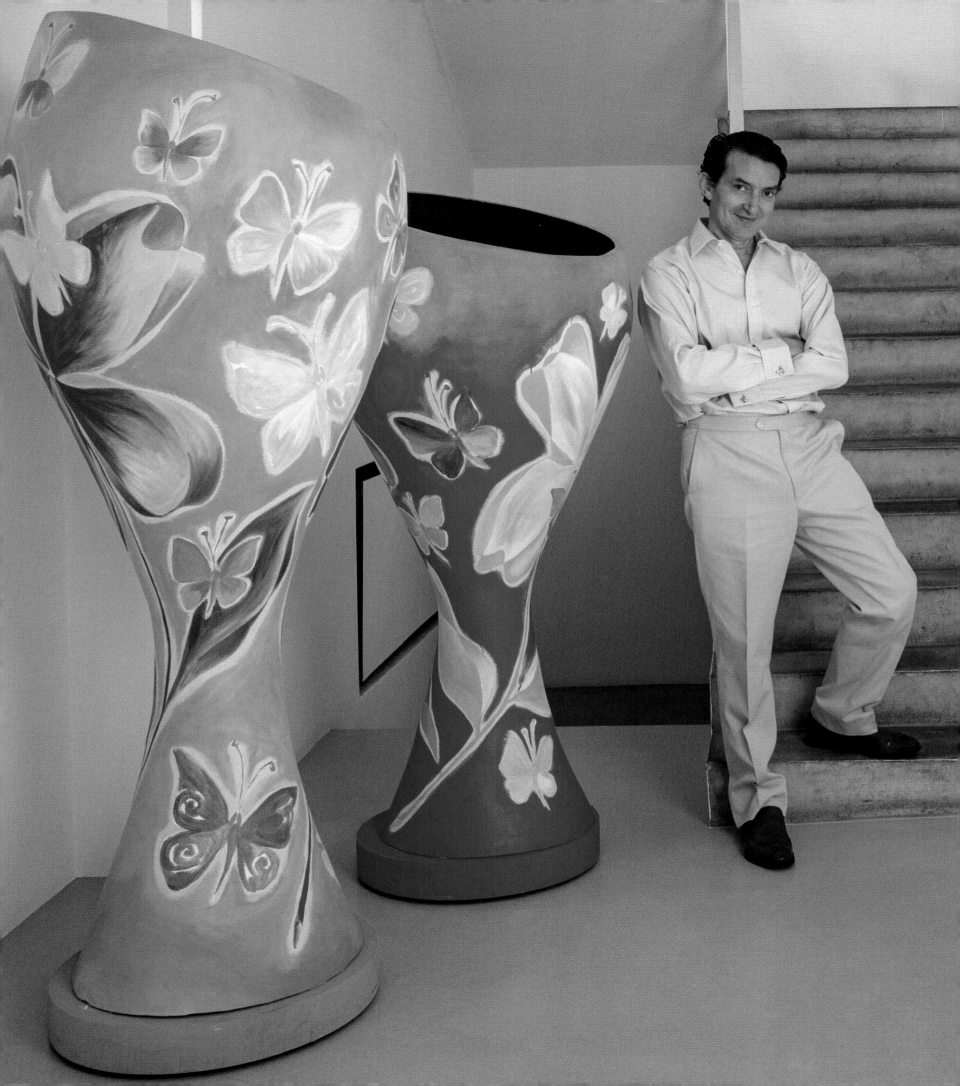

# WHAT IS DESIGN-ART?

I feel privileged to introduce you to the creativity and innovation of David Gill and David Gill Gallery. Working with some of the best artists of our time, David initiates collaborative designs of three-dimensional furniture, accessories and sculptures based on their art. In thirty years, David has almost single-handedly created the increasingly important field where contemporary fine art morphs into design editions. Influenced by a youth spent in different pockets of Europe, as well as having a "natural eye" for the aesthetics of the unusual, he has broken down the barriers between art and applied art.

David Gill was born in the early 1950s and brought up in Zaragoza, the capital of the mediaeval kingdom of Aragon in North East Spain. His father worked in property and was away a great deal, so his mother raised his elder sister, brother and David in a matriarchal custom, as was not uncommon in Spain at the time. David often went with his mother to her dressmaker and to the cinema; he looked at her magazines and became interested in fashion, style and design. He was thirteen when he first left home for boarding school, but then returned after a year and went to study at Toulouse University to keep abreast of his French. Thereafter, he persuaded his parents to let him live in Paris for a year, on his way to university.

"It was Paris that opened me up," he remembers. "Paris made me want to share the beauty I saw all around me, and this was when I discovered all the amazing designs of the Twenties and Thirties that no one at the beginning of the 1960s was really interested in, but which I had seen on films and in magazines. That year was really like a sabbatical –

I didn't really study, but took a break. I lived in a tiny studio apartment in the Marais and at night went to the club le Sept, a tiny dining and disco club in Rue St Anne owned by Fabrice Emaer. It became my haunt, where I met fashion and interior designers. During the day I visited museums and galleries and discovered many things from the past and the present – fashion, style, ballet, design."

"I got my buying 'eye' from many visits to the Marché aux Puces where you could find things for nothing. This was where I discovered the chair by Emilio Terry which had belonged to Carlos de Beistegui. The stall it was stood on was closed; I waited for hours until he opened, and I bought the chair, which I still have. "There were also three or four dealers on the Left Bank that had slowly started to sell classical Art Deco which opened my eyes to almost forgotten designers like Gilbert Poillerat and Eugene Printz."

*OPPOSITE: David Gill with a pair of Monumental Vases by Grillo Demo, 2003, Loughborough Street Gallery, Vauxhall. ABOVE: Diego Giacometti in his Paris workshop (top left), Eugene Berman, Russian painter and stage designer, backstage, 1960s (right) and Jean-Michel Frank coffee table and "oreiller chinois" terracota lamp with panelled parchment wall behind, 1929.*

"When I returned home, my mother wanted me to go to university in Spain, but I was drawn to life in a big city." So, from Paris David went to London and to Birkbeck College where he studied Seventeenth century Baroque History of Art. The Twentieth century came later. He didn't finish his degree, but instead went to Christie's as a Modern Print specialist and intern in the Picture Department, under Noel Annesley. "At the time they were selling everything together – Old Master pictures, drawings, watercolours and prints right up to, but not really including, Twentieth-century works, which they called Modern Art," David remembers. "It was very interesting because everyone came together to discuss all the categories and subjects. I wasn't an expert; I was more of an administrator, but I listened and, most importantly, I learnt."

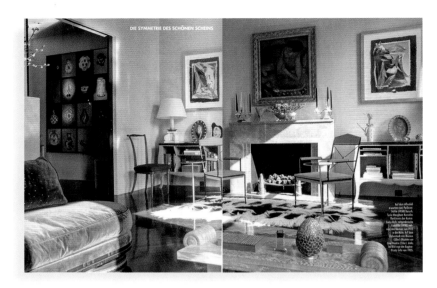

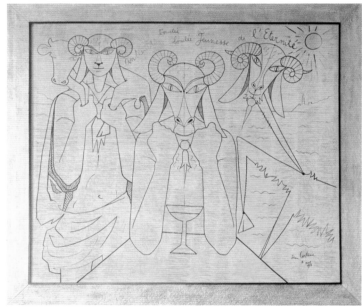

*ABOVE, TOP: Gill's apartment at Lexham Gardens, featured in Ambiente Magazine (Germany), January 1994 Issue.*
*ABOVE: "Antiquité bouclée, Jeunesse d'éternité", ink on paper, Jean Cocteau, 1958.*
*RIGHT: "Chérie", gilded box, Line Vautrin, 1950.*
*OPPOSITE: Gill's apartment at Lexham Gardens, featured in Architecture & Wohnen Magazine (Germany), December/January 1994 Issue.*

He also went to houses all over the world on valuations and he feels that these experiences were his true education: "My time at Christie's opened my eyes more and more to the Twentieth century, and I began to realise that the best accolade you could give yourself was to live with art from today. I was looking at the work of Picasso and Fontana with Art Deco and the neo-romantics as a reference and then I slowly began to discover contemporary art."

He was living, at the time, in a large Italianate flat in Palace Gate, and in 1987 decided, with no money, to open his own gallery, with shows selling the neo-romantic furniture and art he had been discovering in Paris. But he didn't have the money to lease the small shop he had set his eye on in Fulham Road – until he realised that the tiles surrounding the fireplace at Palace Gate were rare blue and white Seventeenth-century delft and he removed and sold them. With the proceeds, he immediately started his business.

It was in his early days as an art gallerist in this bandbox boutique in Fulham Road, Chelsea that I first met David. In his first exhibitions, one was always sure to re-discover some of the forgotten, but most important and influential, names in art and design from the inter-war years. David unearthed these treasures during a lengthy stay in Paris, on his many visits to the Marché aux Puces, the auctions at Drouot and in the emerging specialist galleries on the Left Bank which dealt in important neo-romantic and modernist designers of the inter-war period, some of whom had all but faded into anonymity.

His first London show, at his Fulham Road gallery, was on the inter-war art objects and furniture of Alberto and Diego Giacometti. Further ground-breaking exhibitions followed, featuring neglected artists and designers such as Jean Cocteau, decorators like Jean-Michel Frank, whose inter-war shop and practice was the centre of a highly creative group of artists and designers, and later the "poet of metal" and ceramicist Line Vautrin.

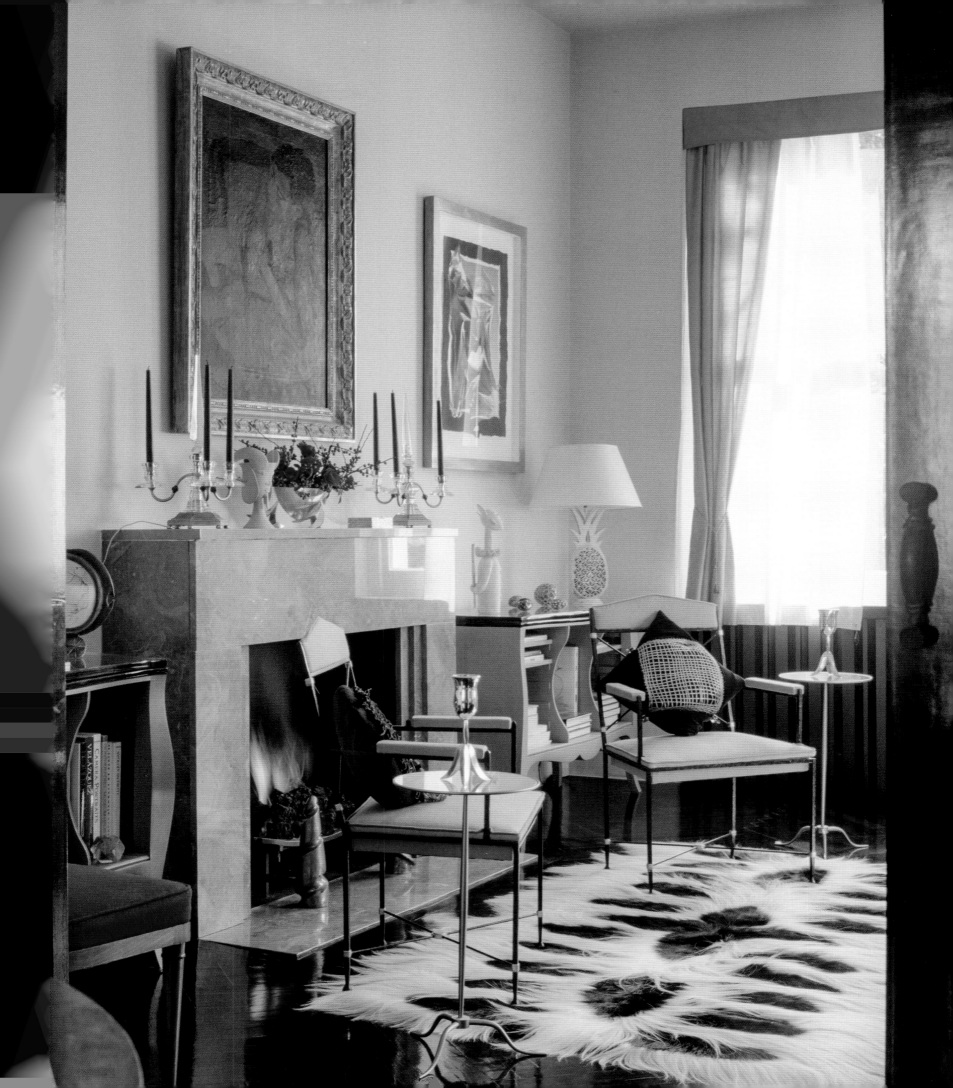

There was always something magical, both old and very new, to discover in this small boutique, from Cartier-Bresson's photographs of Antoine's metal wigs in the "50 years of Fashion" show, to Donald Judd's minimalist wall shelf installment (the first time Judd's work was shown in London), and the first London exhibition of Grayson Perry's ceramics. With David's visionary thought and gift for understanding art that resonates, collaboration became an inevitable development.

The precursors of this movement linking art and design can be traced to pre-war surrealism and the crusading figures of Salvador Dali, and his patron Edward James. James was the rich son of an Edwardian industrialist and Dali, the rampaging creative surrealist force. This was the perfect partnership of art and design whose most famous collaborations were the Mae West lips sofa (which James commissioned from Green & Abbott in Golden Square after a painting by Dali), followed by the lobster telephone, and later by standard lamps featuring metallic champagne coupes. When James took over his parents' small summer retreat, built by Lutyens in the hills above his main house in West Sussex, Dali spattered the stair carpets with dog paw prints, the bedroom carpet with the wet foot marks of Edward's ex-wife, the dancer Tilly Losch, and curtained the outside of the house in metal swags.

David Gill found his own Dali figures in the form of Elizabeth Garouste and Mattia Bonetti, two French designers well-known in Paris, who were combining their already-established original neo-Baroque revival furniture with motifs from the uncharted seas of "Barbaric Baroque", going back to the dawn of art for inspiration. This collision of history looked entirely new. When David showed the Garouste & Bonetti "Prince Imperial" and "Barbare" chairs in the window of his shop they caused a genuine sensation among passers-by and regular clients, including David Mlinaric, Jacob Rothschild, Doris Saatchi and the art critic David Sylvester. Garouste left the partnership in the mid-1990s and since then, David and Bonetti have worked together, producing nine collections of three-dimensional art.

Further avant-garde adventures with architects such as Zaha Hadid, and artists such as Barnaby Barford and Fredrickson Stallard in the UK, were followed by collaborations with Jorge Pardo and the Campana Brothers, discovered by David in his travels round the world. He encouraged them to make furniture sculpture and accessories, which he showed at Fulham Road, then in a loft-like building South of the River Thames in Vauxhall, architected by David after New York lofts he had admired. Later the pieces became prominent features in important interior schemes for private clients as well as in David's own homes, developed with the designer Francis Sultana. Now, after thirty years, *David Gill Editions* are shown in his spacious galleries in King Street.

David has exhibited all over the world, and works from the gallery can be found both in public and private collections, including the Victoria & Albert museum in London and the Museum of Modern Art in San Francisco.

In recognition of his work, David has been awarded the Chevalier of the Ordre des Arts et des Lettres and subsequently was made an officer of the Order.

This book showcases the demanding and provocative results of contemporary art reimagined through the eyes and mind of David Gill – aided by his partner in business and in life, Francis Sultana – into extraordinary three-dimensional design.

## Meredith Etherington Smith

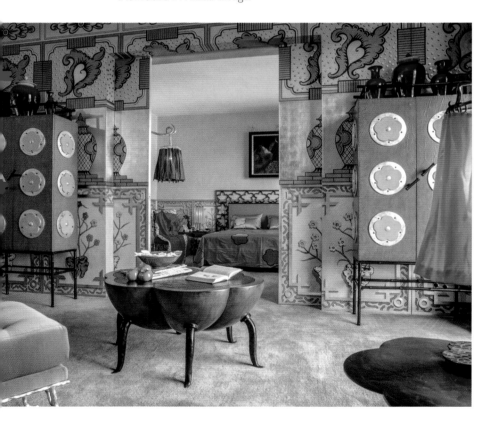

*LEFT: Nelson Woo's Hong Kong apartment showing Mattia Bonetti designs supplied by Gill, featured in Elle Deco, 1996.*
*OPPOSITE: David Gill stands by "Picabia", by Paul McCarthy, in his apartment at his Loughborough Street Gallery, Vauxhall, London.*

# FULHAM ROAD
# 1987–1999

David Gill Gallery was established in 1987 behind the rendered cement, sand shopfront and imposing floor-to-ceiling window of a little bandbox boutique in the Fulham Road, still the haunt of artists at the time, many of whom, such as Jim Dine and Sandra Blow, lived in the studios behind the shop. Though the Fulham Road was termed "the decorator's dream" with everything from OF Wilson, Apter Fredericks and Robert Dickson antiques jostling with the contemporary Oggetti and Lewis Caplan Associates objects of the Twentieth century, the David Gill Gallery refused to blend in. Hemmed in by shops with Nineteenth-century façades selling Georgian furniture, chintzes, wedding dresses and costume jewellery, and next door to an old-fashioned pub, this little shop commanded an identity of its own. Its contemporary aesthetic, juxtaposed with Georgian and Victorian antiquity, meant it immediately attracted attention, much like the work it housed.

Collectors, designers and critics flocked to the "jewel box" on Fulham Road which exposed work and artists David found exhilarating and inventive. He had an eye for art that was unexpected and yet demanding: bold statements that asked more questions than they answered, arresting pieces that challenged the purveyor to befriend them. And herein lay his visionary gift. He introduced London to art it had previously been blinkered to, and which demanded a dialogue.

David Mlinaric wasn't alone in his understanding and appreciation of what David was doing – he became a great collector, as did Jacob Rothschild, the art critic David Sylvester, and Charles Saatchi's first wife, Doris. The small gallery became a club for collectors, artists and journalists interested in viewing pieces that couldn't be seen anywhere else in London.

*"Where have you been?"* cried the pre-eminent interior designer, David Mlinaric, as he stopped his car outside the gallery.

Here, David soon became well known for showing period classics including works by Jean-Michel Frank, Gilbert Poillerat, Eugene Printz and Alberto and Diego Giacometti whose sculpture and furniture was the first show David put on at Fulham Road, together with furniture by Jacques-Emile Ruhlmann. Later the gallery showed works by Charlotte Perriand, Jean Prouvé and Line Vautrin, amongst others. New, contemporary artists had their first exhibitions in London, notably Donald Judd's aluminium shelves, Grayson Perry's ceramics, Nicholas Alvis Vega's chairs and Oriel Harwood's ceramic Baroque pieces – all of which debuted in the small David Gill Gallery.

Jean Cocteau plates were collected for a special centenary show, and jostled with neo-romantic artists such as Christian Bérard and Tchelitchew on the walls. Pride of place was given to the large Baroque chair David identified in the Marché aux Puces. It had belonged to the inter-war patron of the applied arts, the South American Carlos de Beistegui, and had been used by Le Corbusier on the famous roof-top drawing room the architect had designed for de Beistegui in the 1930s, complete with working fireplace, all open to the Paris sky.

### DAVID GILL
#### DECORATIVE & FINE ARTS

60 FULHAM ROAD · LONDON S.W.3
TEL. 589 5946

*OPPOSITE: Gill at the window of his gallery, 60 Fulham Road, 1988*
*LEFT: David Gill's business card, Pierre Le Tan, Ink on Paper, 1987*

*Portrait of Reggie by Pavel Tchelitchew.*
*Pastel. Circa 1930.*
*Provenance: Leonid Berman.*

*Monumental chair. Painted carved wood.*
*Bavaria, 19th century.*
*Provenance: Norman Hartnell.*

*David Gill commissioned Pierre Le Tan to illustrate catalogues for several of the early*
*exhibitions at Fulham Road; the cover and two pages from his first, in 1987, are above.*

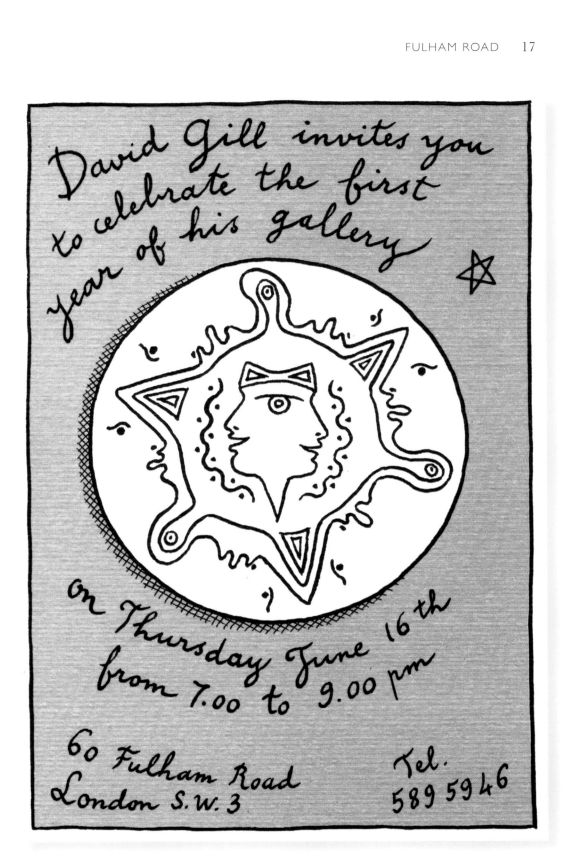

*Cover for the 1989 Cocteau exhibition (top left) which included the "Petit Faune" (left)*
*and the Invitation to the Gallery's First Year party, by Pierre Le Tan, 1988 (right).*

Line Vautrin

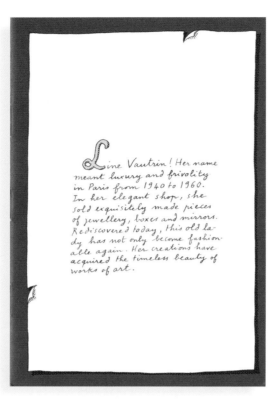

ℒine Vautrin! Her name meant luxury and frivolity in Paris from 1940 to 1960. In her elegant shop, she sold exquisitely made pieces of jewellery, boxes and mirrors. Rediscovered today, this old lady has not only become fashionable again. Her creations have acquired the timeless beauty of works of art.

Lapel pin · Bronze doré

Brooch in bronze doré

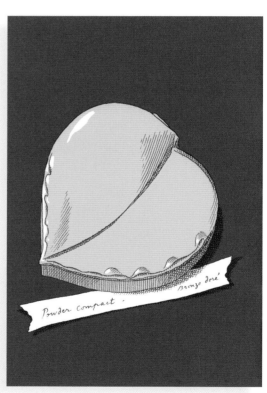

Powder compact ·   bronze doré

ABOVE: Cover and pages illustrated by Pierre Le Tan for the Line Vautrin exhibition at Fulham Road, 1988, together with "Gold Amphora" brooch and "Poudrier Feuille" powder compact, gilt bronze, 1950s.
OPPOSITE: "Mazarin" Mirror, c.1960, decorative and jewellery items by Line Vautrin displayed in the 1988 exhibition of her works at Gill's Fulham Road Gallery.

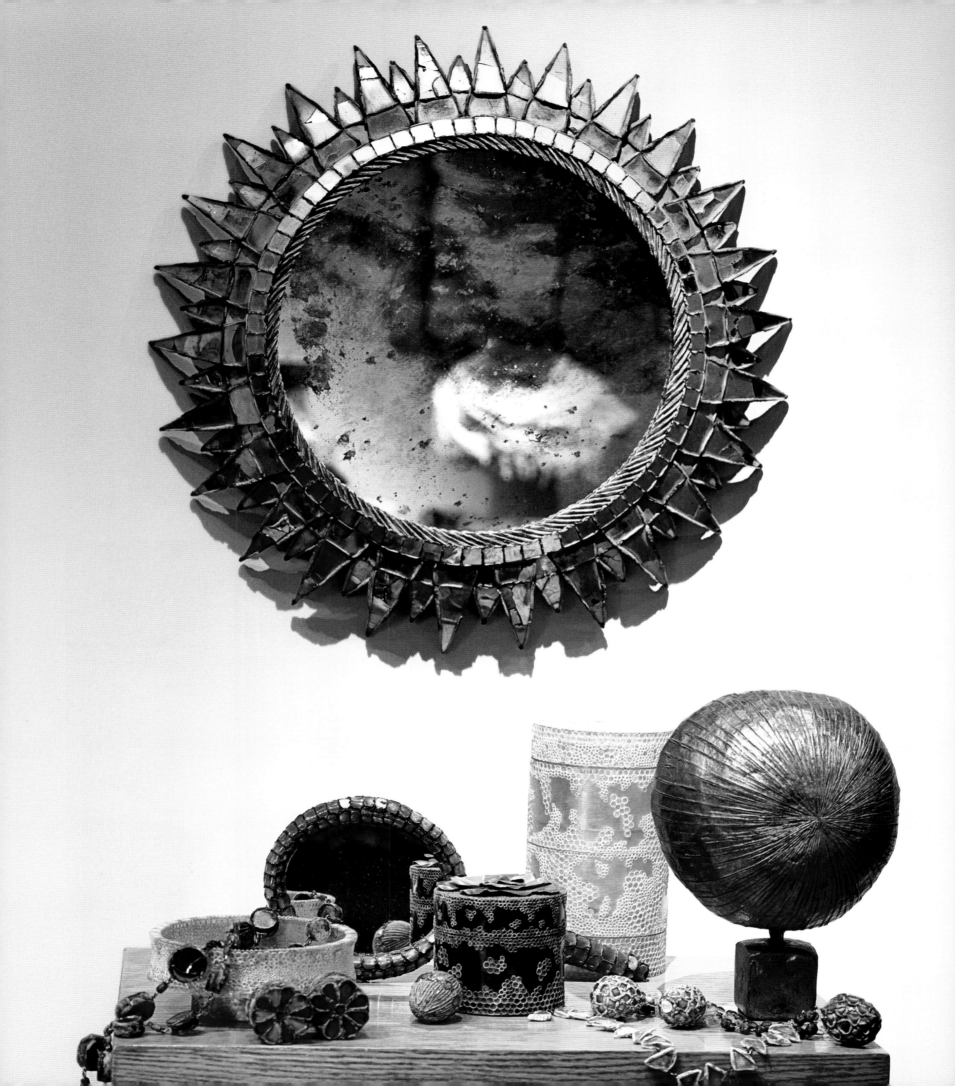

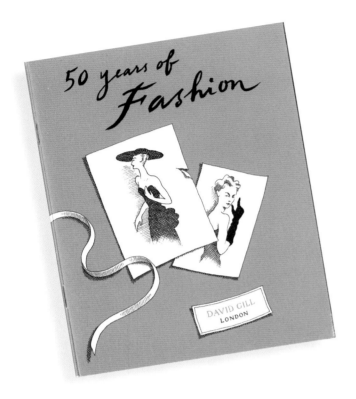

*Photograph by Brassaï of a hairstyle sculpted by Antoine*

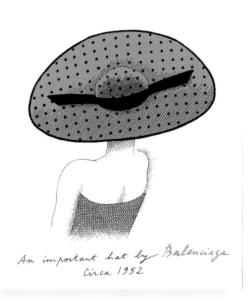

*An important hat by Balenciaga Circa 1952*

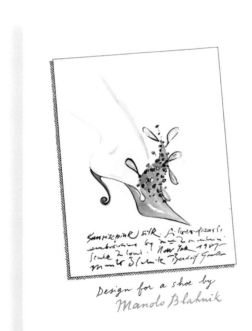

*Design for a shoe by Manolo Blahnik*

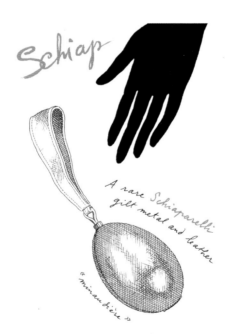

*A rare Schiaparelli gilt metal and leather*

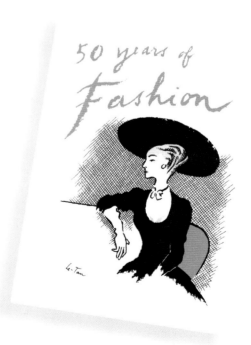

*Cover, page spreads and invitation, all illustrated by Pierre Le Tan, for Gill's "50 years of Fashion" exhibition, November 5–December 31, 1987.*

The initial success of the gallery provided David with opportunities to be more than a gallerist. Though not an artist himself, he sought to work with contemporary artists to create complementary collections, provoked by original work, but unique to the symbiotic relationship formed between the artist and the gallerist. Consequently, in 1989, *David Gill Editions* was created. Contemporary art now began to be valued not just for its own sake, but also as the prototype for a limited-edition series of objects exclusively produced by David. This endeavour has produced a body of work which encompasses art, architecture, jewellery, lighting, furniture, objects such as candlesticks, carpets, textiles and silverware, and even entire rooms and houses.

The first of these prototype projects began in 1988, born from an exhibition of French furniture designers called Avant Première at the V & A Museum, sponsored by the French government under the influence of the then Minister of Culture, Jack Lang, which was designed to re-establish Paris as the centre for innovative design – as it had been before the Second World War.

The original intention was for each of the twelve designers in the exhibition to show individually in a satellite gallery after the group show in the V&A. In the event, David was the only gallerist who selected designers for a show. These designers were the then partnership of Garouste & Bonetti, whose neo-Baroque designs for the new Christian Lacroix Haute Couture house and for Le Privilège, the restaurant at the Palace nightclub, had already firmly established them amongst the avant-garde in Paris, selling to art galleries and working on increasingly important commissions such as the refurbishment of Picasso's château Boisgeloup outside Paris for the artist's son, Bernard.

At the time that they showed in the V&A, Garouste & Bonetti were radically changing direction, away from the neo-Baroque with which they had made their name in Paris, to something much more challenging and original; they were diving into pre-history and primitive art and design for inspiration. And they didn't disappoint.

When the raffia "Prince Imperial" and roughly thonged "Barbare" chairs were first shown in the window of the Fulham Road gallery, they caused a sensation because they defied the neo-Baroque and minimal Modernism fashionable at the time. Instead, the "Prince Imperial" meshed resonances of French royalty with Zulu Africa in a jarring dialogue on power and tragedy. The, now infamous, "Barbare" chair dared to demand consideration of a time when furniture had little to do with the ideals of comfort and status it had since claimed. The window of David Gill's Fulham Road gallery, with its artistic embodiments inspired by the past, was displaying the future – as his windows have done ever since.

*Prince Imperial Chair, wood and raffia, from Garouste & Bonetti's "Autumn Leaves" exhibition at Gill's Fulham Road Gallery, 1988.*

# Autumn Leaves

The first show Garouste & Bonetti worked on with David Gill was taken from Bonetti's favourite natural inspiration, and was called "Autumn Leaves." It featured a sofa standing on a woven carpet, both of which incorporated a leaf motif. Groups of small buttoned chairs and tables on bronze legs in the neo-primitive manner completed the vanguard exhibition. David was instrumental in the design process, whereby the pure idea was developed through the work of specialist craftsmen to assume three dimensions.

In the introduction to the "Autumn Leaves" Limited Edition catalogue, Jacqueline du Pasquier, the influential curator of the Musée des Arts Décoratifs in Bordeaux at the time, made the point that Garouste & Bonetti were completely at odds with Twentieth-century design; however, their sense of fantasy and their freedom from contemporary trends prevailed. "Their objects and their furniture cannot be labelled utilitarian or functional, but neither can they be said to be wholly decorative, superfluous or frivolous," she pointed out. "They revert to a tradition of pomp and refined comfort that is unfamiliar in our own age [...] All this implies not a nostalgic clutching at the past, but a new and deliberate revival of old attitudes. It is their idea of what is true and false, the borderline between illusion and reality, this dreamland that has the greatest capacity to affect us and perhaps explains the great interest aroused by their work."

Thirty years and nine shows later for *David Gill Editions*, specially commissioned pieces are now created for David's major private clients. Bonetti works in a neat white studio in North Paris, with one assistant, in a very particular and unique way. He visualises a piece in his mind, makes an exquisite drawing or painting which, after long discussions with the client or gallery, is then handed over to an army of technical masters ranging from bronze casters to carpet weavers to furniture makers. There may be many iterations in the process from exquisite sketch to finished three-dimensional design before both Bonetti and Gill are satisfied. No one piece in an edition relates as such to any other; deliberately, Bonetti does not do collections. Each piece must stand on its own.

"One of David's strongest suits, certainly in my case, is to launch ideas which are his, and sometimes this can be disappointing because they do not correspond with mine, or don't explain enough to the client commissioning the works." Bonetti sees this as being "both strong and weak, pushing [him] to compose and invent with very little material to start out from."

"It is a long-term relationship, not only focused on design but also in other fields of the arts," he explains. "Strangely enough, we are both, often without knowing, driven by similar forms, sensibilities, tastes, and dislikes!" He admits he tends to look backward more than David, but this is "probably due to [his] upbringing."

*"I try to situate myself and my designs in a gap where things do not exist. And it is this gap I always want to find, to explore all by myself. I don't know whether you can call my work only Design or only Art, it is something in between, where there is a special space."* MATTIA BONETTI

"I don't know what the future will bring us," Mattia muses. "But as far as I am concerned, I hope it will continue for a long and productive time. Of course, it will very much depend on the nature of future projects. It is," he admits, "difficult to say, to predict, to foresee." Whatever the future of the partnership, its history incites a discourse about what it means to inspire, to design, and to create.

ABOVE: *Mattia Bonetti and Elisabeth Garouste, by Jean-Erick Pasquier. OPPOSITE, FROM TOP LEFT: "Boite Pandora" illustration, "Fauteuil" chair, "Kris" side table, "Bougeoir No 5" candelabra illustration, "Autumn Leaves" sofa illustration, "Pois" table illustration and "Carre" mirror, from "Autumn Leaves" exhibition, Garouste & Bonetti, Fulham Road, 1988.*

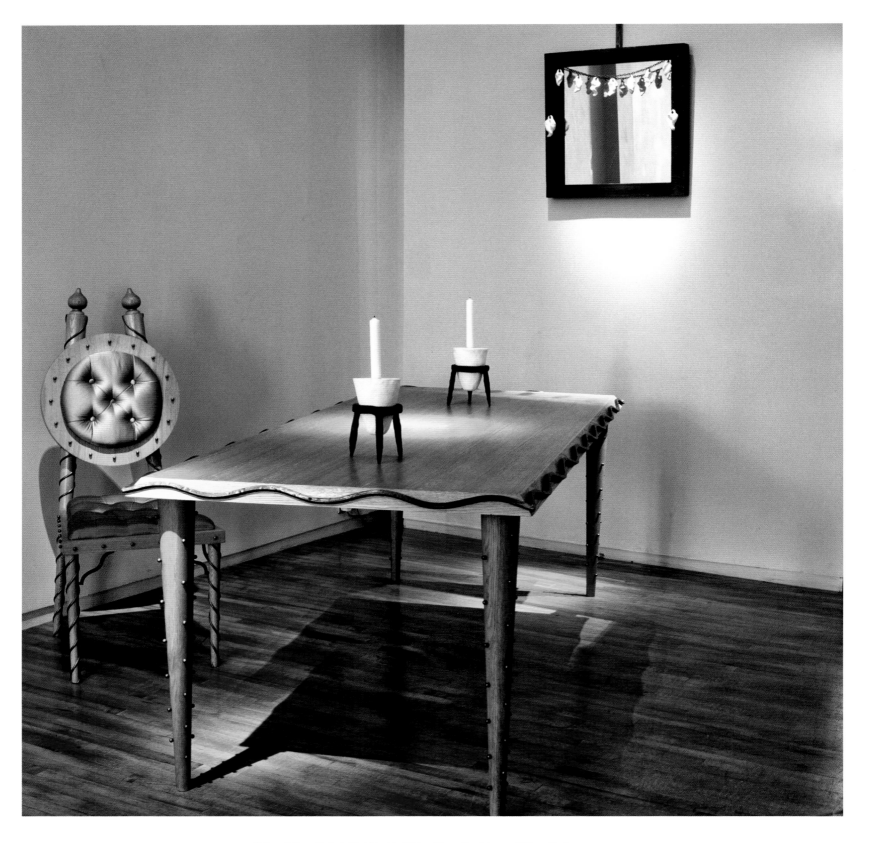

*"Grand Canal" chair, "Pois" table, "Tripod" candlesticks and "Carre" mirror,
from "Autumn Leaves" exhibition, Garouste & Bonetti, Fulham Road, 1988,
David Gill Editions.*

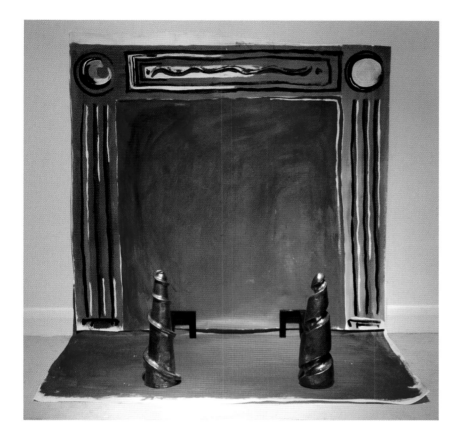

*"Inspirale Espirale" firedogs (top left), "India" guéridon side table (top right), "Boite Pandora" on "Autumn Leaves" rug (below left) and "No 5 Candelabra" on "Cabinet de Terre" (below right), from "Autumn Leaves" exhibition, Garouste & Bonetti, Fulham Road, 1988,* David Gill Editions.

Fulham Road quickly became the venue which drew collectors to emerging, ground-breaking artists they had not yet been brave enough to consider. David Gill's increasing reputation for housing work which excited the senses, and which was unlikely to be found elsewhere in the country, reassured potential buyers and critics that a visit to Fulham Road would be more than worthwhile.

Among the artists David was introducing to a new audience was Donald Judd, one of the most significant American artists of the post-war period, but as yet, unseen in London. David hosted Judd's inaugural show in the capital, and the response to Judd's "Aluminium Furniture" exceeded expectation. Part of the Minimalist movement, though he refused to acknowledge the association, Judd's work epitomised exactly where British interiors were heading, something that David recognised before other gallerists could boast the same vision.

Judd's designs were crafted from industrial materials – steel, iron, Plexiglass and plastic – and were given a polished finish. Each piece was representative purely of itself, and asked an audience to focus solely on the individual work. This literalist vision of art, design and architecture asserted the paradoxical, yet inherent, complexities within simplicity. In an article for the *Financial Times* entitled "Design Dragons" David describes Judd as one of his heroes, alongside Hicks and Messel.

Throughout the 1990s, Gill showcased an eclectic menagerie of objects, from furniture to paintings and jewellery, all of which marked the Fulham Road gallery as a paragon of the avant-garde. In 1992, the Italian postmodernism of Aldo Mondino was followed by a show of Patrice Butler's chandeliers, which in turn preceded Grayson Perry's ceramics. Every season promised a fresh, dynamic interaction with art and the purveyors of objets d'art.

*ABOVE, RIGHT: "No. 60 Bookshelf", painted aluminium, Donald Judd, 1984.*
*ABOVE: "No.45 Chair", painted aluminium, Donald Judd, 1984.*
*BELOW, RIGHT: "No. 56 Desk", painted aluminium, 1984. All from the*
*"Aluminium Furniture" exhibition, Fulham Road, 1990.*

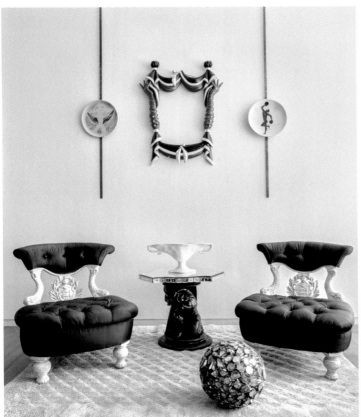

ABOVE: David Gill's Fulham Road showroom in the 1990s.
LEFT: A Brian Irving Mirror, Jean Cocteau plates, a pair of Syrie Maugham's tufted dolphin chairs, a Serge Roche and Syrie Maugham table with vase by Constance Spry, and a decorative ball by Line Vautrin, in David Gill's London gallery, May 1993.
BELOW: "Pompeii" chandelier, Patrice Butler, 1980s.
OVERLEAF, LEFT: David Gill, photographed by Henry Bourne, in front of Aldo Mondino's "L'Architetto e L'Imperatore", 1990.
OVERLEAF, RIGHT: "Lord Biron", oil on linoleum, Aldo Mondino, 1990.

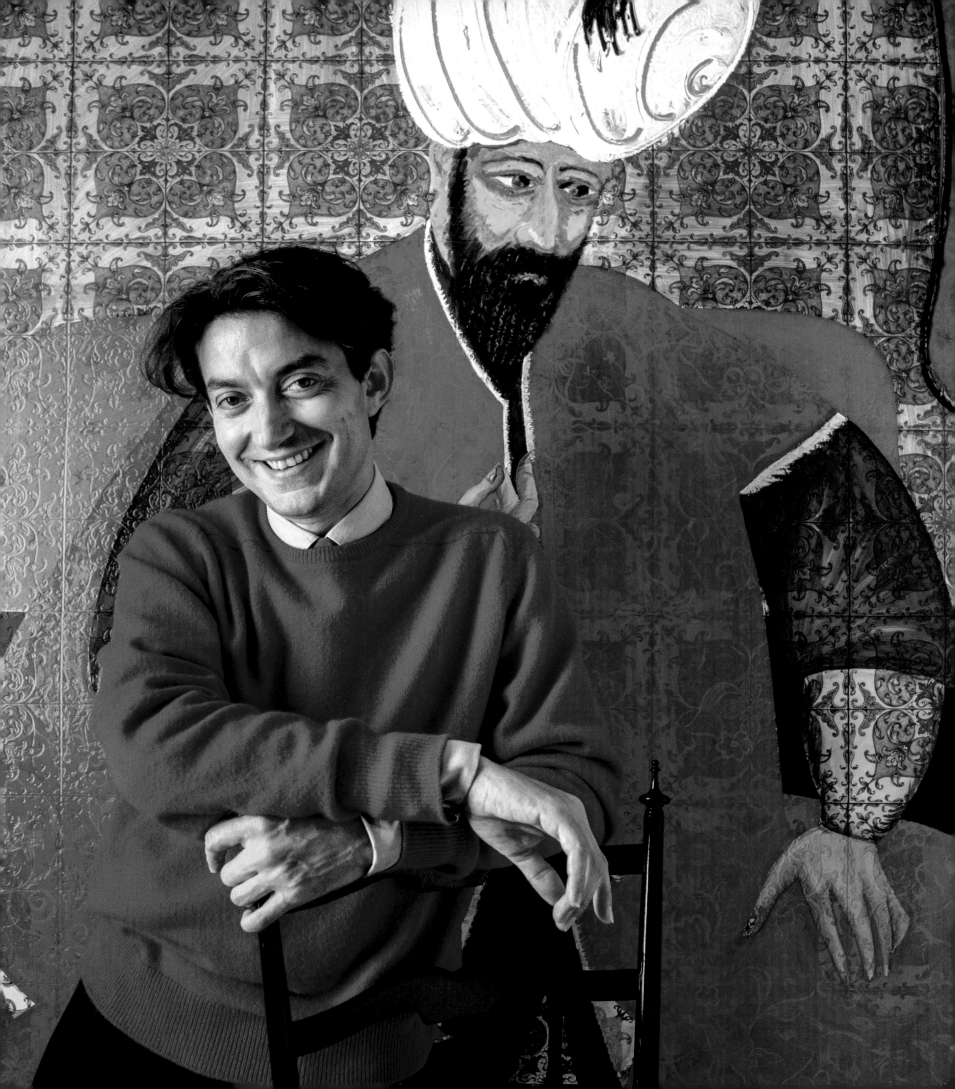

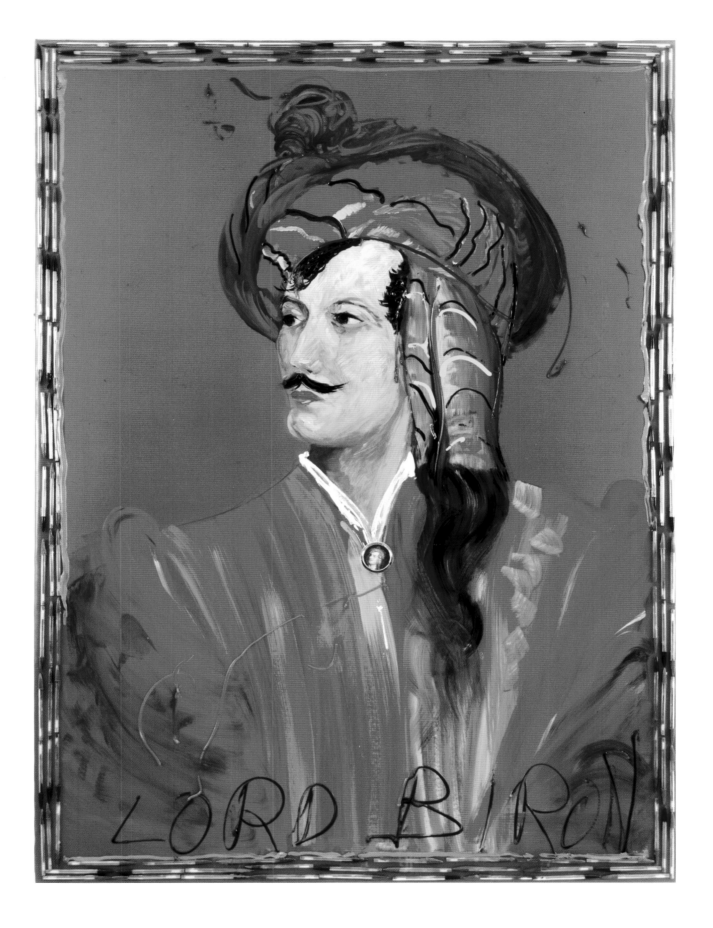

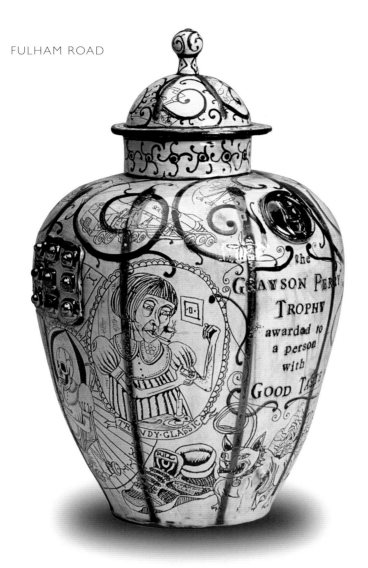

The collaboration between Perry and David Gill became one of the resounding highlights of the Fulham Road legacy. Perry was already making jugs, vases and pots which fought against society's sense of order and convention. Subversive at their most subtle, and seductively outrageous at the polar end of the spectrum, the "wonky" vessels harangue an audience and blur the boundaries between art and offence. Some sport messages to incite: "A Monument to the Unbearable Ugliness of the Working Class"; others portray images of violence, death, and sex. Each of his pieces begs to be touched and poured over, and they seem to reveal more with each conversation one's eyes are permitted to indulge in.

It took a long time for the art world to catch up with David Gill's appreciation for Perry's work. Twelve years after first exhibiting at Fulham Road, Perry received the coveted Turner Prize (in 2003), and he has continued to receive a steady stream of acclaim for his continuing body of work ever since.

Making a modest entry into the show world at the same time was Nicholas Alvis Vega, who David finally persuaded to exhibit at Fulham Road in the early 1990s. David described Vega's furniture pieces as possessing a "potency… which makes them impossible to ignore." Fascinated by the notion of comfort and the "parasitic addiction" humans have with it, Vega aimed to create functional work "with a spirit… that should enhance rather than detract from [a] person's dignity."

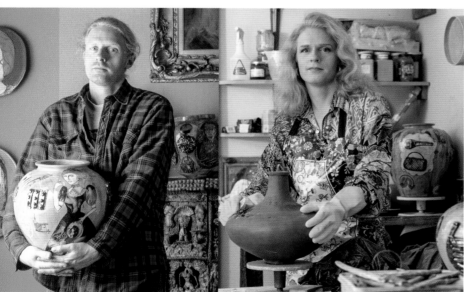

*ABOVE: Ceramicist Grayson Perry/Claire at home and in the studio, 1993.*
*RIGHT: "The Grayson Perry Trophy awarded to a person with good taste" and "My Heroes" vases, exhibited at Gill's Fulham Road Gallery, 1992*
*OPPOSITE: Nicholas Alvis Vega's work, including this brass "Chair", was exhibited at Gill's Fulham Road Gallery, November 1992.*

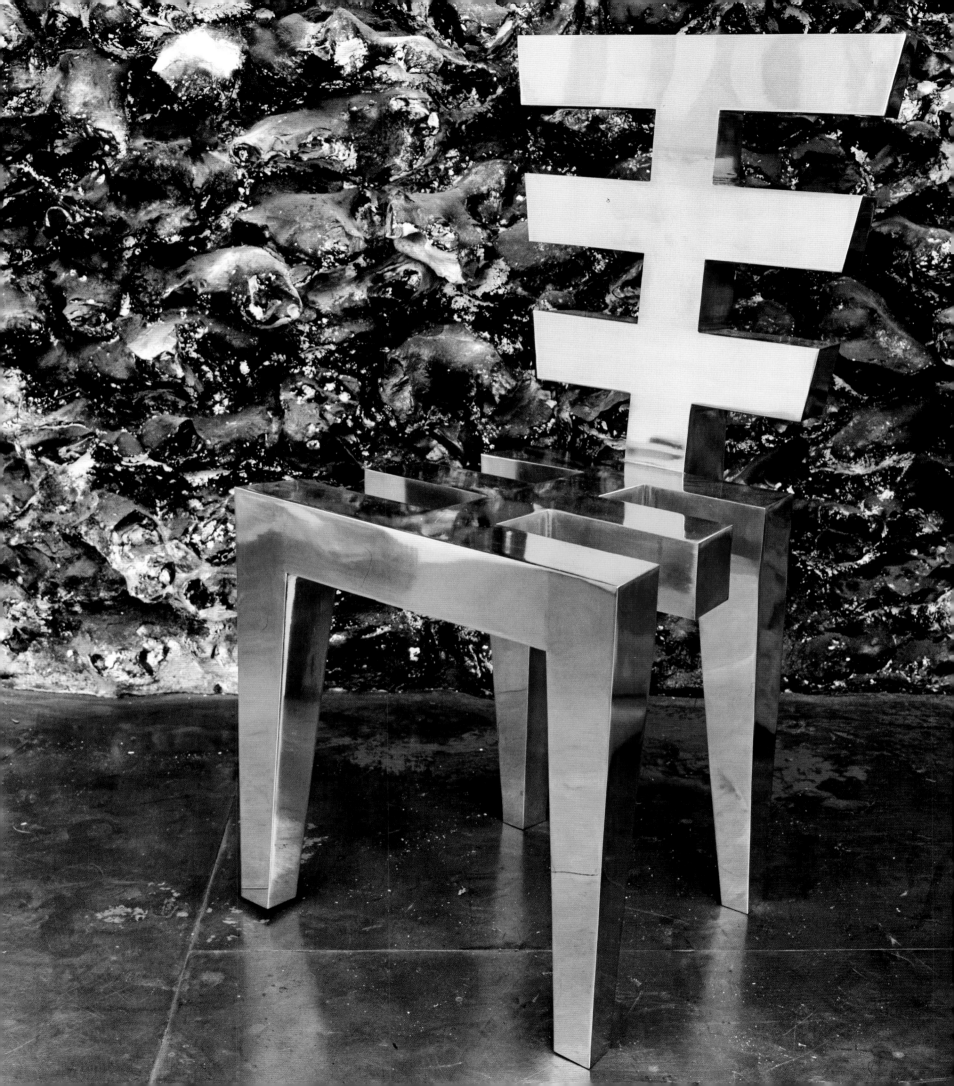

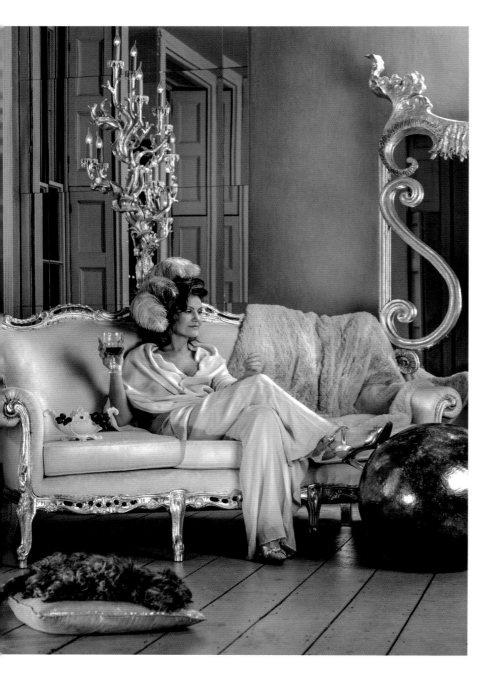

*Portrait of ceramicist Oriel Harwood at her London home, by Armin Weisheit, 2008 (above). Her "Romantic Pieces" exhibition was held at Gill's Fulham Road Gallery in 1998 (opposite).*

Soon to follow in the remarkable catalogue of Gill shows was the ceramicist Oriel Harwood. Her first exhibition at the Fulham Road Gallery was in 1993. She had met David four years earlier, following his esteem for a Harwood mirror seen in the Leighton House museum and gallery.

"I first worked with David on a project in 1991 after he had admired a large faceted mirror piece I had made in the form of a Jacobean jewel," Harwood remembers. Not long afterwards, David asked Harwood to make him a coral and sea life table centre for a client. "I then presented him with some drawings I hoped to realise for a future exhibition. Happily, he agreed, and my first exhibition at Fulham Road happened a year later." This was the first of several exhibitions during the life of the gallery and pre-dated David's move toward cutting-edge contemporary art.

*"David has a fantastic eye. He pushes me to see more possibilities within the development process, to look at the more unusual options, to turn things completely on their head."* ORIEL HARWOOD

"His strongest suit as a commissioning design gallerist is his ever-growing expertise and further reach through the art and design world," she believes. "David has a marvellous ability to put together a stable of fascinating designers and curate an eclectic mix of fine art and art furniture and then create glorious, grand, luxe installations in his St James's Street gallery and for interiors for his private clients' homes."

Further collaborations between Oriel and David have since explored their mutual desire to expand the boundaries of design and expectation as well as their shared respect for the ornate and Baroque.

The 1990s continued with shows designed to exalt what David already recognised as sensational, including the cushions, furniture and accessories of Ulrika Liljedahl, the silver and gilt tableware "personalities" of Richard Vallis, and the cross-continental fusion of style and sculpture in Richard Snyder's cabinetry, as well as continuing to showcase the evolving collections of the established elite such as Line Vautrin and Garouste & Bonetti.

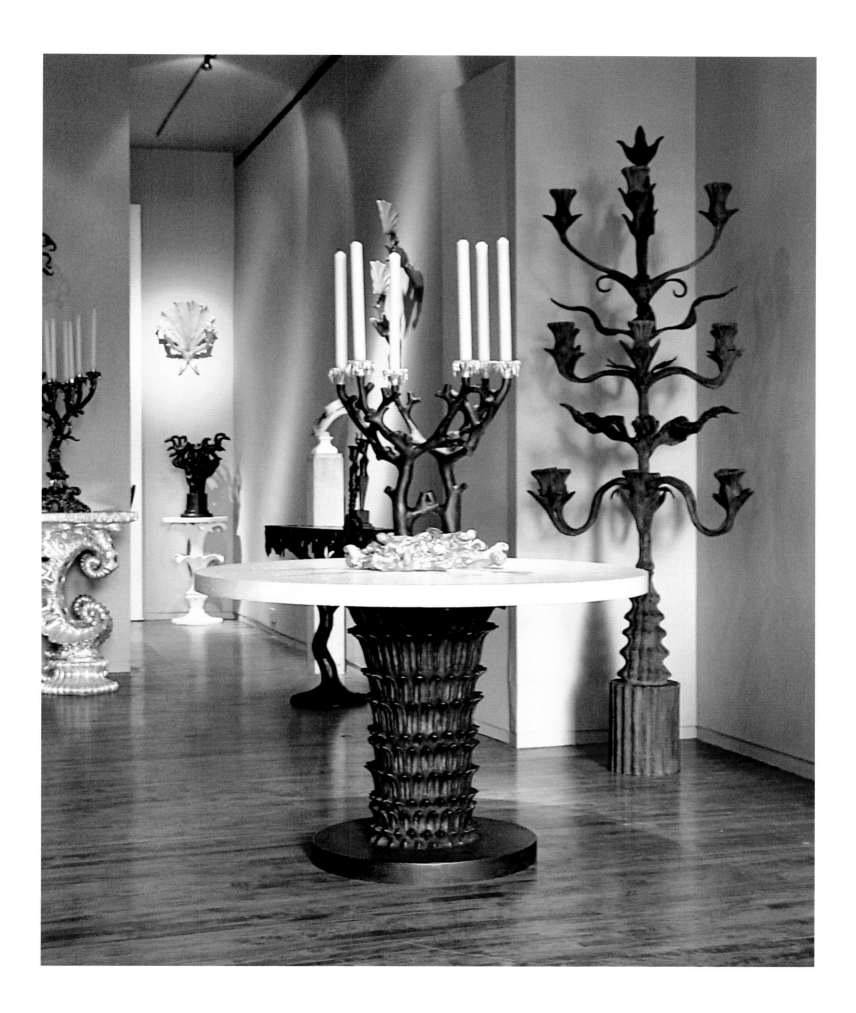

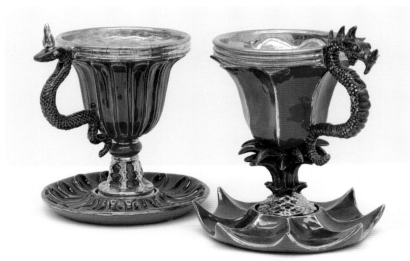

CLOCKWISE FROM LEFT: A selection of Oriel Harwood pieces: "Leaf Mirror" reflecting Garouste & Bonetti's "Tripod" candelabras; "Snake" and "Dragon" cups and saucers and, from left, "Cloud", "Flaming Orb" and "Minotaur" candlesticks, from "Flights of Fancy", 2005. Below left, "Shell" wall sconce, from "Ornamental Excess", 2002.

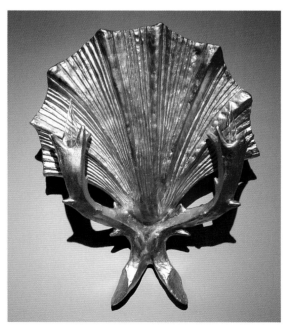

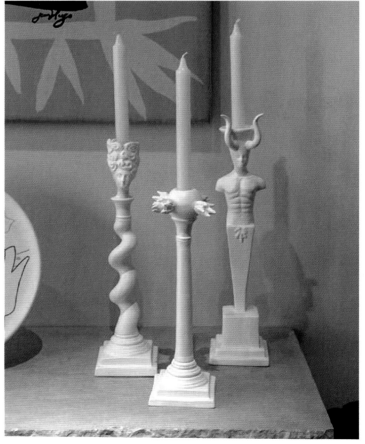

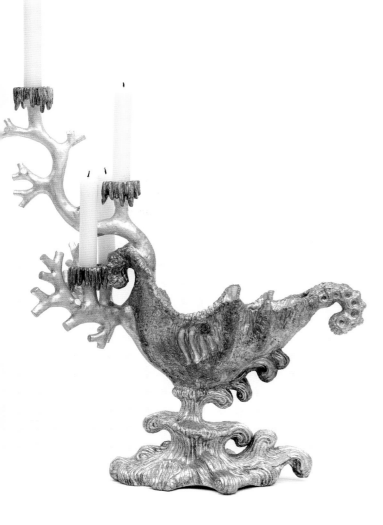

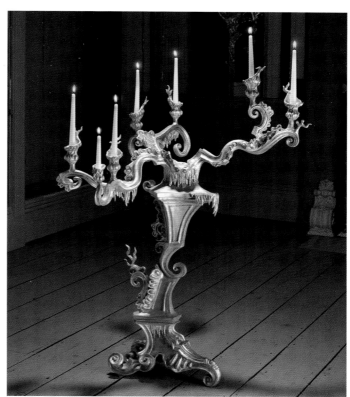

CLOCKWISE FROM ABOVE: A selection of Oriel Harwood pieces: "Voluta" gilt metal table, 2009; "Poseidon" candelabra, from "Flights of Fancy", 2005; "Voluta" candelabra, 2009; "Wings head" bronze, and "Coral Grotto" wall appliqué, from "Ornamental Excess", 2002.

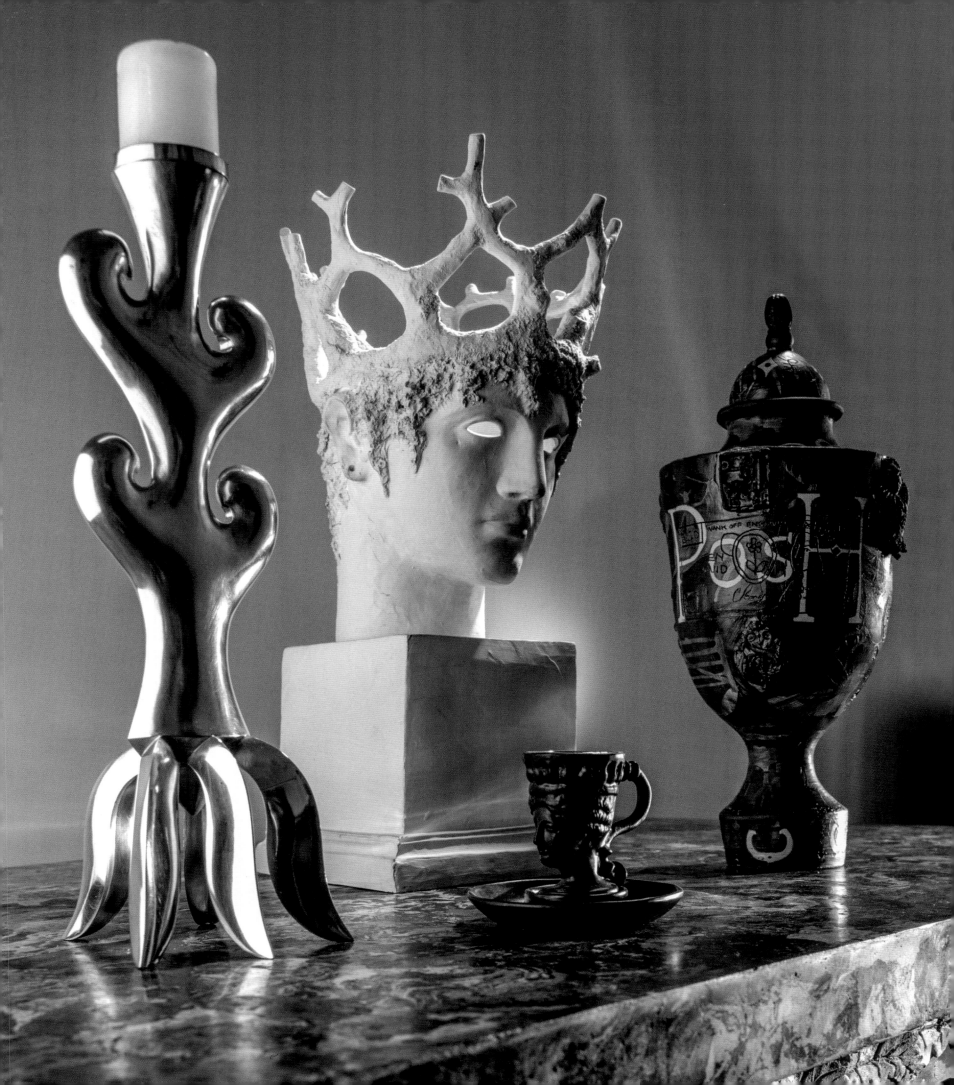

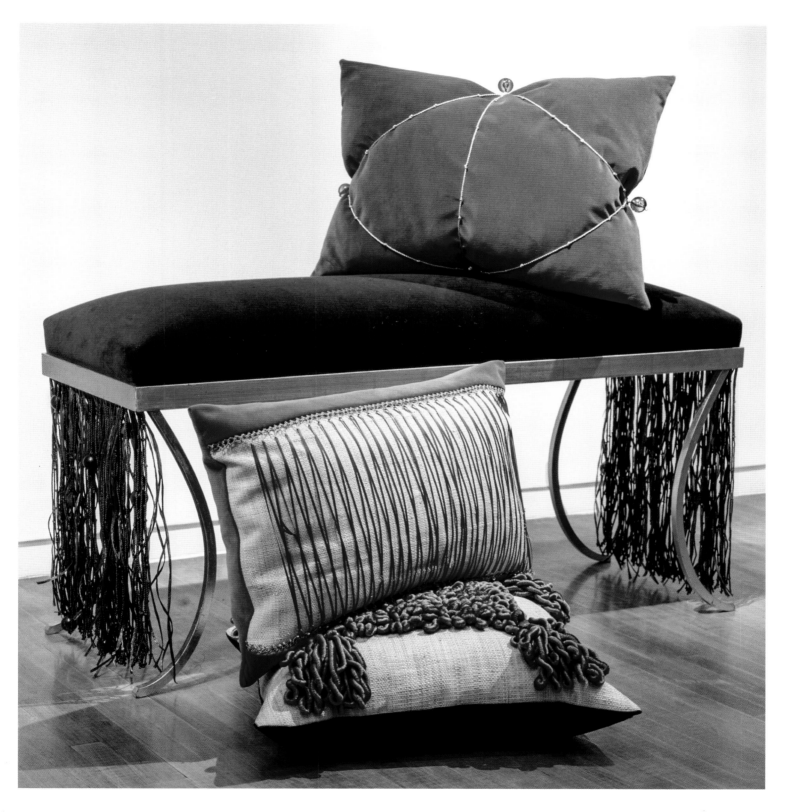

OPPOSITE: Silver Candlestick by Richard Vallis, "Coral" ceramic head, and cup and saucer, by Oriel Harwood, "Posh" urn by Grayson Perry, 1992, featured in Elle Decoration, October 1994.
ABOVE: Gill exhibited textiles and soft furnishings by Swedish designer Ulrika Liljedahl at Fulham Road in 1993.

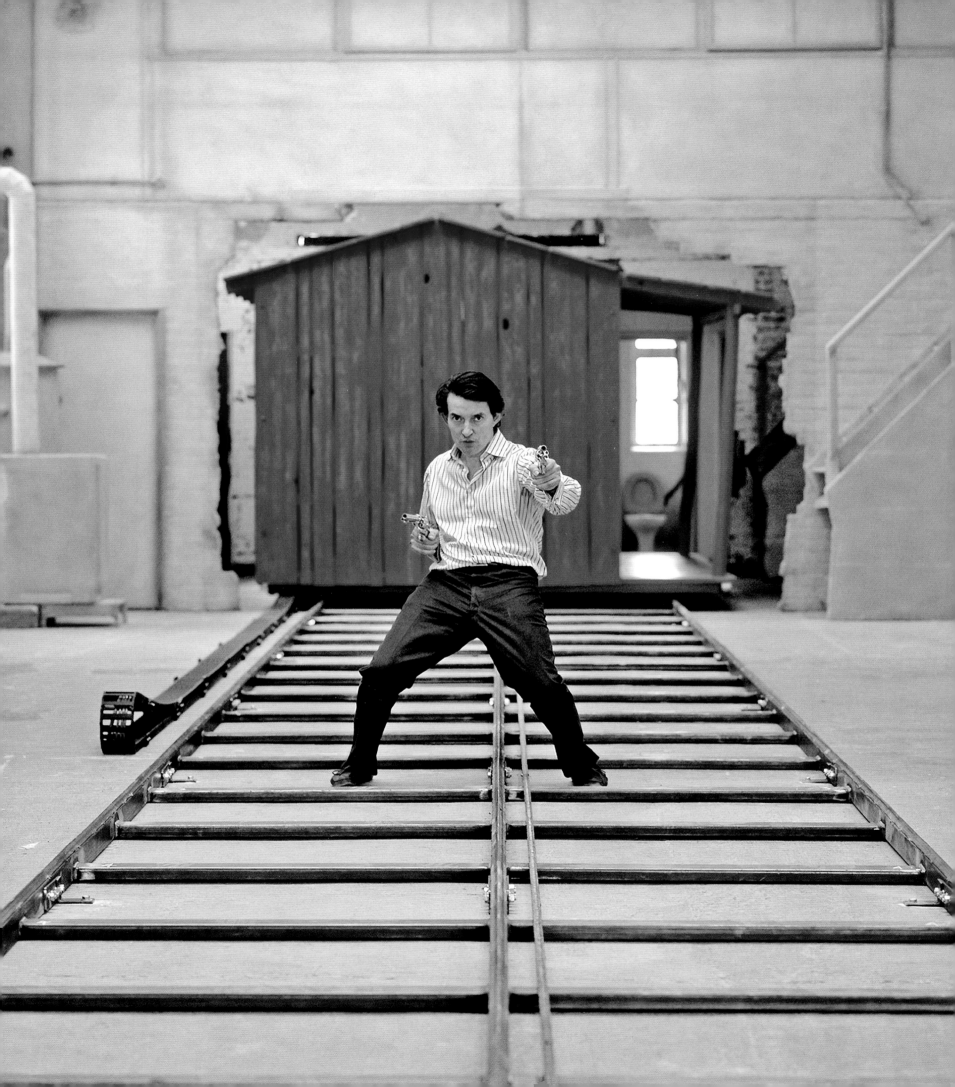

# LOUGHBOROUGH STREET 1999–2012

After ten years, and many successful shows of essentially small pieces such as the intoxicating jewels of Line Vautrin, in the Fulham Road gallery, David realised he had underestimated how important a much larger space was going to be to the contemporary art and applied art shows he now wanted to put on. "After each show, I would have to empty the shop, and put the entire exhibition into storage. Nobody saw it again – all the unsold treasures from the shows I had done over the years just disappeared," he says. He had been inspired by the vast spaces of the fashionable lofts worked and lived in by artists and gallerists he had seen in downtown New York, and it became his ambition to live and exhibit in a similar huge, loft-like space in London. But, in those days, there were no lofts as such in London.

"The idea of a loft building was that it would give me the breadth of being able to create family groups of small pieces – like the Jean Cocteau plates and Picasso ceramics from previous shows – in the mezzanine rooms, which was where I wanted to live, and yet have an amazing space, like a museum on the ground floor. In fact, I must admit that some people could not read the furniture as it might appear in a home environment because the volumes were so vast," he remembers.

Keeping the original gallery, which showed items for his growing decoration business, David made a brave move away from fashionable Chelsea, and bought a former handbag factory originally discovered by the designer Tom Dixon. Built in the 1930s, the new gallery was situated in a building south of the river, on Loughborough Street, in a fairly unrefined area just off the Kennington Road: not a thriving hub of culture and art.

In a monumental effort to craft the existing space into something which would complement art, David redesigned the structure of the edifice himself. An engineer lived in the building for almost a year, constructing a mezzanine which was arrived at via a very long metal staircase. The staircase led from the vast ground floor exhibition space to various rooms on the mezzanine, including a private living apartment for David which could also be accessed from the tiny lobby.

*"I made it less of a loft and more of a space, designing the interior of the building myself. Inspired by the architecture of Corbusier, I knocked all the internal walls down, placed columns to create the volume and poured cement on the floors."* DAVID GILL

*LEFT: David Gill in front of the "Yah Hoo Town Bunkhouse" installation, Paul McCarthy, Vauxhall, 1996.*

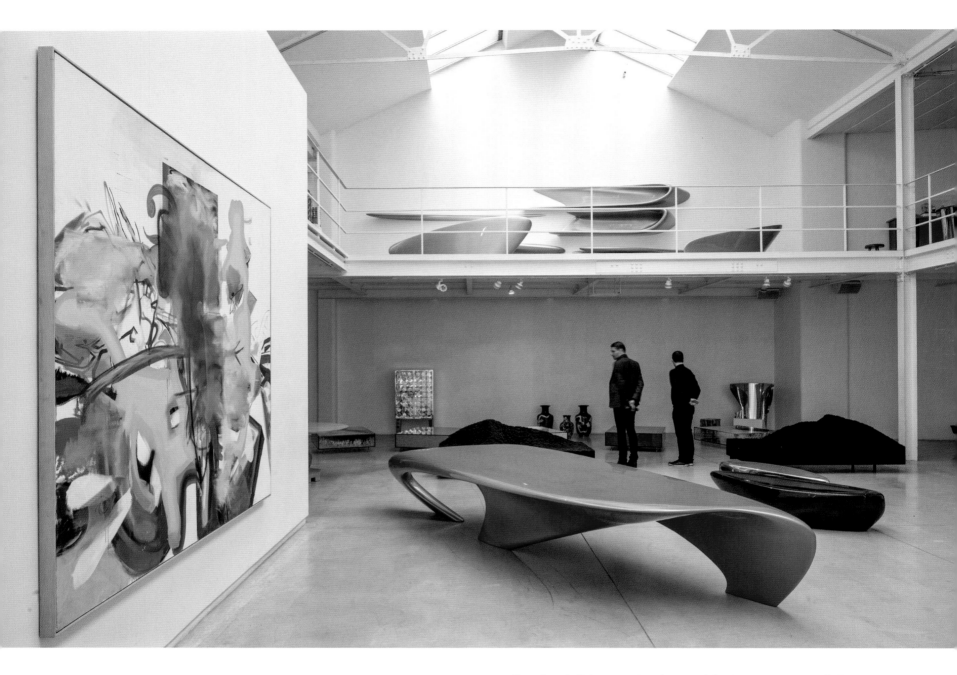

"I enjoyed living upstairs for a while; it was a novelty," David reminisces. I threw lots of parties and we had fun. Pieces from Fulham Road exhibitions sat next to contemporary applied art pieces from Mattia Bonetti and art pieces like 'Bunny Girl' by Sarah Lucas. I didn't want much in terms of knowing people who lived around the gallery – people would be invited for lunch or dinner from the other side of the river, so I wasn't really aware of the neighbourhood outside the metal-framed windows."

Showing work within his own living space was a revolutionary concept, and his treatment of the gallery downstairs was no less innovative: "What was great about the main part of the ground floor was the lighting – I was super optimistic about what I was doing, but I hadn't thought about the budget, which was unstoppable," David recalls. "I devised all these floating walls and spaces, painted them white and then lit them with shades and washes of colour which I could change to anything I wanted… blue, pink, yellow. I remember Lord Rothschild came to have a look and said, 'Where is the lighting?' It was not necessarily ground breaking, but it was well before many architects had used it extensively."

David's first major exhibition in the new space was with Mattia Bonetti, now working on his own without Elizabeth Garouste, for which the collaborators came up with a totally new breadth of work – quite different from the neo-Baroque work of Bonetti's earlier collections. These large monochrome cabinets in silvery metal were distinctive from previous exhibitions in their space-age neutrality, engineered drawers and overall geometric precision.

"We went the whole way," David fondly recollects. "We made a chest of drawers for which we had to find metal an eighth of a millimetre thick, which was almost impossible. We also made a 'Fakir' cabinet for which we sourced 25,000 cylinders, all of which were hand polished."

This was a challenging show, dissimilar to those Bonetti and David had done before; it was the first show of true contemporary applied art in a contemporary art gallery. "People didn't understand it at the time; now everyone is on to it," David muses. The highly successful show then travelled to Bonetti's New York gallery, Luhring Augustine.

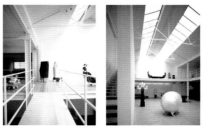

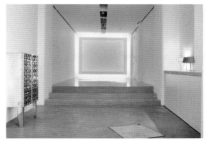

## David Gill Galleries

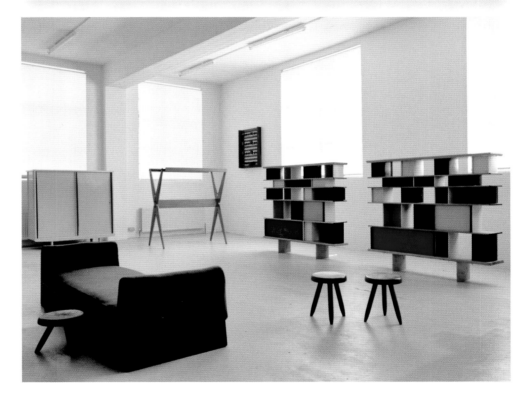

OPPOSITE: Loughborough Street Gallery, Vauxhall, circa 2000, painting (left) by Albert Oehlen, and including works by Zaha Hadid, Mattia Bonetti and Fredrikson Stallard.
TOP: Postcard advertising the opening show at Loughborough Street Gallery, Vauxhall, with works by Mattia Bonetti, Tom Dixon and others, 1999.
ABOVE: Jean Prouvé cupboard, table and bookcases are displayed with stools by Charlotte Perriand and seat by Ernest Boiceau, circa 1999.

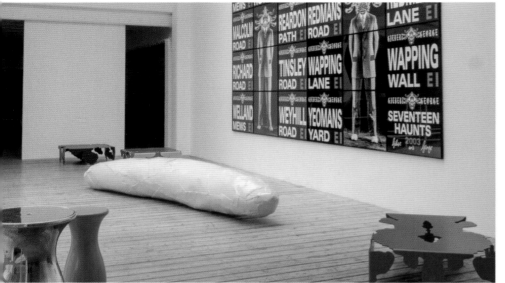

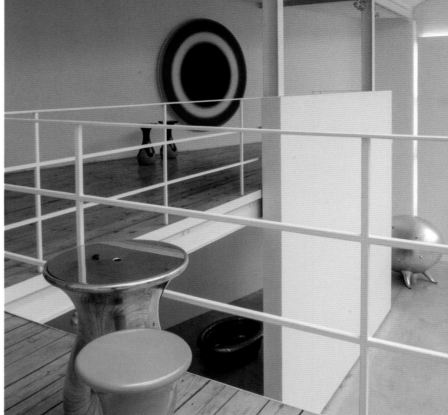

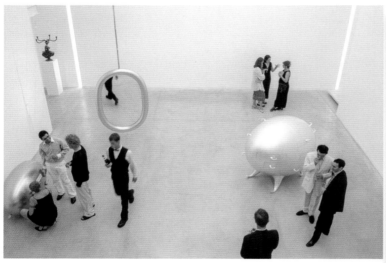

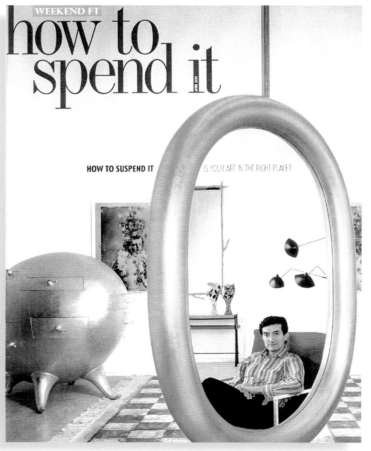

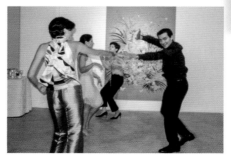

TOP ROW: The Vauxhall Gallery, London mezzanine, including works by Mattia Bonetti, Fredrikson Stallard, Gilbert and George, Franz West and Ugo Rondinone, June 2007.
LEFT: Guests at the 2000 Vauxhall launch party included Nicky Haslam (far left, with David Gill) and Patrice Butler (centre left).
ABOVE: Front cover of the Financial Times' How To Spend It magazine, shows David Gill amongst furniture by Mattia Bonetti, and ceramics and art by Grillo Demo, April 2001.

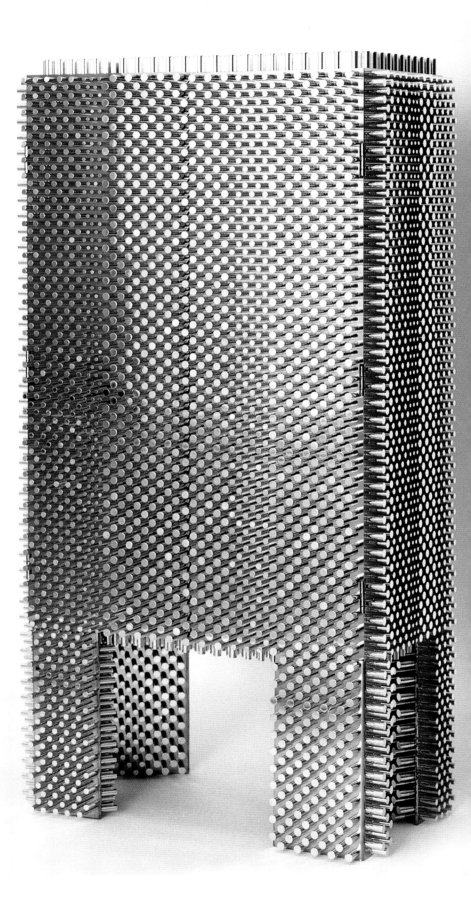

ABOVE: View from the mezzanine into the vast gallery space below, where Gino Marotta's exhibition, "Naturale, Transparente, Artificiale" was shown, October–December 2006.
RIGHT: "Fakir" cabinet, stainless steel, nickel-plated aluminium, Mattia Bonetti, 2004.

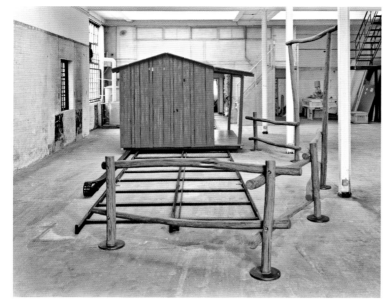
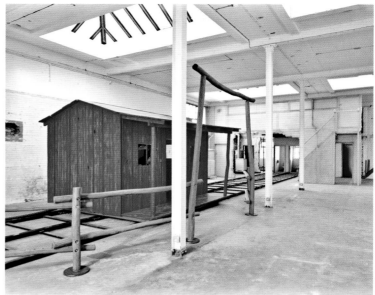

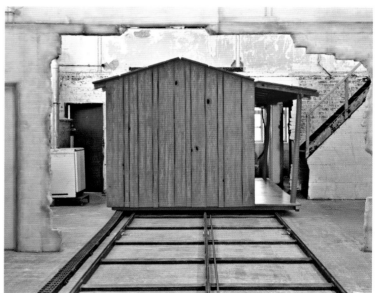

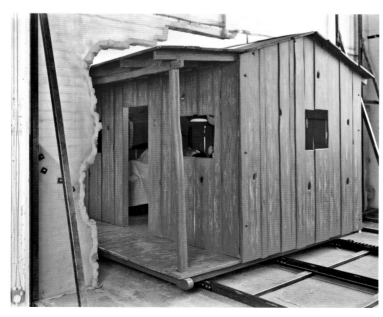
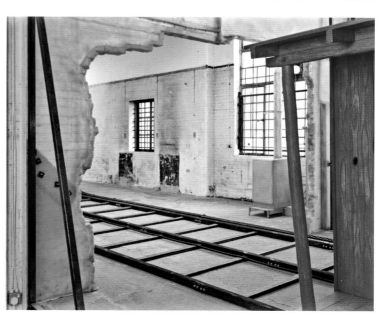

# Yaa Hoo Town, Bunkhouse

One of the salient exhibitions David held at Vauxhall was "Yaa Hoo Town, Bunkhouse", by L.A. based artist Paul McCarthy for which he built a working railway line in the first-floor exhibition room. McCarthy, one of the world's most influential artists, was resident among a kindred group in L.A., and coming to wider public notice in the 1970s with his performance and video work. McCarthy's pieces deal with the language and imagery of consumer culture, from Disneyland to the Hollywood dream factory, giving them an alternative commentary by transposing the commonplace into the disturbing and the grotesque, and consequently unmasking the dysfunctional reality that lurks behind the American dream.

The turning point between McCarthy's performances and installations, which first brought him to attention, was works of motorized sculpture which he started to create in the late 1980s. These meant that he was able, for the first time, to transmit the ephemeral qualities of his performances into a permanent construction that could be experienced without the artist's presence.

Arguably, McCarthy's most significant excursion into this area was the installation work "Yaa Hoo Town, Bunkhouse" (1996), shown at Loughborough Street. This was a technically and physically ambitious work centred around a moveable bunkhouse that slid along railway lines. The work incorporated moving animated figures that mimicked the wholesome, low-tech aesthetics of Disney theme parks in perverse ways to express the conflict between American frontier myth and predatory violence.

David built the recreation of the moveable bunkhouse on specially installed railway lines for this show-stopping wild west exhibition.

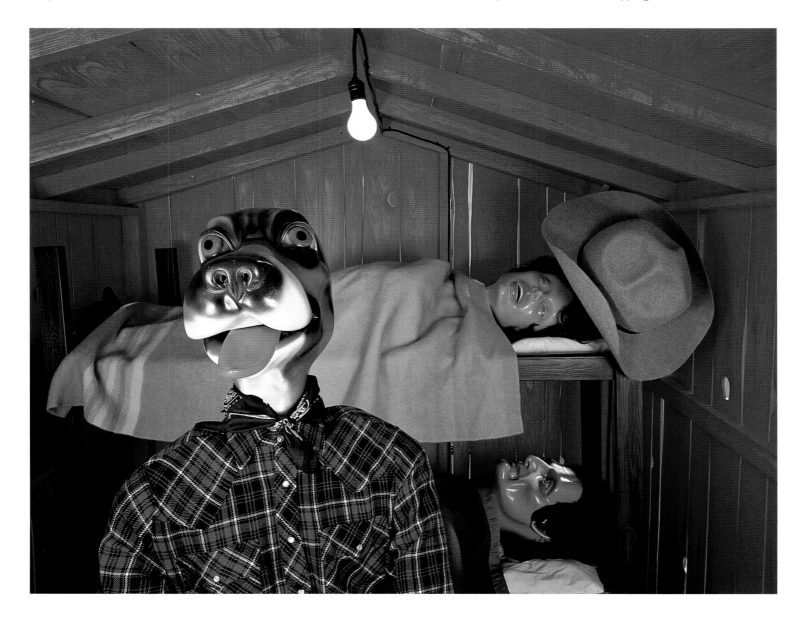

# Mediterranean Digital Baroque

The Spanish artist and designer Jaime Hayon was one of Time Magazine's 100 most relevant creators of the time. He is regularly included amongst the fifteen most important designers on Monocle's list. Born in Madrid in 1974, Hayon studied industrial design in Madrid and Paris, then joined Fabbrica, the Benetton-funded design and communications academy in Italy where he directed the design department until 2003. He set up his own independent studio practice in 2000 and, three years later, he dedicated himself solely to his own projects. "Mediterranean Digital Baroque" was the first of many pure art exhibitions, an installation held in collaboration with David. It threw attention on Hayon's art and installations; consequently, individual pieces he has created are in many important museums worldwide.

For his first pure art installation, Hayon covered the white walls of the Loughborough Street atrium with his elaborate sketches, done freehand on site, and also added a forest of his own objects covering the floor. This imaginary world showed creatures that, in the mind of Hayon, represented and defended the rest of creation: the house, the head, fake and plastic characters, adult games, a virgin defended by supersonic pigs, engulfed in a metamorphic, fragile, traditional, ceramic forest.

This critical exhibition, which established Hayon as an important artist, was a vital and ironic manifesto about his personal cosmogony devised of mature languages from heterogeneous worlds, principally his birthplace in Madrid and the influence of the Francophone culture of his childhood. It included skateboarding from images of Madrid suburbs and Baja, California. In Hayon's own words, "Mediterranean Digital Baroque" included "gesturality, surrealism, Baroque density, dynamism, intuition, dementia, risk, tenderness, mathematical warriors of nature, energetic strength, delirium, histrionic exaggeration, emulation and creativity." All these strands were represented by this multi-faceted artist and designer on the walls and the floor of the Loughborough Street atrium space.

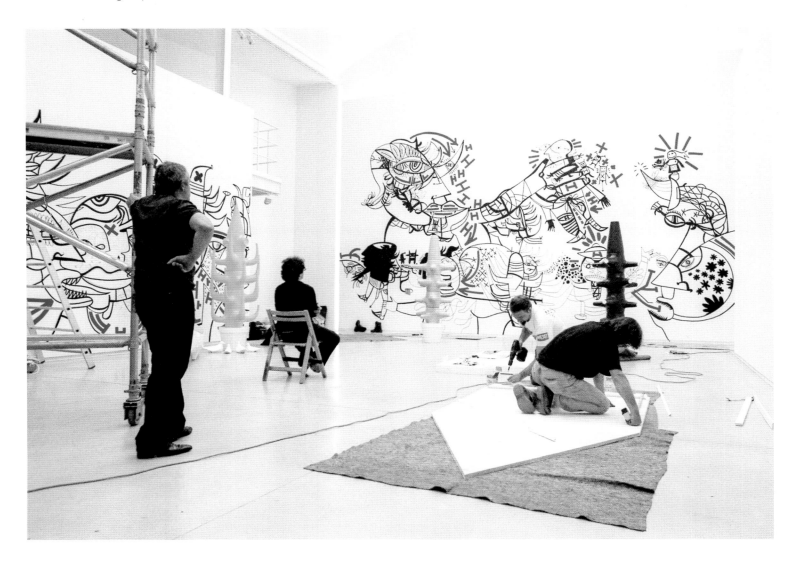

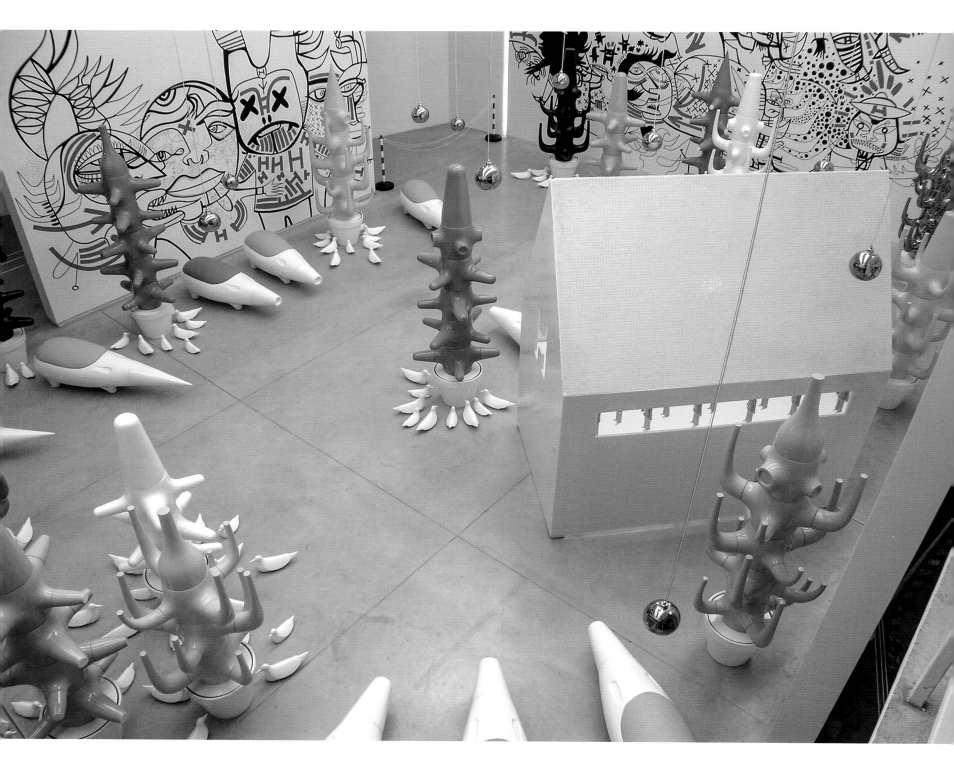

*Jaime Hayon's ideas transferred from his sketchbook pages to the walls of the Vauxhall Gallery as trees, cactus, doves and "supersonic" pigs to become three-dimensional objects, "Mediterranean Digital Baroque" Exhibition, 2003.*

*"The only difference between a designer and an artist is the function... It's decontextualizing function and bringing it to another level."*

JAIME HAYON

David first identified Tom Dixon's unique talent at an early exhibition of "Creative Salvage", a design movement many consider Dixon to have pioneered in the 1980s. Furniture teased from pieces of scrap metal into elaborate ornamental structures struck a chord with David's penchant for a mix of the modern and the ornate: "It was all so powerful, strong and new that I couldn't ignore it, so I came up with the idea of "Plastic Fantastic" – furniture made from functional plastic objects – and thought it would be a great collaboration to do with Tom," explained David.

"Plastic Fantastic" was held by Messe Frankfurt in 1996, a trio of shows which professed to "[present] the spectrum of possibilities: an explosion of visual impulses in all shades; young, energetic design and intensive colours; strange contrasts and harmonies." Rather than a rebirth of the plastic of the Sixties, the exhibition celebrated "a new pop culture, full of intelligence and elegance."

Dixon was also given an exhibition of his works in Hydra, Greece the same year, and later showed new works evolved from the original partnership at David's Loughborough St gallery in 2005. This exhibition represented something of a homecoming for Dixon, who had occupied the same building prior to the gallery's existence.

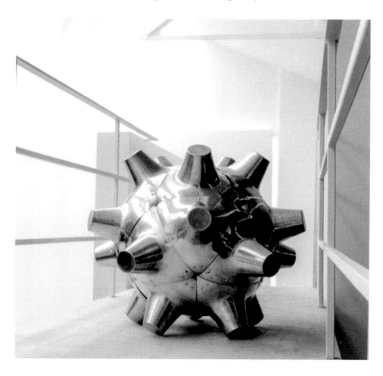

*ABOVE: "Jack" prototype, steel, Tom Dixon, 2005.*
*RIGHT: "Tower", plastic, Tom Dixon, 2005.*

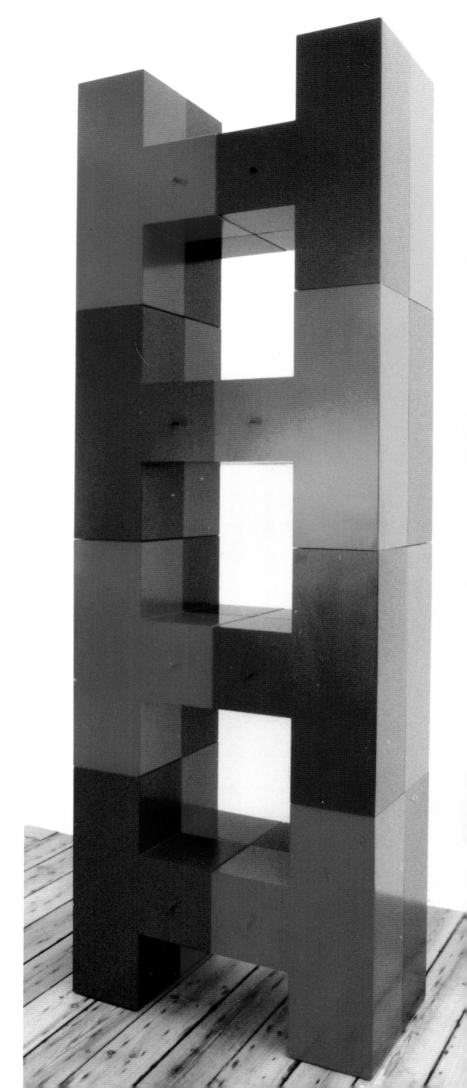

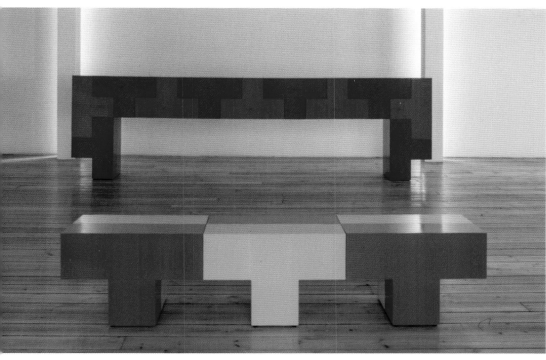

*ABOVE: "T-section" sideboard and bench, "Hexagonal Chest" and "Bench", plastic, by Tom Dixon, 2005.*

*"The planet is full of problems, and who better to harness problem-solving brilliance than designers?"*

TOM DIXON

Grillo Demo's exhibition at Vauxhall, 2003, included textiles, soft furnishings and art (above) as well as furniture, such as the "Butterflies" cabinet, 2003 (right).

# Grillo Demo Exhibition

Spellbound by the beauty of the jasmine flower, Grillo Demo's art was first recognised after he painted the flower over celebrity photographic portraits, creating surreal images which challenge the viewer's notion of beauty. In 2003, Loughborough Street housed its first Demo show, including the "Bambino" series, representative of the many Catholic influences in Demo's work, where each edition of the same photographic image of the infant Jesus is overpainted in a different colour and adorned with cascading jasmine.

Jasmine continued to pervade the work Demo created alongside David. The portrait collection was extended to include furniture and sculpture, all depicting what Demo terms the "iconic pattern" of the jasmine flower.

Choosing to work with whatever medium is close at hand, Demo thrives on spontaneity. He paints onto books, ceramics, wood, furniture: anything he has at hand, including garbage, if he is driven to create. Loughborough Street consequently hosted an eclectic range of his pieces, some functional, others ornamental.

Perhaps the most evocative pieces were the grand scale, asymmetrical vases which stood taller than Demo himself, displaying the splendour of the flower motif through bold colour against striking backgrounds, suggesting the importance of the flower over its vessel.

Now established world-wide, it wasn't until 2008 that Demo first exhibited in America. Once again, David's "legendary eye" had spotted something special long before others began to appreciate Demo's abstraction from the provenance of traditional painting. His work now hangs in the houses of the rich and famous, including Elle McPherson and Madonna.

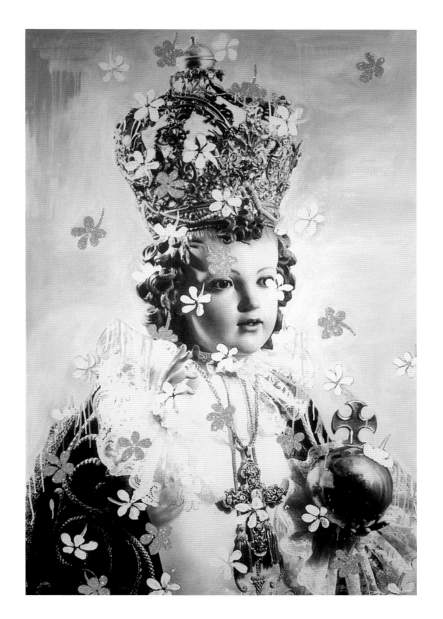

*ABOVE: One of the "Bambino with Falling Jasmine" series, Grillo Demo, 2003.*
*LEFT: Silver cast jasmine flower paperweight, Grillo Demo, 2003.*

*"I do not pretend to be a designer. Everything comes from my diaries. I like spontaneity... Every day is a wonder; osmosis is what I live by."* GRILLO DEMO

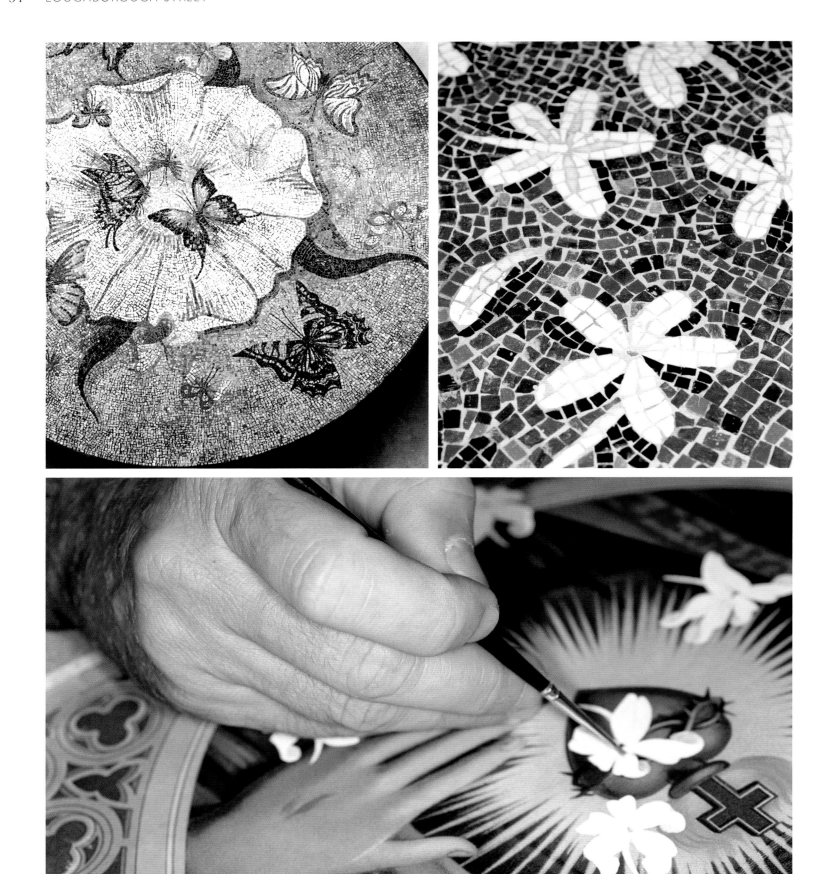

OPPOSITE: Details of "Almond Blossom" table, jasmine flowers mosaic, painting jasmine on "Madonna", Grillo Demo, 2003.
ABOVE: Details of "Monumental Vases" (above and top left) and "Jasmine Vases" (left), Grillo Demo, 2003.
OVERLEAF, LEFT: "Monumental Vases, Black and Turquoise", with details of work in progress, Grillo Demo, 2003.
OVERLEAF, RIGHT: Details of "Monumental Vases, Red and Turquoise", Grillo Demo, 2003.

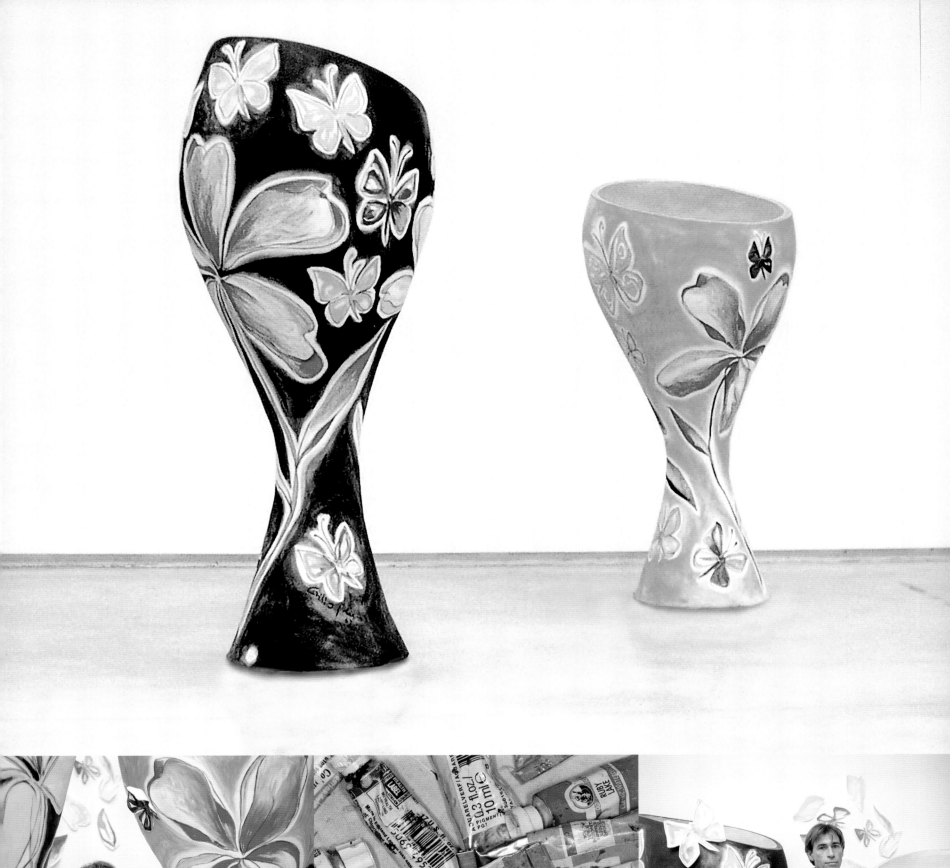
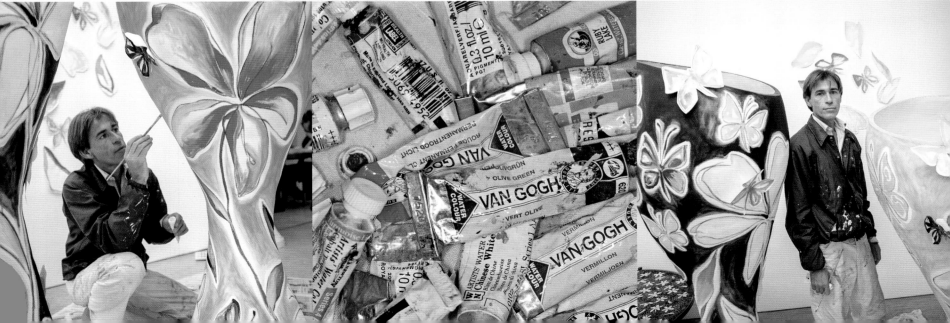

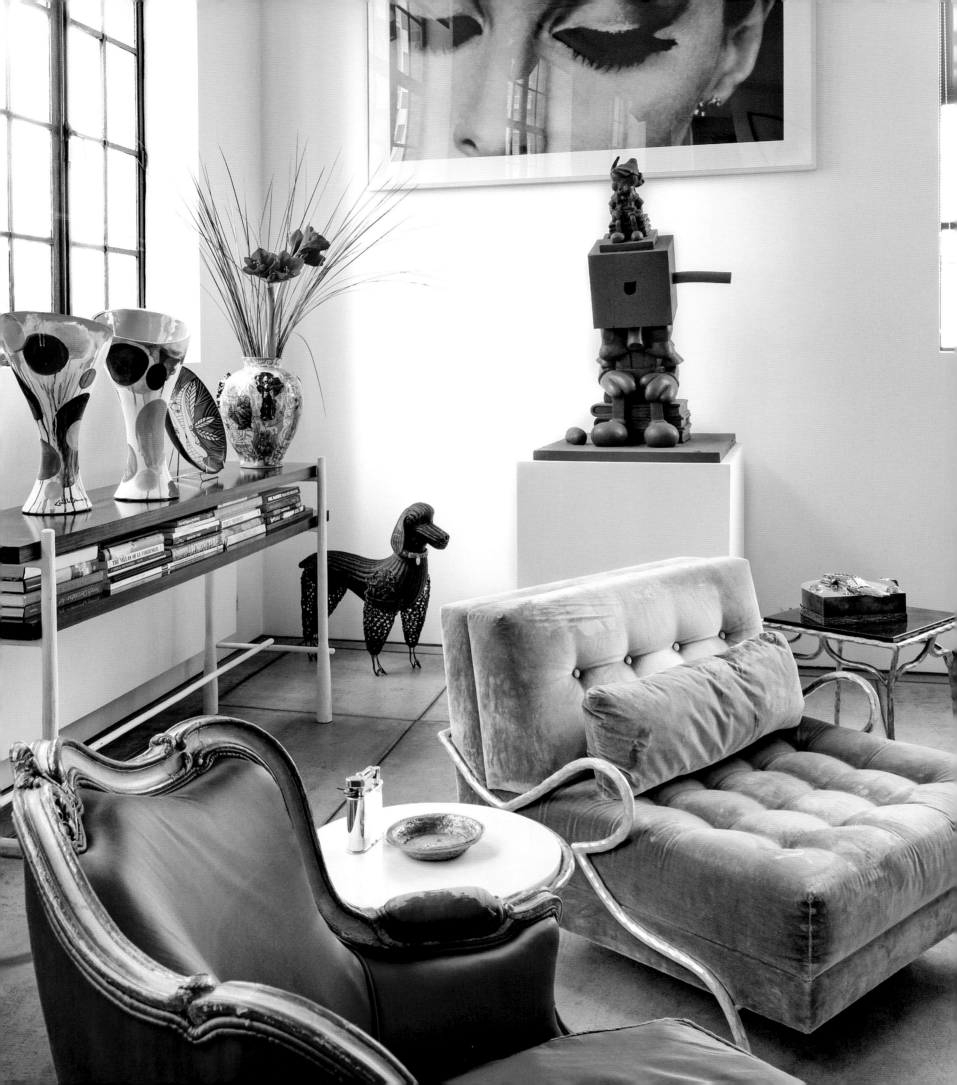

# The Very Private Art Dealer

Parallel to creating prototypes with artists and mounting exhibitions in his Vauxhall headquarters, David was also establishing his reputation amongst a chosen group of collectors as a very private art dealer. "This started from my own collecting, my own curiosity," he says. "When I first opened the Fulham Road gallery, I had shown inter-war neo-romantic art, such as early Twentieth-century art from Christian Bérard, Pavel Tchelitchew and other Russian masters working in Paris in the early 1920s which were symbiotic with the furniture and objects I was showing at the time."

But as he looked further and travelled all over the world in search of artists, he began to understand what was happening in contemporary art, and started to buy for himself. "Very soon, people would come to my apartment in Vauxhall, to see – for instance – a work by Ugo Rondinone and would say, "I love this, I love that."

"Not only did I begin to collect seriously for myself, but I also advised collectors who wanted to buy contemporary art." He has done this for the last fifteen years and says that to some extent he can pinpoint the great names that everybody wants, amongst them work by artists then at the beginning of their careers such as Christopher Wool, Albert Oehlen and Richard Prince.

*OPPOSITE: Gill's apartment at Vauxhall was also a showroom of his artists' work, including: "Untitled" art by Richard Prince; "Block Head" sculpture by Paul McCarthy; vases by Grillo Demo and Grayson Perry; plates by Jean Cocteau (also overleaf, left); silver box by Luigi Scialanga; grey "Chaise Brisée" by Garouste & Bonetti, 1994 and an armchair from Carlos Bestegui's apartment by Emilio Terry.*
*ABOVE: "Dennis", a 1930s wicker poodle, is Gill's mascot in every gallery.*
*BELOW: Art "Untitled" by Christopher Wool, 2000, also pieces by Berlinde de Bruyckere and Richard Prince, "Twilight of the Idols (Virgin Mary)" sculpture by Kendell Geers, 2002 and figurines by Barnaby Barford (and overleaf, right).*

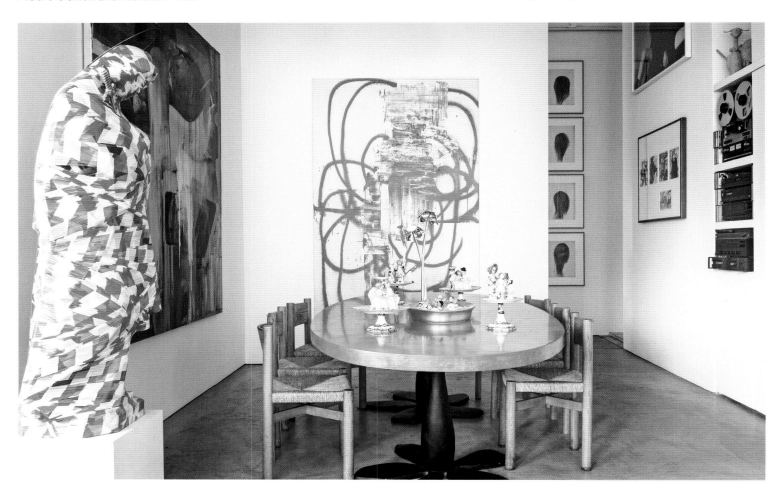

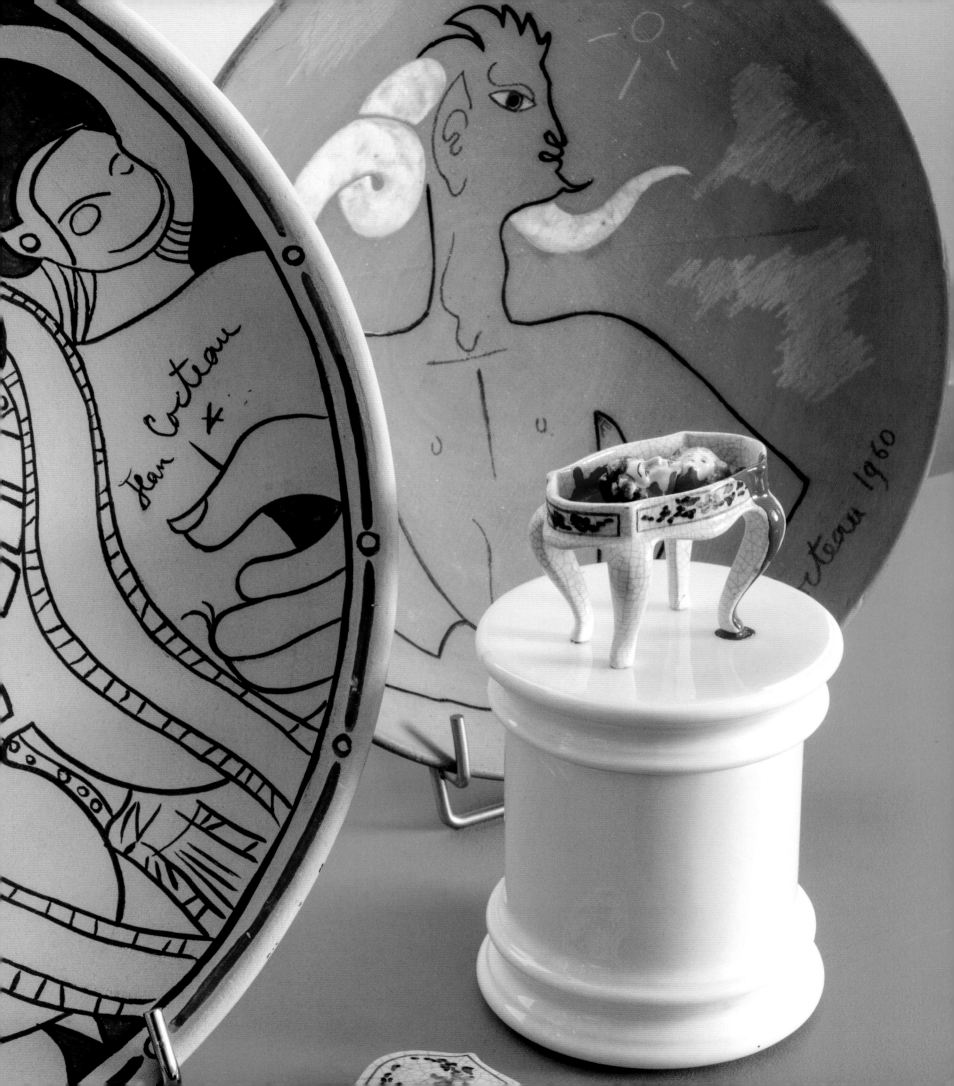

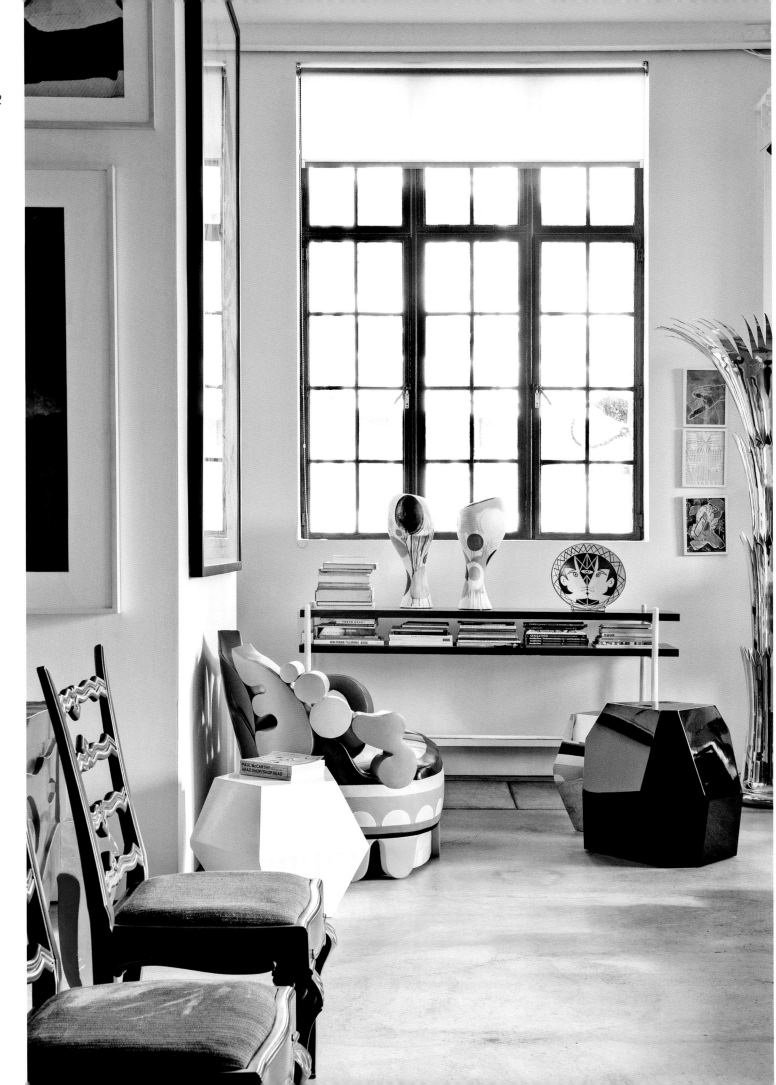

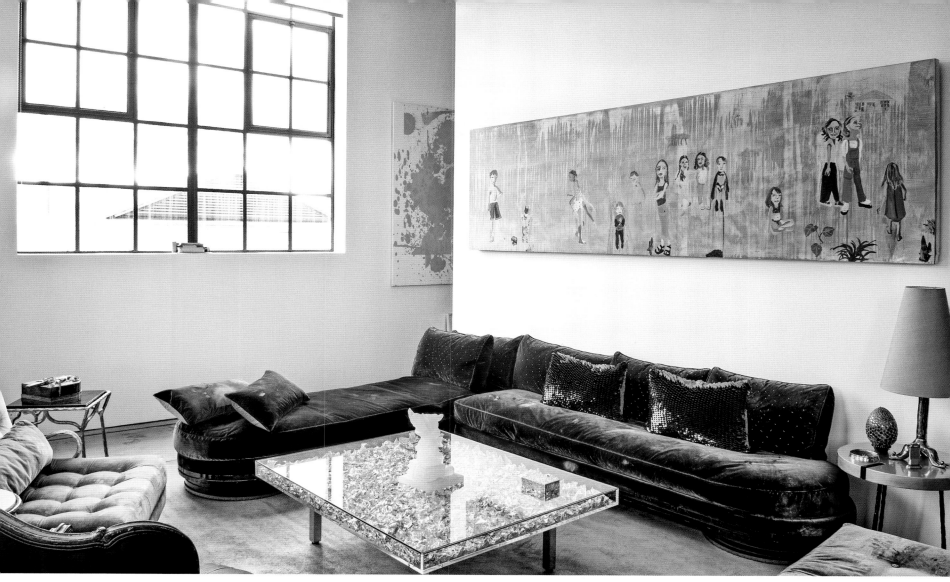

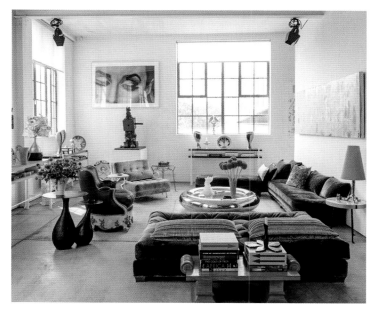

THE LIVING AREA: Further views of Gill's Loughborough Street, Vauxhall apartment, with its ever-changing display of art including: Mattia Bonetti's "Cut Out" Sofa and "Polyhedral" side tables (opposite); a painting, "Untitled" by Chantal Joffe, 2001, and a "Pinocchio" statue by Paul McCarthy, 1994, on a Garouste & Bonetti "Ring" coffee table, 1999 (above), a "Monogold™" coffee table by Yves Klein, 1961 (top); plates by Jean Cocteau, "Tinkerbellend" figurine by Jake & Dinos Chapman, 2012, "Petra" table lamp, Garouste & Bonetti, 1999, decorated with cut-out butterflies by Grillo Demo (right).

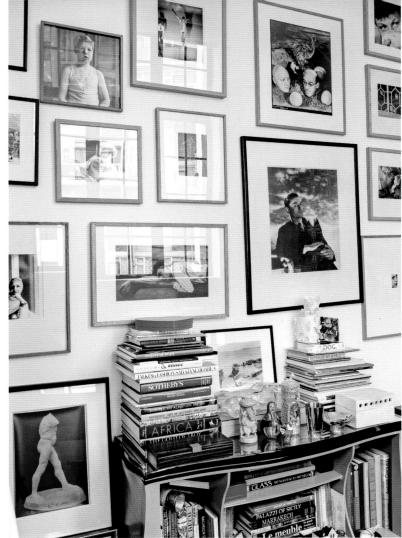

*CLOCKWISE FROM TOP LEFT: Chair, and side table, "Turandot", Mattia Bonetti, 1991; a collection of framed prints, including works by Angus McBean and Horst P Horst, above a painted bookcase (top right); "Head" vase, Oriel Harwood and "Falling Jasmine" plate, Grillo Demo, stand on Richard Snyder's "Venetian Magician's Chest" (above); a Grayson Perry plate and "Spaghetti" table lamp by Garouste & Bonetti, 1994, stand on an Syrie Maugham book-case before "Untitled" by Richard Prince, 1997.*
*OPPOSITE: Ulrika Liljedahl cushions on a "Christina" daybed by Francis Sultana, "Bullet Hole" paintings by Nate Lowman, ceramics by Giacinto Cerone on Richard Snyder's "Venetian Magician's Chest" and a "Fakir" cabinet, Mattia Bonetti, 2004.*

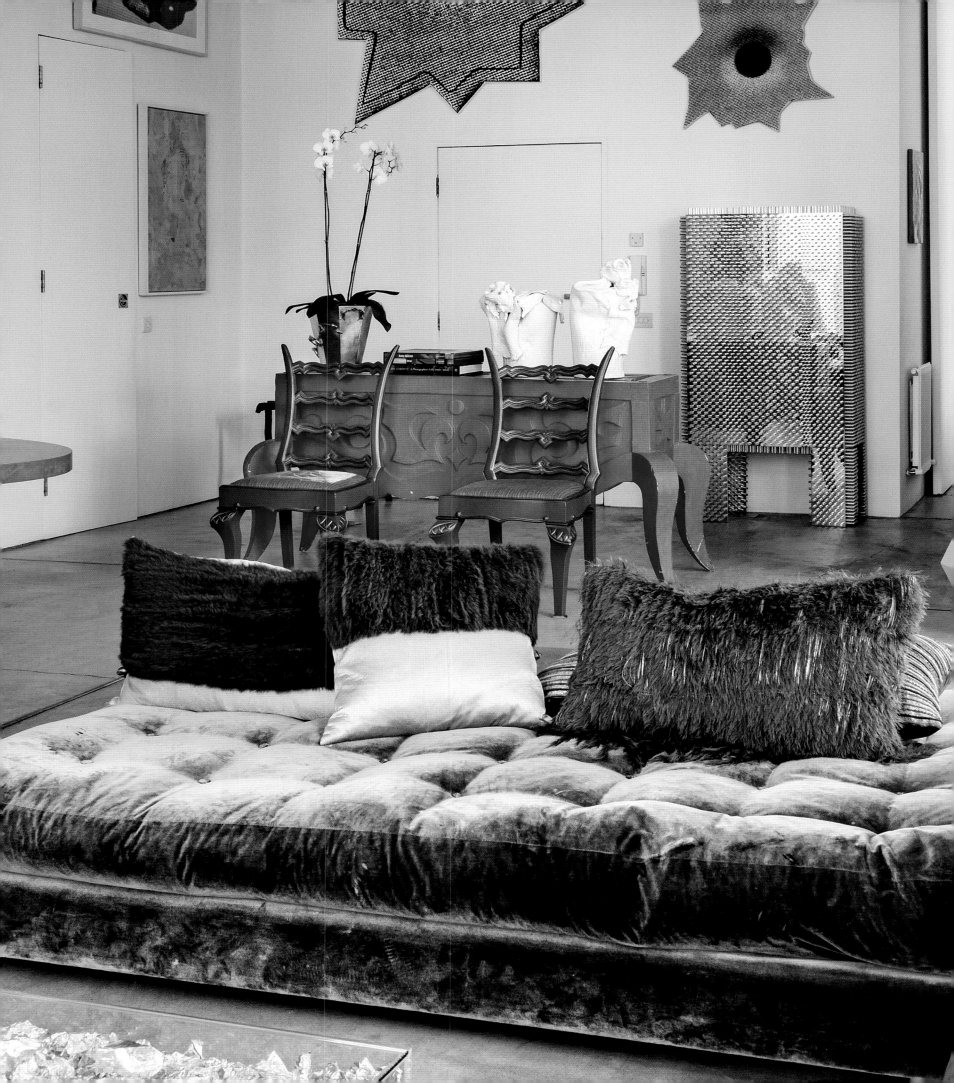

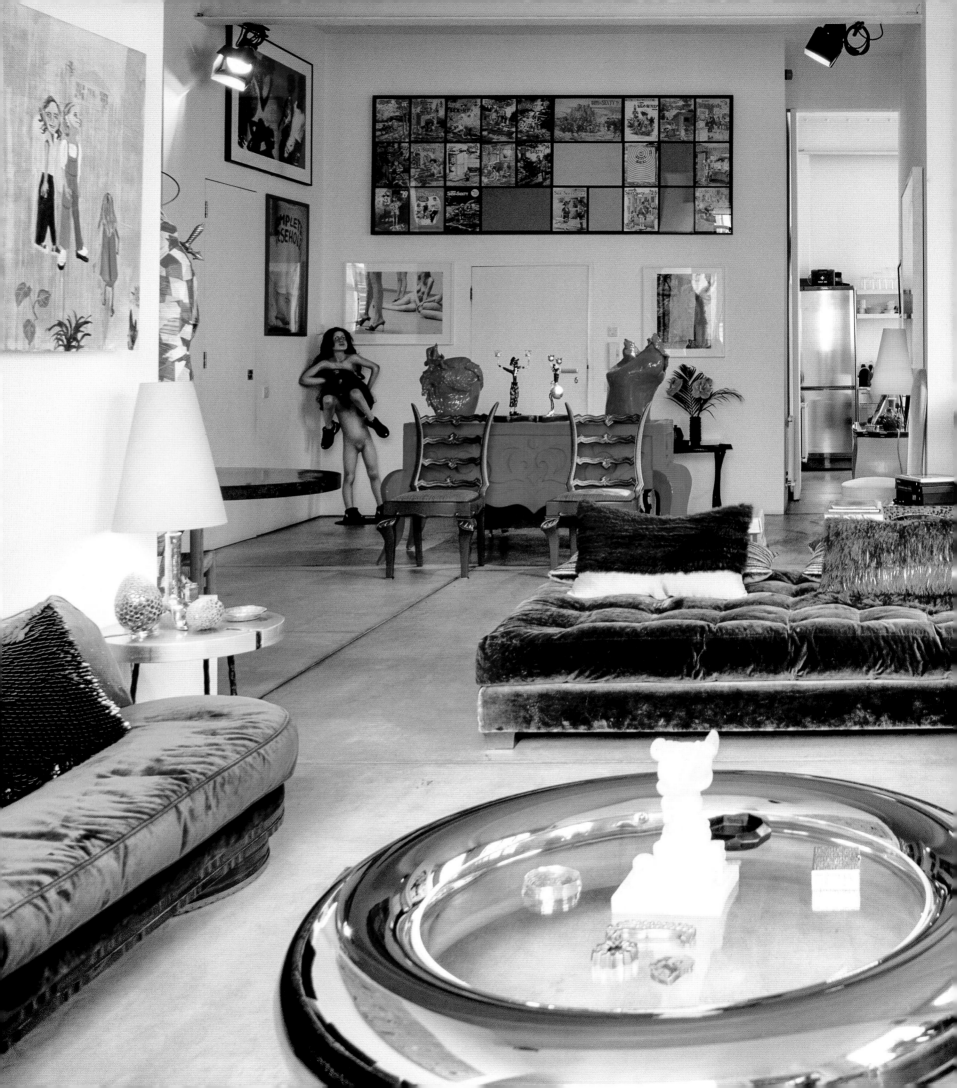

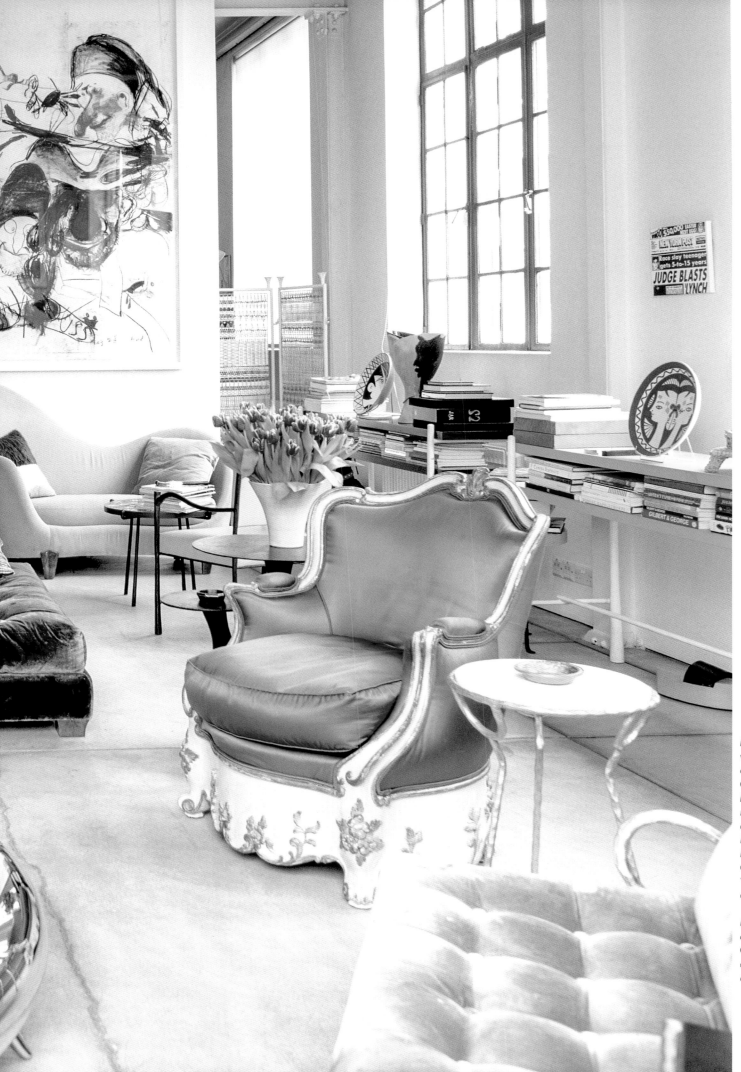

*PREVIOUS LEFT: Detail of Grillo Demo vase, Jean Cocteau plate and Balinese door lock, found in Ibiza, painted by Grillo Demo.*
*PREVIOUS RIGHT: An antique Spanish relic stands amongst Gill's collection of objets d'art, including a sculpture by Dallas and Texas.*
*LEFT: Ceramics by Giacinto Cerone, Grillo Demo and Jean Cocteau, with "Pinocchio" statue by Paul McCarthy on "Ring" coffee table, Mattia Bonetti, 1999. One of Paul McCarthy's "Pirate Drawings", 2001 – just one of the artists whose works grace the walls of Gill's Vauxhall apartment; other works are by Chantal Joffe, Vanessa Beecroft and Mike Kelly.*

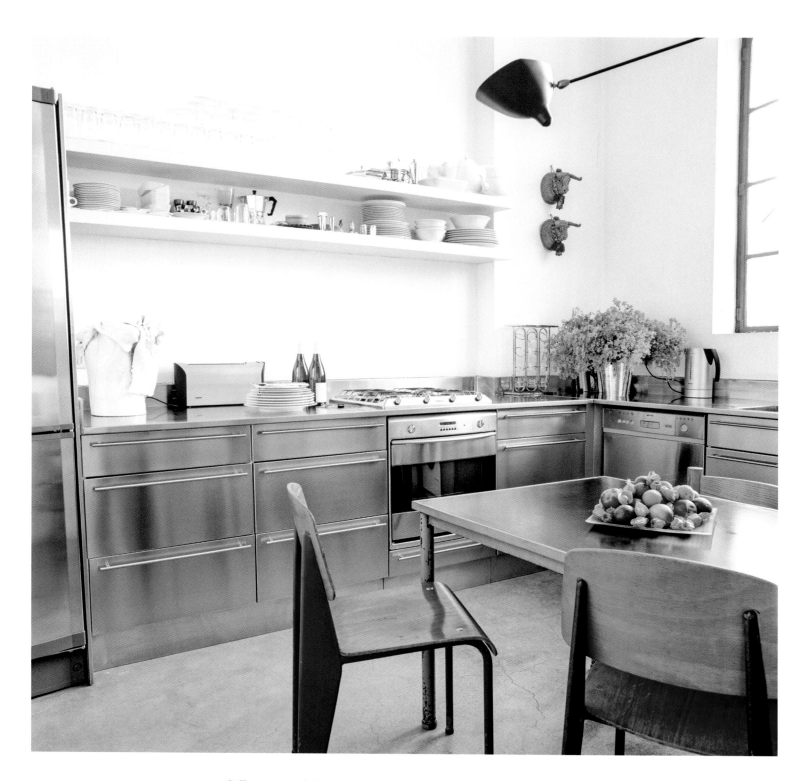

*Different views of the kitchen at Gill's Vauxhall apartment, including chairs by*
*Jean Prouvé and a wall lamp by Serge Mouille, above a table by Le Corbusier.*

David has patrons and collectors for whom he is always on the look-out and always advising. "I keep it to a maximum of five collectors," he explains. "I don't want to work with any more, because there can be a conflict of interests in terms of who gets the right piece. The work must speak to me – I go back to Brice Marden, to Cy Twombly, to Jackson Pollock and to their history and also to my own travels in America, Latin America and Cuba and I look at new work by young up and coming contemporaries. When I do buy or recommend young artists whose work I really like, I don't buy them with the idea that they are going to go up in value, but because, as in the case of Joe Bradley for instance, whose colour field and minimalist paintings I am hanging in my house in Valletta, I truly like their work. Pointing my private clients toward this work and witnessing their reactions always reveals the pieces in a new perspective; uniting a collector with an object they are illuminated and redefined by can be art itself.

*THE BEDROOM: Mirror by Oriel Harwood, "Gunship Grey" statue, Don Brown, 1997; art by Giacinto Cerone (against wall), Ugo Rondinone (landscape) and "Semen", Francesco Clemente, 1987; "Three Graces" table lamps, Garouste & Bonetti, 1999, stand on antique side tables by T H Rossjohn-Gibbings.*

# KING STREET
# 2012 ONWARDS

As the new century advanced, things were changing in St James's, which had been the centre of art dealing since the mid-Eighteenth-century days of James Christie. The Old Master dealers, traditionally based in the area, were moving out and the contemporary galleries were moving in, starting with White Cube's pocket-sized gallery in Duke Street.

"Mayfair was quickly becoming the destination for residential brands and galleries," says David. Art was returning to its original West End home in a contemporary form. But moving from his loft-like gallery south of the river to this newly-exciting modern art arena was a major decision. "I rejected every space I had viewed previously in Mayfair," David recalls. The move was only ever going to happen if the perfect space was found, and fate had something special in mind.

Twenty-five years after David left Christie's to pursue his artistic vision, he was to come full-circle, back to the very pavements and brickwork that had awakened his sensibilities to the potential of contemporary art. The huge gallery, with light pouring in from the newly-opened floor to ceiling windows, became the perfect setting for a new era of David Gill Gallery and its major exhibitions. The ground floor office space is reserved for private client conversations and private views of new small works. Off to one side is a more intimate library and sitting room furnished with key small pieces from artists so that clients can see these pieces in a more domestic surrounding.

As had always been the case with David Gill Gallery, the St James's gallery soon asserted itself as ahead of its time. David, constantly challenged by changing technologies and trends in both materials and aesthetics, revels in showing people what they can't see for themselves. The art buyer of the twenty-first century appreciates and understands art differently, and consequently consumes art differently, but David continues to encourage the breaking of boundaries and urges the prospective buyer or collector to demand the unseen, the provocative, and the dangerous. Persistently evolving in cohesion with an ever-changing world and consumer market, David now curates small shows for innovative, new designers, but David Gill Gallery has become such a pivotal arena for artists and designers, that the majority of the exhibits are now for bespoke editions conceived for the gallery itself by leading creators within the contemporary art world; creators that continue to discover new worlds through collaboration with a man who is not just designing art, but who has redesigned the art world.

*"I found the perfect gallery corner spot in St James's, right in front of Christie's."* DAVID GILL

*OPPOSITE: Portrait of David Gill by Solina Guedroitz, 2012.*
*ABOVE: The impressive facade of the King Street Gallery, London, above which David has his office.*

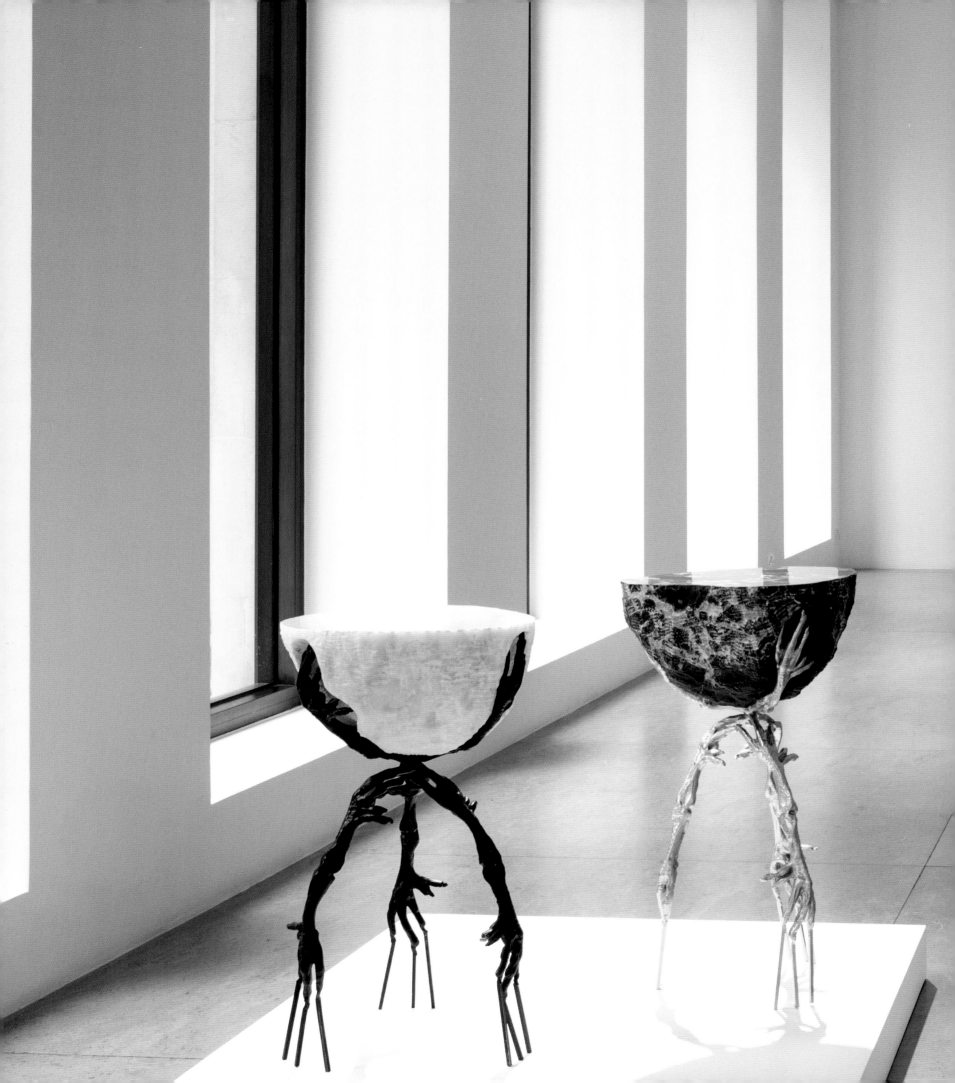

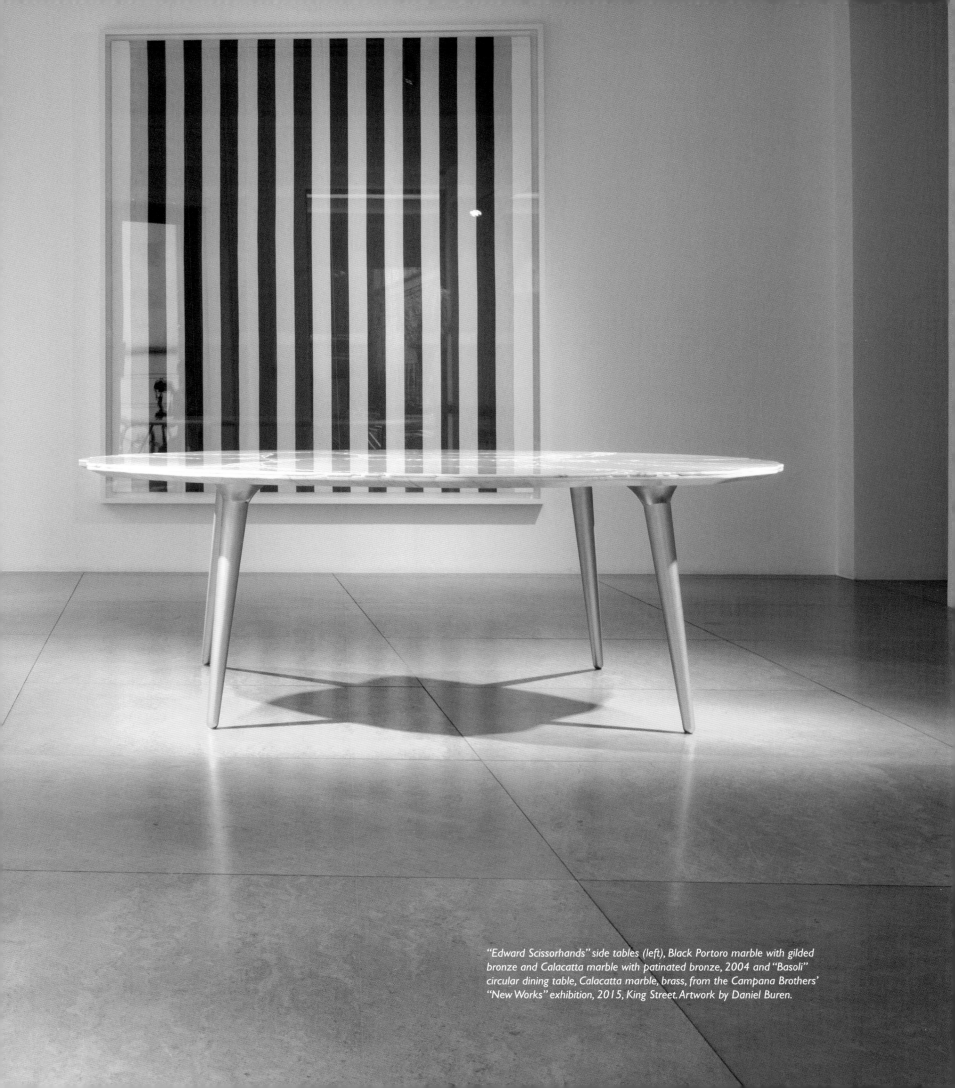

*"Edward Scissorhands" side tables (left), Black Portoro marble with gilded bronze and Calacatta marble with patinated bronze, 2004 and "Basoli" circular dining table, Calacatta marble, brass, from the Campana Brothers' "New Works" exhibition, 2015, King Street. Artwork by Daniel Buren.*

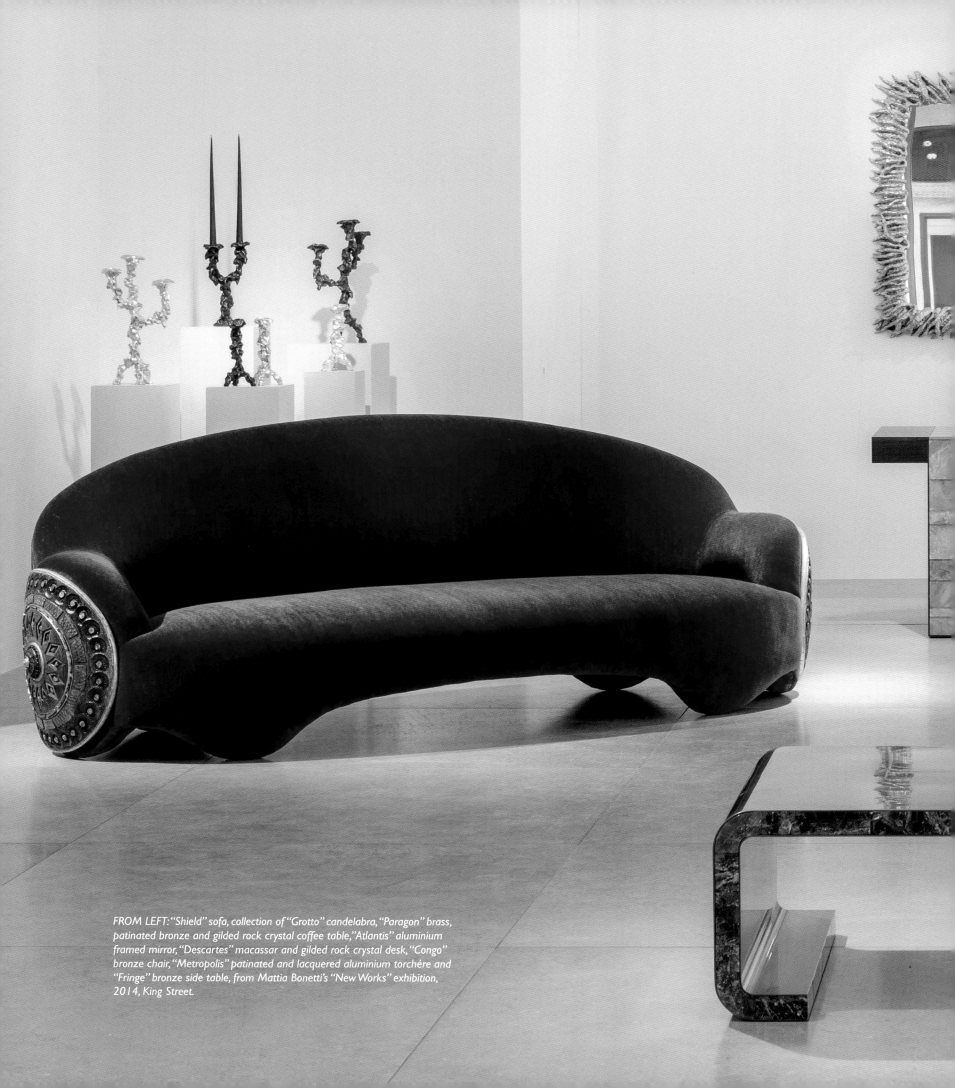

FROM LEFT: "Shield" sofa, collection of "Grotto" candelabra, "Paragon" brass, patinated bronze and gilded rock crystal coffee table, "Atlantis" aluminium framed mirror, "Descartes" macassar and gilded rock crystal desk, "Congo" bronze chair, "Metropolis" patinated and lacquered aluminium torchére and "Fringe" bronze side table, from Mattia Bonetti's "New Works" exhibition, 2014, King Street.

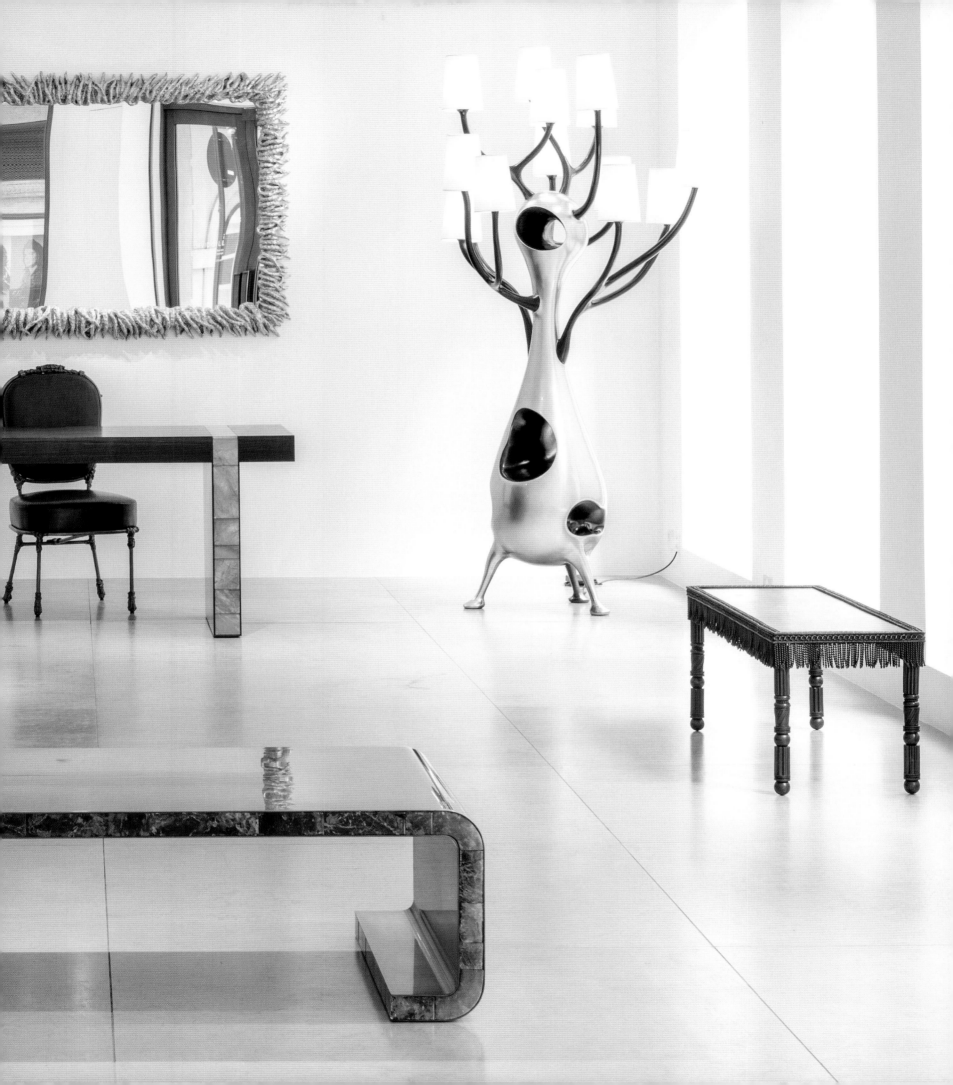

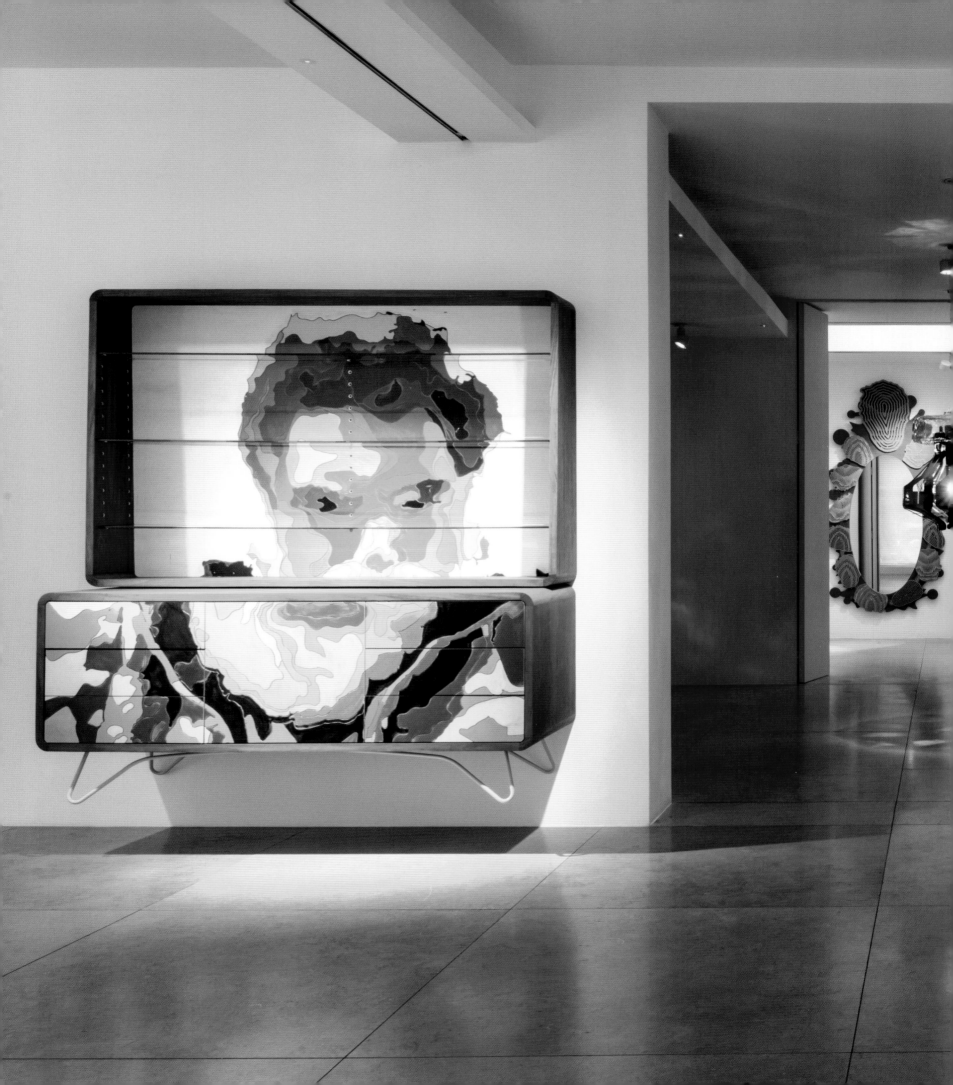

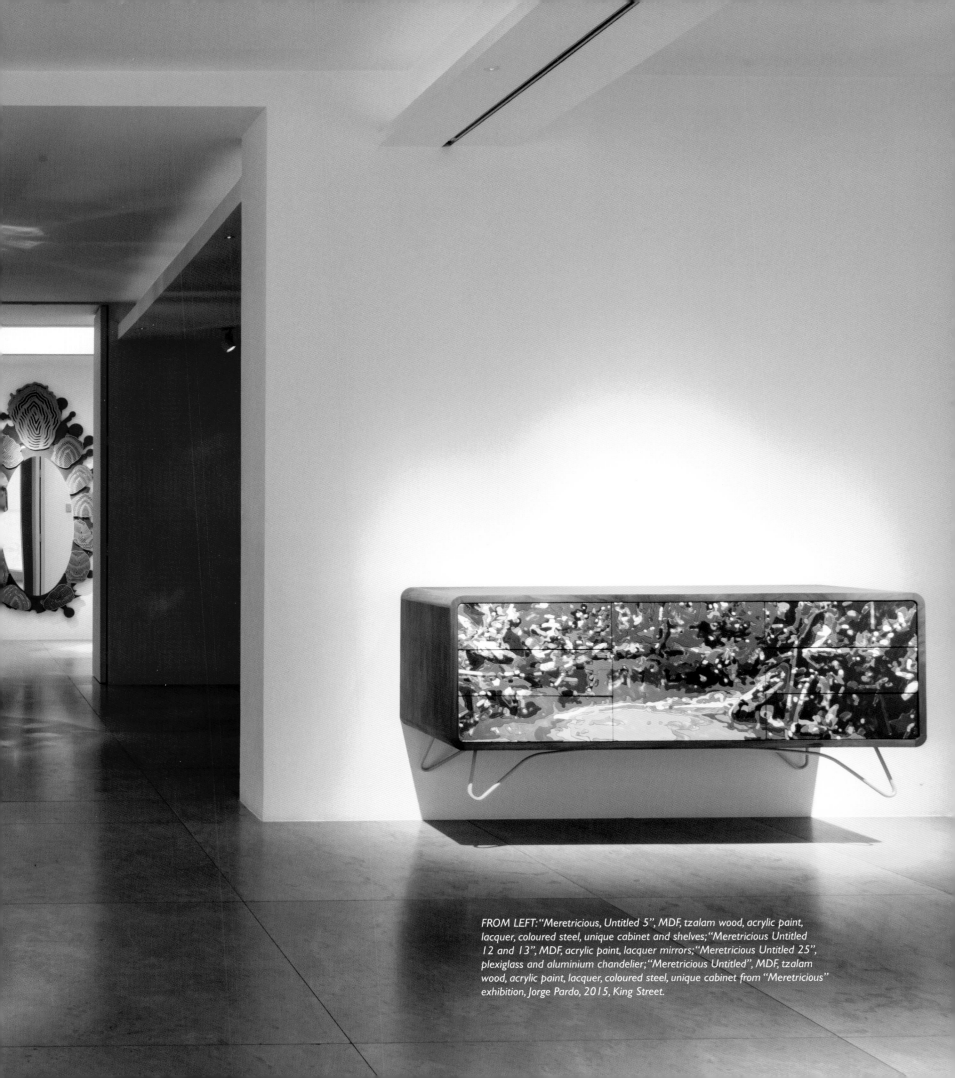

FROM LEFT: "Meretricious, Untitled 5", MDF, tzalam wood, acrylic paint, lacquer, coloured steel, unique cabinet and shelves; "Meretricious Untitled 12 and 13", MDF, acrylic paint, lacquer mirrors; "Meretricious Untitled 25", plexiglass and aluminium chandelier; "Meretricious Untitled", MDF, tzalam wood, acrylic paint, lacquer, coloured steel, unique cabinet from "Meretricious" exhibition, Jorge Pardo, 2015, King Street.

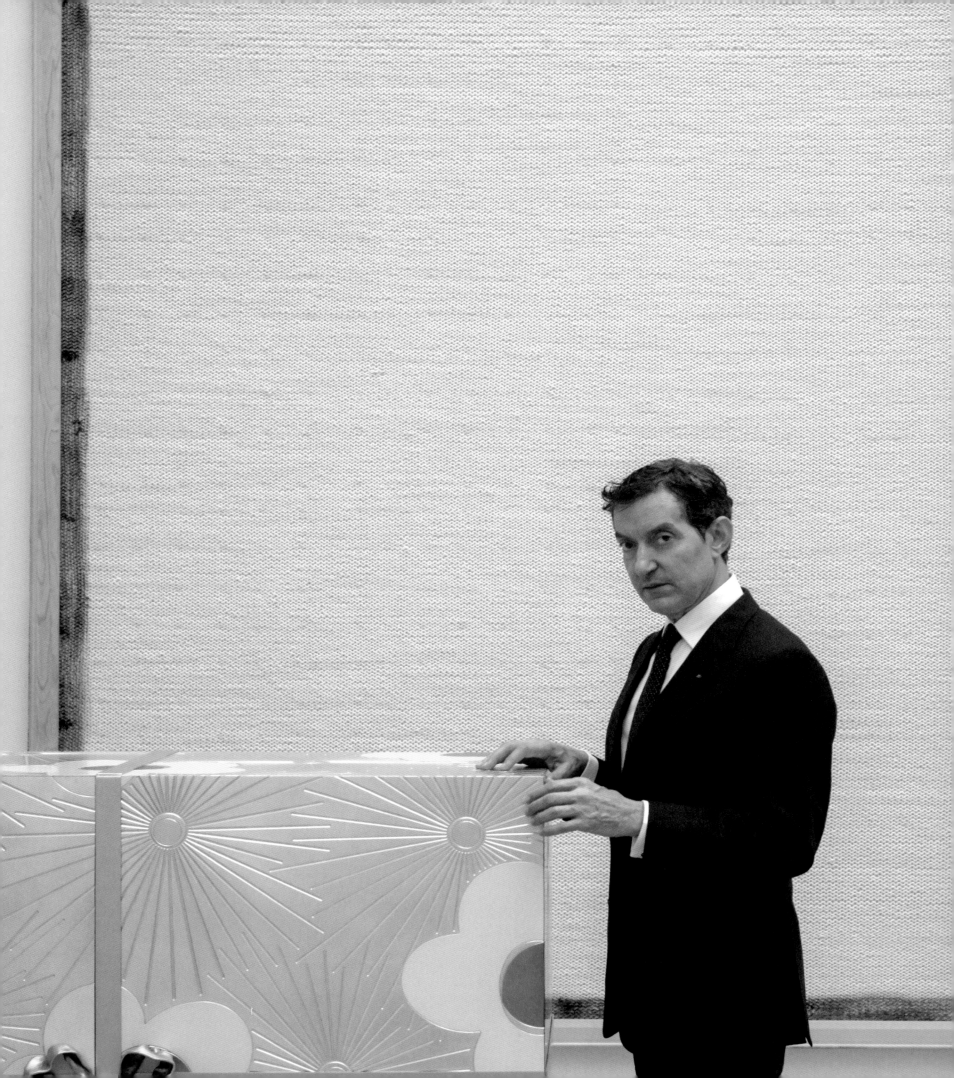

# SELECTED
# DESIGNER-ARTISTS

*OPPOSITE: Gill stands next to "Happy Birthday" cabinet by Mattia Bonetti, 2008, in front of "Waterfall" by Rosemarie Trockel, 2006, photographed by Steve Double, 2012.*

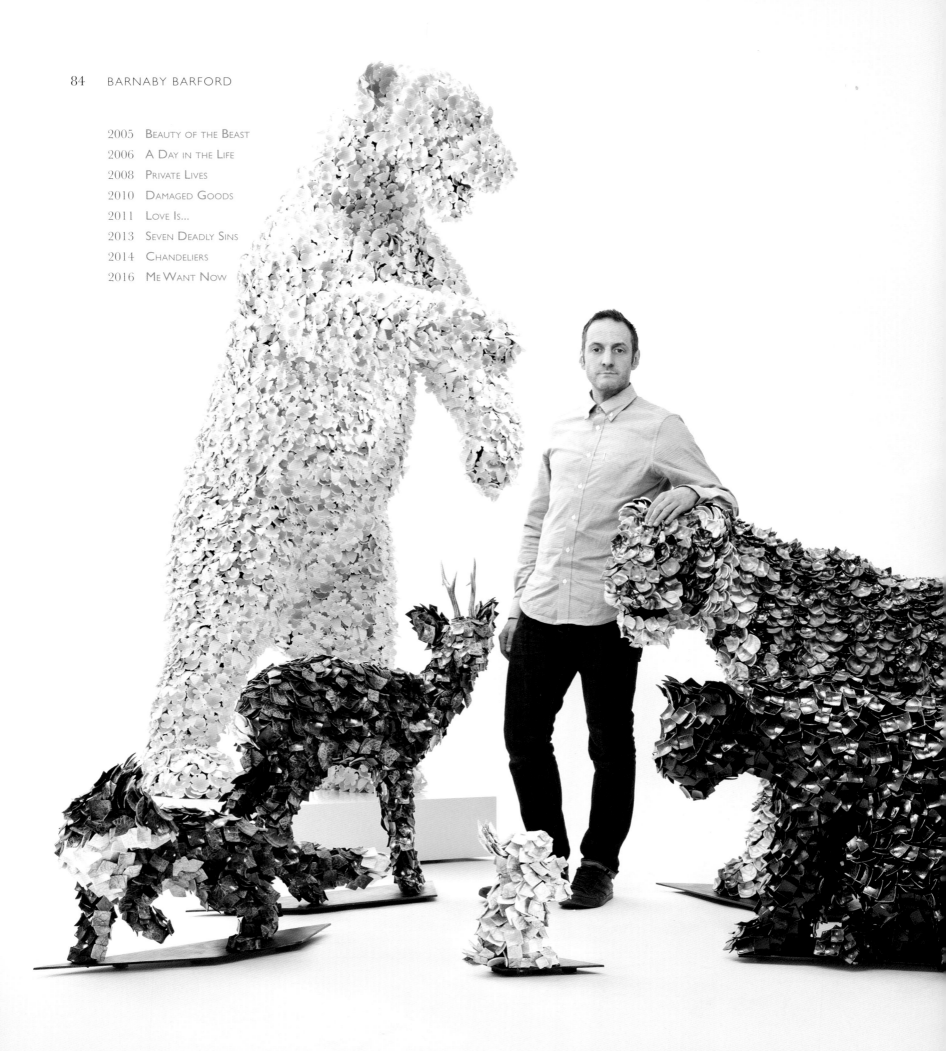

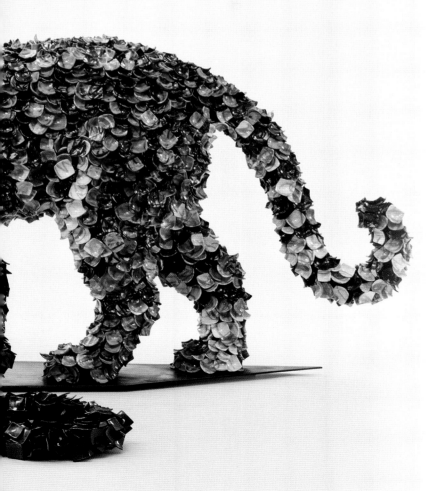

"BRILLIANTLY **PUCKISH,** AND SOMETHING OF AN **AGENT PROVOCATEUR.**
BY **SEDUCTION** AND **GUILE,** HIS WORK EXPOSES OUR **INNER FRAILTIES, PREJUDICES** AND **DESIRES,** HOLDING UP A MIRROR TO US BOTH METAPHORICALLY AS WELL AS – ON OCCASION – PHYSICALLY. FEW ARE SO **INCISIVE** AND **INSIGHTFUL.**"

ALUN GRAVES
SENIOR CURATOR, CERAMICS AND GLASS, V&A.

"I first saw Barnaby Barford's work at the Royal College about ten years ago," David recalls. "As I remember, he was cutting dark Seventeenth-century plates into shapes and gluing them together to make them part of a wall, like a decoration or a cloud. They weren't intended to be any particular form or have a message; they were simply plates cut in a way that created something like a sculpture in the wall." At the time, David thought it was an interesting idea, bordering on craft, not contemporary art: "I am always looking for the intellectual or art approach, not craft pieces," he emphasizes, regarding his choice of artists and architects with whom to collaborate.

Years later Barford was asked to show David his sculptures. "At the time he had used fake Indian silver trays, which he bought cheaply in street markets, on which he put groups of Edwardian porcelain figures he had manipulated by cutting their heads and arms off," explains David, recognising this as a transition away from the aesthetic of craft into intellectual comment about contemporary India.

Barford has shown with David Gill ever since as an artist making his own pieces. "I did say to him when we first worked together that it would be tough because, obviously, at the beginning of their careers, artists have to earn their living from what they sell. Emerging artists are forced to choose between earning a living by producing a design product and creating contemporary art and sculpture pieces – which is what he really wanted to do – and which was what I admired in his work."

David encouraged Barford to focus on creating more mirrors and adding his extraordinary figures to them, so that they became personalities looking at their own reflections, each suitably ironically titled. "He has done amazingly well," says David. "He's developed his own strength in his language and is exceptionally gifted; he can draw very well, but his true strength is developing an idea into a vision previously inconceivable. The animals he produced for his 2016 show with me, for example, live in a world with a language: he has covered the animals with words such as 'hope', 'fate' and 'future', asserting their position as not just a decorative animal ceramic, but a symbol of political awareness and a commentary on today's society."

*LEFT: Barnaby Barford stands amongst his porcelain animal menagerie, "Me Want Now" exhibition, King Street, 2016.*

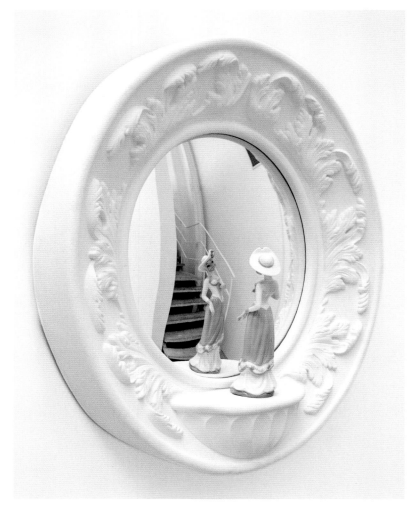

OPPOSITE: "Beauty of the Beast" was Barford's first exhibition with Gill at the Loughborough Street Gallery, Vauxhall in 2005. Clockwise from top left are "Natural Beauty", "Well If Julia Can" and "Ooohh You're Gorgeous You Are".
ABOVE: "It's OK, He's Rich" (top), "Pssst, It's Bullshit" (above) and "What's Wrong With The Fokin Beatles" (right), from the same 2005 exhibition.

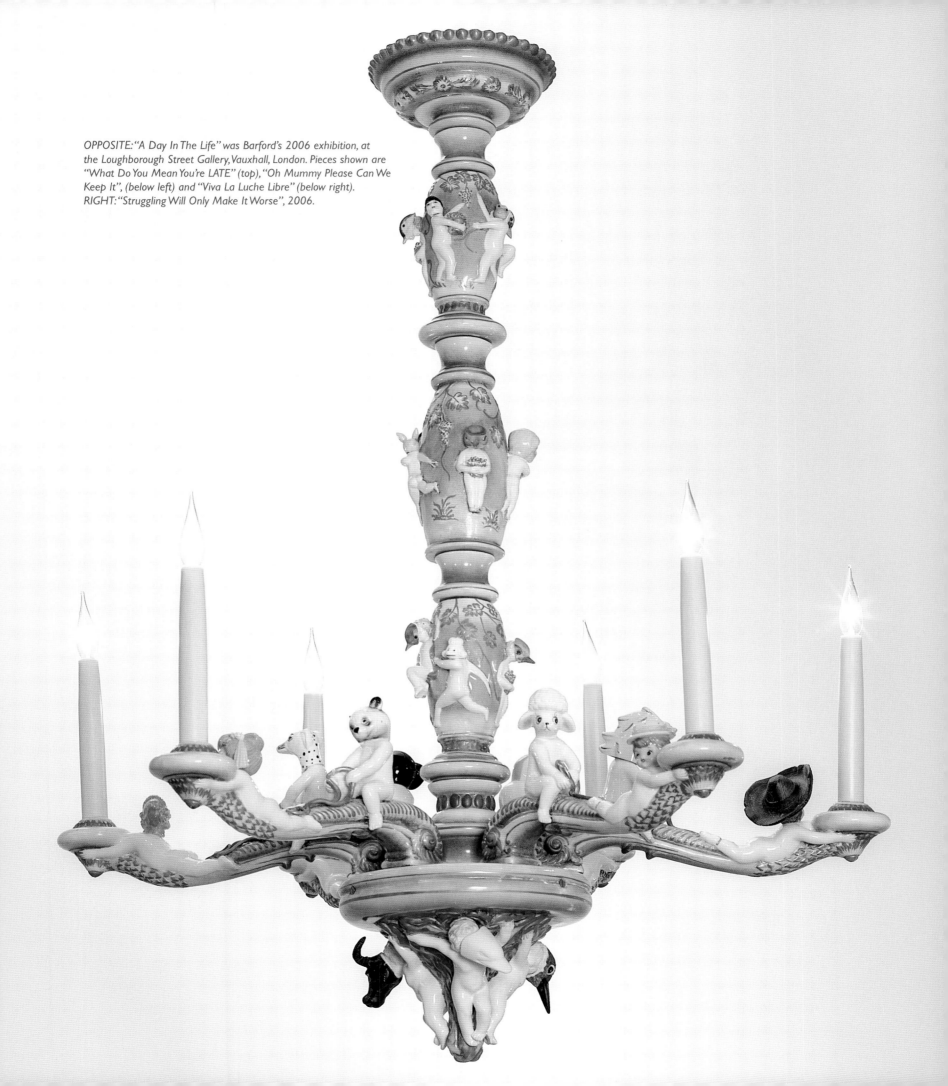

OPPOSITE: "A Day In The Life" was Barford's 2006 exhibition, at the Loughborough Street Gallery, Vauxhall, London. Pieces shown are "What Do You Mean You're LATE" (top), "Oh Mummy Please Can We Keep It", (below left) and "Viva La Luche Libre" (below right).
RIGHT: "Struggling Will Only Make It Worse", 2006.

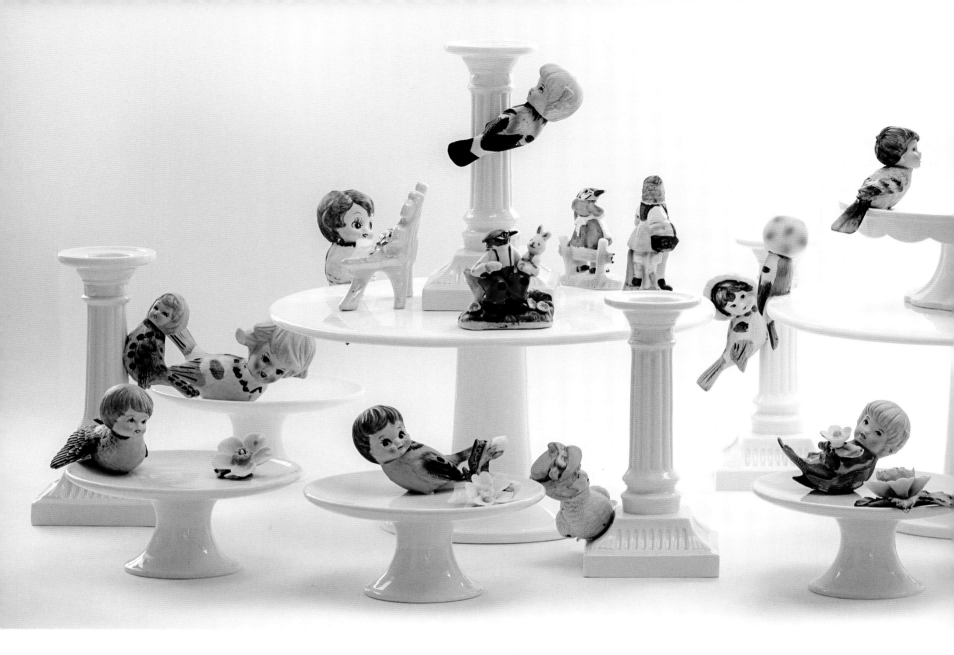

Barford's 2008 exhibition, at the Loughborough Street Gallery, Vauxhall, was entitled "Private Lives". Works included "Park Life" (above), "Stick That On YouTube" (right), "Come On Alan You Little Bitch" (centre right) and "Mary Had A Little Lamb" (far right).

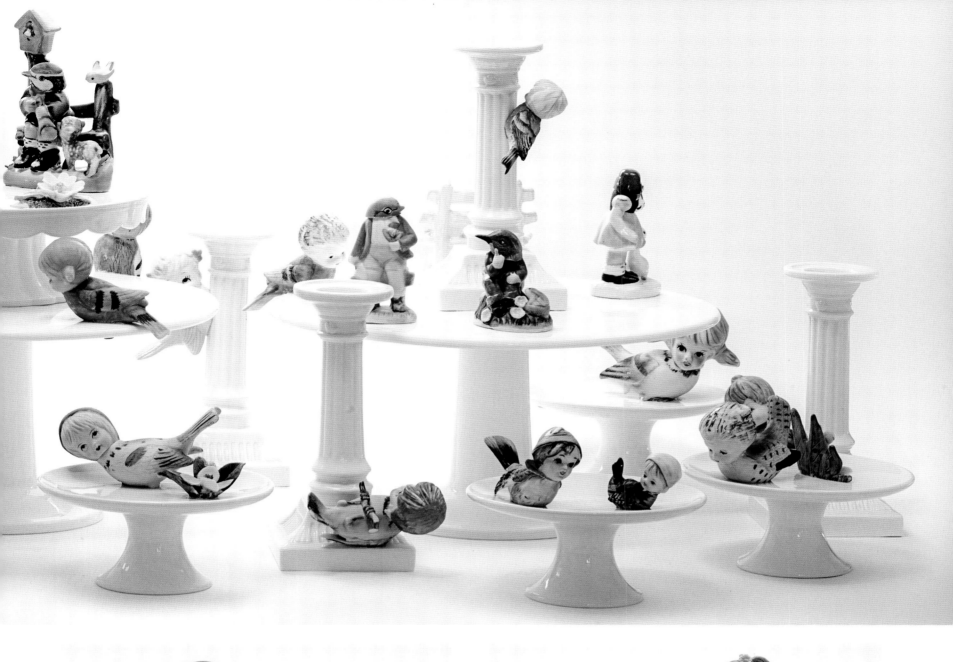

OPPOSITE: For Barford's 2010 exhibition "Damaged Goods", he created set "tableau vivant" pieces, including "BOOM!" (top) and "The Strongest Man In The World" (below).
ABOVE & BELOW: In the same 2010 exhibition he also showed "Sorry" (above) and "If You Play Your Cards Right" (below).

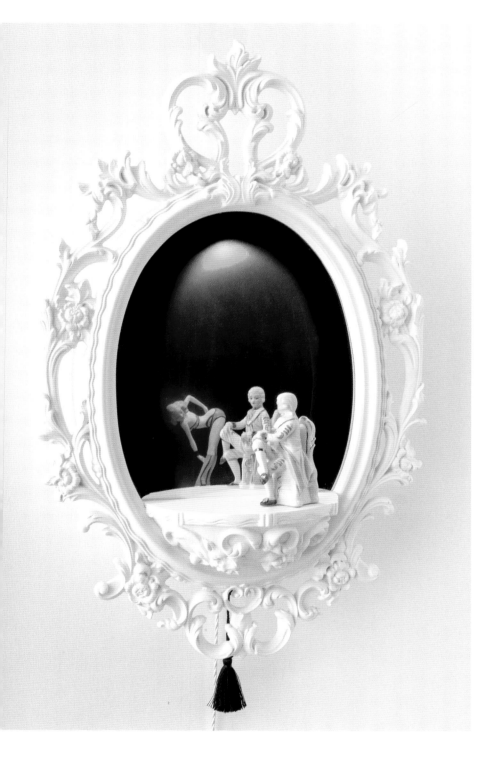

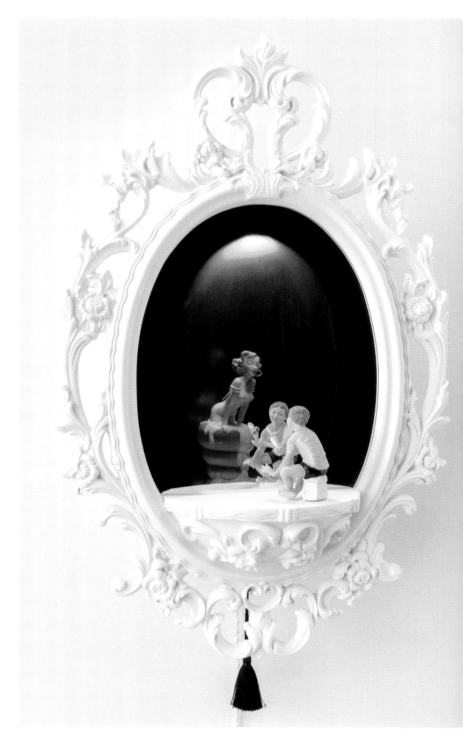

*ABOVE: Barford's final exhibition in 2011 was entitled "Love Is..." which included a series of intriguing mirrors, where, once illuminated, another figure was revealed behind the glass to complete the narrative. "Show Me The Money" (left) and "You Scream, I Scream, We All Scream For Ice Cream" (right) are just two examples of this innovative concept.*

*ABOVE: Barford's interest in the human condition was further explored in the same exhibition with pieces such as "Secret To A Happy Marriage" (left) and "Lawfully Wedded Wife" (right).*

**Barnaby Barford**
The Seven Deadly Sins

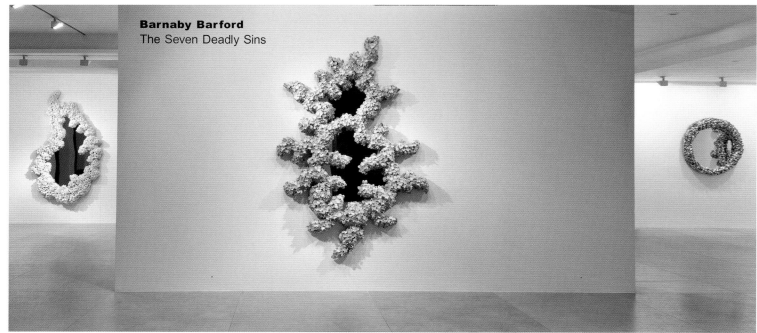

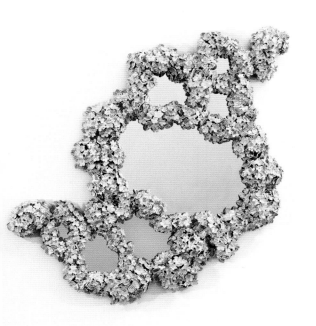

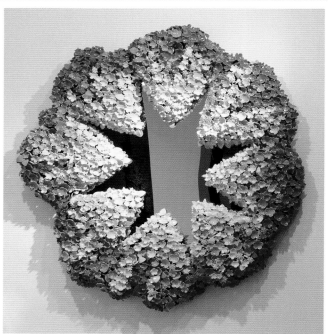

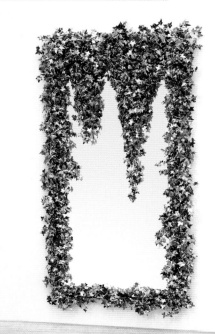

2013 heralded Barford's first exhibition at Gill's new King Street Gallery, and something of a change of direction for the artist. For "The Seven Deadly Sins" he created a series of mirrors to "reflect" each of these extreme sensations, using intricately applied individual ceramic pieces which in themselves bear images loaded with emotional messages (right). Shown here are "Sloth", "Avarice" and "Pride" (top, left to right), "Gluttony" (above left), "Wrath" (above centre) and "Envy" (above right), and in the reflection of "Mirror Mirror" (opposite) is "Lust".

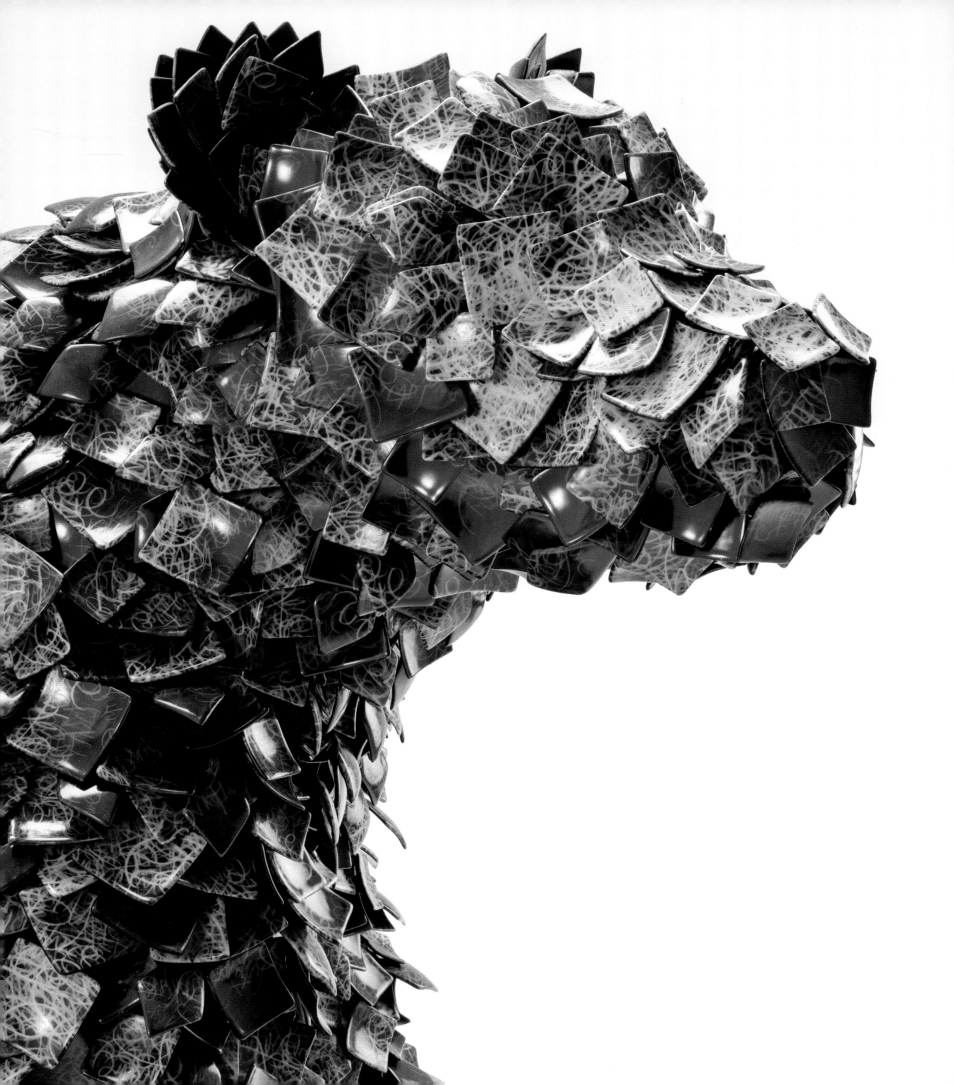

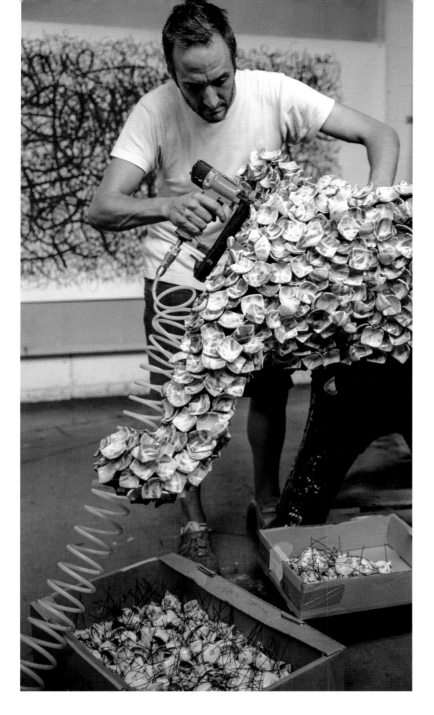

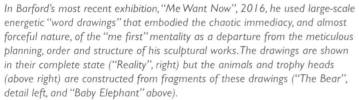

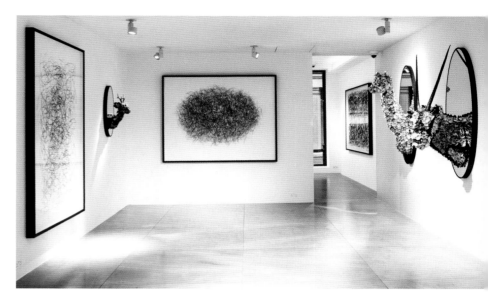

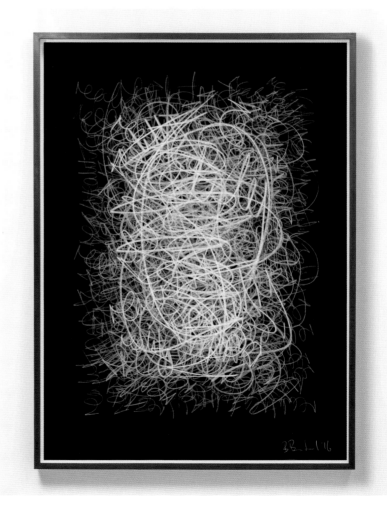

*In Barford's most recent exhibition, "Me Want Now", 2016, he used large-scale energetic "word drawings" that embodied the chaotic immediacy, and almost forceful nature, of the "me first" mentality as a departure from the meticulous planning, order and structure of his sculptural works. The drawings are shown in their complete state ("Reality", right) but the animals and trophy heads (above right) are constructed from fragments of these drawings ("The Bear", detail left, and "Baby Elephant" above).*

"*MATTIA BONETTI'S ARTISTIC CREATIVITY IS **LIMITLESS**. HE HAS THE **SKILL** AND THE **IMAGINATION** TO CREATE A RANGE OF ARTISTIC WORLDS; FROM THE **MOST METICULOUS** AND EXACT, TO THE **MOST BIZARRE** AND **OUTLANDISH**, HIS WORKS ARE ALWAYS SO **DIVERSE** AND YET ALWAYS RETAIN AN ELEMENT OF HIS OWN **DISTINCTIVE** STYLE.*"

JACQUES GRANGE,
INTERIOR DESIGNER

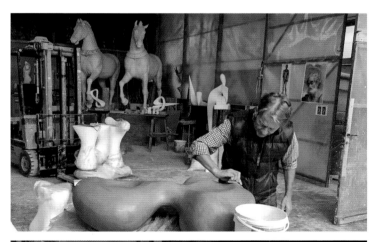

Mattia Bonetti is a Paris-based artist and designer whose work has been called whimsical, surreal and unique. Consistently merging the boundaries between art and design, Bonetti, who was born in 1952 in Lugano, Switzerland, initially studied textile design at the Centro Scolastico per l'Industria Artistica. Moving to Paris in 1972, Bonetti began work within his chosen field of textile design, subsequently becoming a stylist and photographer. Working in black and white film, Bonetti would shoot miniature interiors that he had made by hand, which in turn led to his love of furniture. An artist in the purest sense of the word, Bonetti's work has always begun with a free-hand sketch, and culminates in a piece fabricated in the most luxurious materials.

In the 1970s Bonetti partnered with the designer Elizabeth Garouste, working on the interior décor of the famous Parisian nightclub Le Palace, and restaurant, Le Privilege. Employing a neo-Baroque language blended with prehistoric and primitive touches, Bonetti's terracotta masks were labelled "barbarian". Unfazed, and perhaps encouraged, by such a review, the pair went on to set the pace for cutting edge Parisian design, creating a unique and inventive modern dialogue on "Baroque".

In 1987 Garouste & Bonetti worked with Christian Lacroix on his couture house interior. French Eighteenth-century chairs were upholstered in electric blue, lilac, orange and raspberry. Hot-red consoles were given branches for legs, and stools were designed to look like tree stumps. Nature has never been far from Bonetti's work, wherever his imagination and materials might take him. Drawn to the pair's use of innovative materials and imaginative shapes, David Gill first worked with Bonetti in 1998, the beginning of a creative relationship which has lasted more than thirty years.

David Gill Gallery has regularly shown Bonetti's new work, including tables, upholstery, lighting and accessories. Bonetti's now iconic themes and forms appear in materials such as patinated bronze, marble, gilded rock crystal and glass. In June 2015 the gallery hosted the UK launch of a two-volume book on Bonetti's career.

Consistently working with many of the same craftsmen and ateliers since beginning his career, Bonetti exploits the most luxurious materials, but also pushes technological boundaries, using contemporary skills including 3D printing, modern acrylics and robotics. Every Bonetti piece exudes his personality; he is a true trailblazer for contemporary avant-garde design. His work is included in numerous public collections, including the Centre Pompidou in Paris, the Musée des Arts Décoratifs in Paris, the Cooper-Hewitt National Design Museum in New York, and the Victoria & Albert Museum in London.

*OPPOSITE: Portrait of Mattia Bonetti by Jude Edgington, 2012.*

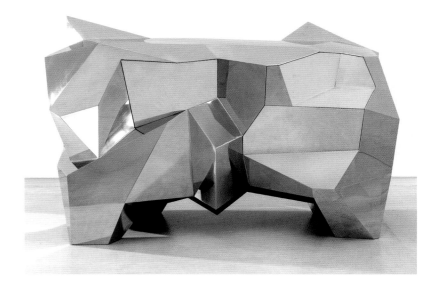

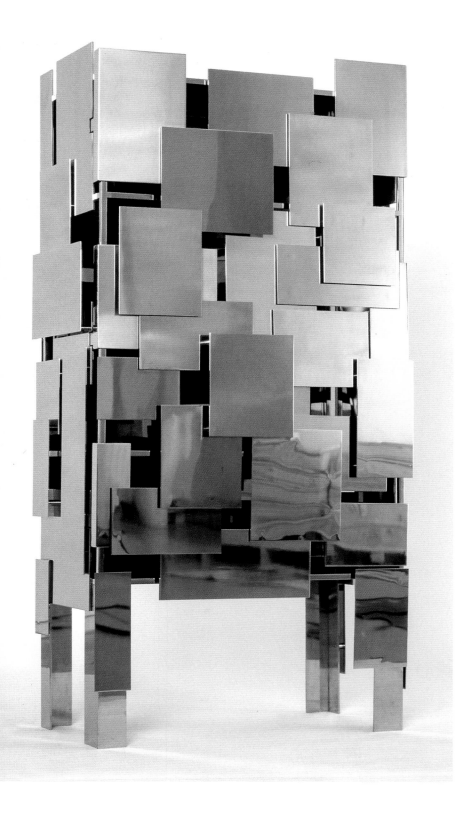

LEFT: "Strata" stainless steel cabinet.
ABOVE: "Polyhedral" chest of drawers.
BELOW: Detail of "Fakir" stainless steel and nickel-plated aluminium cabinet.
All by Mattia Bonetti, from the opening show at Gill's Loughborough Street
Gallery, Vauxhall, 2004.

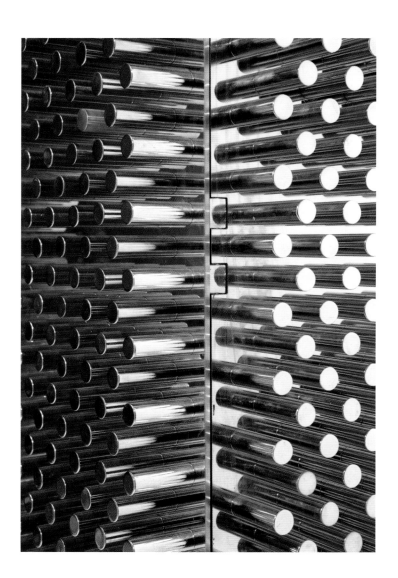

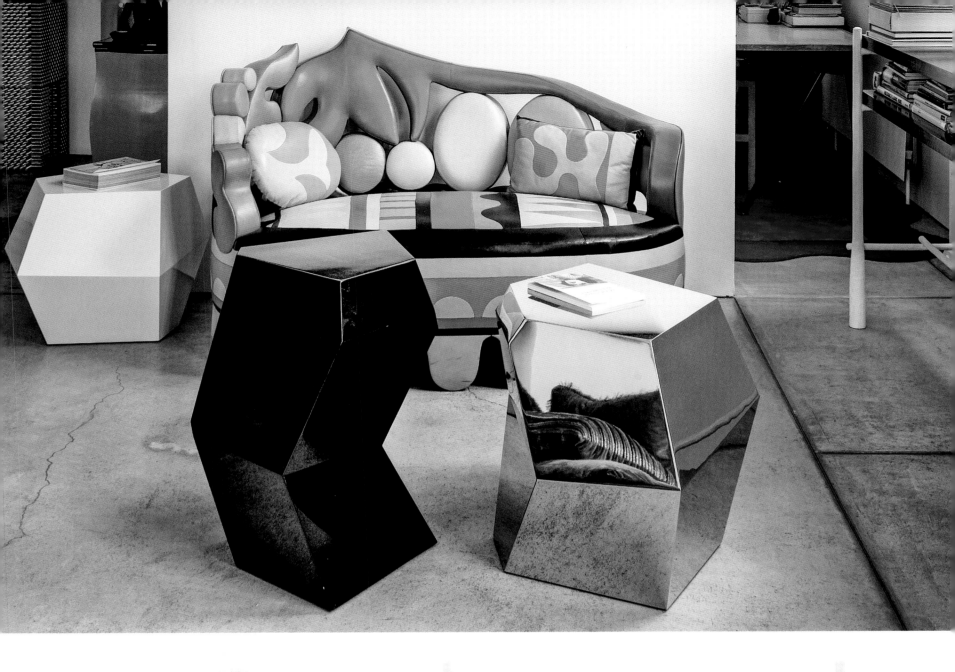

*ABOVE: "Cut out" leather upholstered sofa, and "Polyhedral" stainless steel or lacquered wood side tables shown from sketch to reality.*

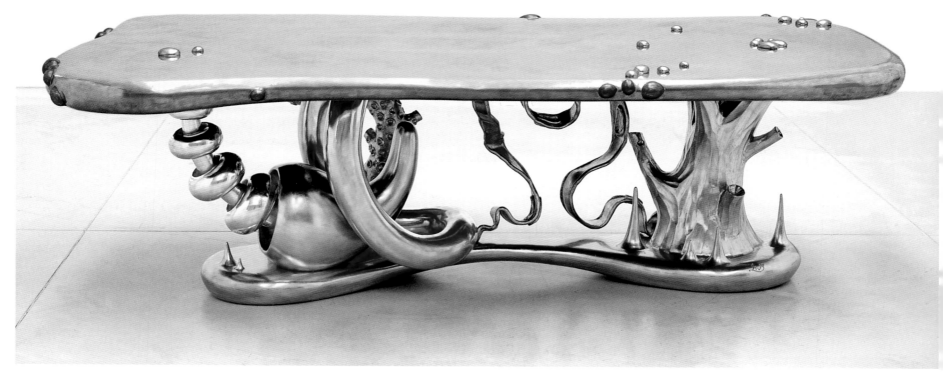

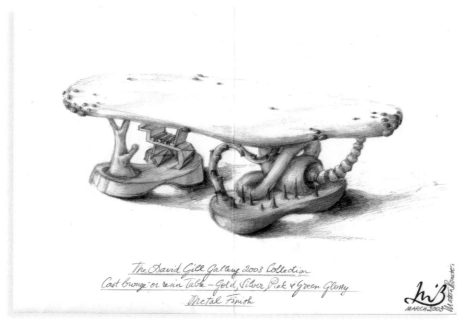

*The David Gill Gallery 2003 Collection*
*Cast bronze or resin Table – Gold, Silver, Pink & Green Glossy*
*Metal Finish*

MARCH 2003

Mattia Bonetti's magnificent "Abyss" dining table was first shown in his 2004 "New Works" exhibition at Loughborough Street, Vauxhall (above) and bought by the Whitney Foundation, later sold.

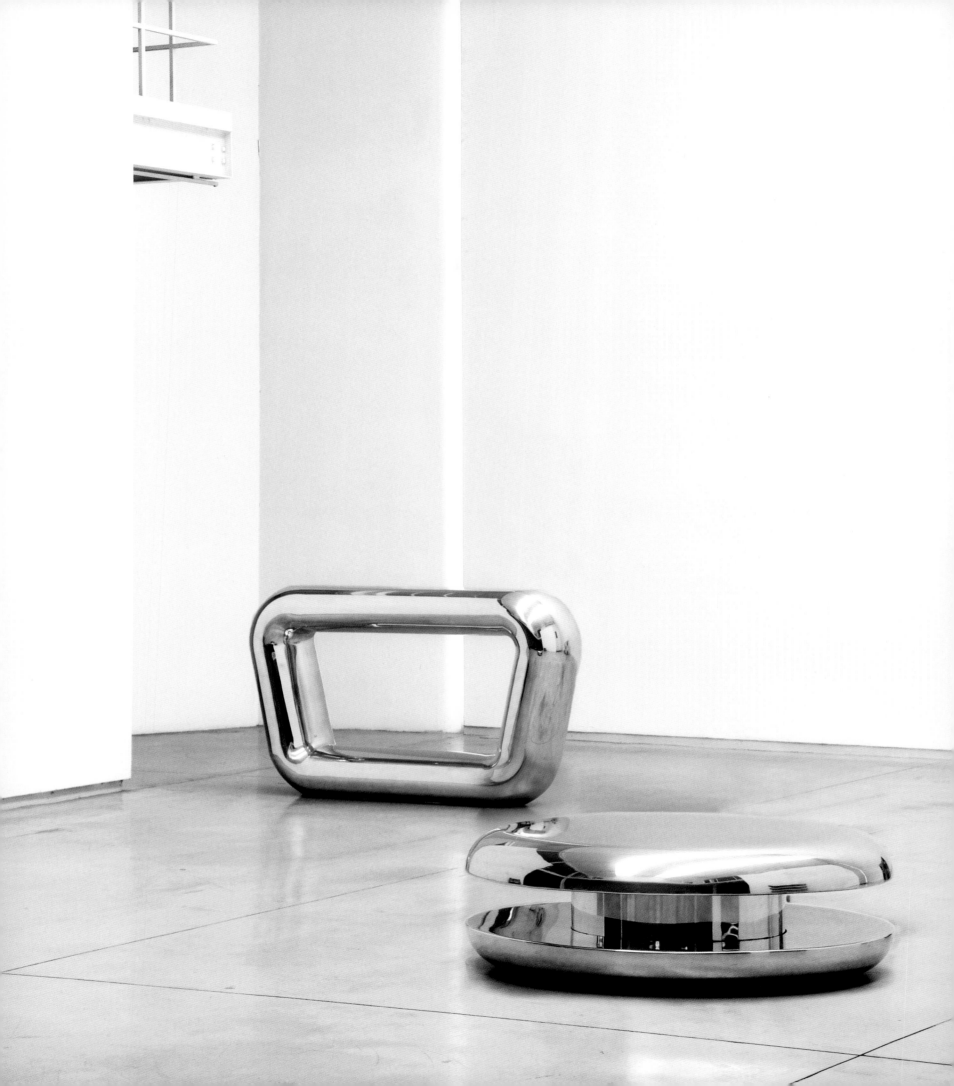

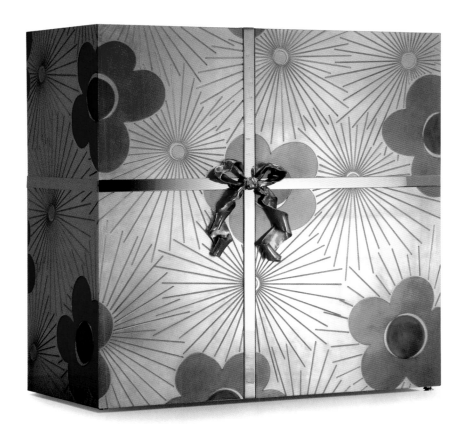

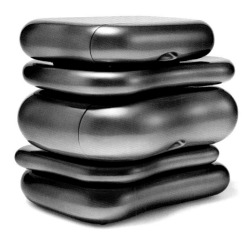

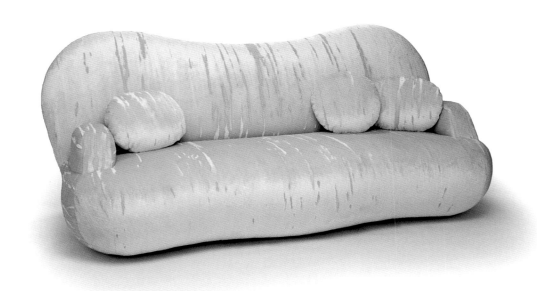

*OPPOSITE: Mattia Bonetti's 2008 "New Works" exhibition at Vauxhall featured the "Alu" console and "Yo-Yo" coffee table. TOP ROW: "Happy Birthday" cabinet (left), "Bubblegum" side table (right). Mattia Bonetti, "New Works", 2008.*
*BOTTOM ROW: "Toast" side table (left), "Cloud" sofa (right). Mattia Bonetti, "New Works", 2008.*

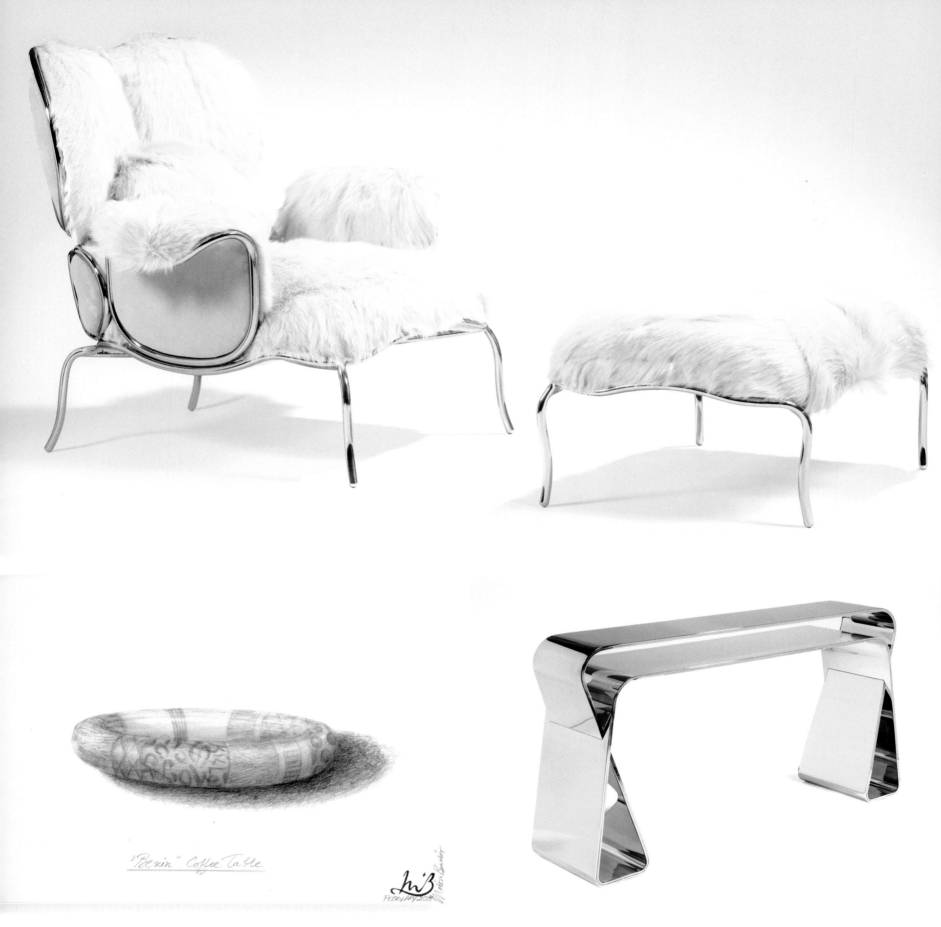

"Benin" Coffee Table

TOP: "Big Jim" armchair and ottoman with nickel-plated steel frame, fur and suede, Mattia Bonetti, "New Works", 2012.
BELOW: "Benin" coffee table (drawing, left) and "Endless Ribbon" console (right), Mattia Bonetti, "New Works", 2012.

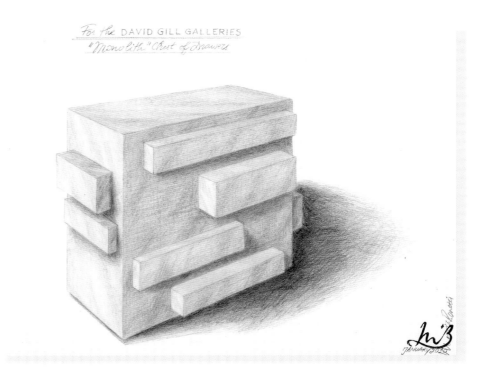

For the DAVID GILL GALLERIES
"Monolith" Chest of Drawers

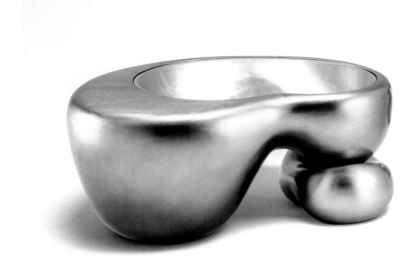

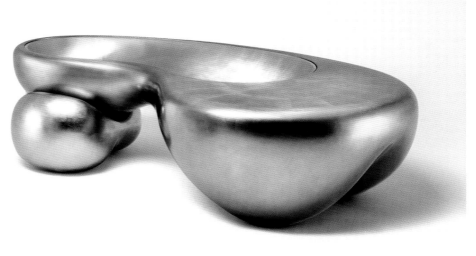

TOP: "Incroyables" table lamp (left), "Monolith" chest (drawing, right), Mattia Bonetti, "New Works", 2012.
BELOW: "DW4" and "DW5" coffee tables, Mattia Bonetti, "New Works", 2012.

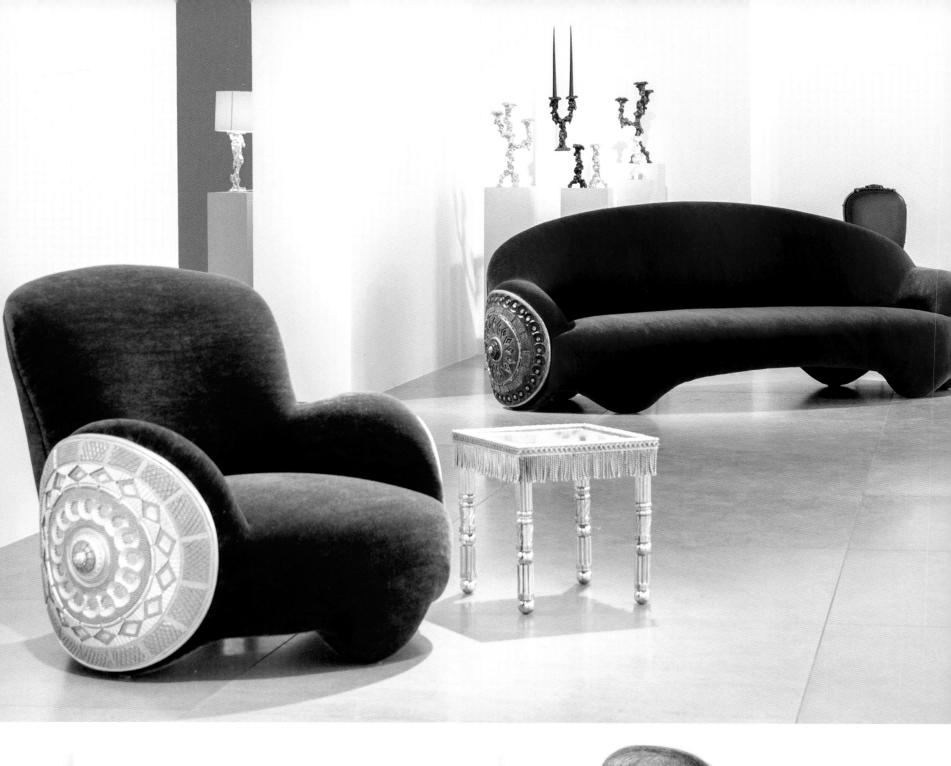

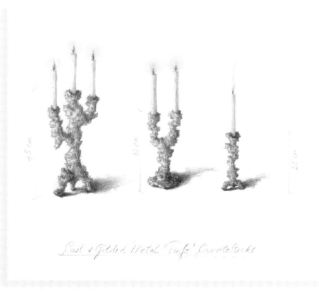

Cast & Gilded Metal "Tufa" Candlesticks

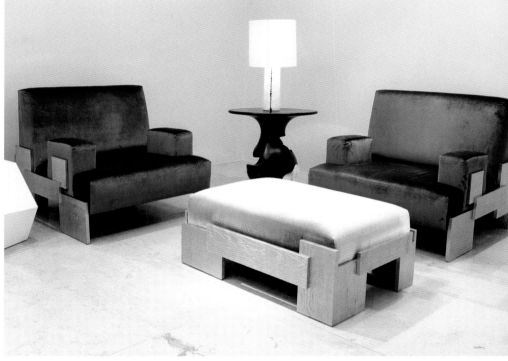

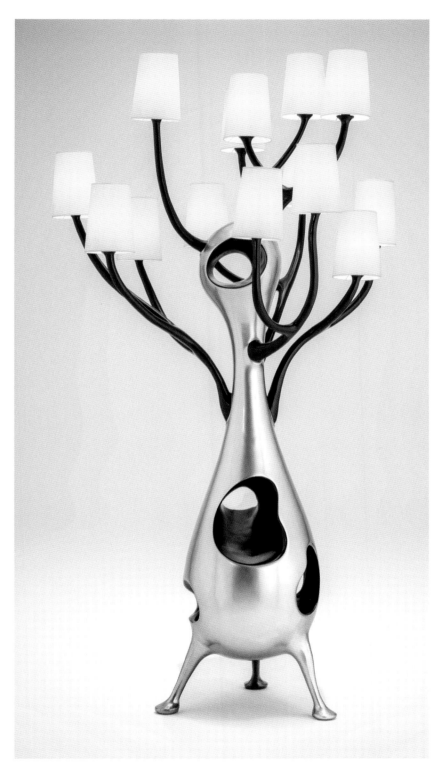

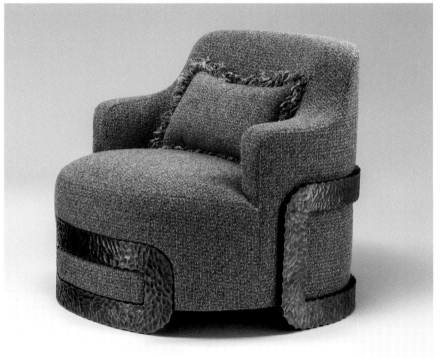

OPPOSITE: "Shield" armchair and sofa, with "Grotto" candelabras, and Bonetti's illustrations of the same (below), together with "Fringe" side table, from Bonetti's 2014 "New Works" exhibition at King Street.

LEFT: "Metropolis" torchére. Mattia Bonetti, "New Works", 2014.
ABOVE: "Strata" armchairs and ottoman with "Taurus" side table.
BELOW: "Buckle" armchair (right, and drawing, opposite) from the same 2014 "New Works" exhibition at King Street.

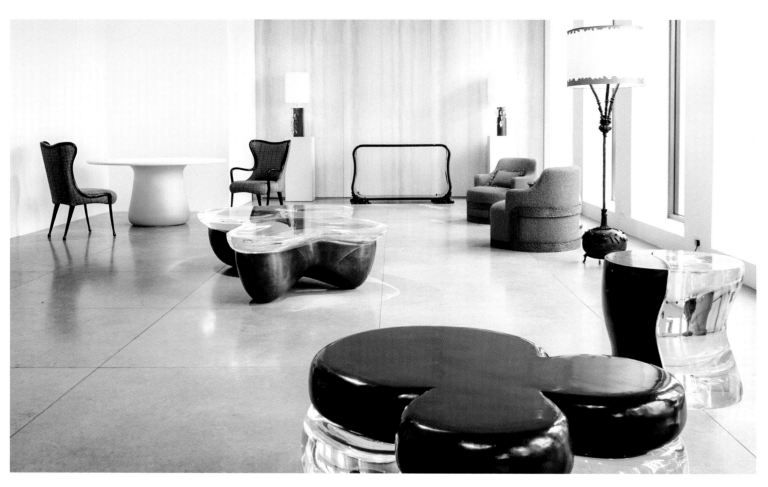
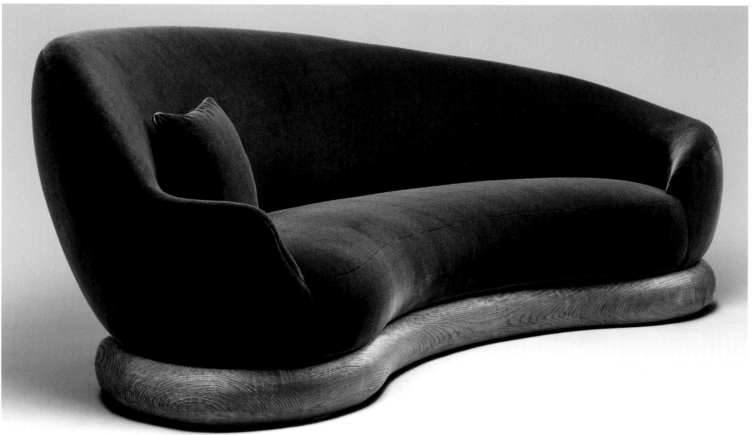

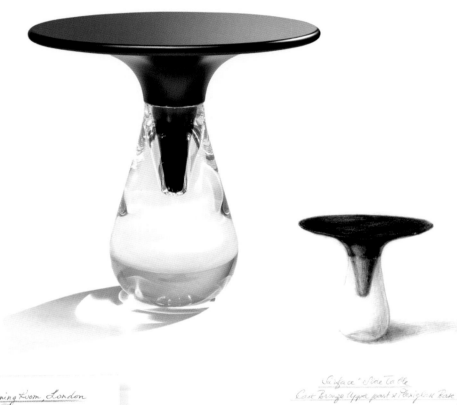

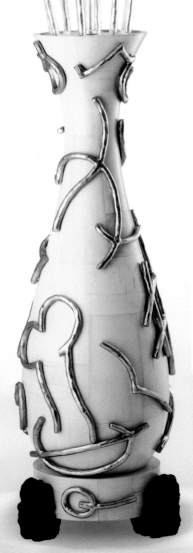

*Mr. and Mrs Burgess Dining Room, London*

*"Banana" Standard Lamp. Ceramic vase with gilded wrought iron motifs. Silk leaves or coloured gilded leaves*

*"Surface" Side Table. Cast Bronze Upper part & Perspex Base*

OPPOSITE: *Mattia Bonetti's installation at King Street, 2017, included the "Buckle" and "Palermo" chairs (top) and "Cylinder" sofa (below).*
ABOVE: *"Surface" side table, with original design drawing, Mattia Bonetti, "New Works", 2017.*
LEFT: *"Jungle" torchére, with original design drawing, 2017.*
OVERLEAF: *A selection of Bonetti's original design drawings for David Gill Editions, and private client commissions, from across the years.*

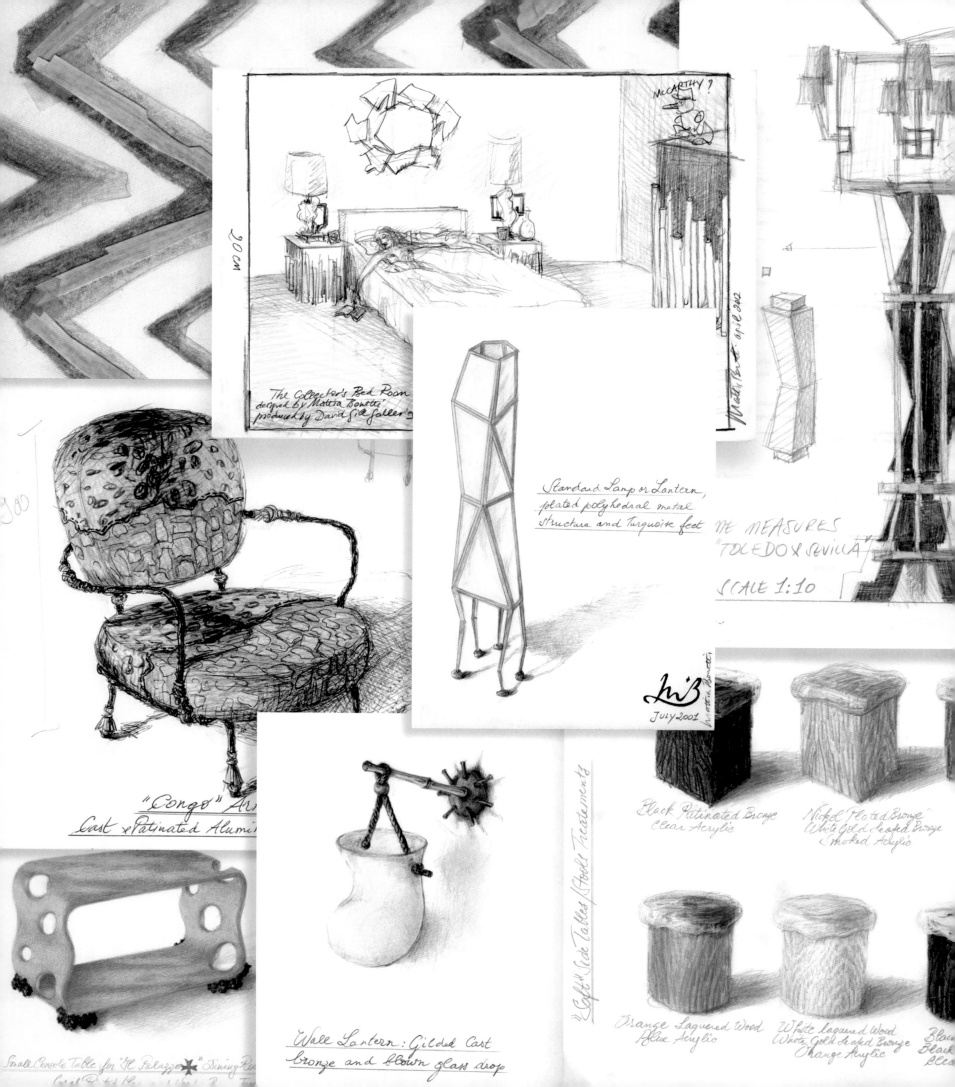

The Collector's Bed Room
designed by Mattia Bonetti
produced by David Gill Gallery's

McCARTHY?

20 cm

Standard Lamp or Lantern,
plated polyhedral metal
structure and Turquoise feet

MᵇB
July 2001

ME MEASURES
"TOLEDO & SEVILLA"

SCALE 1:10

"Congo" Arm
Cast & Patinated Alumin

Black Patinated Bronze
Clear Acrylic

Nickel Plated Bronze
White Gold Leafed Bronze
Smoked Acrylic

"Soft" Side Tables / Stools Treatments

Wall Lantern: Gilded Cast
bronze and blown glass drop

Orange Laquered Wood
Blue Acrylic

White Laquered Wood
White Gold Leafed Bronze
Orange Acrylic

Black
Black

Small Console Table for "Il Palazzo" Dining Roo

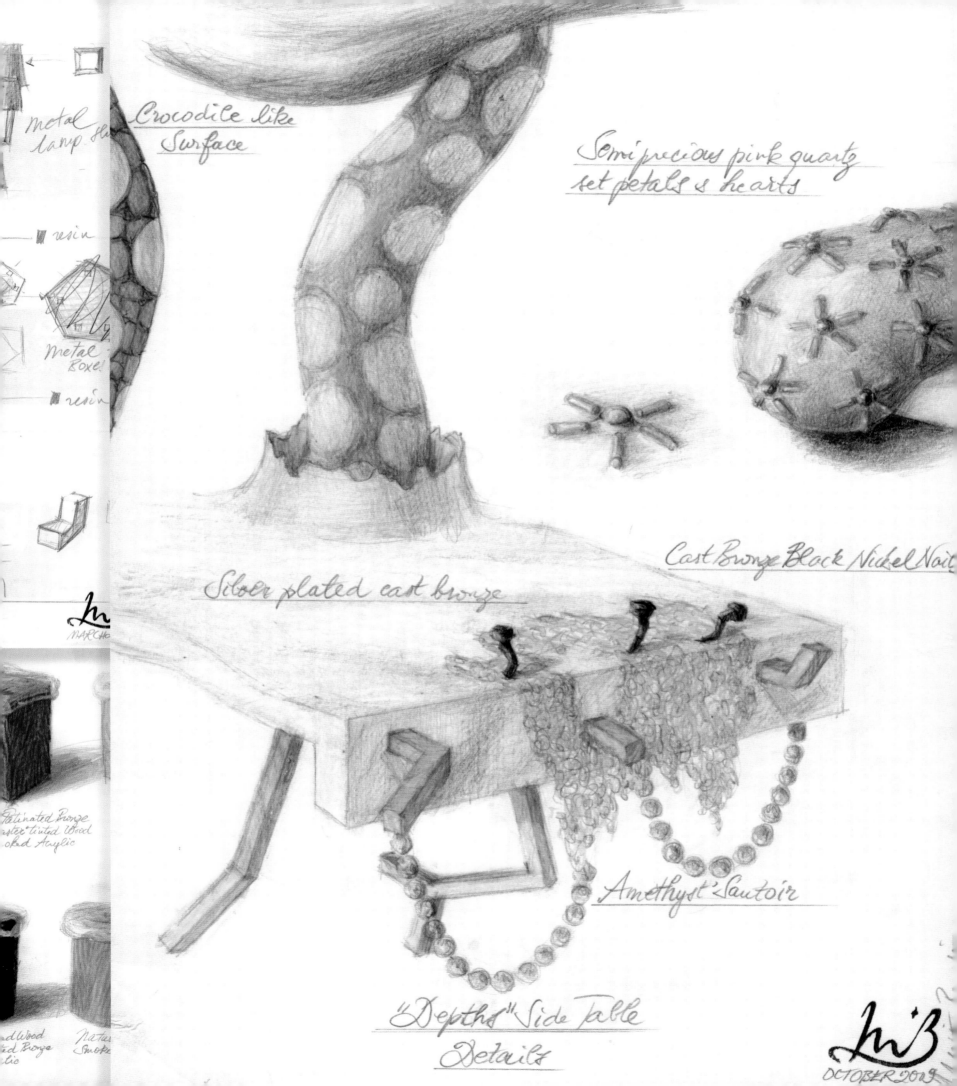

metal lamp.she

resin

Metal Boxes

resin

resin

Crocodile like
Surface

Semi precious pink quartz
set petals & hearts

Cast Bronze Black Nickel Nail

Silver plated cast bronze

Amethyst Sautoir

"Depths" Side Table
Details

Patinated Bronze
aster tinted Wood
oked Acrylic

d Wood
ed Bronze
lic

Natur
Smoke

OCTOBER 2009

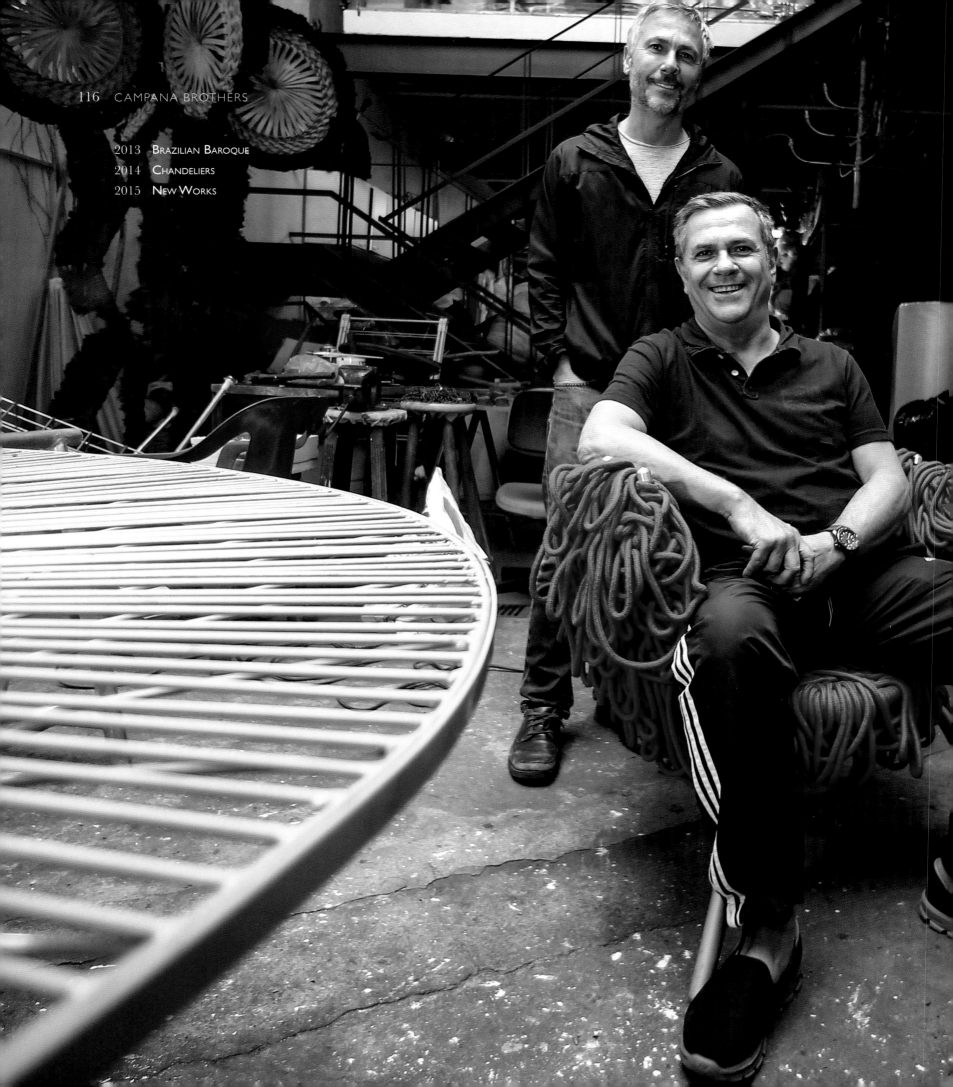

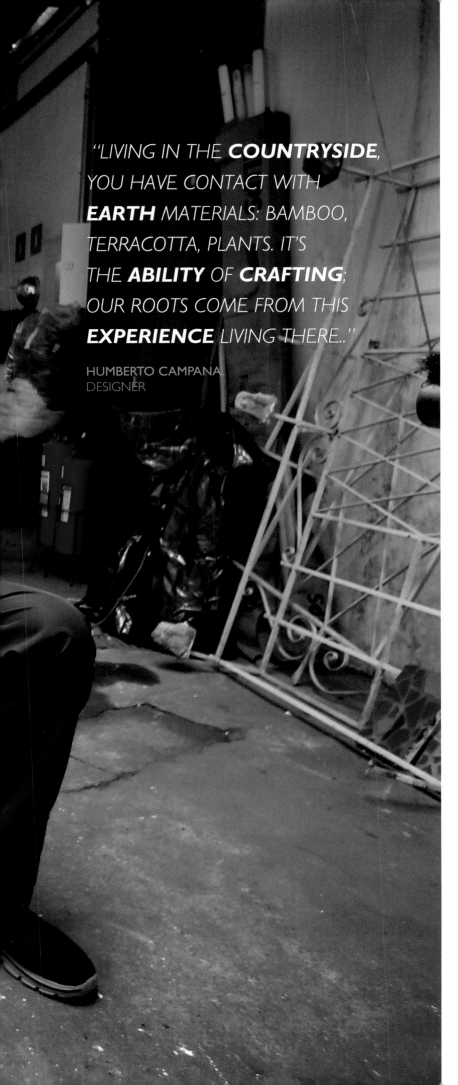

"LIVING IN THE **COUNTRYSIDE**, YOU HAVE CONTACT WITH **EARTH** MATERIALS: BAMBOO, TERRACOTTA, PLANTS. IT'S THE **ABILITY** OF **CRAFTING**; OUR ROOTS COME FROM THIS **EXPERIENCE** LIVING THERE.."

HUMBERTO CAMPANA
DESIGNER

The Campana brothers began working together in 1983 in Sao Paolo where they still live and work. Humberto trained to be a lawyer, but gave it up to be a sculptor and though Fernando studied architecture, he decided to work with his brother to experiment with design and making furniture. They first made their name with their "Favela" chair: pieces of wood, roughly jigsawed together.

Inspired by Rome and its complex artistic heritage, the Campana Brothers' "Brazilian Baroque" collection was brought to life in the city in 2011. Exclusively edited by Giustini / Stagetti Roma and produced in Roman workshops specialising in the manufacturing of bronze and marble, the collection is the ever-evolving product of an osmotic collaborative relationship between the Brazilian designers and the indigenous artisans. The result of this connection is a body of work which the brothers term "transgenic", and which embodies their own personal definition of the Baroque: furniture adorned with intricate collages of gold and bronze motifs reference ornate Baroque decoration from the Seventeenth and Eighteenth-centuries in Italy, Spain and South America.

The brothers created a series of pieces from jumbles of metal emblems and figures including gold and bronze leaves, keys, animals and figurines, all of which were welded together to create elements such as the legs of stone tables and fur-covered chairs. Shades for floor and pendant lights were constructed in the same way, whilst the brothers piled up small gold crocodiles to form one of the candle holders.

These detailed pieces were first shown at Rome's Palazzo Pamphilj in 2011 and then at the Musée des Arts Décoratifs in Paris a year later. Ever an advocate of the arrestingly ornate, David Gill has actively contributed to promote the collection's success in the UK since 2013.

"This project," say the brothers, "was a gift. Everything took place in an absolutely spontaneous way … We took some details of the city, its architectural extravagance, aesthetics and created a record of its different historical periods. We then disorganised them to obtain a personal collage, a layering of elements reassembled into a new shape, free from prejudice."

The continuing development of the *Brazilian Baroque Collection* has led the Campanas to experiment with new interpretative possibilities using materials and techniques from the classical age, especially marble and bronze. Remaining consistent with the creative spirit and working methods that have always set their artistic discourse apart – assemblage and the idea of recycling – the now iconic collection continues to evolve and provoke.

*Humberto (left) and Fernando Campana at their Sao Paulo studio, Brazil, 2016.*

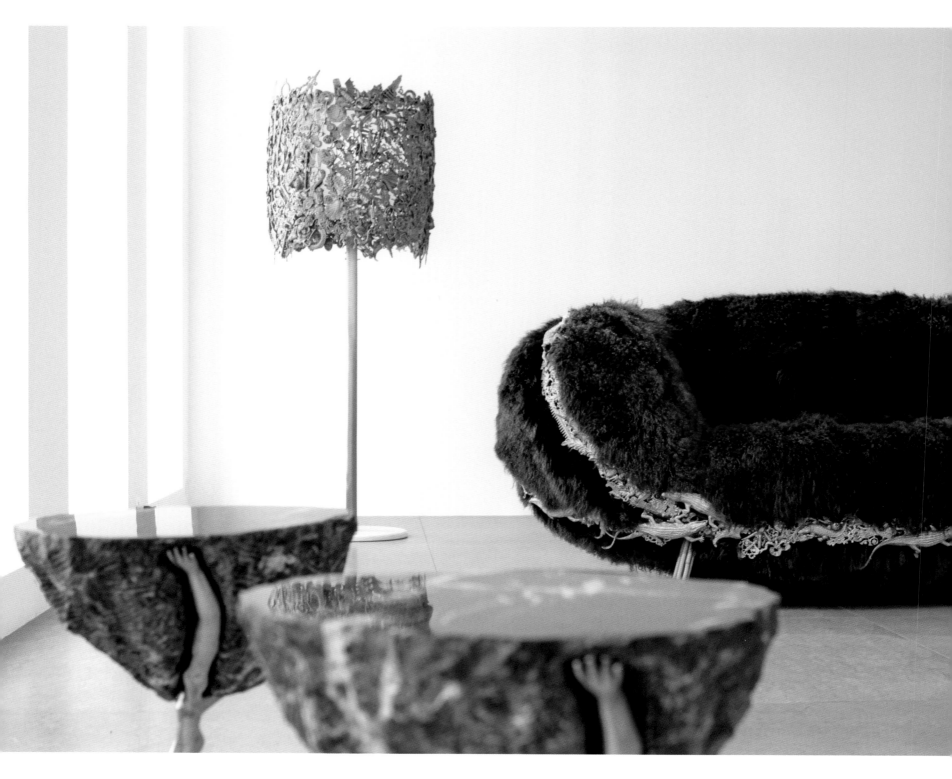

*ABOVE, L-R: "Humberto" side tables, burnished bronze, Portoro marble, 2012; "Ouro Preto" floor lamp, gilded bronze, Carrara statuary marble, 2012; "Anhanguera" sofa, gilded bronze, Mongolian fur, bamboo, 2012, "Brazilian Baroque", King Street, 2012.*

*RIGHT: "Lacrime di Coccodrillo" candlestick, ancient marble, gilded bronze, 2012, "Brazilian Baroque", King Street, 2012.*
*FAR RIGHT: "Lupa" chair, gilded bronze, eco-fur, 2011, "Brazilian Baroque", King Street, 2012.*

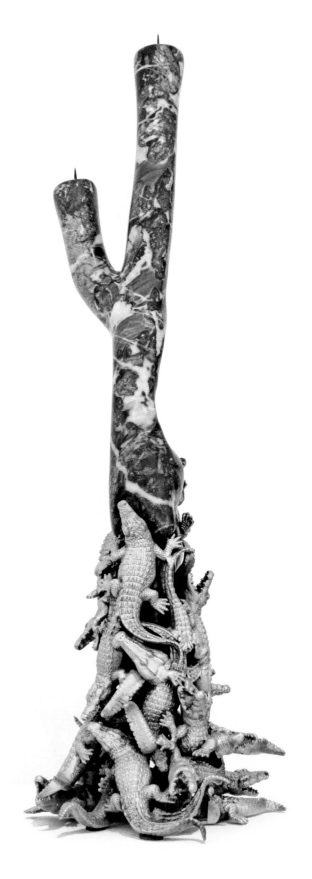

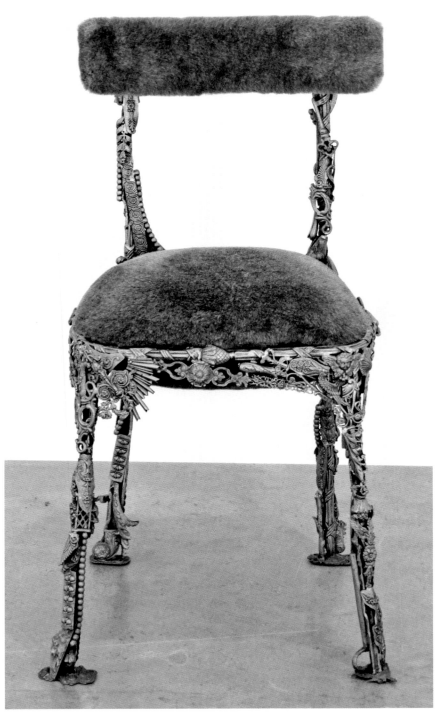

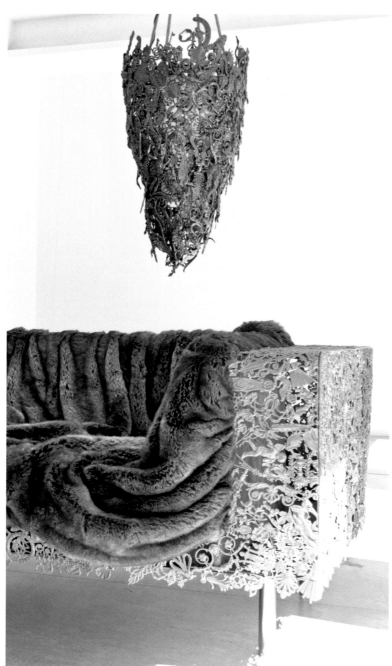

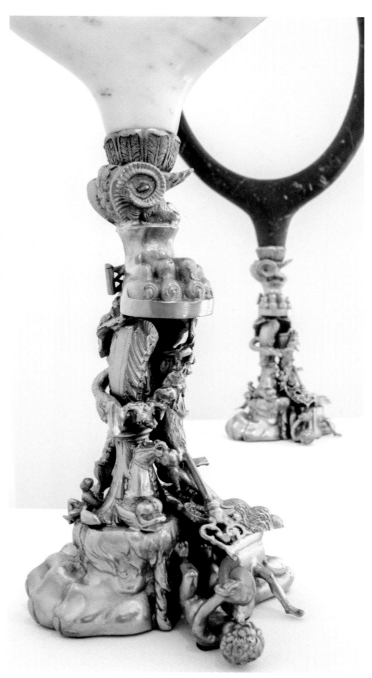

*OPPOSITE, L-R: "Aleijadinho" candlesticks / Ancient Marble, gilded bronze, black aquitania marble or Carrara statuary marble (details right), 2011; "Angra" coffee table, gilded brass and black Belgian marble, 2013; "Tarquinio" sofa, gilded bronze, eco fur (detail above), 2012; "Pamphilj" chandelier, gilded bronze (detail above), 2011, "Brazilian Baroque", King Street, 2012.*

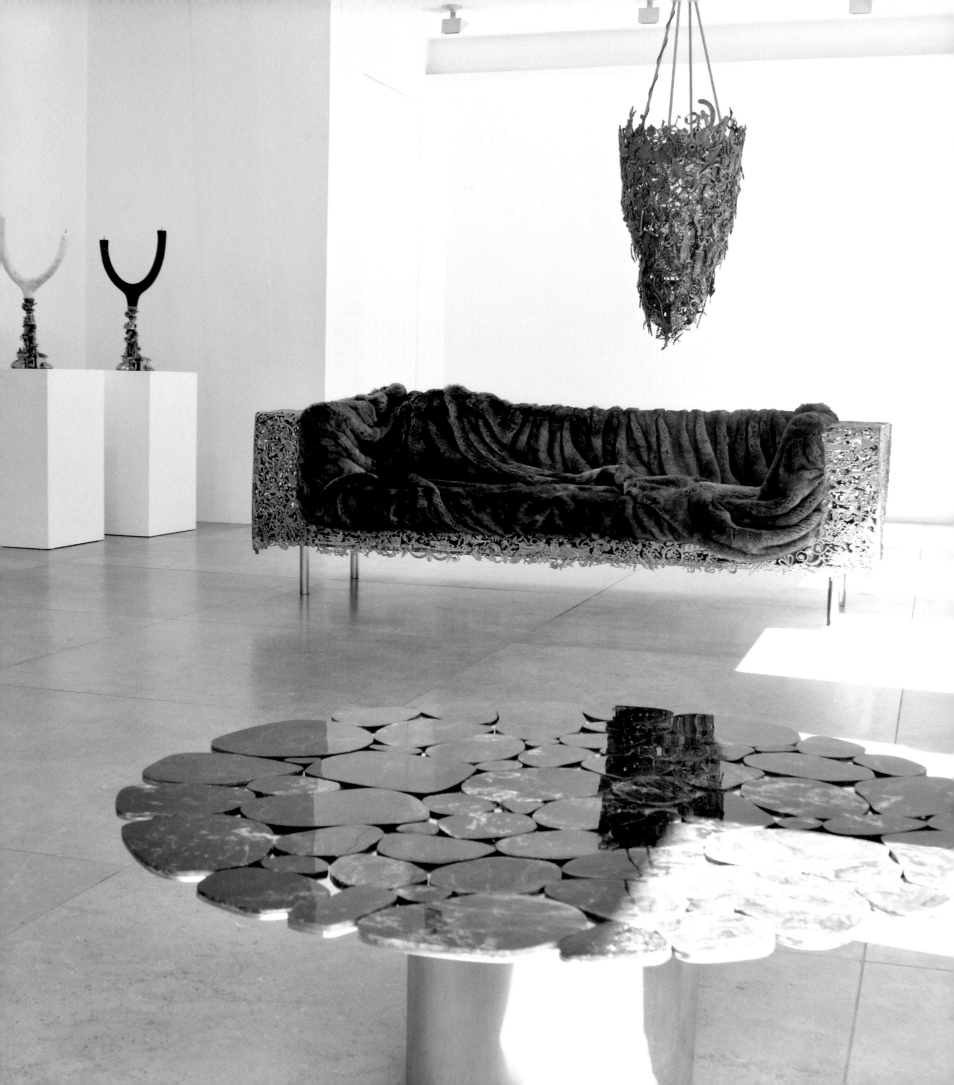

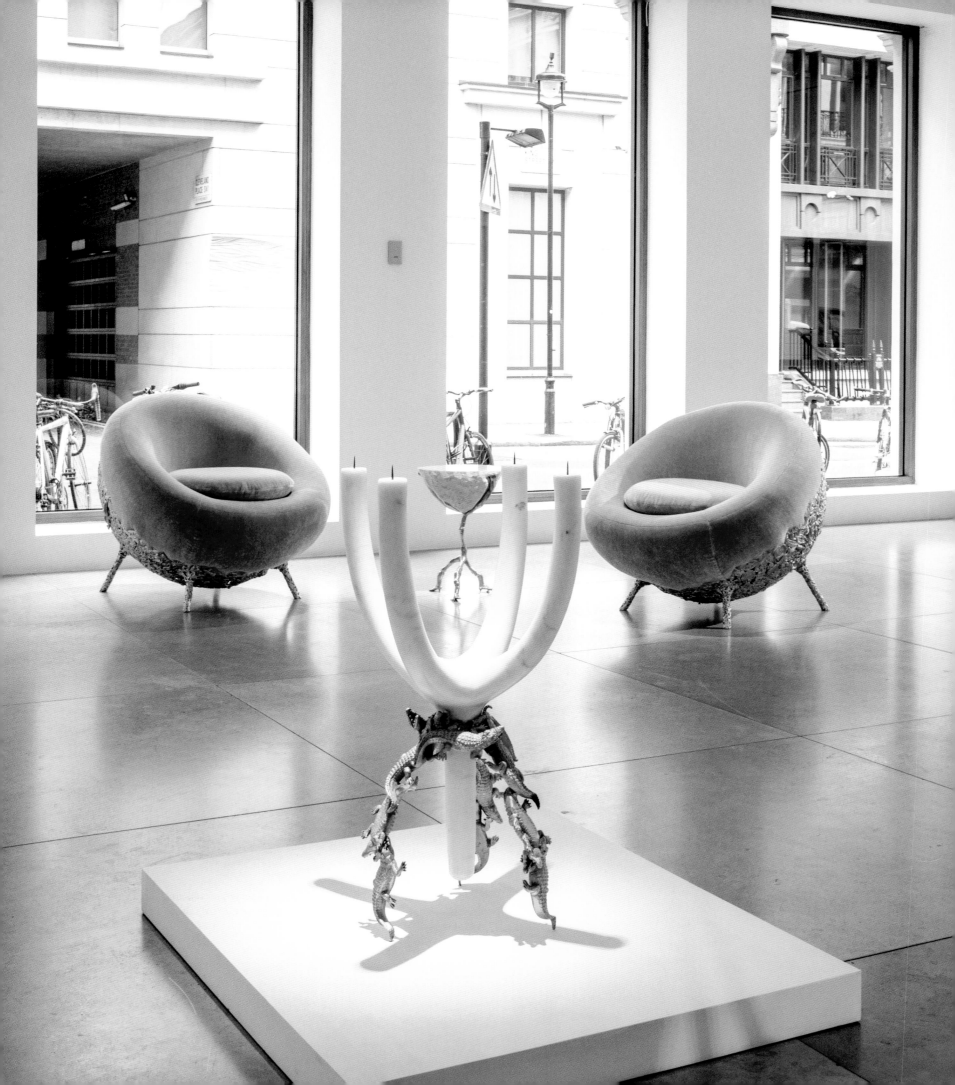

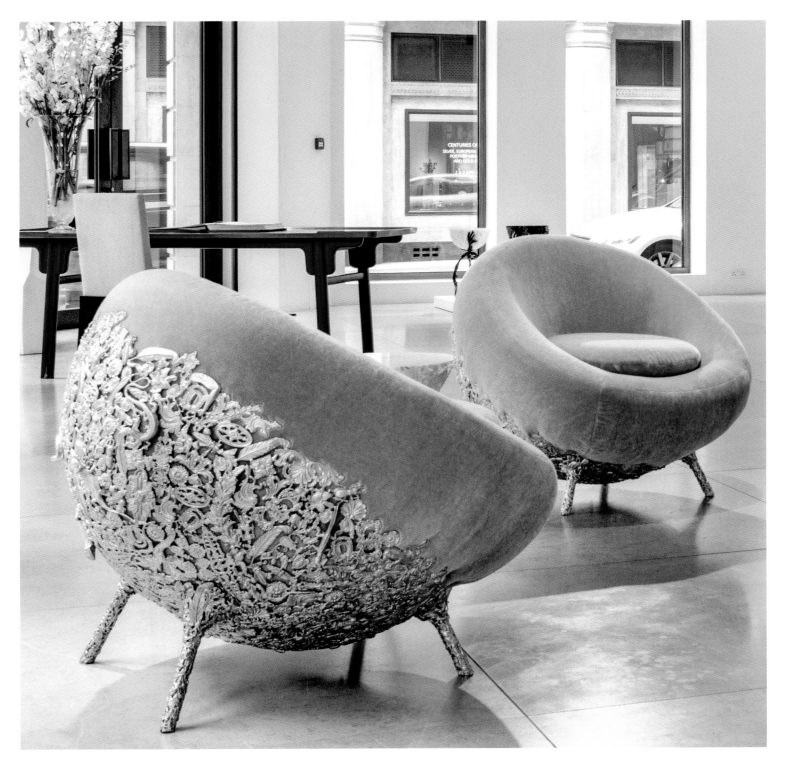

*OPPOSITE, L-R: "Lina" armchair, gilded bronze, mohair wool velvet (detail above), 2014; "Humberto" side table, gilded bronze, Carrara statuary marble, 2012; "Tritone" candlestick, gilded bronze, Carrara marble, 2012, "New Works", King Street, 2015.*

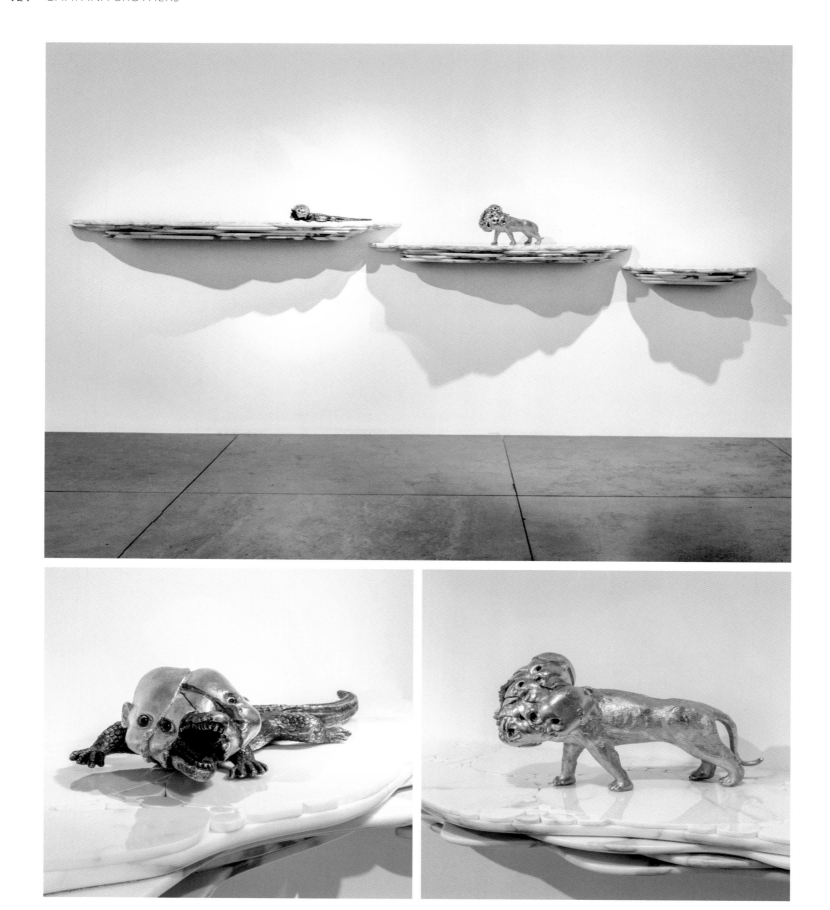

*OPPOSITE: "Basoli" consoles, Calacatta marble, 2014; "Alligator Toy" and "White Tiger Toy", gilded bronze and glass, 2014, "New Works", King Street, 2015. ABOVE: "Basoli" circular dining table, Calacatta marble, brass, 2014, "New Works", King Street, 2015. Artwork by Daniel Buren. All pieces edited by Giustini / Stagetti Roma.*

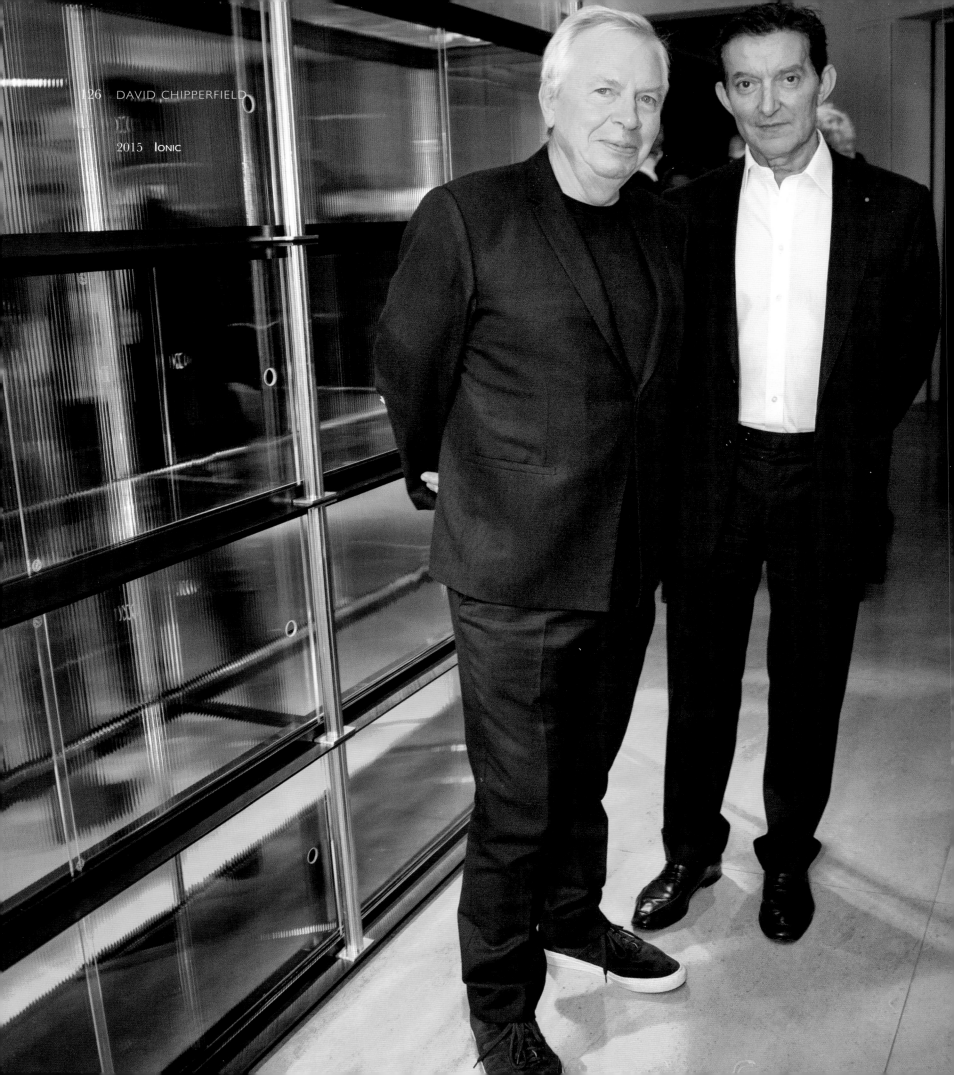

2015 Ionic

*"DAVID CHIPPERFIELD'S **NEW** SERIES OF **CABINETS** AND **CONSOLES** FOR DAVID GILL GALLERY ARE A **MICROCOSM** OF THE BRITISH ARCHITECT'S LARGER **ARCHITECTURAL VISION** – FULL OF ORTHOGONAL **GEOMETRY** AND **RESTRAINT**."*

ALI MORRIS,
WALLPAPER

Internationally acclaimed architect Sir David Chipperfield had previously undertaken commercial design projects for e15, Artemide and Wästberg, B&B Italia and Cassina. The series of cabinets, bookcases and consoles for the 2015 "Ionic" capsule collection at King Street was, however, the first time he had worked with a gallery.

Freed from the typical market constraints of furniture production, strengthened ribbed glass was framed with fluted bronze columns and blackened steel – materials carefully selected to invoke external architectural design, yet maintain the utilitarian necessities of a collectable piece of interior furniture. Every material element was considered in great detail, as were the technical and production processes, to ensure the most exquisitely tactile and elegant collaborative outcome.

The signature columns of one of the three orders of Classical Greek Architecture, Ionic, simultaneously uphold values of aesthetics and function. The collection reveals a recurrent theme throughout Chipperfield's designs: the beauty that can lie in structure and form.

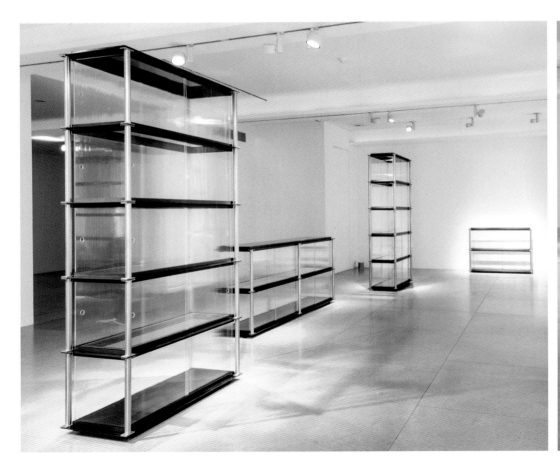

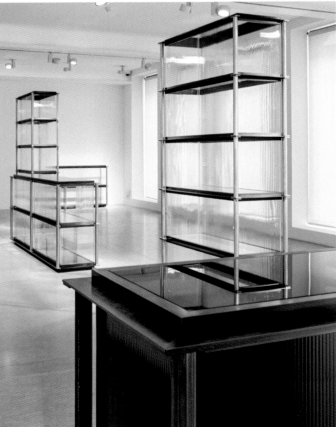

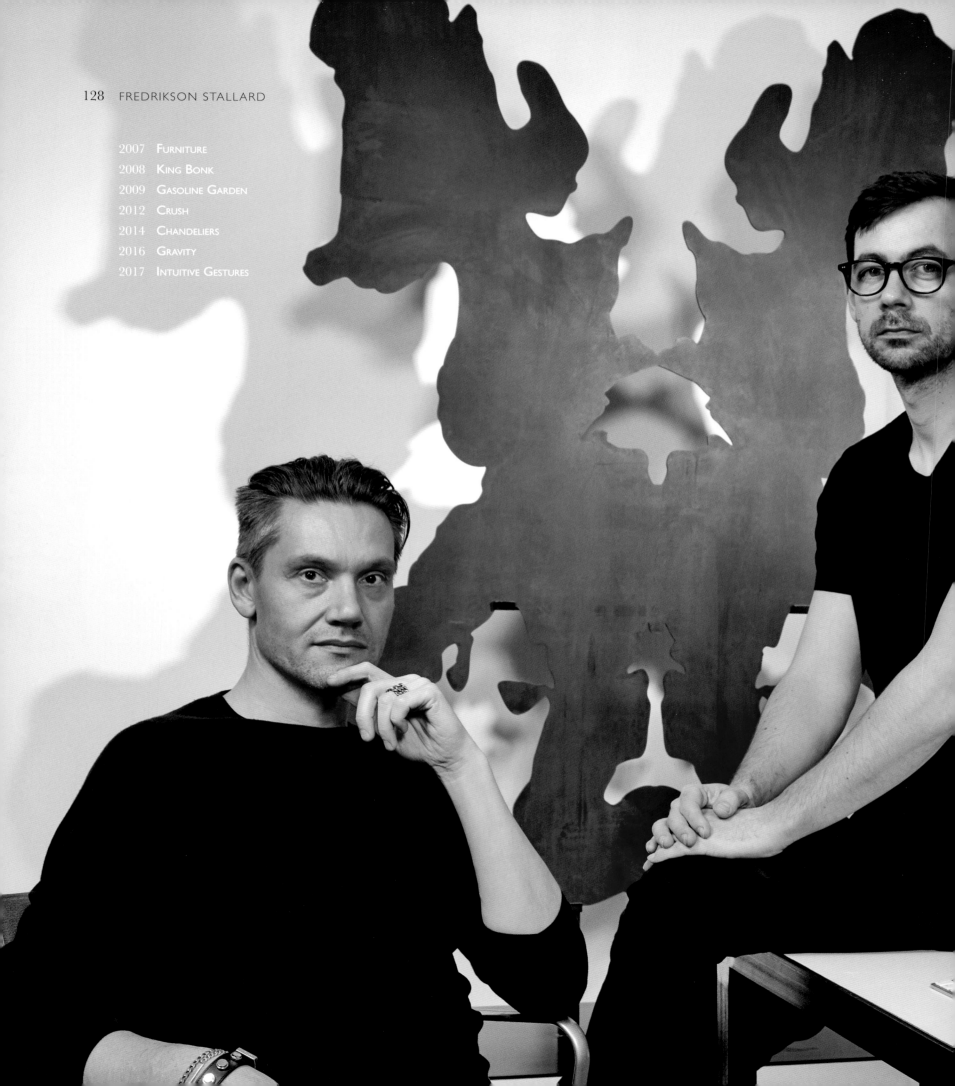

"I have been aware of this duo forever," says David, "and I have always kept an eye on what they've been doing; but of course, as with all my artists, everything takes time to mature." What eventually brought Fredrikson Stallard together with David Gill was a table they had made called "The Crushed Table". "I spent some time absorbing its beauty," recounts David. "Looking at a slab of ice as a table, tracing its cracks, was like reading someone's soul through the history on their face." Thus commenced ten years of collaboration, over six shows, creating sculpture-designed furniture. "I think that this is an element in their work which they feel very comfortable with – Patrik comes from architecture and Ian comes from ceramic sculptures, and the fusion of these shared ideas are inventively brought together."

The collaborative process starts with the pair showing David their drawings, then models are made and discussed further, during all the manufacturing processes, until the finished product, which is both a beautiful sculpture and also a piece of furniture that has to function with all the requisites that entails.

"Over the twenty years or so we have known him, David has always made us aware of the work of other artists and sculptors whose pieces he sees around the world," says Ian Stallard. "He doesn't attempt to influence our own work – far from it – but he does open our minds to all sorts of ideas and influences."

"Our work is an infusion of the digital and analogue worlds," adds Patrik Fredrikson. "There is always a strong element of handcraft in what we do, which we combine with digital solutions," elucidates Ian. "Our work develops in an organic way… one work leading to another; in the show "Intuitive Gestures", for example, there are three separate groups of work, one group leading instinctively to another."

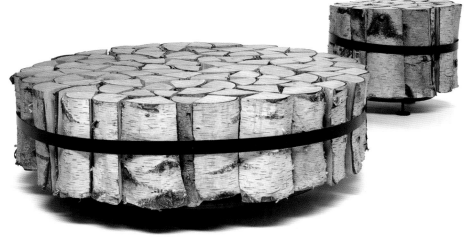

*LEFT: Patrik Fredrikson (left) and Ian Stallard in their London studio.*
*ABOVE: "#1 (Log)" coffee table and "#2 (Log)" side table, wood and steel, 2005.*

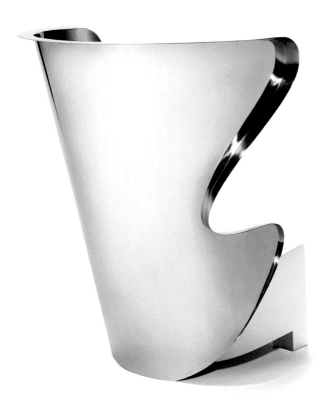

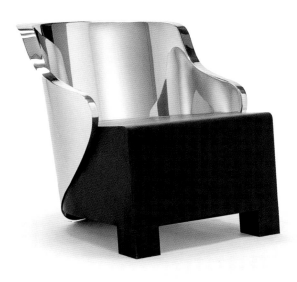

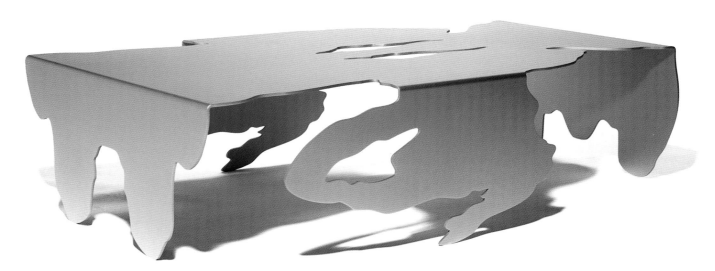

*TOP: "Bergère 2" chair (left) and "Bergére 1" chair (right), stainless steel and rubber, 2007. These chairs were also displayed at the Design Museum, Shad Thames, London (opposite).*
*ABOVE: "Aluminium series", "2-Slit Gold" coffee table, anodised aluminium, 2007.*

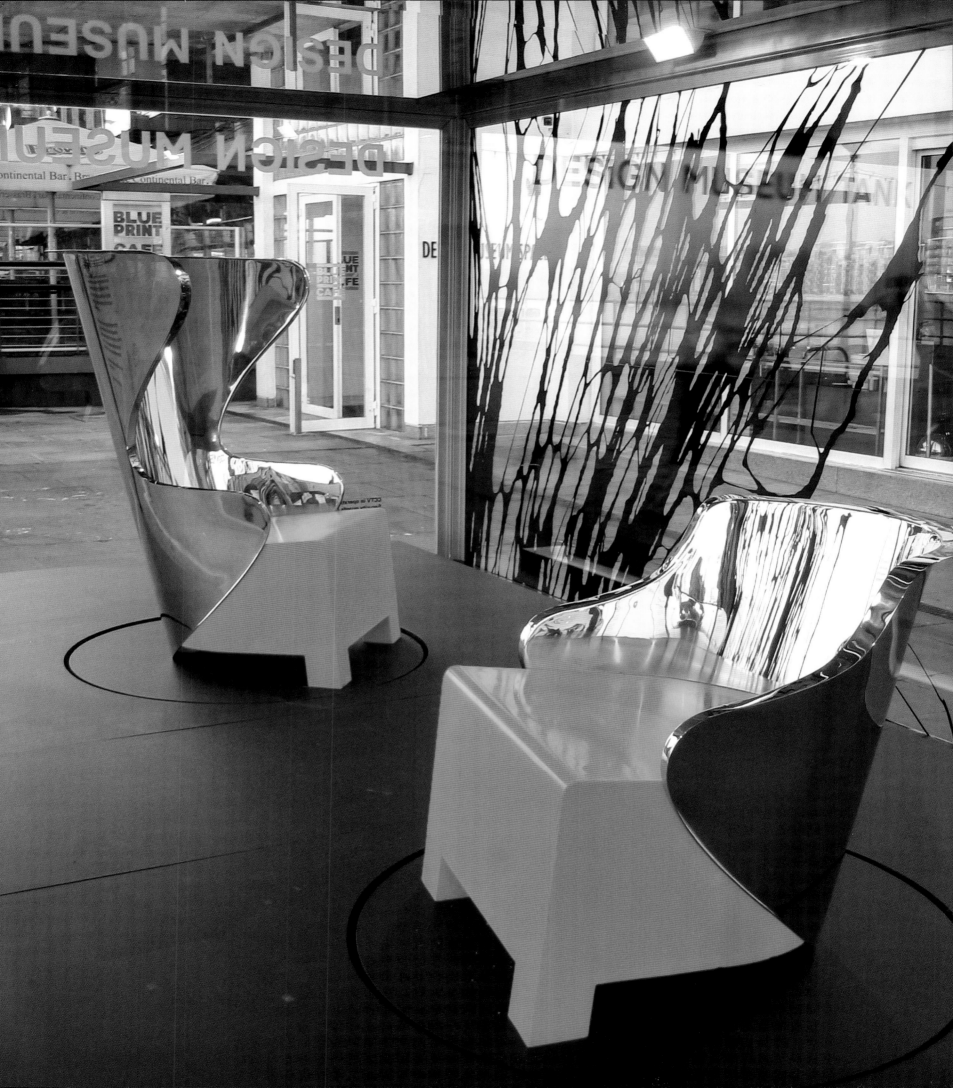

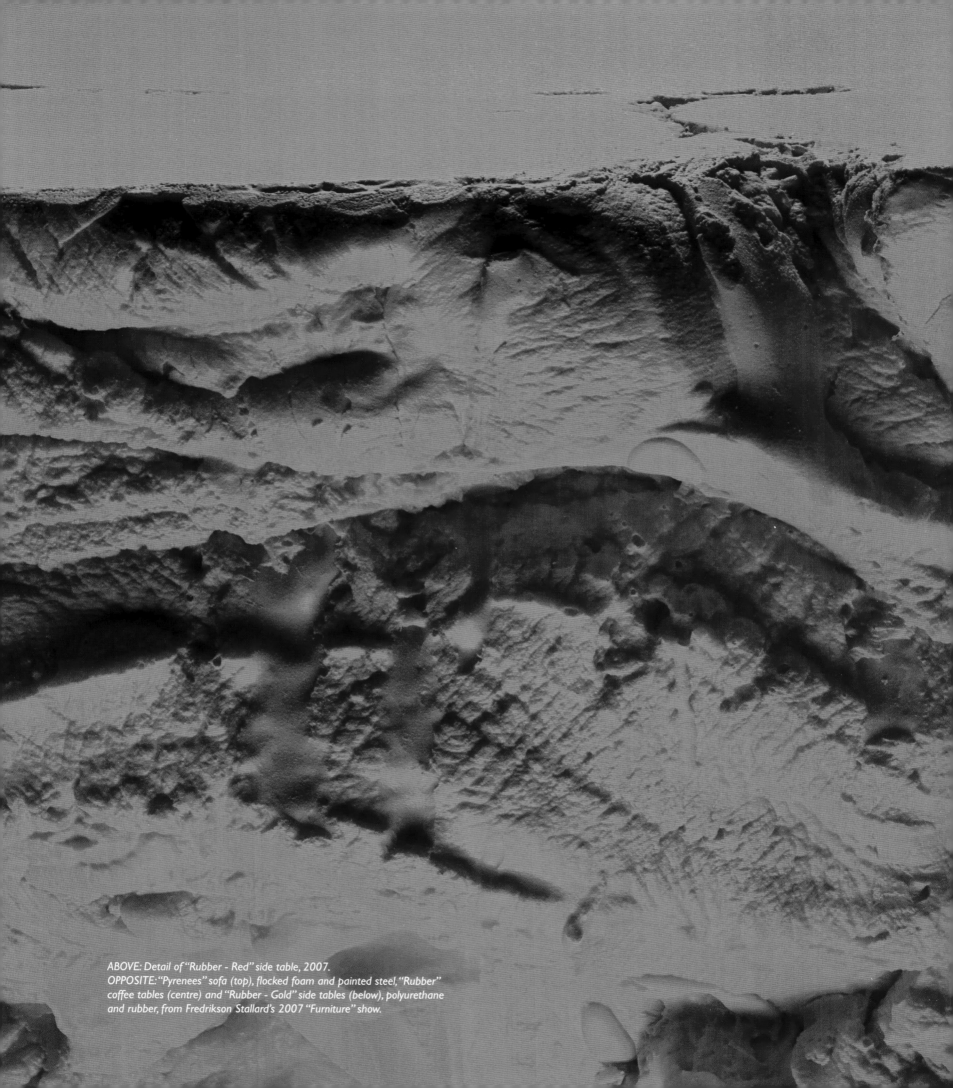

ABOVE: Detail of "Rubber - Red" side table, 2007.
OPPOSITE: "Pyrenees" sofa (top), flocked foam and painted steel, "Rubber"
coffee tables (centre) and "Rubber - Gold" side tables (below), polyurethane
and rubber, from Fredrikson Stallard's 2007 "Furniture" show.

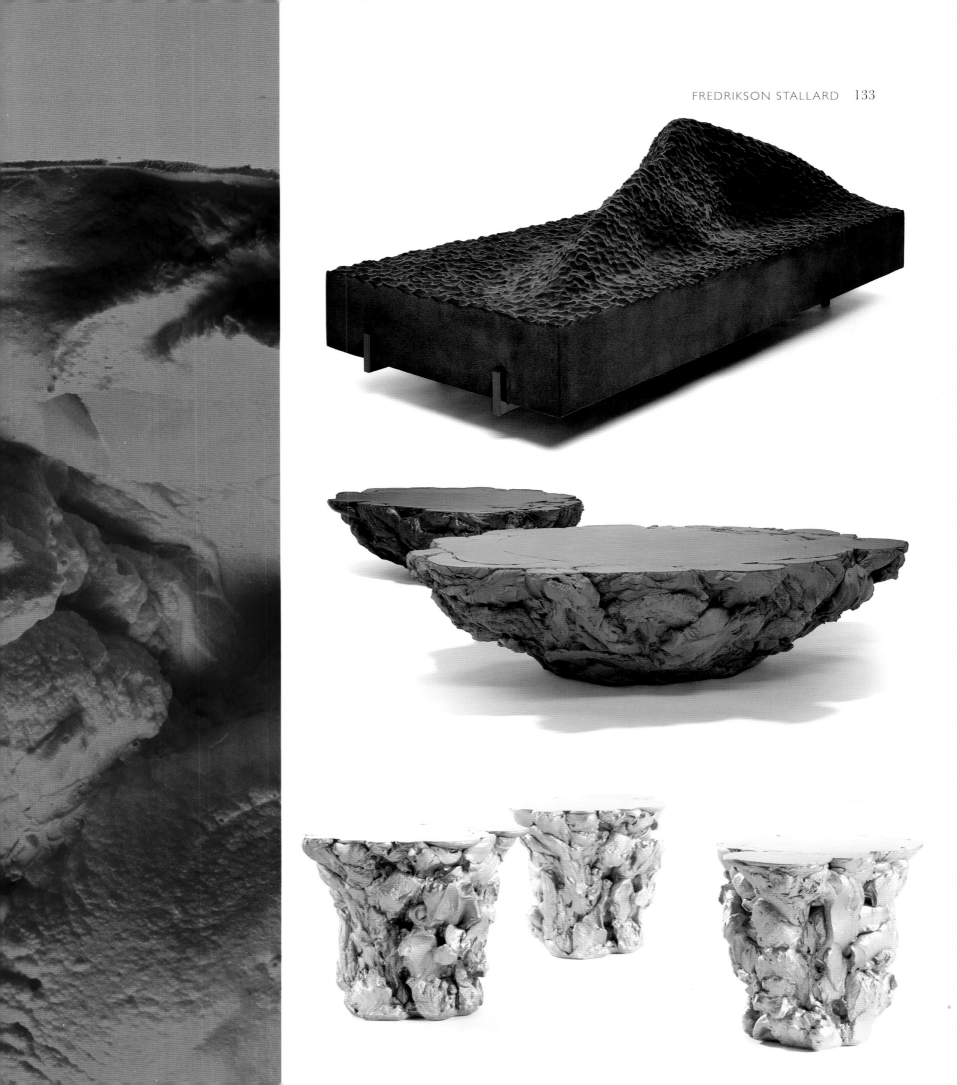

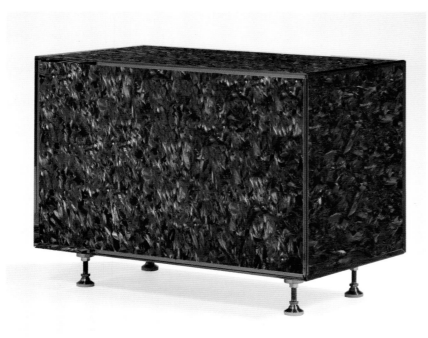

*ABOVE & RIGHT:"Unit #3 Feather" side tables, glass, stainless steel and down.*
*Fredrikson Stallard, 2007.*
*BELOW:"Unit #3" coffee table, glass, stainless steel and down, 2007.*
*OPPOSITE:"King Bonk" armchair and stool, fibreglass with dichroic paint, 2008.*

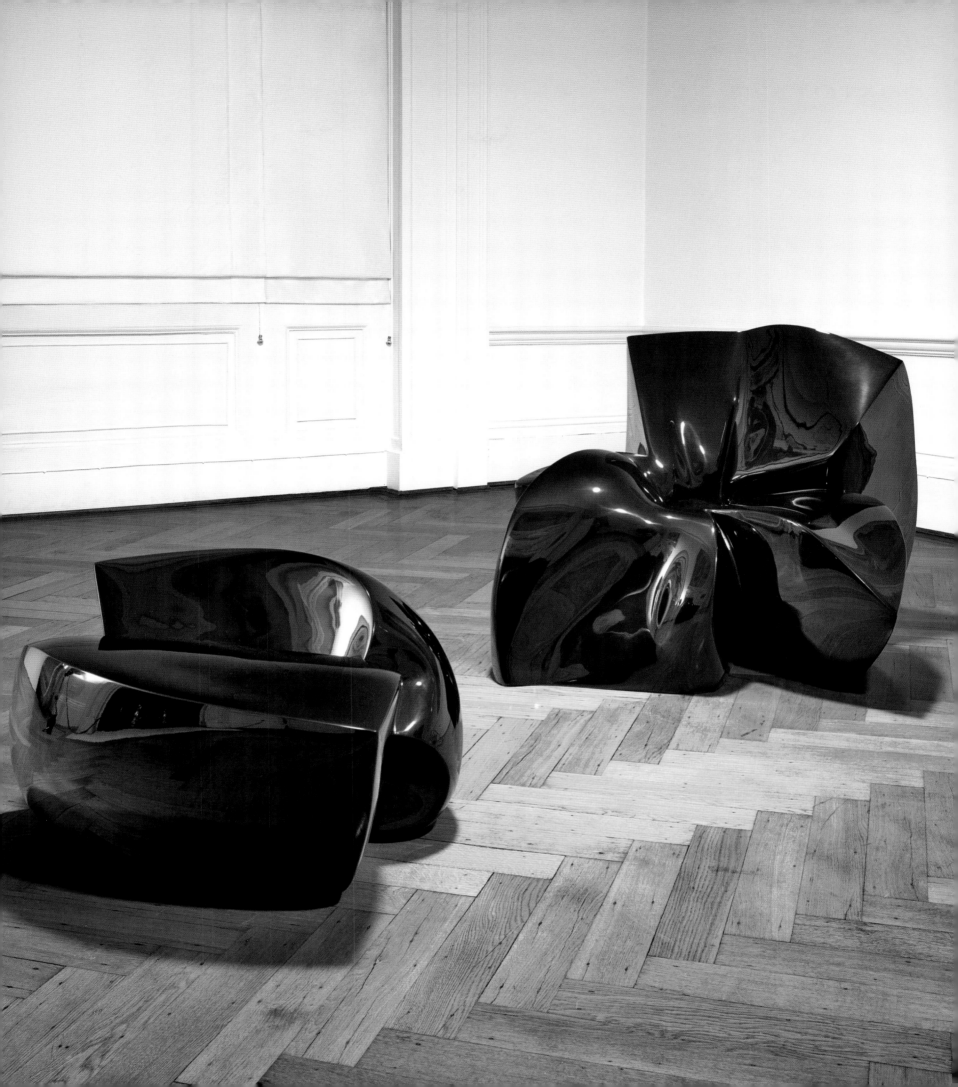

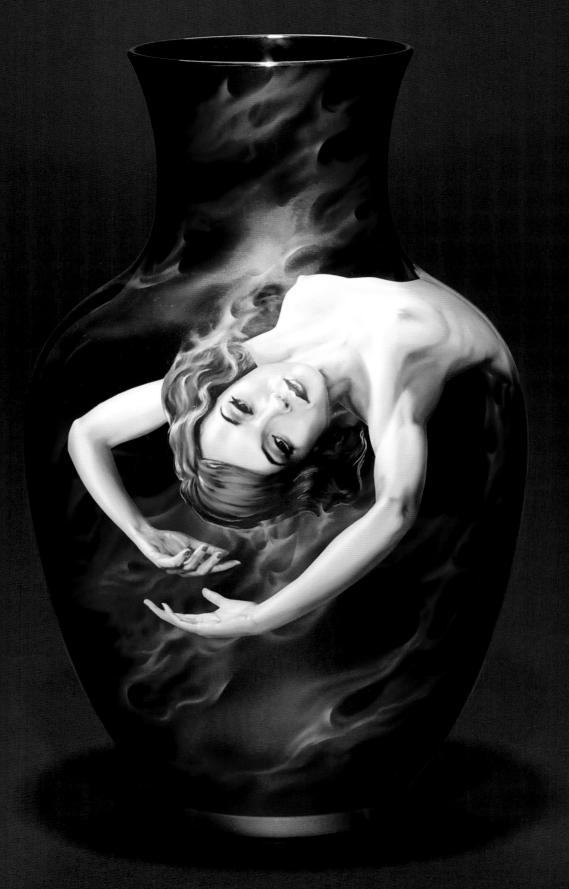

ABOVE: "Lynx" from Fredrikson Stallard's 2009 "Gasoline Garden" exhibition at Gill's Loughborough Street Gallery. Porcelain with high gloss lacquer.
OPPOSITE TOP L-R: "Lynx", "Daytona" and "Phoenix" vases.
OPPOSITE BELOW L-R: "Cadillac", "Aviator 1", Acid Queen", "Pink Corvette" and "Silver Spirit 2" from the same exhibition, Loughborough Street, 2009.

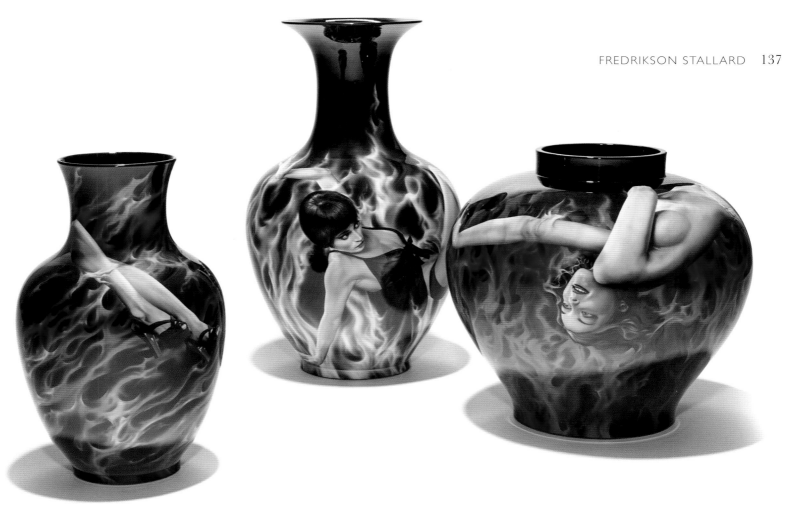

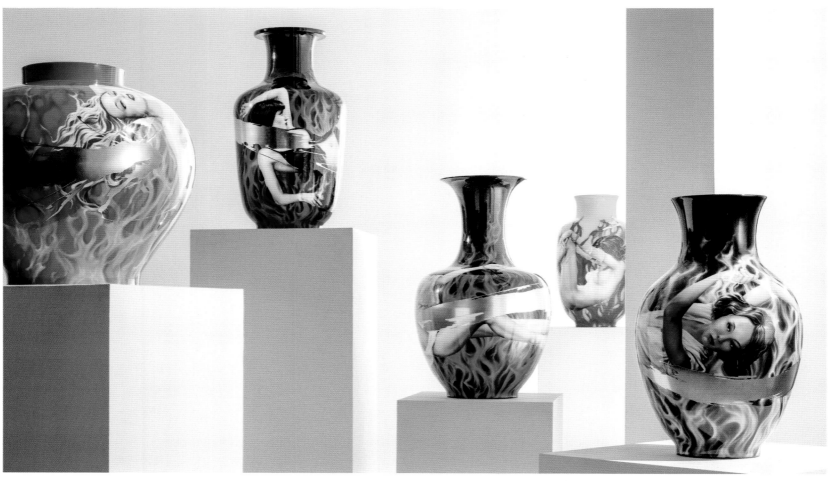

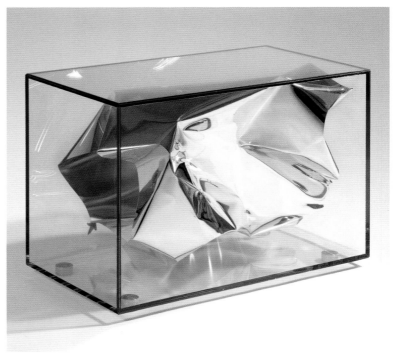

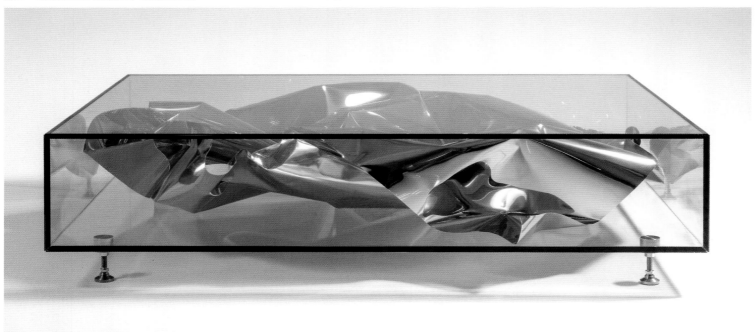

*ABOVE & OPPOSITE: Fredrikson Stallard's "Crush" exhibition in 2012 was their first at Gill's King Street Gallery, featuring works such as "Gold Crush" and "Silver Crush" side tables (top, detail opposite) and "Gold Crush" coffee table (above). Glass, polished aluminium and stainless steel, Fredrikson Stallard, 2012.*

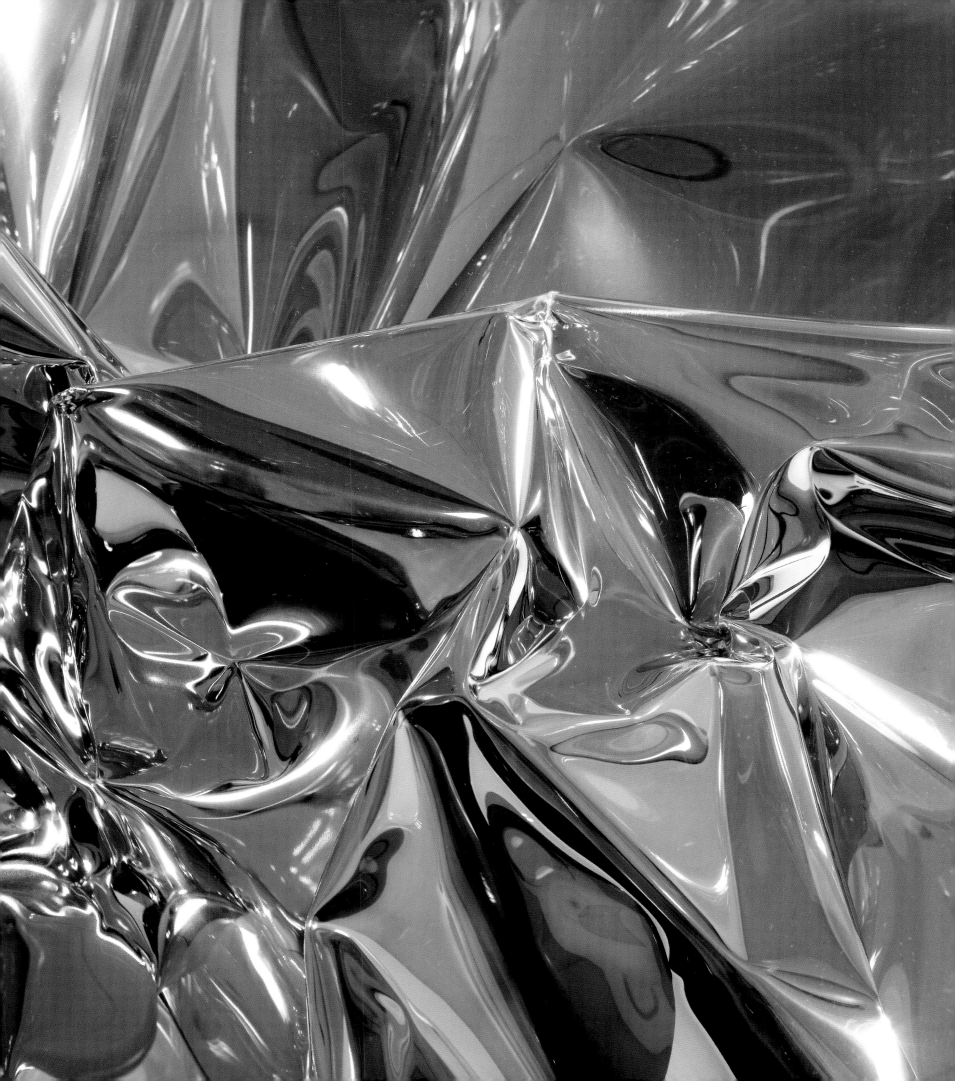

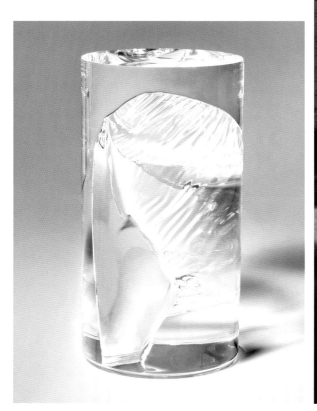

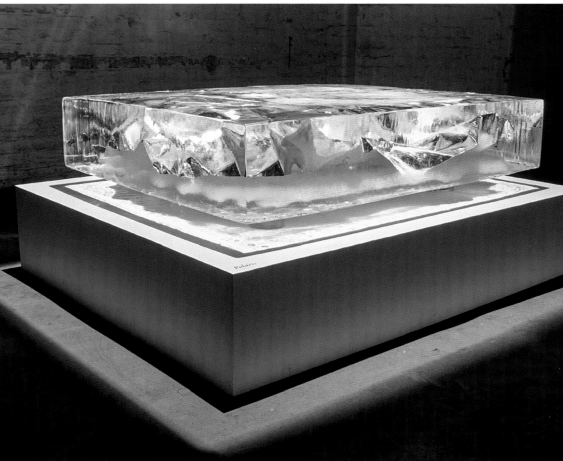

ABOVE: "Gravity" guéridon, acrylic (left), and "Polaris" coffee table, carved ice (right), from Fredrikson Stallard's 2016 "Gravity" exhibition.
RIGHT: "Gravity" coffee table, 2015.
OPPOSITE: "Pantheon" mirror, polished nickel-plated aluminium and pigment paint, 2011, "Species III" armchair, flocked polyester upholstery on carved rubber-coated high-density polyurethane, 2015, and "Atlas II" coffee table, patinated steel and acrylic, 2016.

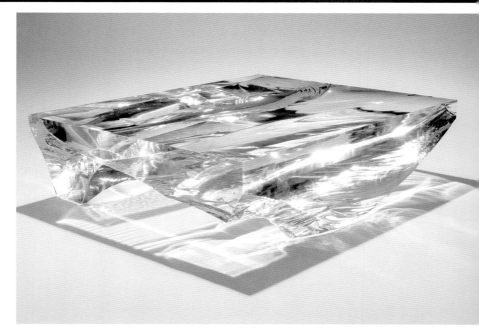

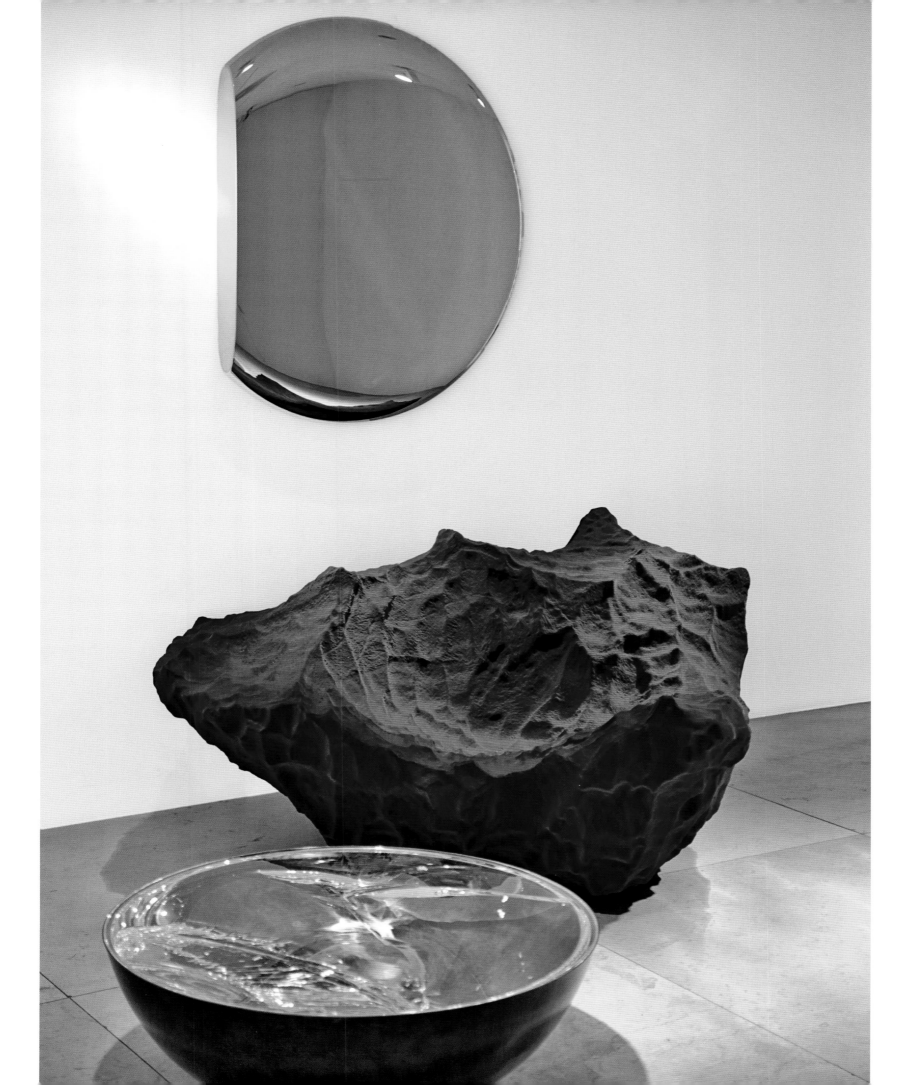

*"To date, I've included their work in six homes, from a Miami apartment to a Greenwich mansion on the water."* FRANK DE BIASI

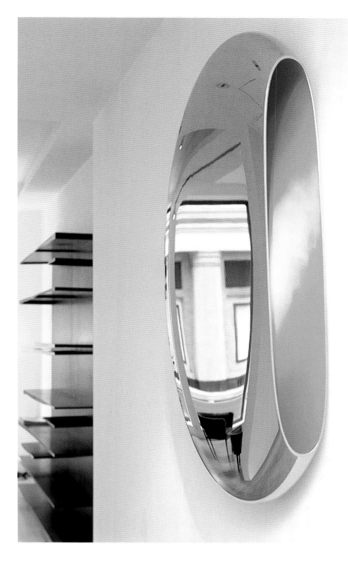

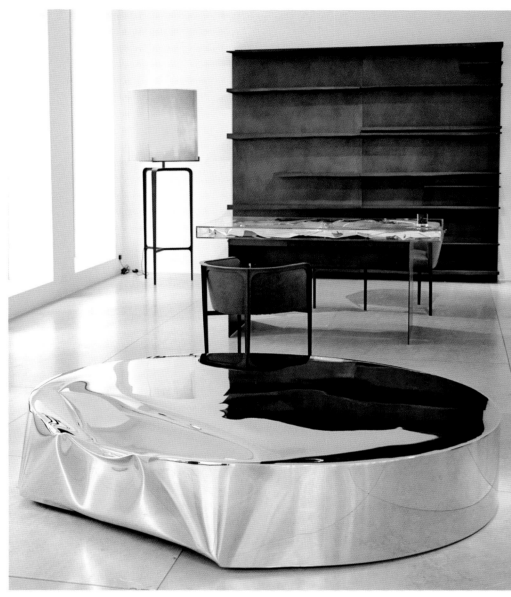

OPPOSITE: Fredrikson Stallard's "Intuitive Gestures" collection, 2017, included "Antarctica Bronze I, II & III" side tables, white and patinated bronze (top left), "Hudson" console, crushed stainless steel sheet, honeycomb structure (centre), and "Untitled" stool, patinated steel with suede upholstery (far left), and with Kenyan Black marble (top right).

ABOVE LEFT: "Pantheon" mirror, polished nickel-plated aluminium and pigment paint, 2011.
ABOVE RIGHT: "Untitled" standard lamp, patinated and lacquered steel, vellum shade, "Scriptus" shelves, patinated and lacquered steel, "Crush Silver" desk, crushed aluminium, glass, patinated and lacquered steel, "Hudson (Diptych)" console, "Untitled (4-Leg)" chair, patinated steel, aniline leather upholstery, and "Tokyo II" coffee table.
LEFT: Detail of "Scriptus II" mirror, polished stainless steel and MDF.

*"ZAHA HADID IS A **FORMIDABLE** AND GLOBALLY **INFLUENTIAL** **FORCE** IN ARCHITECTURE. HIGHLY EXPERIMENTAL, **RIGOROUS** AND **EXACTING**, HER WORK FROM BUILDINGS TO FURNITURE, FOOTWEAR AND CARS, IS QUITE RIGHTLY **REVERED** AND **DESIRED** BY BRANDS AND PEOPLE ALL AROUND THE **WORLD**."*

JANE DUNCAN,
PRESIDENT, RIBA (2016)

*OPPOSITE: Zaha Hadid, photographed by Steve Double/Camera Press, 2008. ABOVE: Karl Lagerfeld with Zaha Hadid, Venice Biennale, 2007.*

Dame Zaha Hadid's architectural career began in the late 1970s, but it wasn't until the 1990s that her fantastical conceptual designs began to be realised in physical form, such as the Vitra Fire Station in Weil-am-Rhein, Germany, completed in 1993. "I first met her as a friend in London through Michael Wolfson with whom she had been at the Architectural Association. We met at a dinner and then we talked about our families and friends, but we never discussed anything serious about work," David explains. Philip Dodd, the Director of the ICA at the time, suggested Hadid might do something both sides of the river, with him at the ICA and with David at Loughborough Street, though the project never came to fruition. However, the seed of a creative collaboration was planted.

David's first show with Hadid was at the *Venice Biennale* in 2007, installed in a church. "We did the whole installation of the show called 'Dune Formations' the same year that Zaha showed in the Chanel satellite show with Karl Lagerfeld," David remembers. "This collaboration was a huge success as it was work that Karl had wanted to do with her for a long time. But our show was successful too; Zaha was motivated to do the 'Dune Formations' spontaneously and quickly."

In 2012, "Liquid Glacial" pieces were developed and shown for the first time — a collection of pieces encompassing tables, chairs, stools and tableware resembling ice formations which took David many, many months to produce — the pieces have smooth tops and seem to ripple underneath the surface. The final collection of furniture they worked on together celebrated Hadid's genius, showcasing brand new pieces and several others that had been shown between 2014 and 2016.

The shapes in this new and softer collection, titled "UltraStellar", revealed Hadid's on-going preoccupation with single fluid, sensuous lines which can be seen within a bowl or a coffee table, single and twin chair, dining table and chandelier. Several pieces were fashioned in walnut, walnut and leather, and walnut and acrylic, revealing her love of the natural finishes of leather and wood, flowing seamlessly into each of the other elements to create furniture of a lightness and beauty that seemingly adapted around the human form.

"What I liked about her," David fondly remembers, "was that even though she became such a famous personality as an architect, she spoke like a normal human being with an amazing sense of humour and wit." Zaha Hadid died in Miami, Florida on 31 March, 2016 after a short illness.

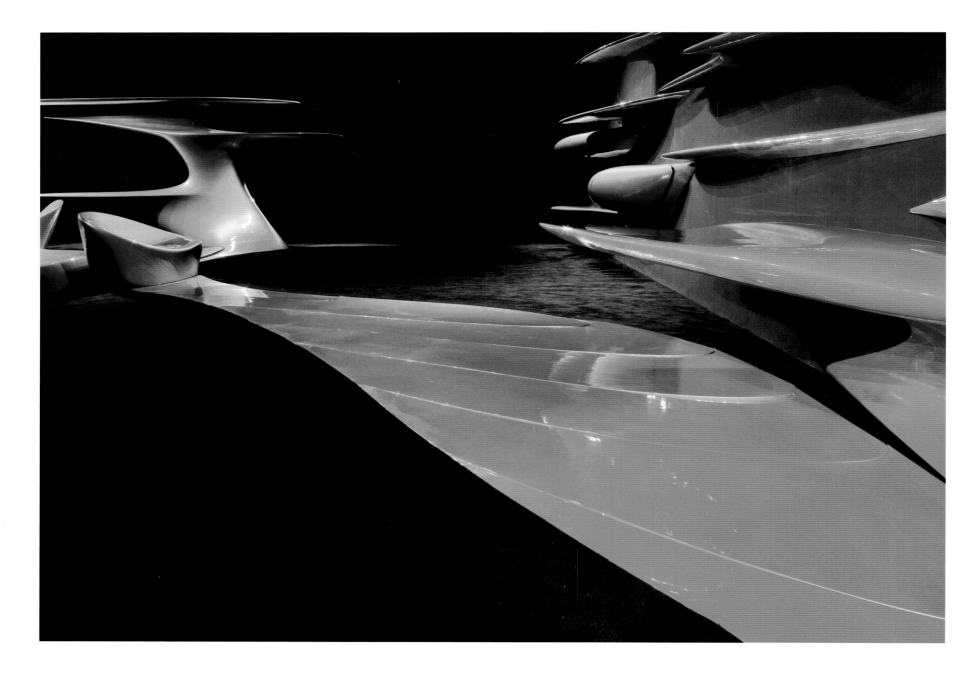

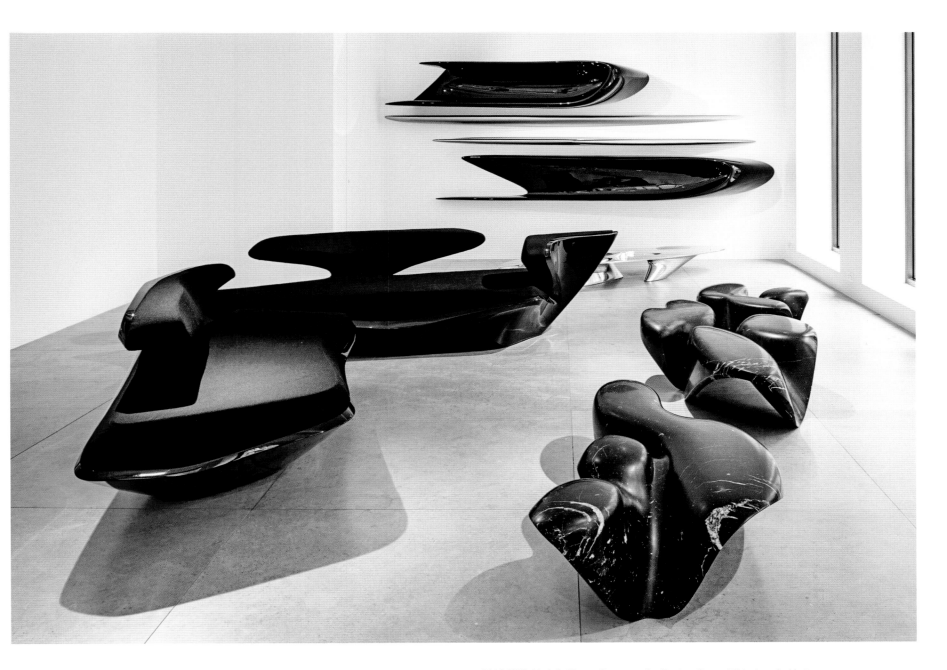

OPPOSITE: Hadid's "Dune Formation" collection, first exhibited at the Venice Biennale, 2007.
ABOVE: "Dune A-G" shelves (black), "Dune 01–07" shelves (chrome), polyurethane resin and lacquer, "Mercuric" stools, Nero Marquina marble, and "Zephy" sofa, lacquered fibreglass, Kvadrat upholstery, exhibited at Gill's King Street Gallery in 2013.

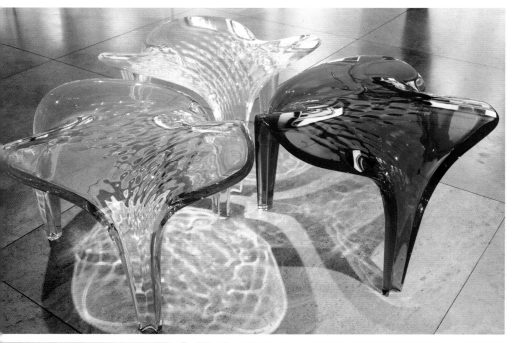

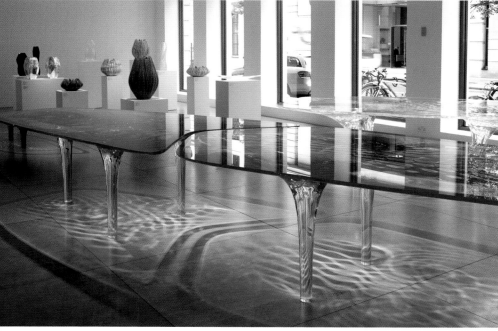

ABOVE: Zaha Hadid's "Liquid Glacial" installation in 2015 included
three acrylic stools (top) and an acrylic dining table (above).
RIGHT: Detail of Hadid's "Liquid Glacial" acrylic table.

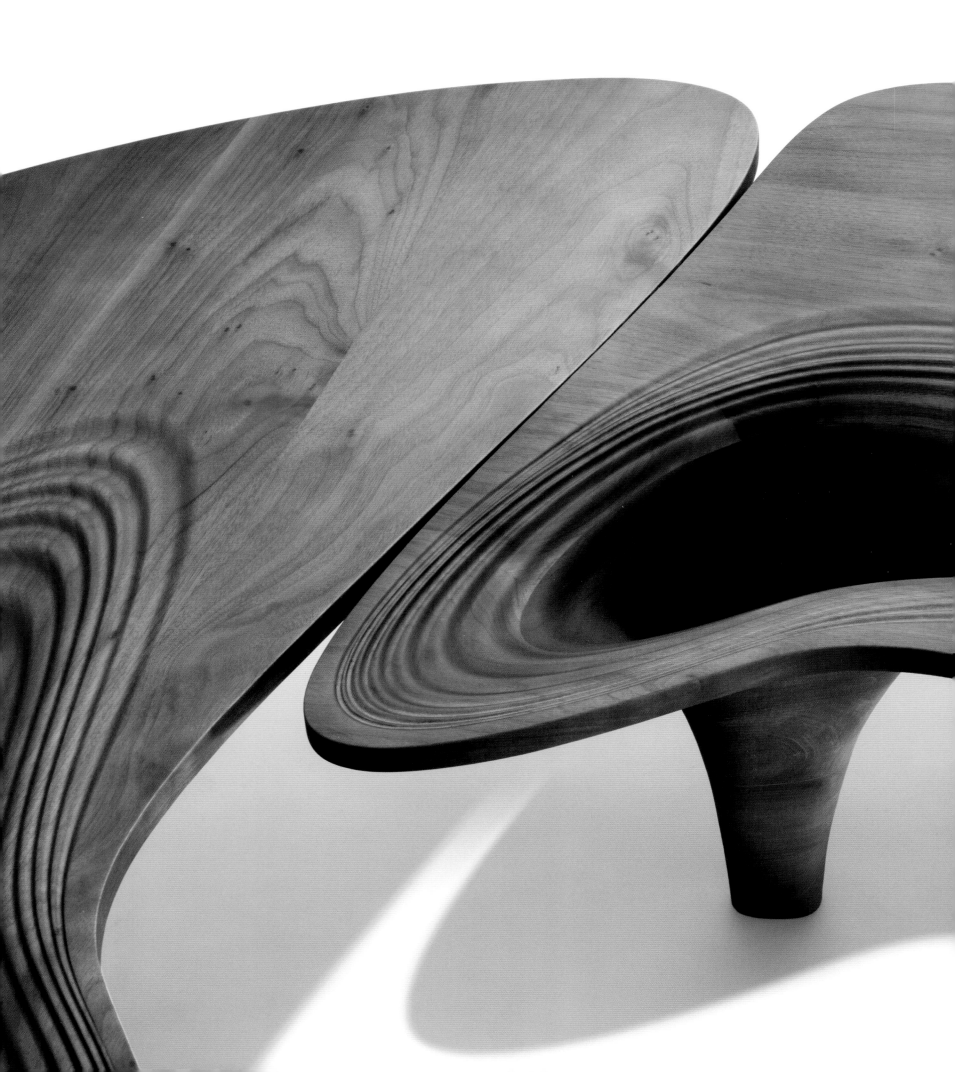

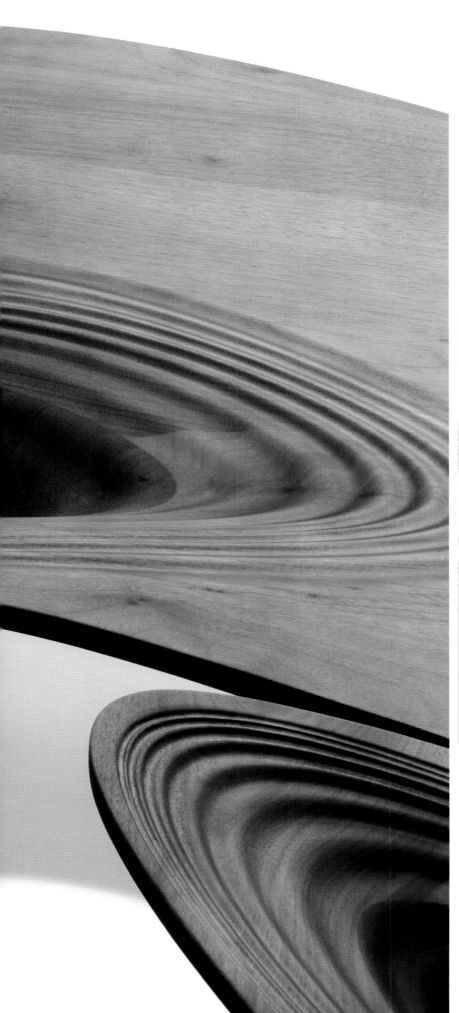

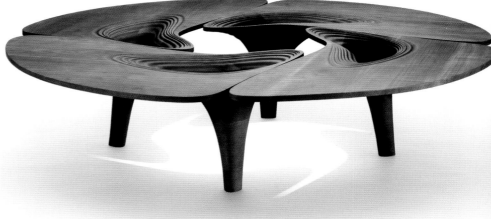

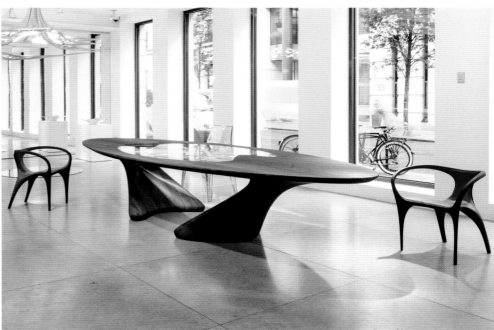

*ABOVE: Coffee table, American walnut; dining table, American walnut and acrylic; and chairs, American walnut and leather upholstery, from "UltraStellar", 2016.*
*LEFT: Detail of the American walnut coffee table, from Zaha Hadid's "UltraStellar" exhibition, King Street, 2016.*

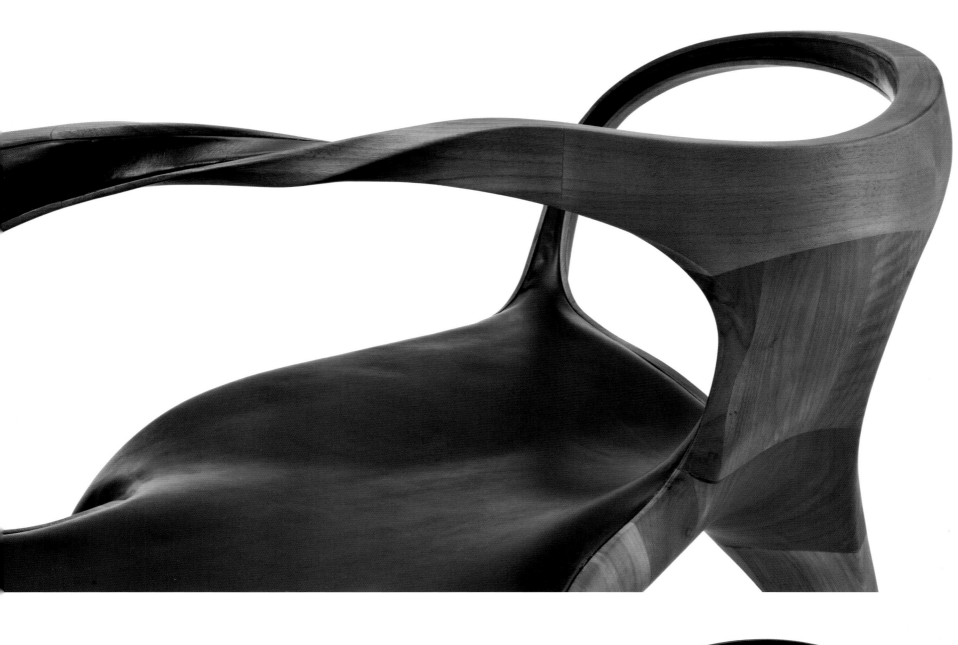

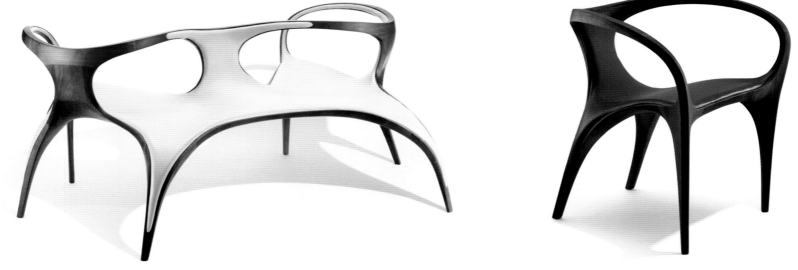

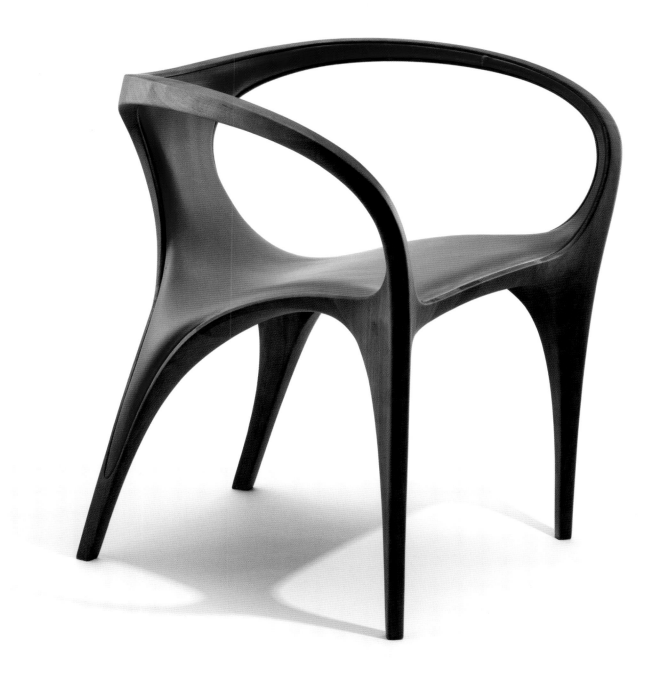

*OPPOSITE: Detail of double seat bench prototype (top) with three-seat bench and grey chair (below), each in American walnut, leather upholstery, from Zaha Hadid's "UltraStellar" exhibition, King Street, 2016.*
*ABOVE: Red chair, American walnut, leather upholstery, from Zaha Hadid's "UltraStellar" exhibition, King Street, 2016.*

*"... **SCULPTURES** THAT RESEMBLE PLANTS, **PLANTS** THAT RESEMBLE SCULPTURES, ROCK SHARDS THAT LOOK **HUMAN**, BRONZE OR WAX FORMS THAT **LOOK** TO BE GROWING, FOSSILS THAT LOOK **MAGICAL**, AND BODIES THAT LOOK VEGETAL."*

GREGORY VOLK,
ART CRITIC & FREELANCE CURATOR

"Modernism is just not, and never has been, part of my DNA," says Michele Oka Doner, the distinguished American artist whose debut show at David Gill Gallery in 2015 was followed by her installation of the winning David Gill stand at PAD, London, in 2016. For the latter, she spent time preparing underwater background scenes for the stand as a foil for her bronze furniture and clusters of small nature-inspired objects, at Loughborough Street.

"When I started in the 1960s, people were doing colour field paintings or huge pieces of iron and bronze sculpture which they would plane into sharp industrial angles," Oka Doner remembers. "I have always preferred to take the infinite variety of nature as my inspiration, from the tiniest seeds to the largest trees."

Nature has always been Oka Doner's constant inspiration, from the time she crawled along Miami beach in a bathing costume at the age of eighteen in search of shells, driftwood and other detritus of the seashore; these early inspirations have, over forty years, continued to fuel this prolific artist to create sculpture, design objects and furniture, and the enormous art installations which have made her name internationally recognised. There are over nine thousand bronzes set into terrazzo with mother of pearl for her floor in the Miami Beach International Airport for instance; it is one of the largest artworks in the world featuring marine constellations, fossils, and the sea bed, where the unsuspecting traveller, walking across the night sky, finds that the milky way becomes an underwater shipwreck.

Her work can also be very small and intimate, however, prompting the onlooker to look ever more closely at the crevices and interiors of the objects she has taken from nature and transformed, such as the palm leaf clutch bag, shown at the gallery in 2015. She creates dream-like objects in bronze inspired by bark, by twisted tree roots uprooted by a violent hurricane, by the striated leaves of the royal palm, by coral and the floor of an ocean reef. In glass, bronze and silver, which she casts herself in one of her two studios, Oka Doner's designs mirror and turn our attention to the natural world: from the "Terrible" chair inspired by sharp twigs, to her chandeliers, again drawing on images of twigs, this time waving in a sudden gust of Floridian wind.

The Marine Invertebrate Museum in Miami, her home town, and the contents of its glass jars are a source of further inventiveness; her 2017 show reflected her continuing studies of the strange sea creatures from the deep, which are her inspiration.

*OPPOSITE: Michele Oka Doner, photographed by Jordan Doner.*
*LEFT: Oka Doner at work in her Soho studio, New York.*

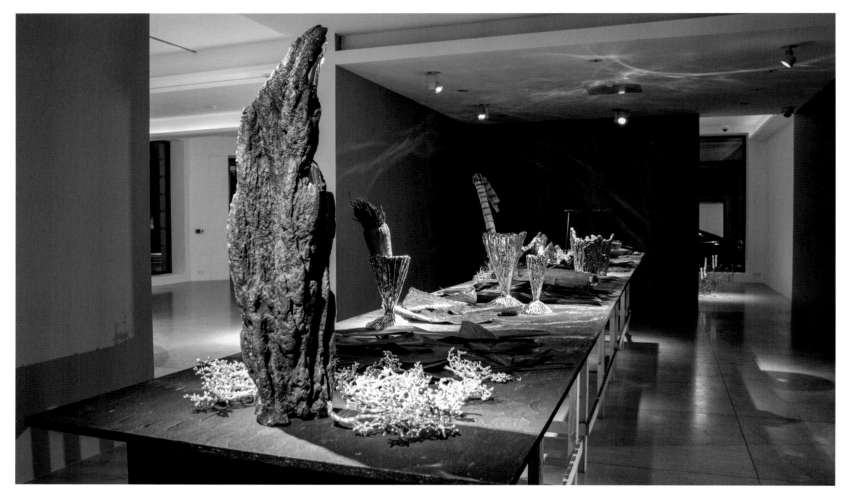

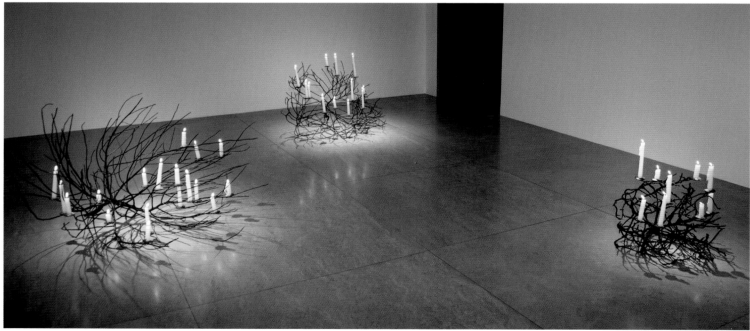

TOP: "Mysterium" exhibition, 2015, including "Underwater City Epergne", "Seated at Shaman's Table" place card holders, cast silver sterling with silver wash, 2003, "Bark Lightning" champagne bucket, sterling silver, and "Palm" large, medium and small vases, sterling silver, 2015.

ABOVE: Set of three candelabras, "Burning Bush", bronze, "Mysterium", 2015. OPPOSITE: Detail of "Ice Ring" bench, bronze, 1989; "Radiant" table, bronze, ferric patina, 1995; and "Ocean Reef", mouth-blown and hand-etched glass bowl, cast bronze base, 2005. Michele Oka Doner, "Mysterium", King Street, 2015.

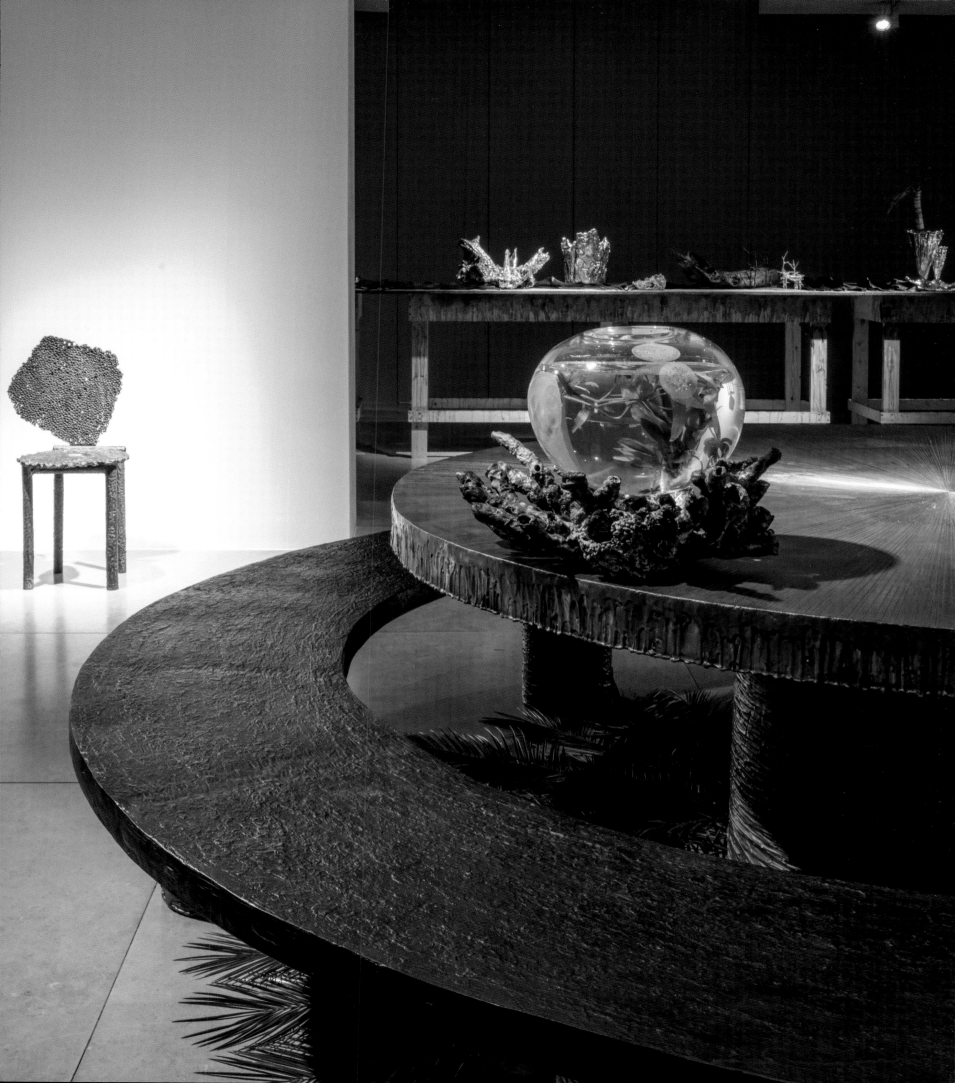

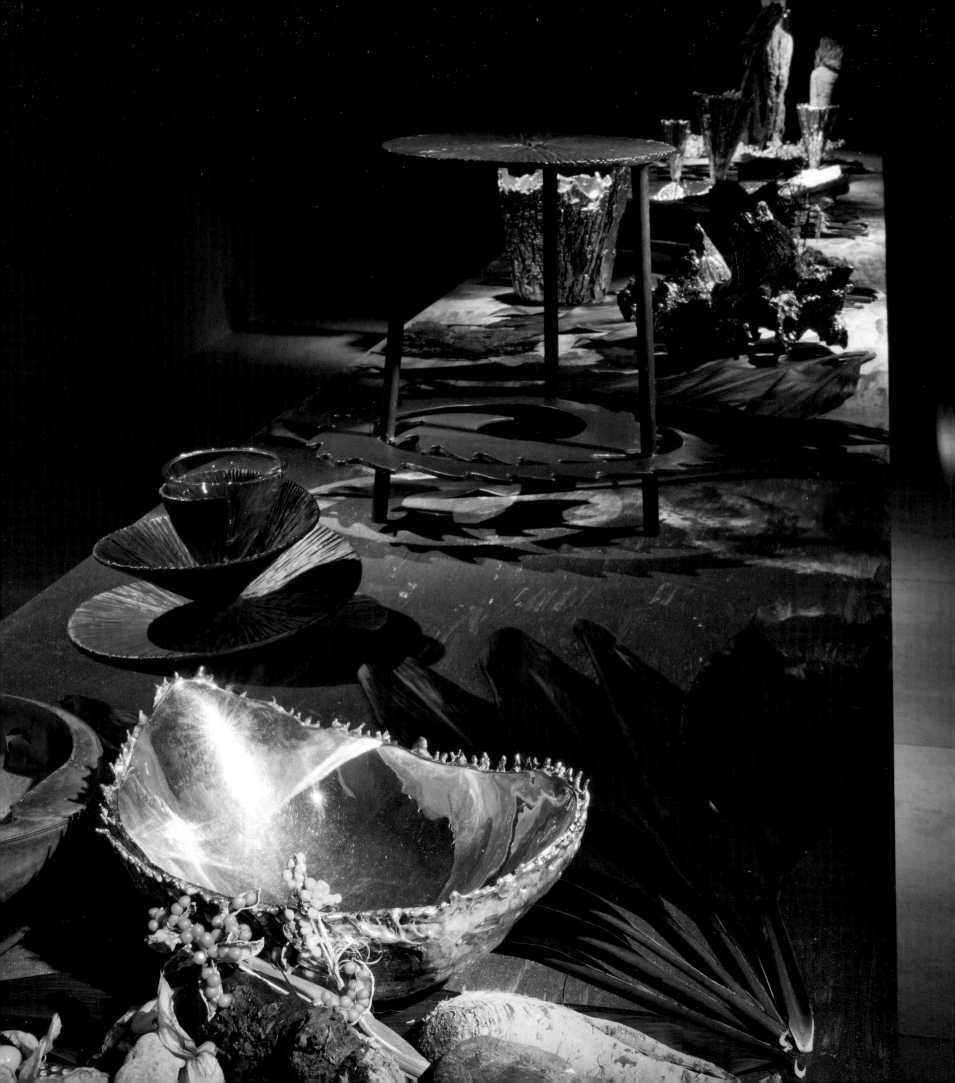

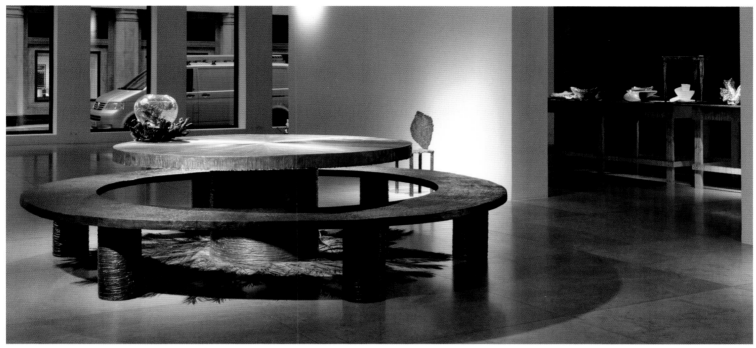

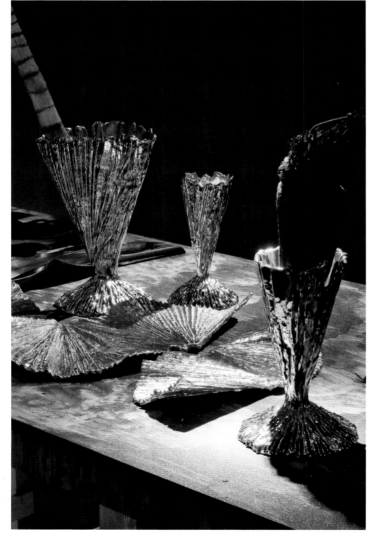

OPPOSITE: "Spirograph II", bronze and glass, 2008; "Bark Lightning" champagne bucket, sterling silver. Michele Oka Doner, "Mysterium", King Street, 2015.
ABOVE: "Ice Ring" bench, bronze, 1989; "Radiant" table, bronze, ferric patina, 1995; "Ocean Reef", mouth blown and hand etched glass bowl, cast bronze base, 2005 (detail above); and "Palm" large, medium and small vases, sterling silver, (left). Michele Oka Doner, "Mysterium", King Street, 2015.
OVERLEAF: In addition to the above are "Fertile Reflection" cast bronze, gold leaf and gilded glass mirror (left); "Radiant" coffee table, bronze, ferric patina, 1995, (right); "Pollinator" sconce, bronze, gold leaf; "Golden Reflection" table lamp, bronze and gold leaf; and "Burning Bush", bronze. Michele Oka Doner, PAD London, 2016.

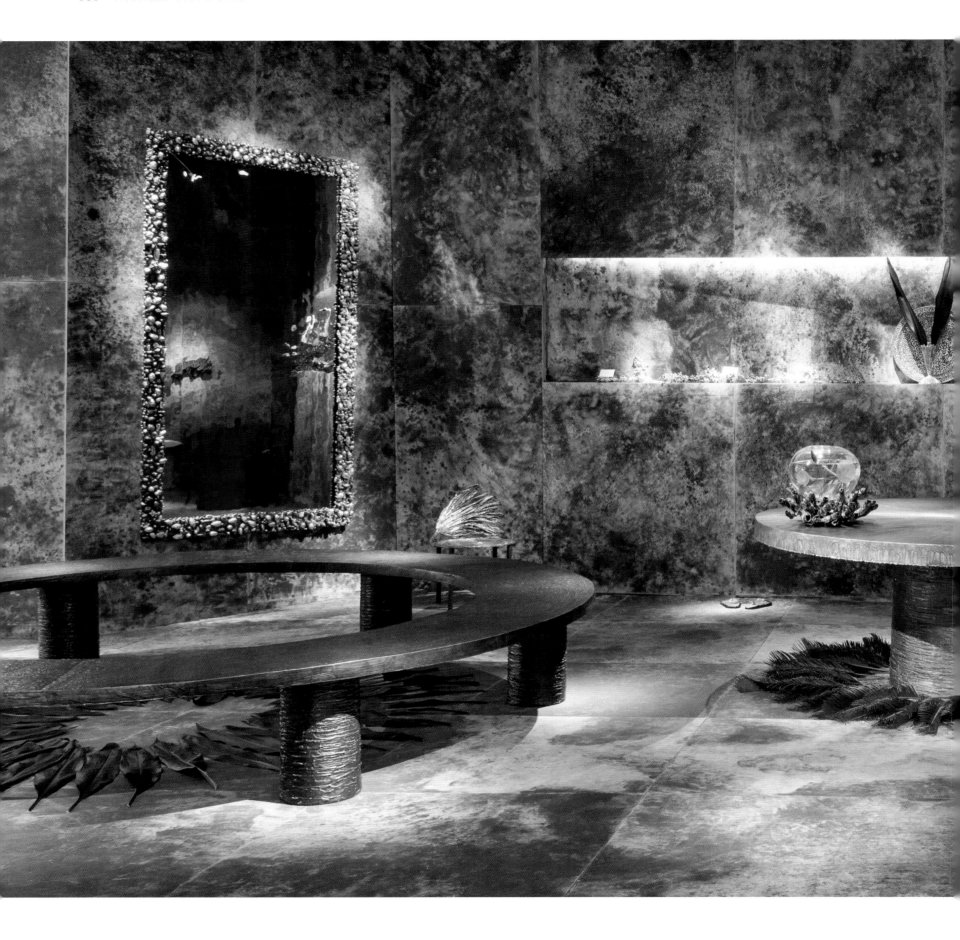

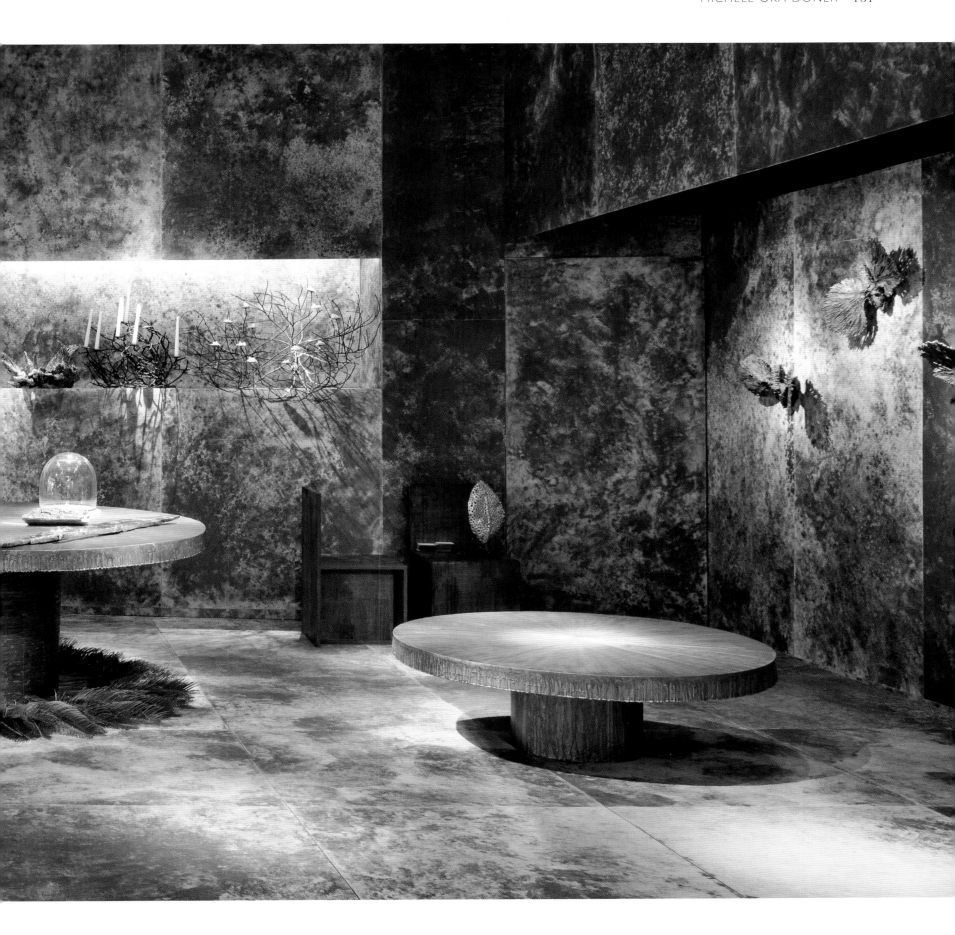

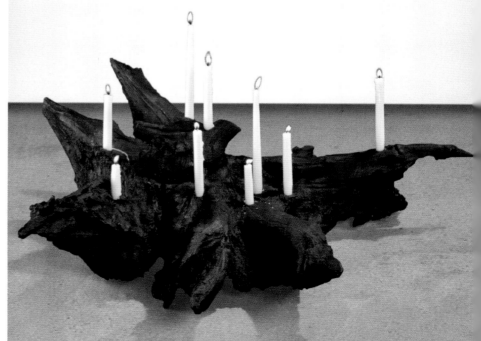

*OPPOSITE: "Altar II" Candelabra, bronze, 2003 (top); "End of Feast I", bronze platter with "Burning Bush 39" candelabra, bronze (below left); and "Burning Tara" candelabra, bronze, 2006 (below right).*
*ABOVE: "Adam From Roots, 2 of 4", 2007 (left); "Primal, 6 of 8", 2008 (centre); "Restless, 2 of 8", 2008 (right), all relief prints from organic material.*
*LEFT: "Totem, 2 of 8" (far left) and "Totem with Crown, 4 of 8" (right), both 2009, relief prints from organic material.*

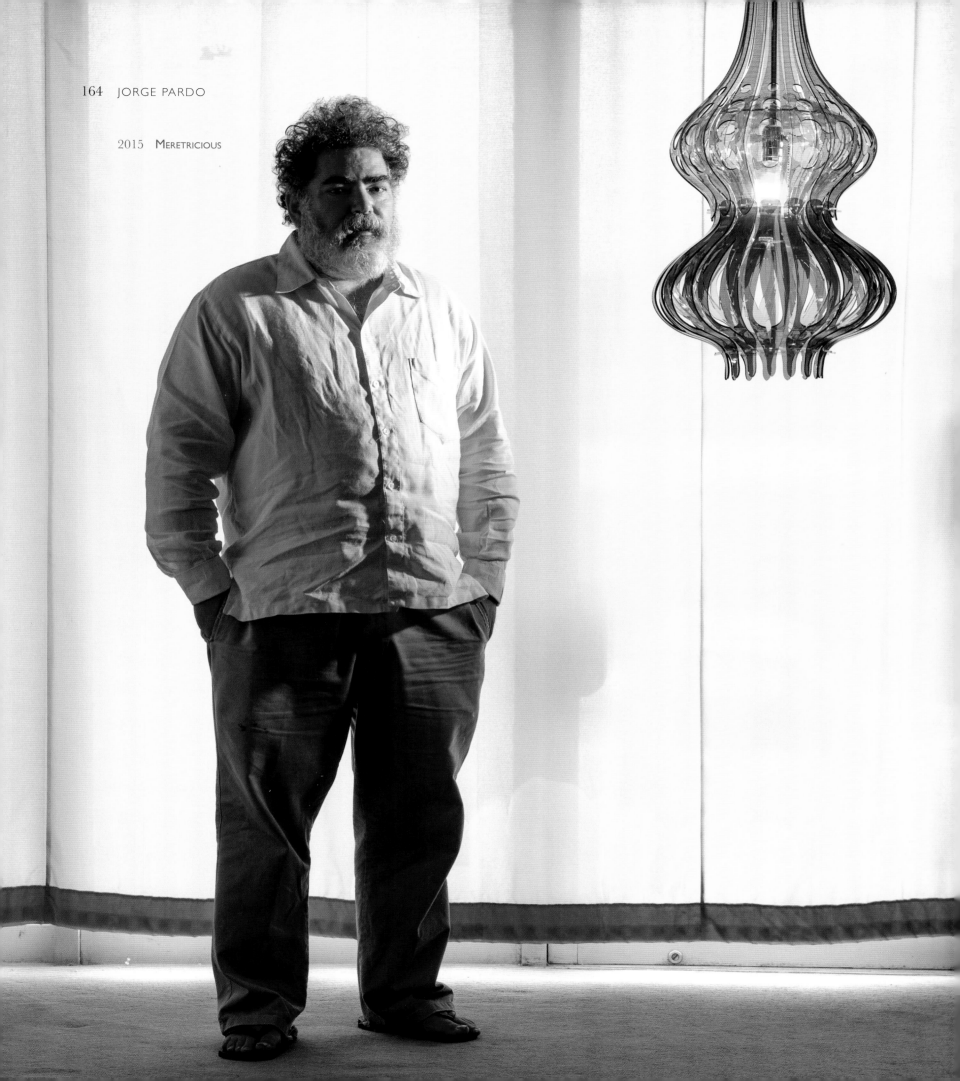

2015 Meretricious

A Cuban-American artist and sculptor, now living and working in Los Angeles, Jorge Pardo has become celebrated for creating both individual pieces and entire living environments. In challenging the boundaries that conventionally exist between art and architecture, utility and aesthetics, design and décor, he claims to "shape space." Such grand-scale designs, where houses are conceived as works of art and site-specific architecture does double-duty as sculpture, have brought him commissions from the Los Angeles Museum of Contemporary Art and many private clients.

"Meretricious" was Pardo's first exhibition for David Gill, and his first in London for seven years. It consisted of twelve oval wall mirrors with sculptural frames decorated with cerebral head scans in silhouette which were portraits of the artist's favourite critics. These were exhibited with a series of cabinets and tables, some hung on walls, featuring portraits of the artist and his family.

The "Meretricious" series of wall mirrors, tables and cabinets, fabricated in Pardo's studio in Merida, dealt with the notion of portraiture by reflecting groups of people in their everyday habits. Pardo explained that he thought "it would be interesting if this show took on the role of a convoluted portrait machine, all the works having different forms of portraits." The exhibition cleverly combined in one environment both usable objects and those intended for visual contemplation: a captivating meld of function and form.

*"JORGE HAS AN **INCREDIBLE** SENSE OF **SPACE**. SOME PEOPLE HAVE A PERFECT EAR FOR MUSIC; HE HAS **PERFECT** SPATIAL **INTELLIGENCE**."*

CÉSAR REYES,
ART COLLECTOR

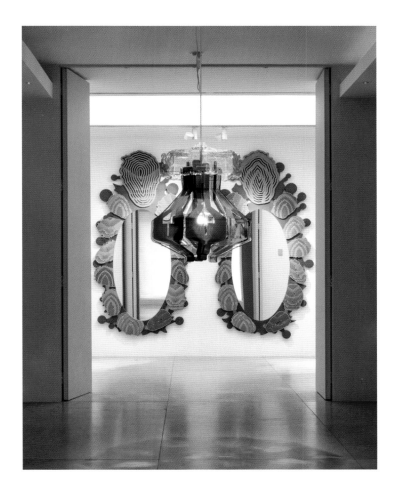

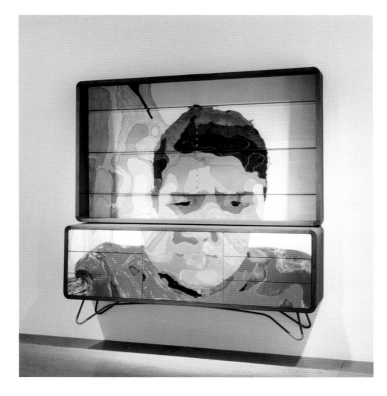

*OPPOSITE: Jorge Pardo in his Los Angeles studio, by Matt Harbicht, 2010. THIS PAGE: Details including "Meretricious Untitled 4", MDF, tzalam wood, acrylic paint, lacquer, coloured steel (right) from Pardo's "Meretricious" exhibition, King Street, 2015.*

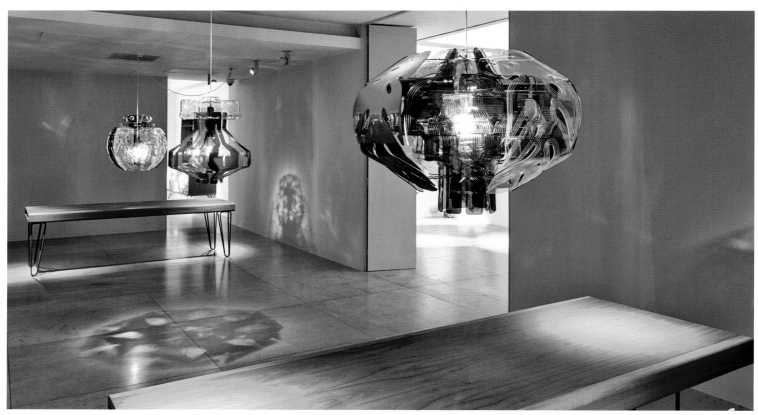

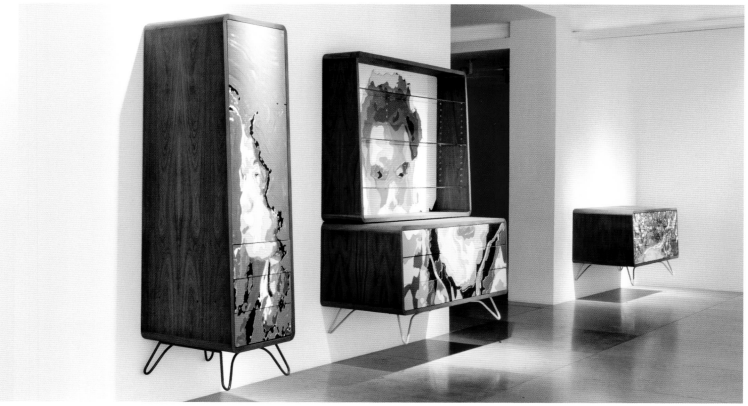

TOP: "Untitled 8" table, tzalam wood, coloured steel; "Untitled 24" mirror, MDF, acrylic paint, lacquer; "Untitled 25" (left) and "Untitled 23" (right) chandeliers, plexiglass, aluminium. Jorge Pardo, "Meretricious", King Street, 2015.

ABOVE: "Untitled 3" (left) "Untitled 5" (centre) and "Untitled 1" (right) cabinets, MDF, tzalam wood, acrylic paint, lacquer, coloured steel. Jorge Pardo, "Meretricious", King Street, 2015.

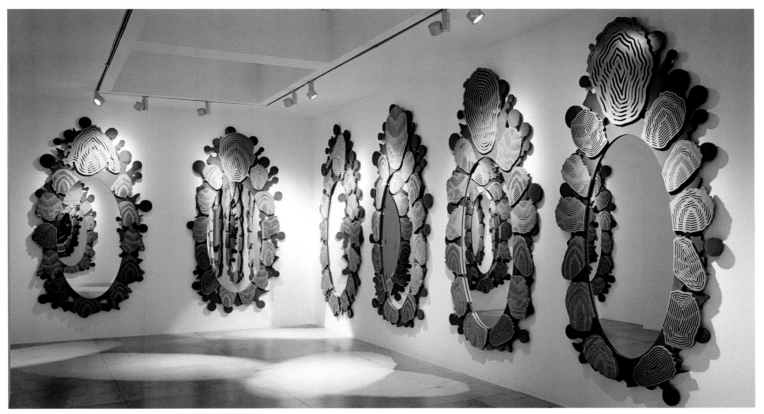

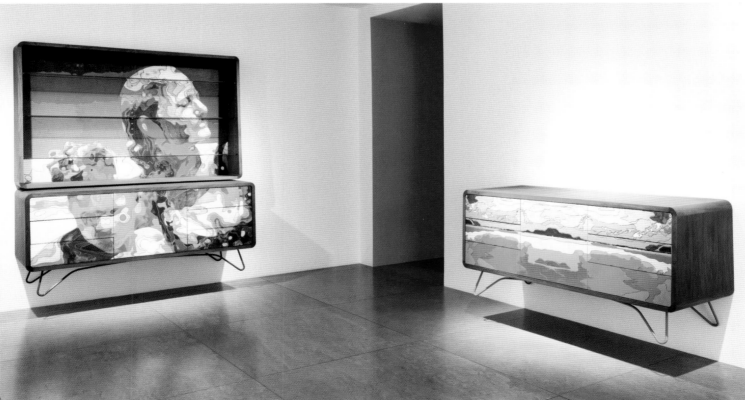

*TOP:"Meretricious Untitled 9-22" mirrors, MDF, acrylic paint, lacquer. Jorge Pardo,"Meretricious", King Street, 2015.*

*ABOVE:"Untitled 6" (left) and "Untitled 2" (right) cabinets, MDF, tzalam wood, acrylic paint, lacquer, coloured steel. Jorge Pardo,"Meretricious", King Street, 2015.*

*"THE **ARCHITECTURAL** EQUIVALENT OF A **BRAINSTORM**."*

NEW YORK TIMES

Gaetano Pesce is an Italian architect and a leading figure in contemporary industrial design. He grew up in Padua and Florence, and for over fifty years has worked as an urban planner and industrial designer. His work is characterised by an inventive use of colour and materials, forming connections between the individual and society through the weaving together of art, architecture and design. Described by the New York Times as the "architectural equivalent of a brainstorm", Pesce's work takes a subject and provides insightful, and at times highly critical, global commentary.

"Since I was 24, I have been preoccupied with the idea that an object, on top of showing a functional and practical side, should also be able to express the author's vision on politics, philosophy, religion, if appropriate, and existence," Pesce claims.

"This very simple assumption, easily understood and probably shared by many, was the foundation for the 'Six Tables on Water' exhibit, curated by David Gill Gallery in 2012. These tables were made to serve as such, but also to bring to the viewer's attention the serious problem of water pollution. Ocean water is still relatively pure, but other basin waters are not. This is true for certain lakes and rivers, for ponds, puddles and lagoons. This is what I wanted to express with these objects."

Pesce's motivation to create art which speaks of environmental concerns produced a series which yoked natural beauty with industrialisation, examining his ethical discomfort through the awkward disalignment of bulky black legs supporting expanses of tabletop water which marginalised the value of humanity in comparison to nature.

The "Chandeliers" installation of 2014 saw Pesce focus on "what it is to be human," manipulating polyurethane, resin and metal to create bold expressions of movement which challenge our perceptions of gravity, science and the human form. His warm palette of reds and skin tones combined with the use of subverted pendants, at once both sensual and arresting, demand a confrontation with one's own psyche. The grand scale of Pesce's contributions to David's "Chandeliers" collection imposes provoking questions quite in keeping with the artist's philosophy for the purpose of aesthetics and form.

*OPPOSITE: Gaetano Pesce wearing his Yohji Yamamoto hat at his Soho studio, New York, by Mark C. O'Flaherty, 2014.*
*LEFT: "Pond" (top) and "Lagoon" (below) tables, rigid polyurethane foam, PVC, epoxy resin, soft urethane resin. Gaetano Pesce, "Six Tables on Water", King Street, 2012.*

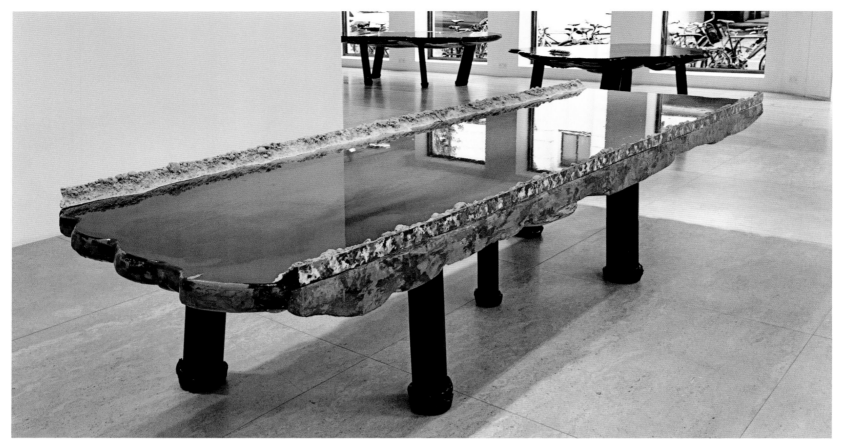

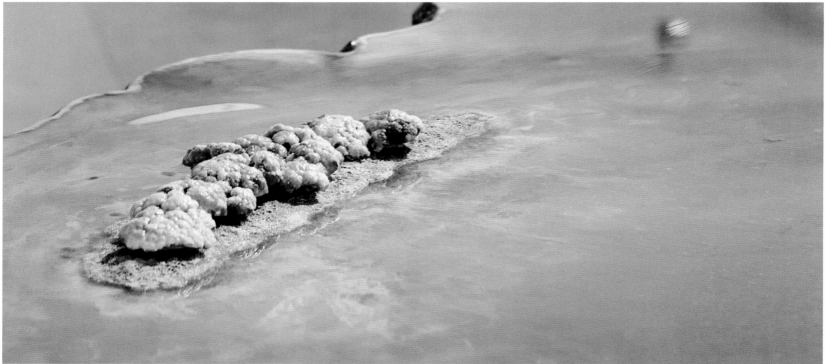

ABOVE "River" (top) and detail of "Pond" tables (below) rigid polyurethane foam, PVC, epoxy resin, soft urethane resin. Gaetano Pesce, "Six Tables on Water" exhibition, King Street, 2012.

OPPOSITE: "What it is to be Human" chandelier, polyurethane, resin, metal structure, 2010, reflected in "Ocean" table, rigid polyurethane foam, PVC, epoxy resin, soft urethane resin. Gaetano Pesce, "Six Tables on Water" exhibition, King Street, 2012.

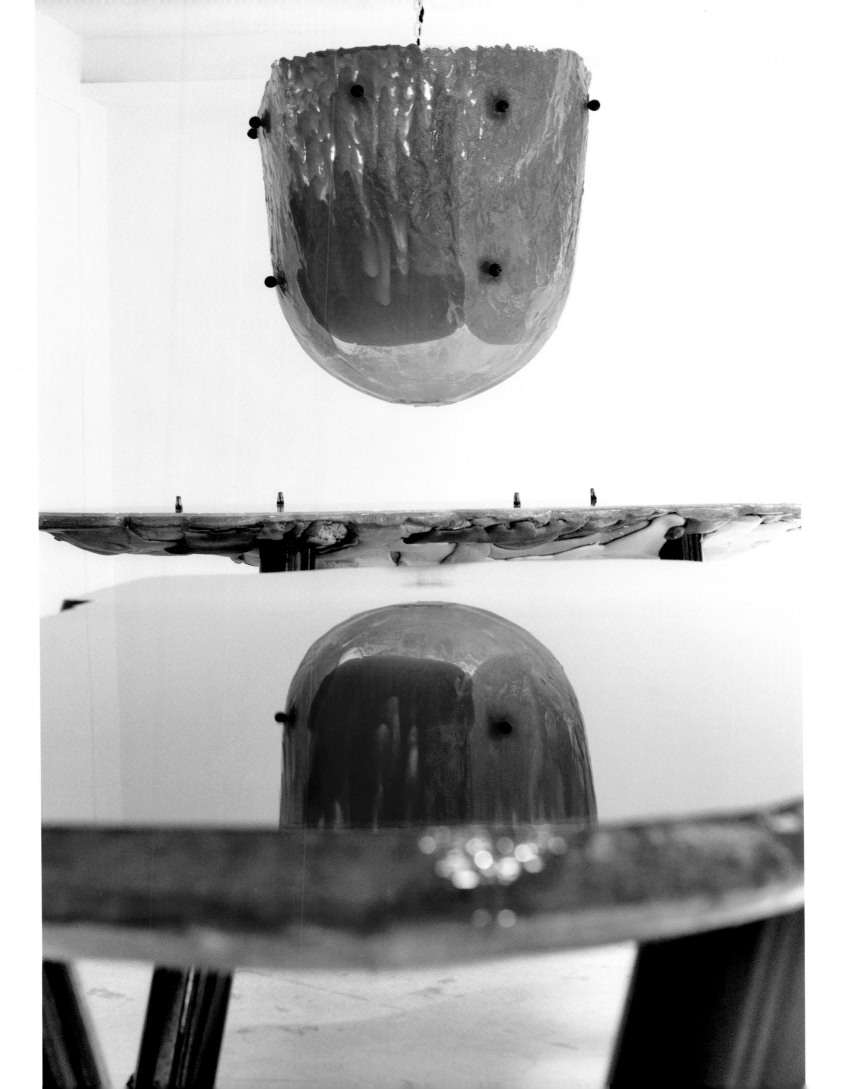

2017   TIERRA MADRE

*"HIS **SPECIAL** WAY OF PAINTING AND HIS **INTERRELATION** WITH MATERIALS… CAUSE THE APPARENT **ABSTRACTION** THEY DENOTE TO TAKE ON A **TELLURIC** AND ALMOST **DRAMATIC FORCE**."*

LAURA SALAS REDONDO,
FREELANCE CURATOR

*OPPOSITE: José Yaque at the opening of his "Tierra Madre" Exhibition, 2017. BELOW: "Mina a Cielo Abierto V", charcoal on cardboard, and "Margarita I", oil on canvas, José Yaque, 2016.*

Presented in collaboration with Galleria Continua, this was Cuban-born José Yaque's first solo exhibition in London. Gill met Yaque in his Havana studio in 2015 and invited him to complete a residency in London in October 2016. The resultant paintings, charcoals and installations filled the entire gallery space at King Street with Yaque's interpretation of and dialogue with "Tierra Madre" (Mother Earth).

"I observe all this, which is denominated 'media' as one single thing which is at my disposal; I simply don't distinguish between one and another in my process," explains Yaque. "Before, drawing was a resource, but nowadays I employ it as an almost verbal form of communication. This line I make now, for me is a becoming, it's a representation, which I later endow with a body, a physical or three-dimensional presence in the installations. On occasion it has to do with a single idea or a single object which is transfigured or trans-formed into something else apparently different, but in its essence it's the same thing."

Reflections of the shining colours of London, the paintings evoke movement and pace, blurring the natural world and its juxtaposition against the modern capital city. Yaque calls his charcoals "open-air mines", a more direct embodiment of his response to the earth.

The 2017 show was accompanied by a two-volume catalogue which portrayed the artist's journey leading up to the exhibition, alongside a critical text by Elizabeth Pozo Rubio.

TOP: "Magnesita I" (left) and "Magnesita III" (right), acrylic and enamel on canvas. José Yaque, 2016.
ABOVE: "Falla en el Horizonte V", acrylic and enamel on canvas. José Yaque, 2016.

OPPOSITE: "Cancrinita I", acrylic and enamel on canvas. José Yaque, 2016.

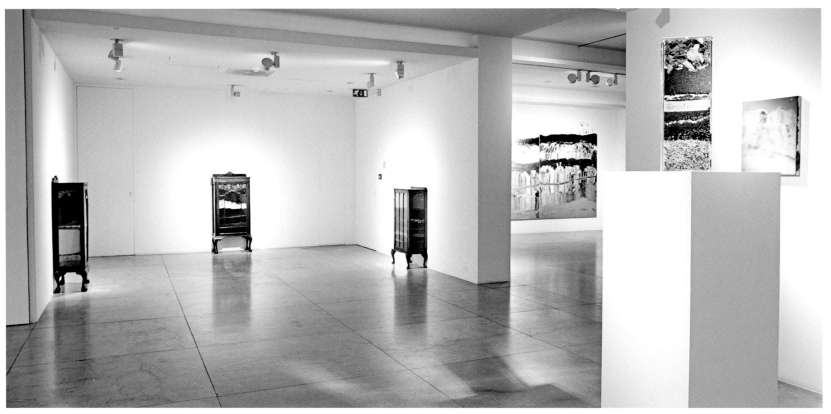

ABOVE & RIGHT: View of the installation of "Tierra Madre" at King Street, with detail (right) of "Tierra Santa", glass, earth, gravel, leaves, bible, 2017.
OPPOSITE: "Suelo Autóctono III", mahogany, glass, earth, gravel, leaves, chinaware. José Yaque, "Tierrra Madre", King Street, 2017.

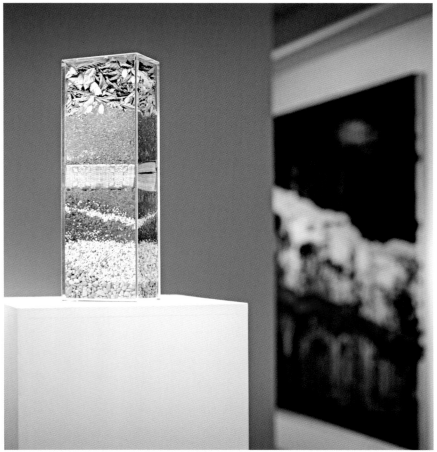

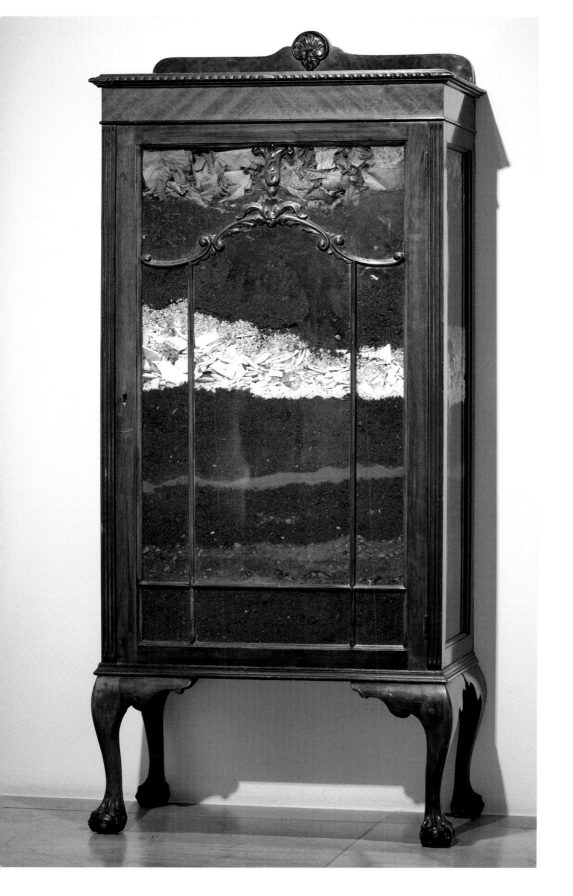

# DESIGN-ART
# A PRIVATE HOUSE PROJECT

"Hydra is a haven composed of tiny hotels around the harbour and secret private houses in the hills," says David. This hilly island off the shore of Greece is where one of his clients hosts an artist residency programme every summer, culminating in art weekends. Artists and gallerists are invited to spend lazy days at the shore and to view the work of the artist in residence, shown in a gallery above the harbour.

This client, who had stayed in various hotels on the island over the years, eventually discovered a house in the hills to spend her summers in, which she asked David to restore. "As with other houses on the island, this one had been inherited from one member of an old Greek family to another over many generations. It is very private, tucked away from the public, at the top of a steep hill looking down to the sea. Part of the property's unique beauty is its own church which is open to the people of the island just once a year, existing also as a monument, so it has to be kept in its original form, as part of the remarkable property."

And what was the design brief for the house? "It wasn't so much of a brief, but more a collaboration between us," explains David. "She wanted to hang some of her existing collection there – those which had a Greek topic – so that influenced the way the house was furnished." The first exhibition in the finished house was of furniture echoing the Greek theme, entitled simply: "The Greek". "The idea was to encourage artists to produce projects which were concerned with the house, the island, and the history of the Greeks, the Turks and as far back as the Phoenicians," explains David.

A number of artists transformed the interiors, furthering the Greek theme. The first was André Dubreuil, who welds his own designs in iron in a barn adjacent to his family château in the Périgord, and whose one-off, personally produced pieces are much admired by David. "The metal work was very much in his hands," David says, and the results throughout the house are sombre and spectacular: bronze lanterns hang impressively either side of the sea-blue double front doors, large trestle tables and small round tables create the perfect marriage of function and form, huge lanterns and beaded girandoles add a wash of soft light that echoes the refracted light on the nearby sea which is then captured in the grand mirrors, and both table and standard lamps adorn every room.

"It wasn't so much a brief, more a collaboration ..." DAVID GILL

*LEFT: "Treet" bench, Claude Lalanne, 2010 and "Ram", François-Xavier Lalanne, 2005.*
*ABOVE: Main entrance, wall lights by André Dubreuil.*
*FOLLOWING PAGES: Courtyard views with table, chairs and bench by Claude Lalanne (page 181, top), and side tables by André Dubreuil (page 181, below).*

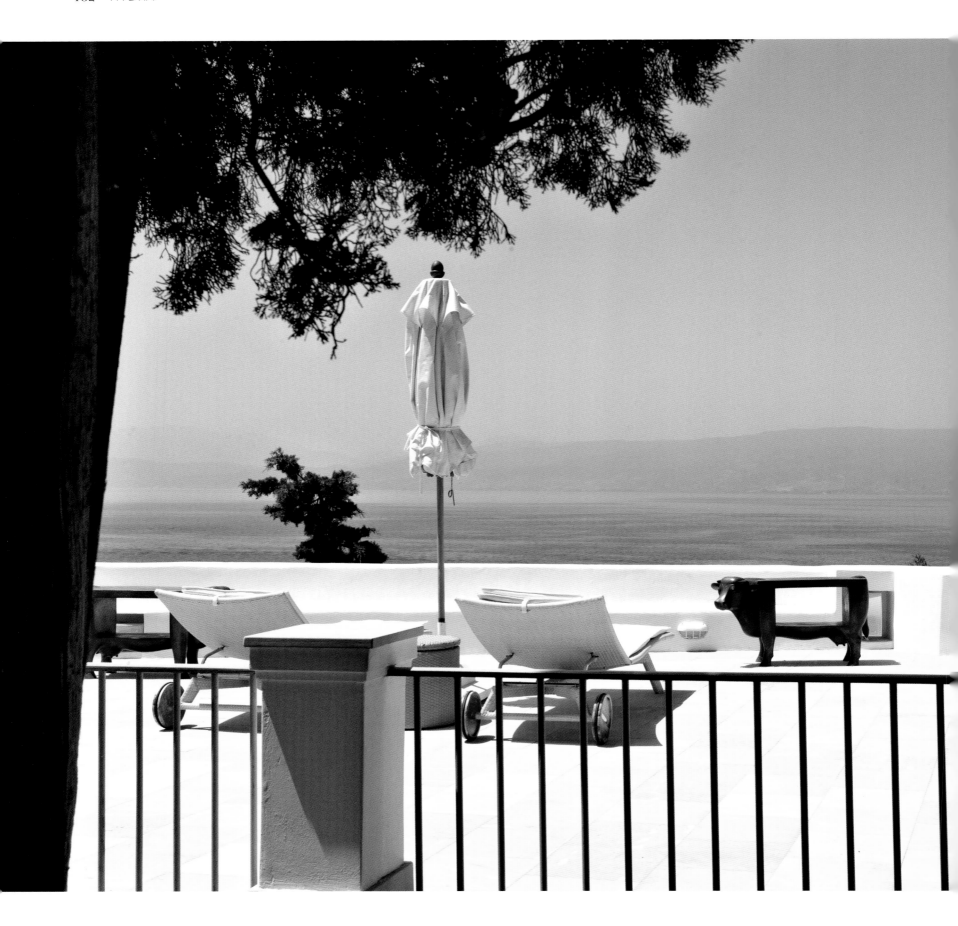

*LEFT: Roof terrace view, "Cow" sculpture by Claude Lalanne.*
*ABOVE: "Moon Rise" head, Ugo Rondinone, c. 2003.*
*FOLLOWING PAGES: Courtyard view, including bronze sculptures: "Tree",*
*Donald Baechler, 1988 (left), and "Woman on Rocks", 1999 (centre) and*
*"Homage to Darwin", Saint Clair Cemin, 1986 (right).*

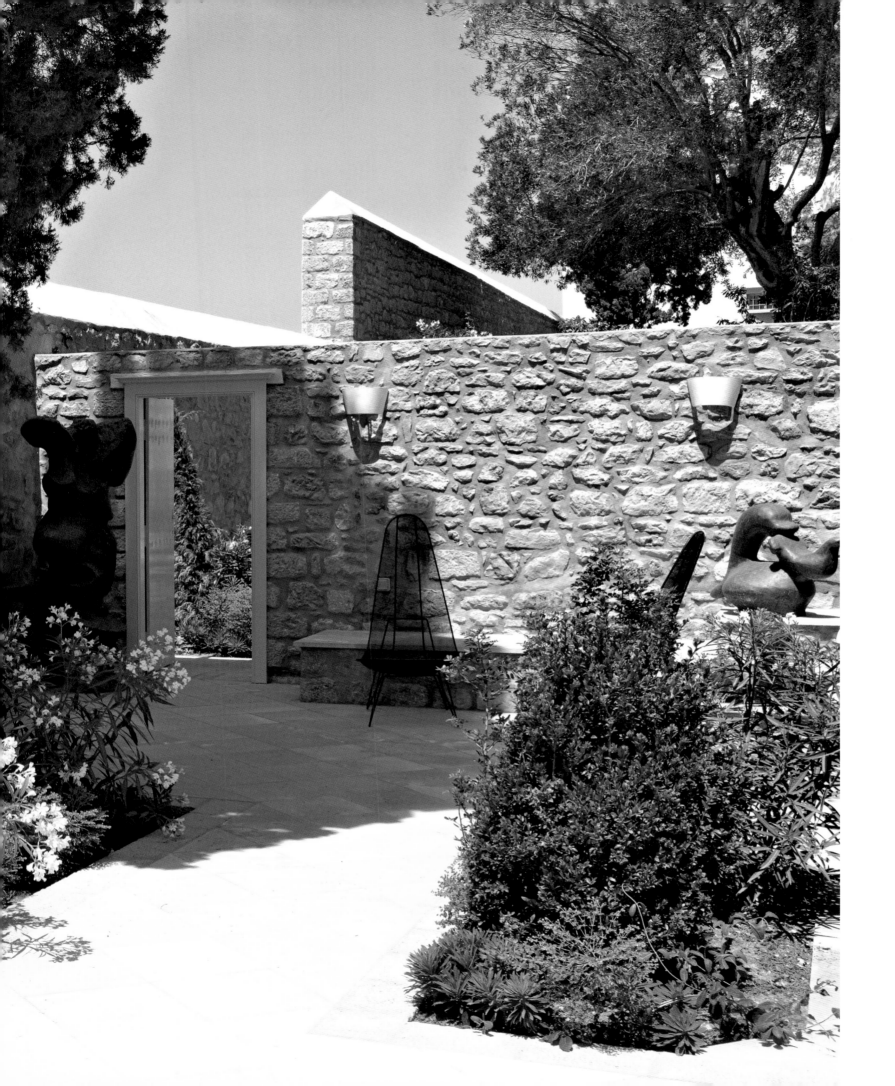

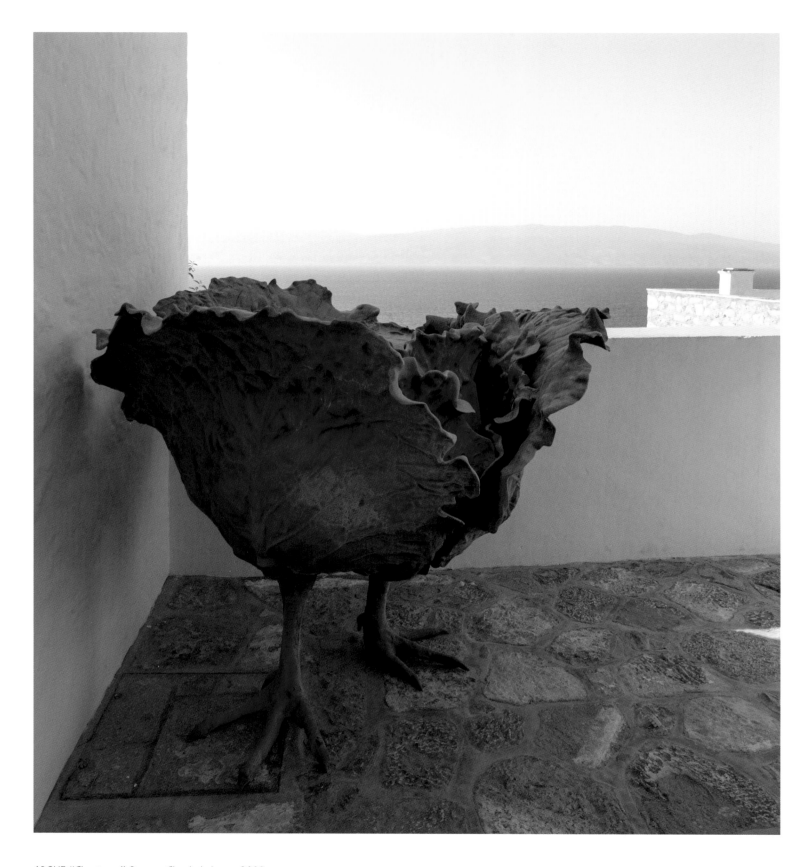

*ABOVE:"Choupette", Bronze, Claude Lalanne, 2008.*
*RIGHT: Sculpture by Andro Wekua, c.2007.*

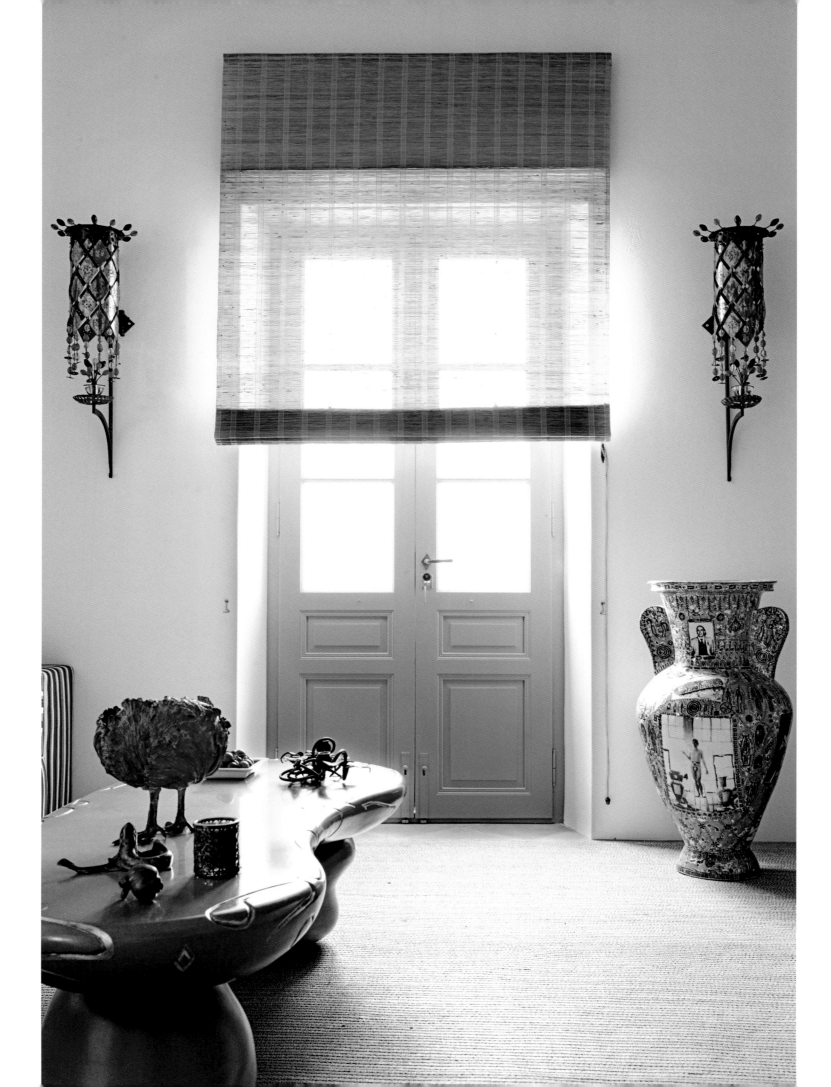

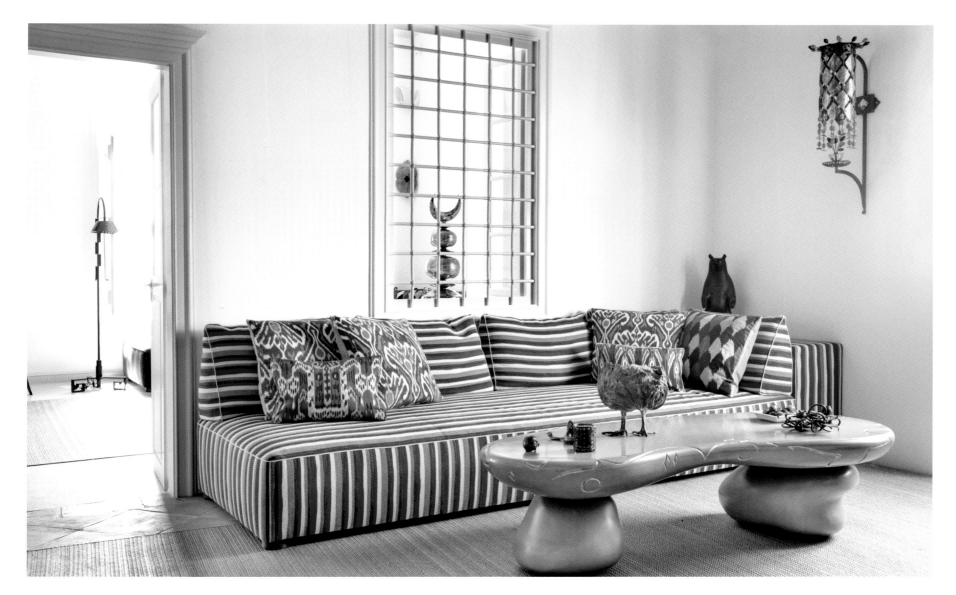

Another key designer, was Mattia Bonetti, who produced bespoke, gently rounded chests of drawers in wood, banded in gilt or scribbled on in gilt curves to emulate the bookcase in the library. In homage to the Mediterranean, viewed from the terrace and the seaward windows of the house, Bonetti painted all the furniture in soft blues and greens."These pale blues and greens allude to the island, and the subtle rounded curves of the furniture go back to the underlying theme of the house: the distant times of the Turks and the Phoenicians," David elucidates.

*LEFT & ABOVE: "Choupette", Claude Lalanne, 2008, on Mattia Bonetti table, "I am my own God" vase, Grayson Perry, and wall lights by André Dubreuil. FOLLOWING PAGES: More interior views, including; specially commissioned tables, bookcases and beds by Mattia Bonetti, lights and mirror (page 192) by André Dubreuil, "Grave Goods" vase by Grayson Perry (page 192), and "Good" and "Evil" paintings by Barbara Kruger (page 193).*

The client has been collecting the work of François-Xavier and Claude Lalanne ever since she first saw it in Paris in the 1970s. "She has had a long-standing relationship with the artists ever since," David says. The custom-made pale blue wrought iron tables and chairs by Claude Lalanne sit on the terrace in a ring surrounding the very old pine tree, facing the sea. Bronze and copper François-Xavier Lalanne animals and birds ornament many rooms of the house. Other art from the client's collection includes a huge floor-standing pot by Grayson Perry, whose first exhibition in London David had showed in the Fulham Road gallery a decade before and who was Artist in Residence at Hydra in 1992.

Continuing the references to Turkey and Greece in this charming, secluded house are the rustic cushion covers and bedspreads specially commissioned in Turkish ikats in colours specified by David.

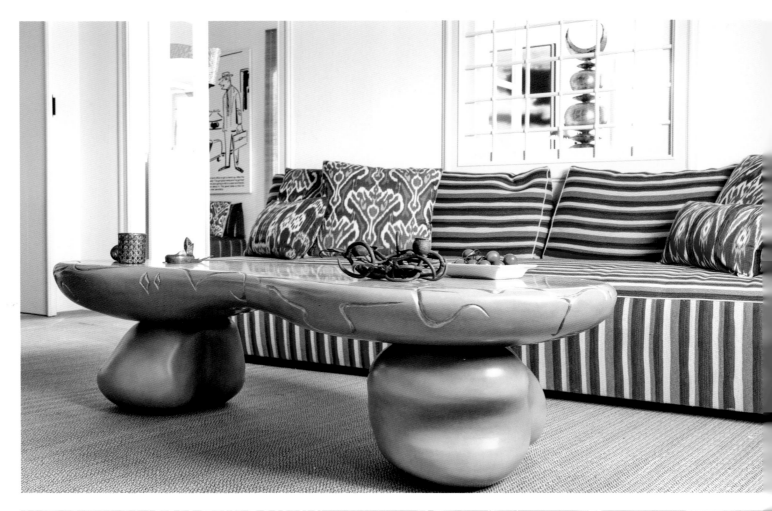

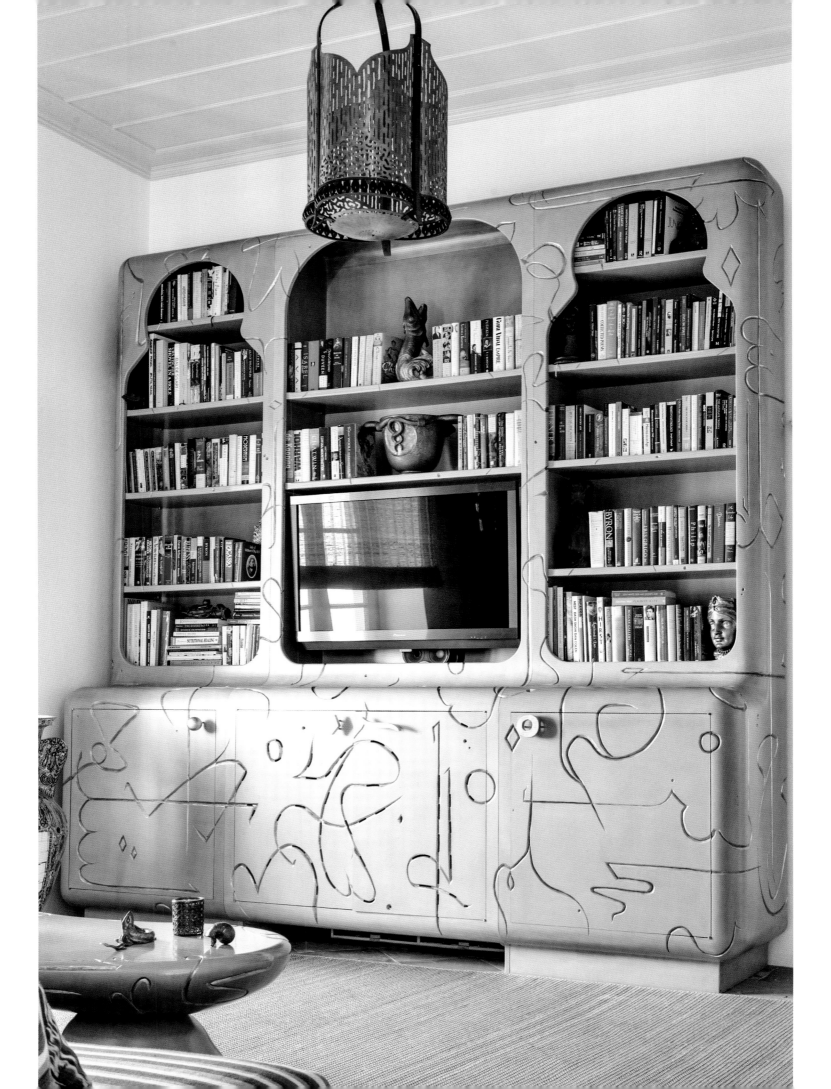

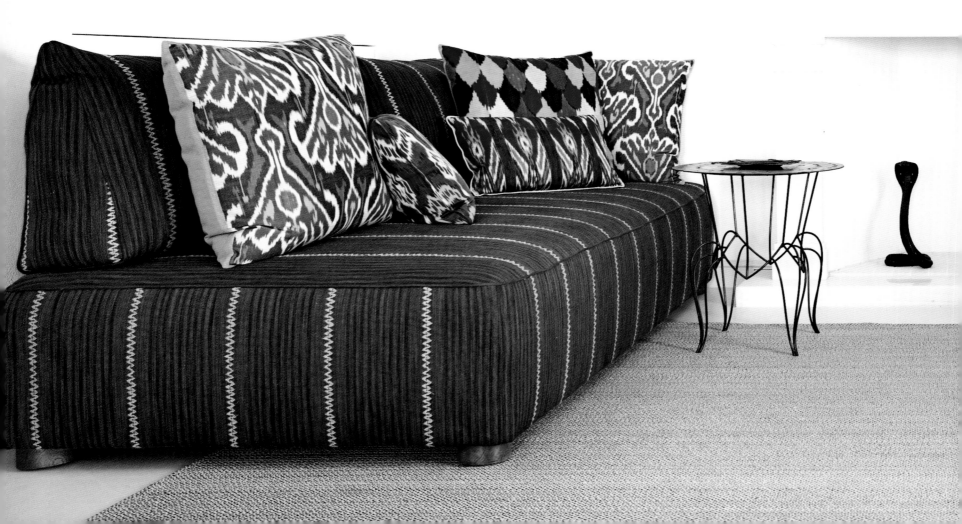

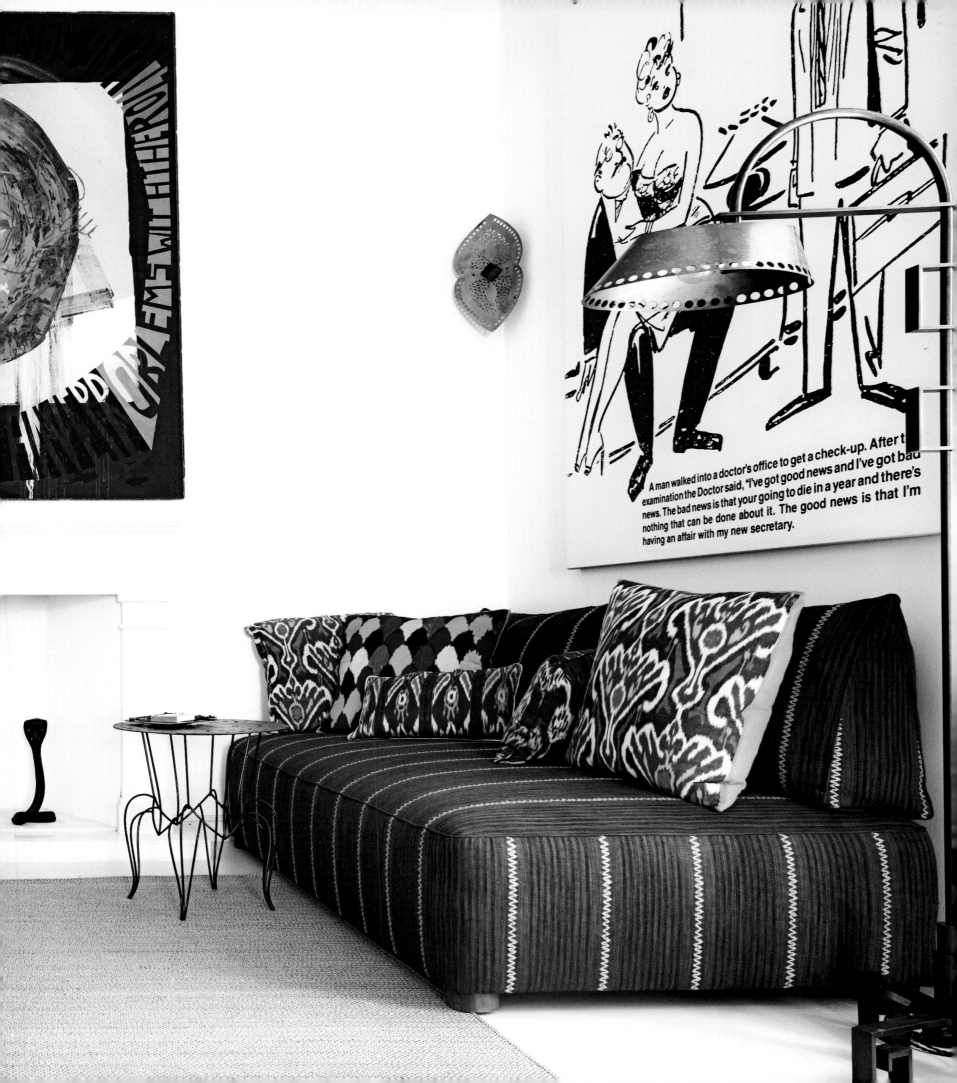

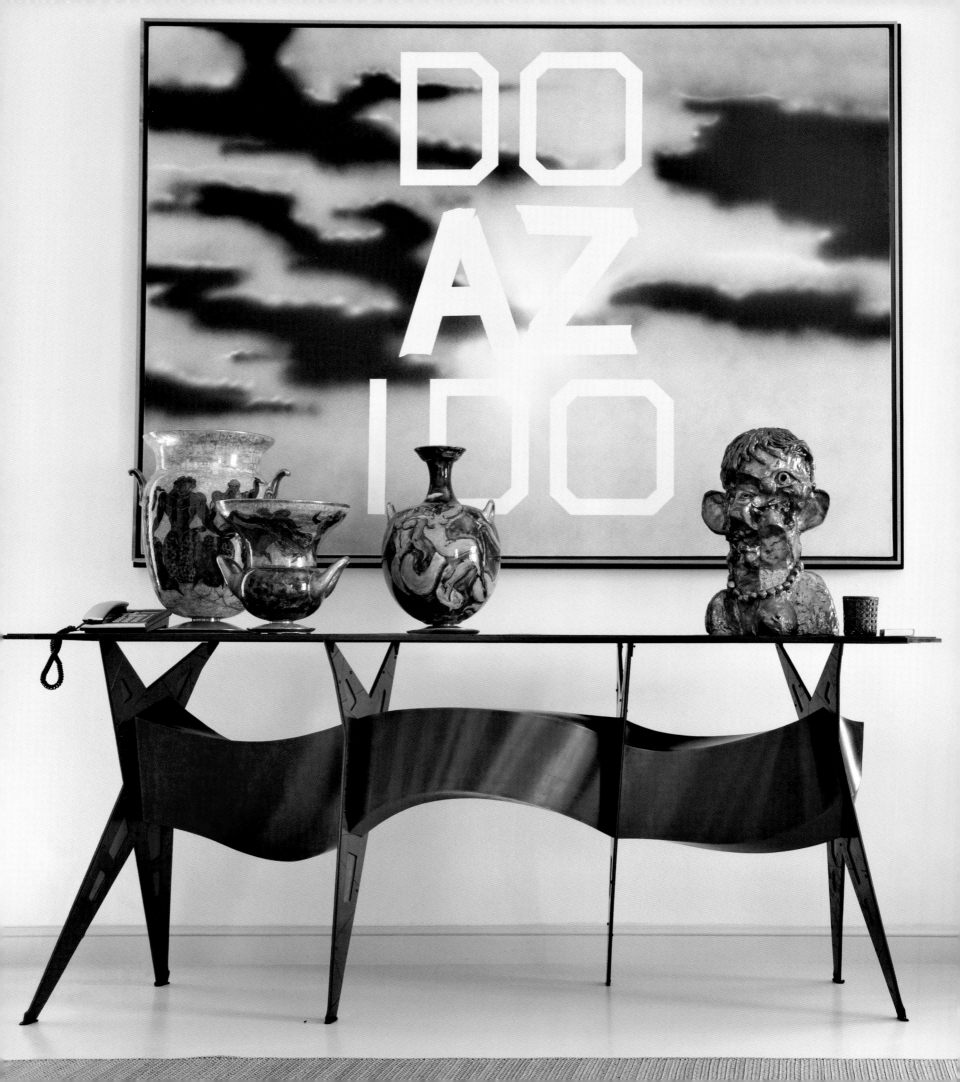

*"Perched high on the island this secretive, private house echoes the themes of both its location and history ..."* DAVID GILL

*PRECEDING PAGES: Artworks including a portrait by Andy Warhol (left), Martin Kippenberger (centre) and Richard Prince (right), adorn the walls of the salon.*
*LEFT: "Young Woman with Pearl Necklace" sculpture, George Condo, 2005, on console, André Dubreuil, below "Do Az I Do" artwork, Edward Ruscha, 1988.*
*FOLLOWING PAGES: Interior views, including specially commissioned furniture by Mattia Bonetti, and lights (page 198) and side table (page 199) by André Dubreuil.*

LEFT: Bathroom, mirror and console, Mattia Bonetti, 2007, "Singe" (Monkey) bronze by Claude Lalanne, and "Échassier" (Wader) lamp, François-Xavier Lalanne, c.1999.
ABOVE: Portrait, Francesco Clemente, c.1980s, above console, André Dubreuil.
OVERLEAF Bedroom furniture and bedside lights, Mattia Bonetti, 2007, and "Grue" (Crane) lights (page 201), François-Xavier Lalanne, 1991.

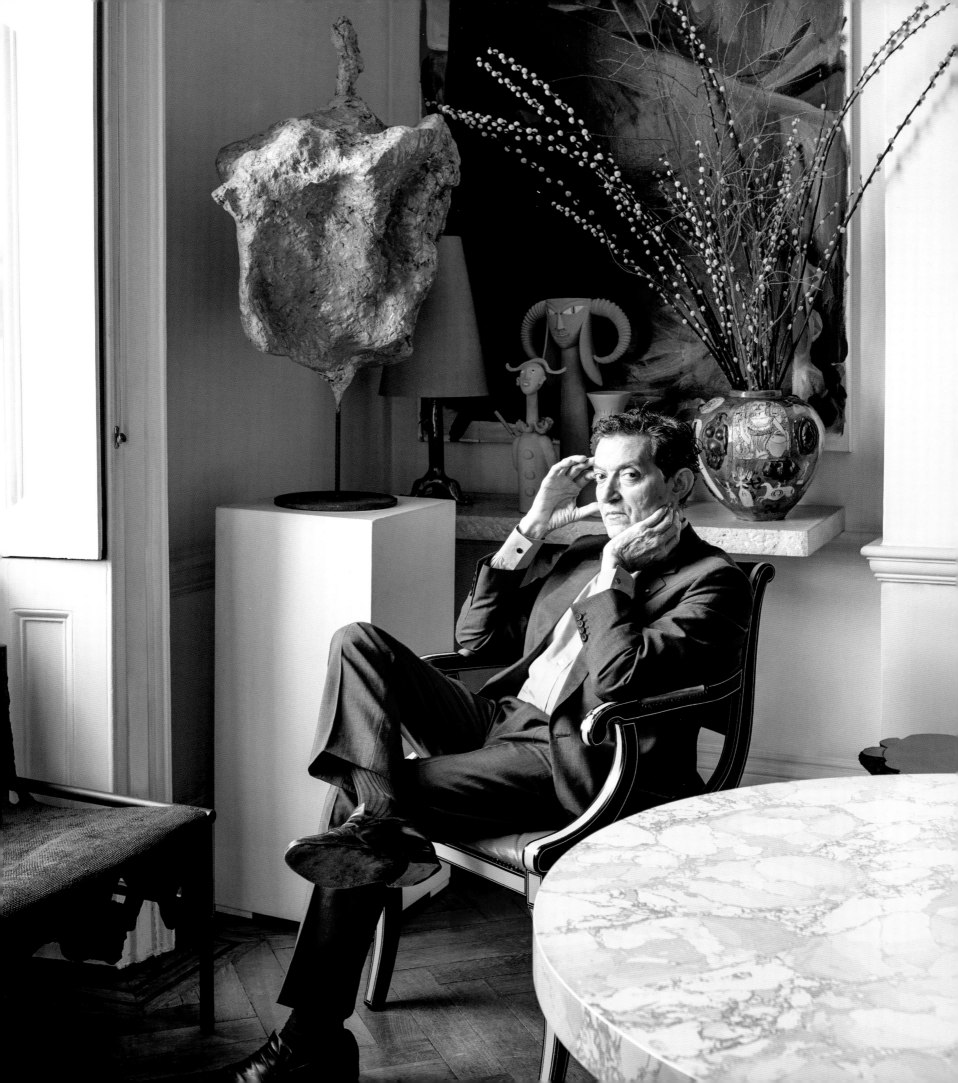

# DAVID GILL AT HOME
## ALBANY, LONDON

"I moved to a top floor apartment – known as a set – in Albany, with my partner, the designer Francis Sultana, when I left Loughborough Road. I was opening my gallery in St James's and thought I had finished with loft-life South of the River in Vauxhall," David says of his move to this top-floor set.

Albany had been built in the Eighteenth century by Sir William Chambers for the newly-created Viscount Melbourne. Later in 1802–1803 it was subdivided into sixty-nine apartments known as "sets" by Henry Holland, who added two courtyard wings stretching back either side to Burlington Street. It was the first block of apartments in Mayfair, and was lived in by Lord Byron along with many members of the aristocracy.

The set David moved into, looking down Old Burlington Street had been lived in by the romantic Regency novelist Georgette Heyer. "Most of the furniture and objects in the apartment came with me from Vauxhall, such as the Picasso and Cocteau ceramics, the Emilio Terry chair designed for Carlos de Beistegui which I had bought during my gap year in Paris, and some of the Ugo Rondinone and Mattia Bonetti pieces. When I moved in, I realised I needed dining chairs. At the same time, a restaurant designed by Oliver Messel had closed and I bought all the chairs from there which were 1950s. I was playing, as I always do, with contemporary art, combining 1930s and 1950s designs, adding new twists to the original Adamesque details of the apartment," he explains.

"If an idea is strong enough, bringing in these pieces keeps it up to date; otherwise you get blandness and uniformity," David believes. Consequently, a large Richard Prince photograph hangs over the fireplace, and art by Christopher Wool and Paul McCarthy seem to find a natural place framed against the early Nineteenth-century detailing of the rooms. The art and furniture, with craftsmanship and design from the Twentieth and Twenty-first centuries, all live together harmoniously."

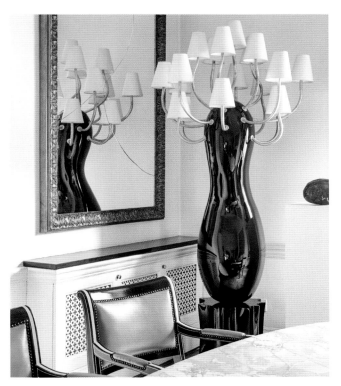

*"It's incredible to live in such a tranquil haven at the very heart of London"* DAVID GILL

*OPPOSITE: David Gill at home in Albany, "Untitled" sculpture, Franz West, 2003; painting, Josh Smith, 2003; ceramics, Jean Cocteau; and vase, Grayson Perry. Photographed by Henry Bourne.*
*RIGHT: "Seville" torchère, Garouste and Bonetti, 1999.*
*OVERLEAF: Sitting room with Line Vautrin eggs (left); "Incroyables" table lamp, Mattia Bonetti, 2012; "Tinkerbellend", Dinos and Jake Chapman, 2002,*
*on shelf (right); and "Belgravia" table lamp, 1989, on "Petit Trianon" side table, 1999, both Garouste & Bonetti. On "Ring" coffee table, Garouste & Bonetti, 1999, (centre) is a collection of Line Vautrin boxes and a small silicone "Pinocchio", Paul McCarthy, 2000. Upholstered Carlos Bestegui chair is by Emilio Terry; sofas, Francis Sultana. Art includes a "Pirate Drawing", Paul McCarthy, 2001; "Untitled", Richard Prince, 1983; "Homage to Henry Moore" firedogs, Mattia Bonetti, 2004, and "Untitled (Brown Brown Rub Mask)", Mark Grotjahn, 2001, sits in the window.*

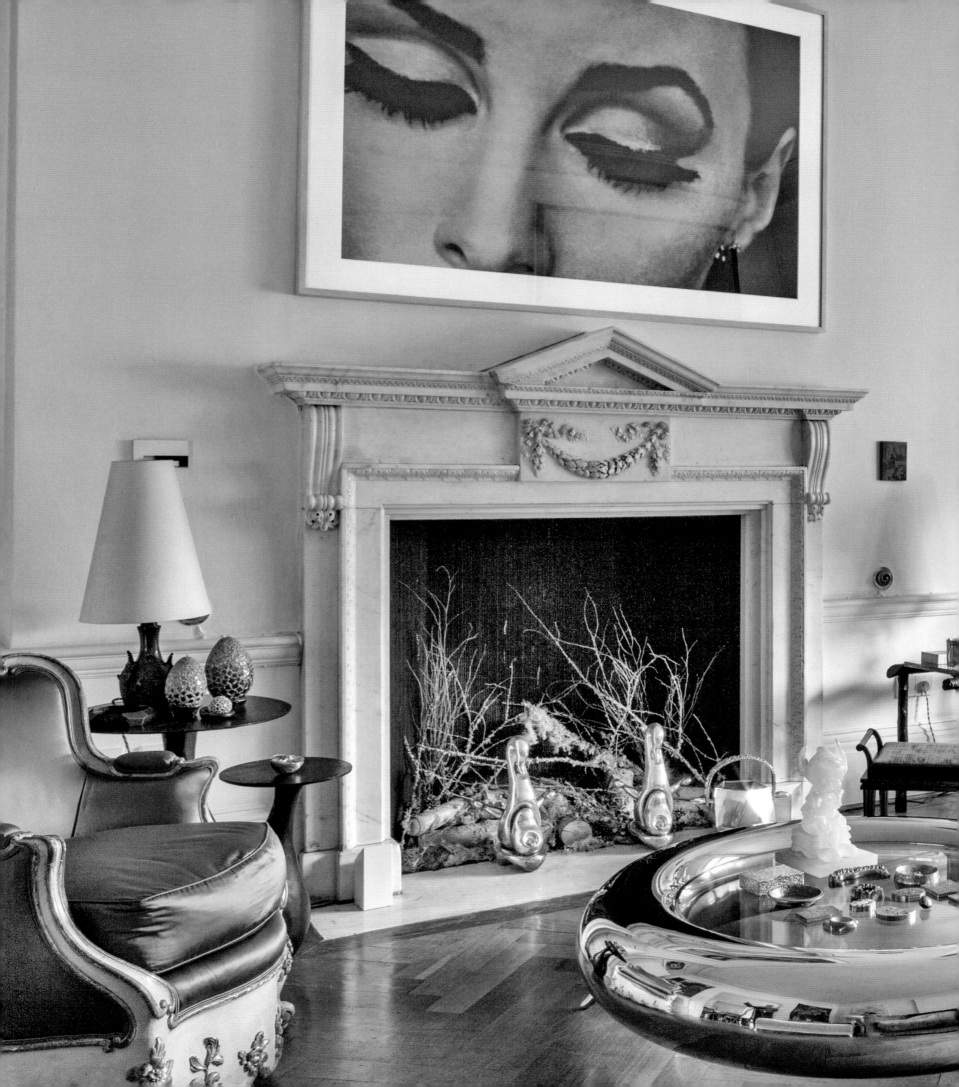

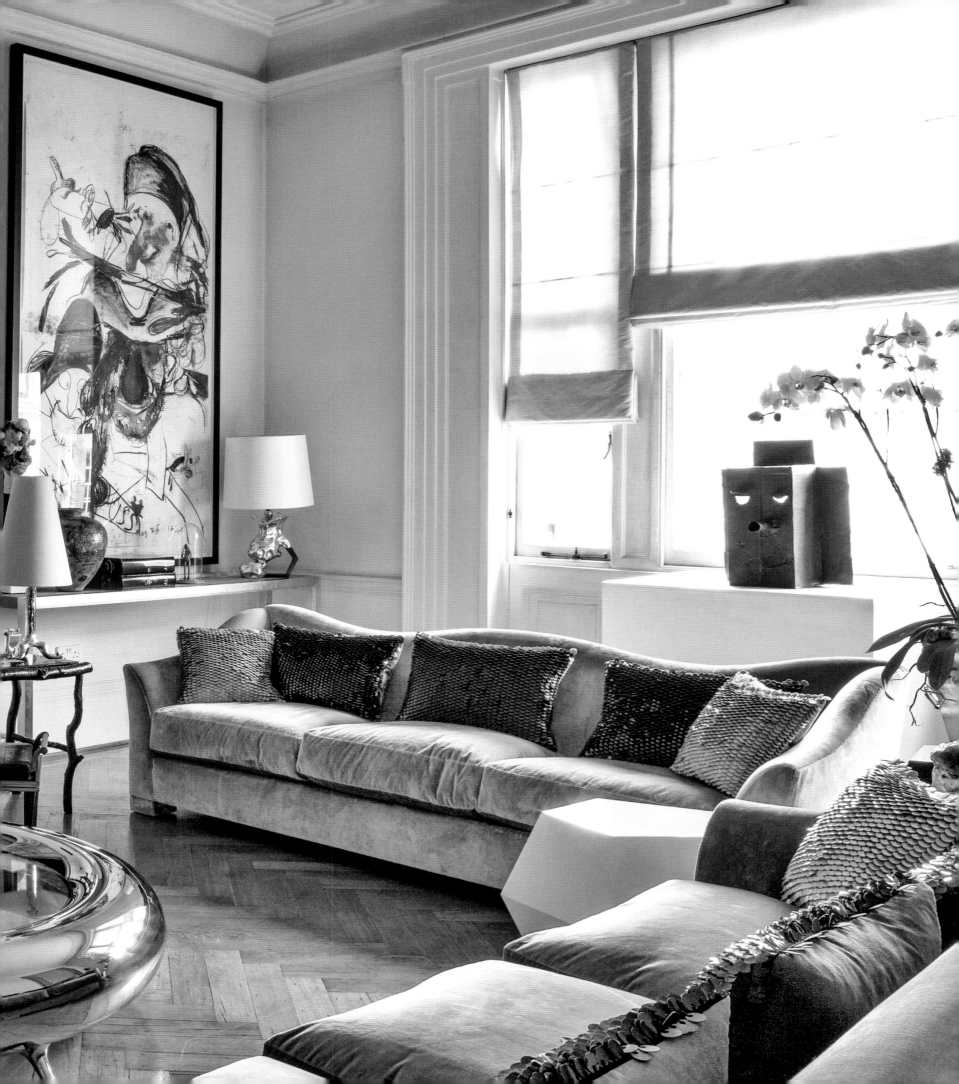

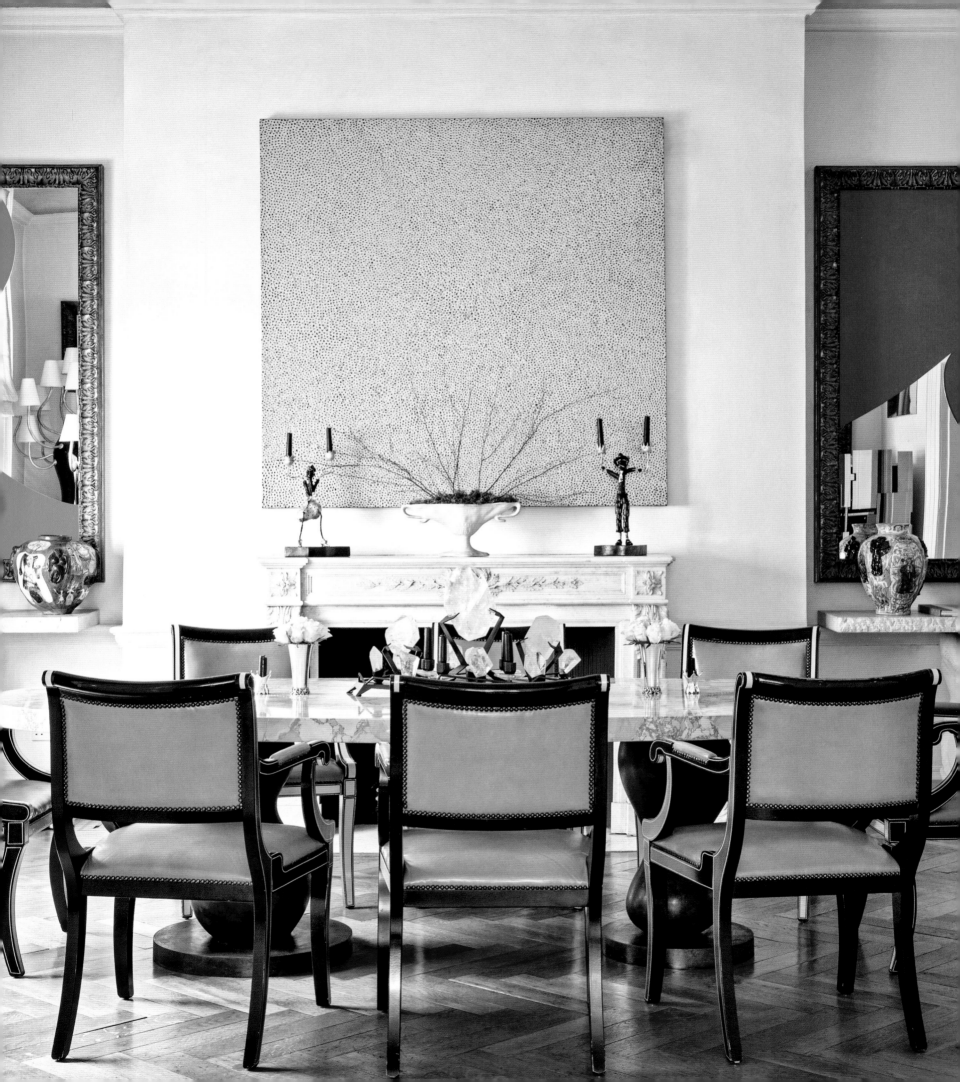

PREVIOUS: On the bespoke scagliola marbleized top of the "Salome" dining table by Garouste & Bonetti are silver vases by Richard Vallis and candelabra by André Dubreuil. "Infinity Nets", Yayoi Kuzama, 2011, is on the wall behind "Boy" and "Girl" candlesticks by Garouste & Bonetti, 1994, and a Constance Spry vase. Two Grayson Perry vases flank the chimney breast.

ABOVE: Above the Eugene Printz sofas in Gill's study is "Cattail Melting in the Snow" by Ida Ekblad, 2010. "Emperor" table lamp, patinated bronze, Garouste & Bonetti 1999, and "Rubber (Gold)" side table by Fredrikson Stallard, 2007.

RIGHT: "Untitled" sculpture by Franz West, 2003, stands to the left of "Belgravia" table lamp, Garouste & Bonetti, 1989, a collection of Jean Cocteau ceramics, and Grayson Perry vase, all in front of "Untitled" by Michelangelo Pistoletto, 2014.

OPPOSITE: In front of a painting by Josh Smith are "Belgravia" table lamp, Garouste & Bonetti, 1989 and a Grayson Perry vase on vintage 1940s "Cherub" console table.

OVERLEAF, LEFT: Behind "King Bonk" armchair and ottoman, Fredrikson Stallard, 2008, and above "Flower" table by Mattia Bonetti, 2005, sits a Barnaby Barford statue, with "Piccadilly Circus Tea Party Pink", Paul McCarthy, 2003, behind. Above "Dune 01-07" shelf, Zaha Hadid, 2007, are "Infinity Nets", Yayoi Kusama, 2008, and "Untitled" Christopher Wool, 2003. "Chewing Gum" side table, Mattia Bonetti, 2005, and "Ottoman Brisée", Garouste & Bonetti, 1994 are to left.

OVERLEAF, RIGHT: "Strata" cabinet, 2004, and "Grotto" lamp, 2014, both by Mattia Bonetti, stand next to "Him" by Steven Shearer, 2005, and "Untitled" by Michelangelo Pistoletto, 2014, respectively.

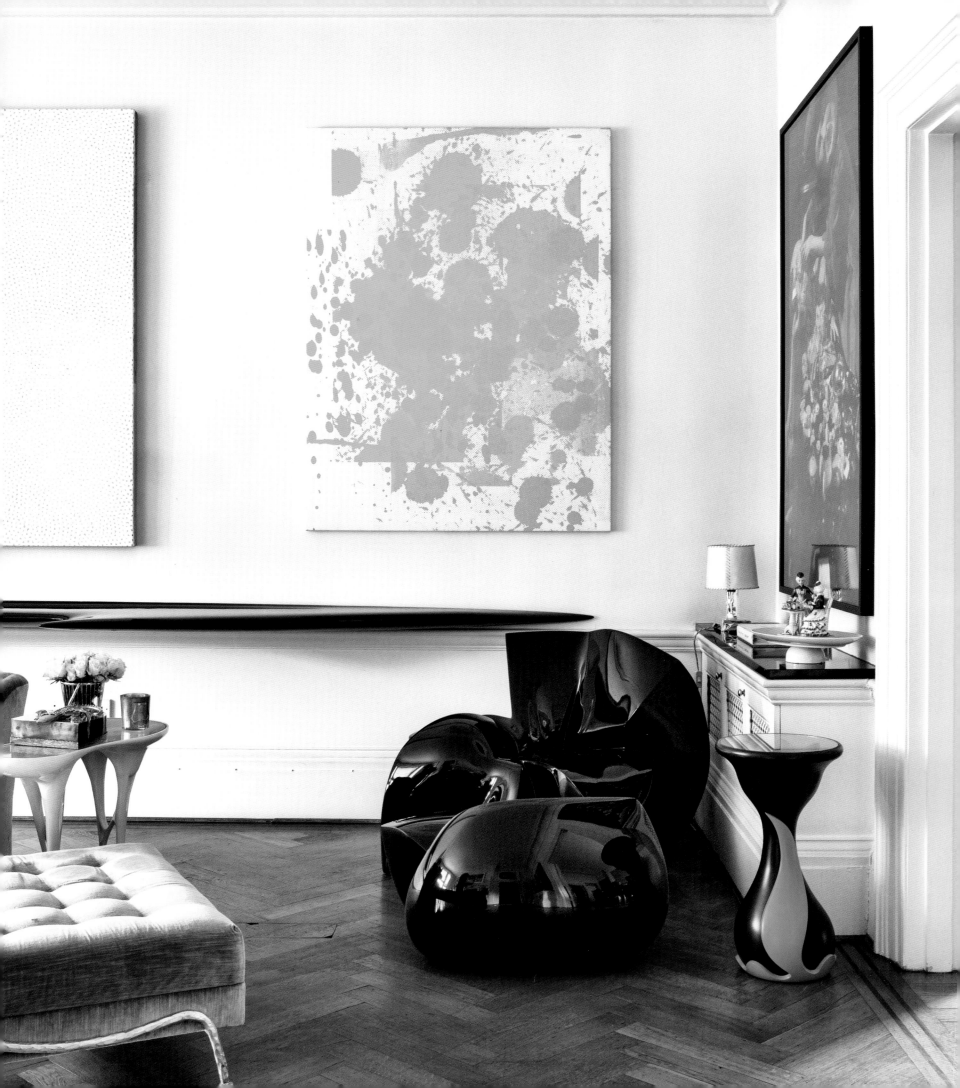

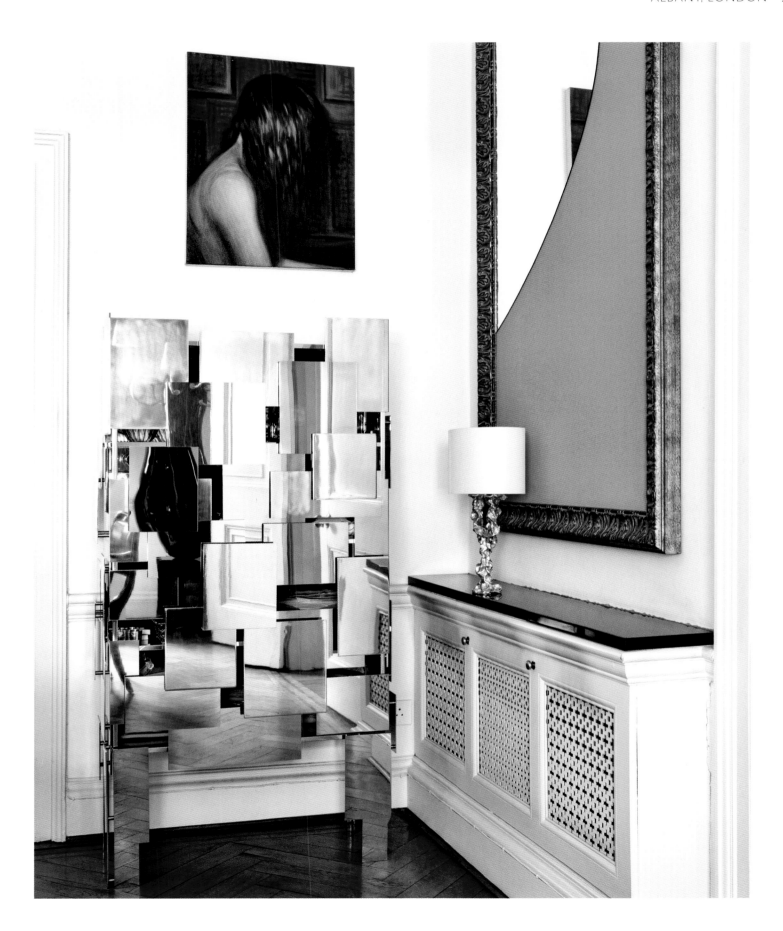

ABOVE: Detail of "Come On You Lightweight, Down It", Barnaby Barford, from "Private Lives", 2008.
OPPOSITE: Below a "Pirate Drawing" by Paul McCarthy, 2001, a Grayson Perry vase and "Shit! Now I'm Going To Be Really Late", Barnaby Barford, stand on an "Alu" polished aluminium console, Mattia Bonetti, 2008.

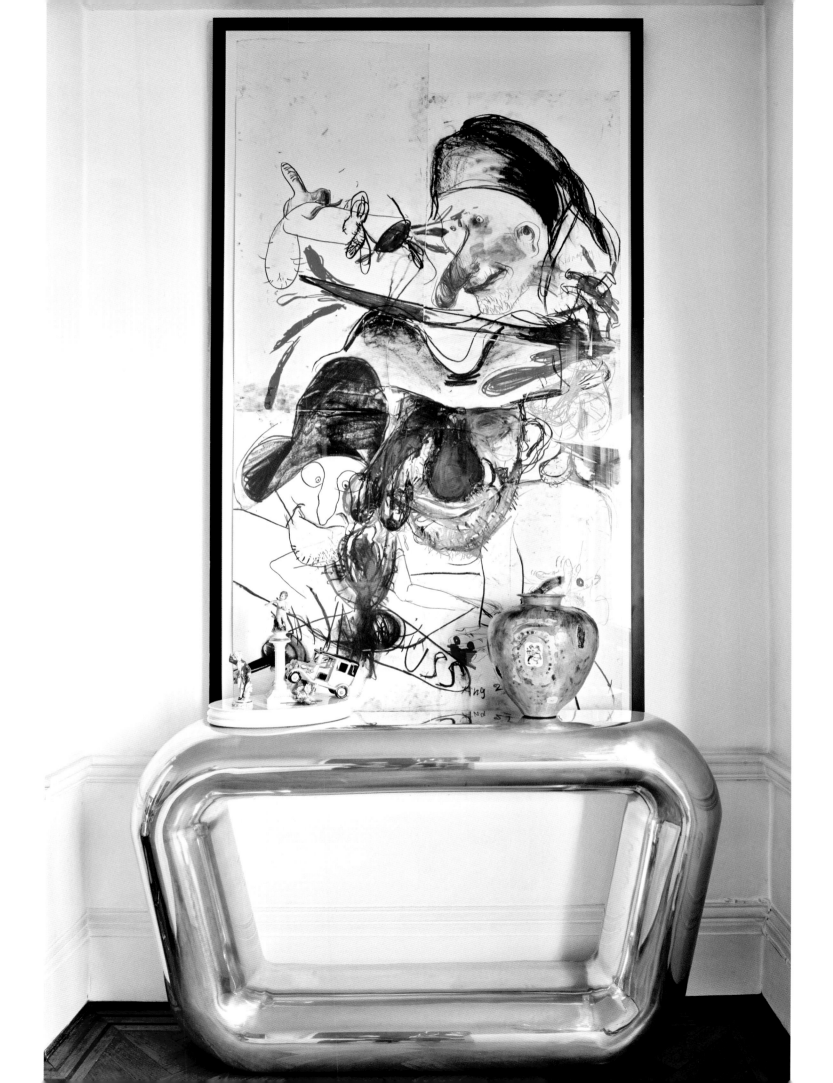

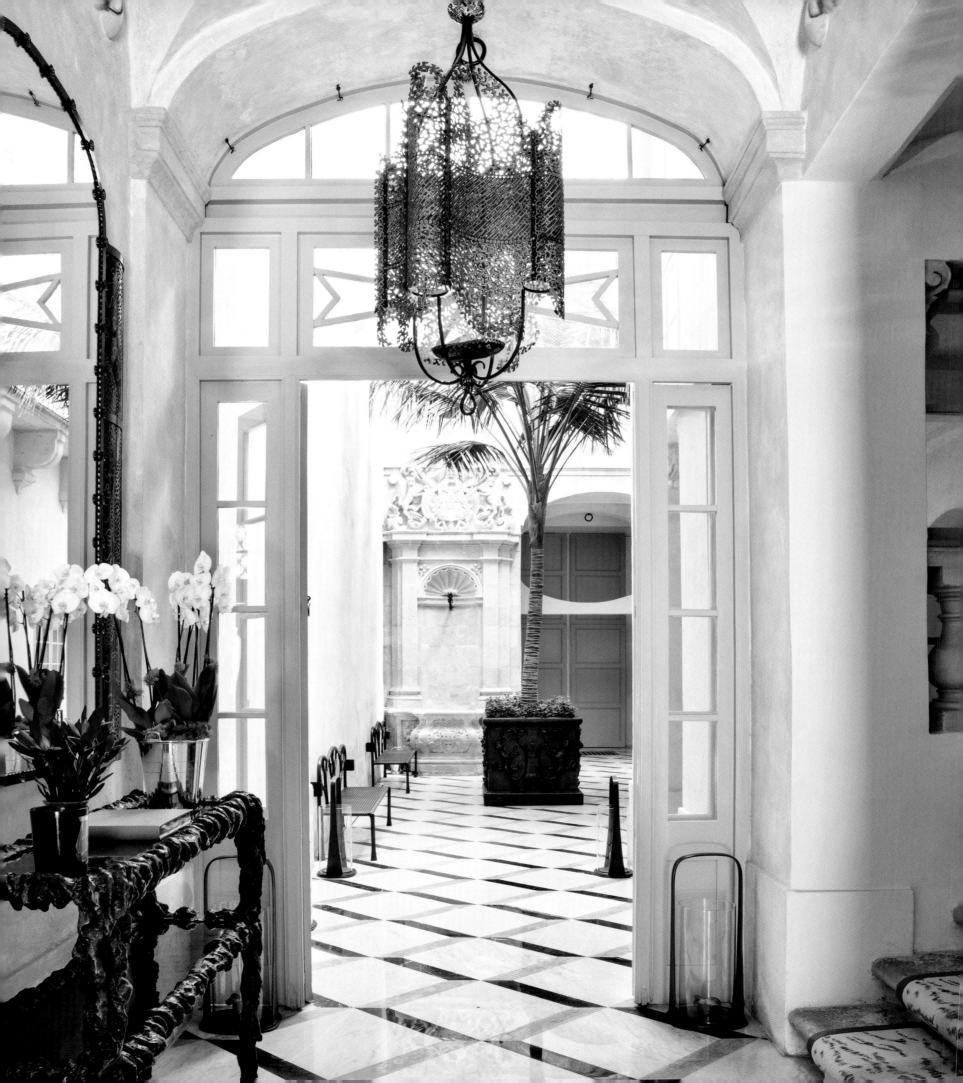

# VALLETTA
# PALAZZO DE TORRES

When David bought this charm, it was completely untouched. The original kitchen was on the ground floor, complete with the old pots and pans, and there were store rooms for hay and other necessities for the horse and cart which lived in the courtyard. Now, the basement, where provisions were kept, is a sky-lit swimming pool.

Historically, the resident Knight would receive his fellow Knights and guests in his office on the first floor, where he would also be served his dinner, and he lived on the *piano nobile*. There was a cosy sitting room with a fireplace, his bedroom, and a bathroom. "It was a beautiful challenge," David recollects.

*"The house is built on bare rock; the same rock which the Knights used to build the palazzo itself. It is a lovely soft honey colour, weathered by the fierce winters we get here. The palazzo is like a little fortress."* DAVID GILL

"None of the furniture was there of course, but the architectural features were all still preserved, so I very much respected all the architecture, all the floors, all the rooms and put back the *cangatura*, or flagstones, used in the palazzo, on the floors. It is unusual to find this kind of historical restoration of such a palazzo today," he explains. "People try to turn these houses into modernist towers, putting in glass and steel, but I decided to stay true to the Eighteenth century. One of the loveliest features is the triumvirate of wells which bring humidity to the house in the long hot summers, one of which is covered in a huge and beautiful ceramic bell to trap moisture."

OPPOSITE: "Atlantis" console, bronze, moulded glass, Mattia Bonetti, 2014; Mirror and chandelier, both, André Dubreuil, 2015 and hurricane lamps by Francis Sultana.
RIGHT: A Nineteenth-century marble head rests on the cangatura of the hallway.

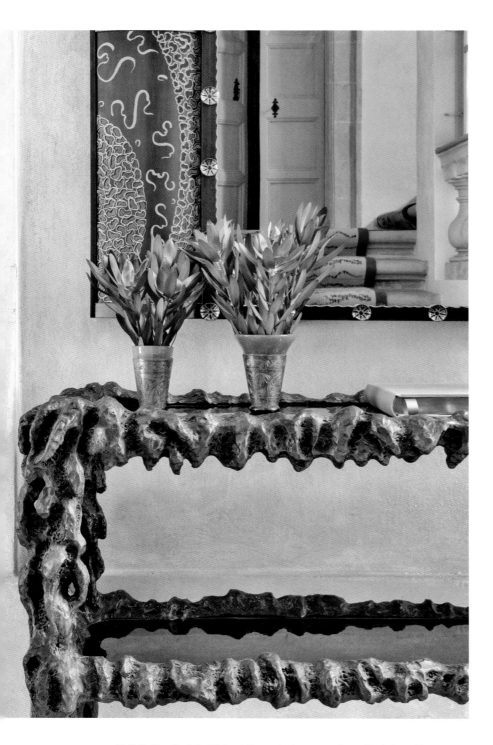

*ABOVE: Detail of the "Atlantis" console, bronze, red moulded glass, Mattia Bonetti, 2014, and mirror, André Dubreuil, 2015.*
*OPPOSITE & OVERLEAF: In the stairwell hangs the light installation "My Madinah. In Pursuit of My Ermitage", Jason Rhoades, 2004, together with "Rising Sun", Eva Rothschild, 2007. On the "Venetian Chest of Drawers", Mattia Bonetti, 2012, stands a Grayson Perry vase. Antique German chair by Gerhard Schliepstein, 1924.*

"The first thing we did was to take all the plaster off the walls to reveal the stone beneath. What I like best is that the majority of it hasn't been retouched in any way – even the original flagstones, though needing restoration and replacement in the hall, were still perfect in the courtyard and the basement. It was a charming project, and I completely preserved the palazzo as it would have been when the first Knights of Castile occupied it."

"I already owned furniture and art that I wanted to put in the house, but new pieces were also specially commissioned. As with so many of these palazzi, the high ceilings were devoid of decoration, so I decided to ask artists to think about work for the ceilings on the *piano nobile*. The French conceptual artist Daniel Buren contributed some site-specific ceiling art, stripping the beams in the drawing room, which is echoed in the boldly striped sofa."

"Jason Rhoades showed a piece I saw at his 1996 exhibition in Ste Gallen called 'My Madinah. In Pursuit of My Ermitage', composed of neon lights," David explains. "When I bought it, I didn't think it would look good in Valletta, but I changed my mind when it was installed in the hall and now I think it looks wonderful."

The dining room is decorated in brilliant turquoise and, inspired by the Knights' escutcheons in St. John's Cathedral, the walls are punctuated with gilded Maltese crosses and the arms of the house to suggest the house's history. "Oriel Harwood, one of the artists I first discovered and showed in the Fulham Road gallery at the beginning of my career, made all the pieces for us," David explains.

"What with complicated permissions, and the painstaking restoration building works, it has taken almost ten years to resurrect the house from its 40 year slumber. Now it is so amazing; it is so right, for it is back to its original plan and appearance," says David.

In summertime, David and Francis mainly entertain friends for long weekend house parties, but they also go to the house on their own for weekends in the winter. "It is very convenient," David says. "You can fly from London every day after work and arrive at midnight, then you wake up in the morning and look out at crystal skies and breathe the sparkling fresh air. It is calm and wonderfully relaxing. You can go and read on the roof terrace, or listen to music, and look out beyond the fortifications of Valletta harbour at the Mediterranean drinking in the blue of the sea.

"Since the war, Malta has been very insular," David explains. "It remains relatively undiscovered by tourists, English retirees, or villa owners, unlike Sicily or Tuscany; why would you go anywhere else?"

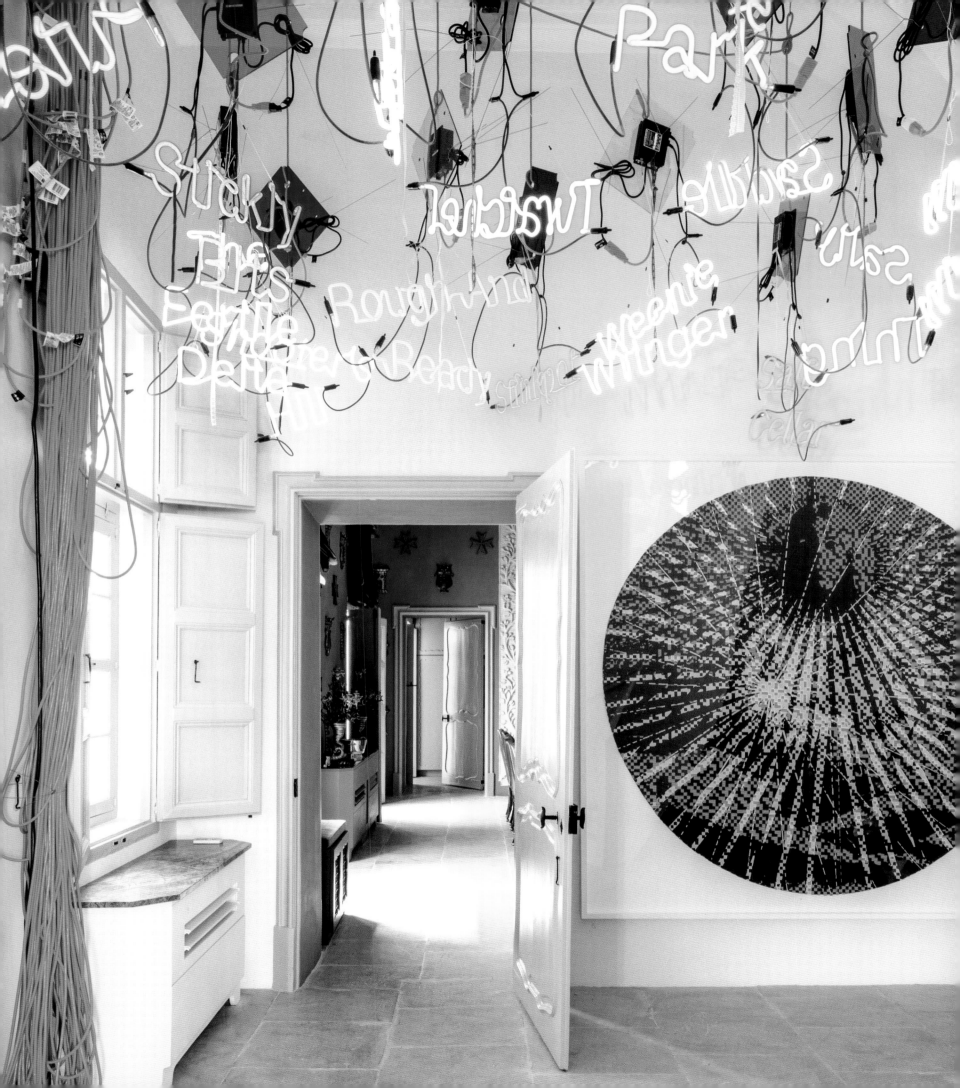

*OPPOSITE: "Michael Jackson Red", Paul McCarthy, 2002, hangs on the staircase wall, illuminated by "Introvert Sun", Olafur Eliasson, 2010.*
*ABOVE: General view of the salon, with ceiling art, Daniel Buren, 2015; "Congo" armchairs, 2014 and pair of table lamps, 2017, Mattia Bonetti.*

*THESE PAGES: Candelabra, André Dubreuil, sits on "Abyss" table, Mattia Bonetti, 2004, flanked by Oriel Harwood mirrors between the French windows to the garden. "Congo" armchair, 2014, and table lamps, 2017, Mattia Bonetti.*
*OVERLEAF: "Palm" dining chairs, Mattia Bonetti, 2012; "Salome" dining table, Garouste & Bonetti; wall bosses and "Blue Coral" candelabras, Oriel Harwood.*

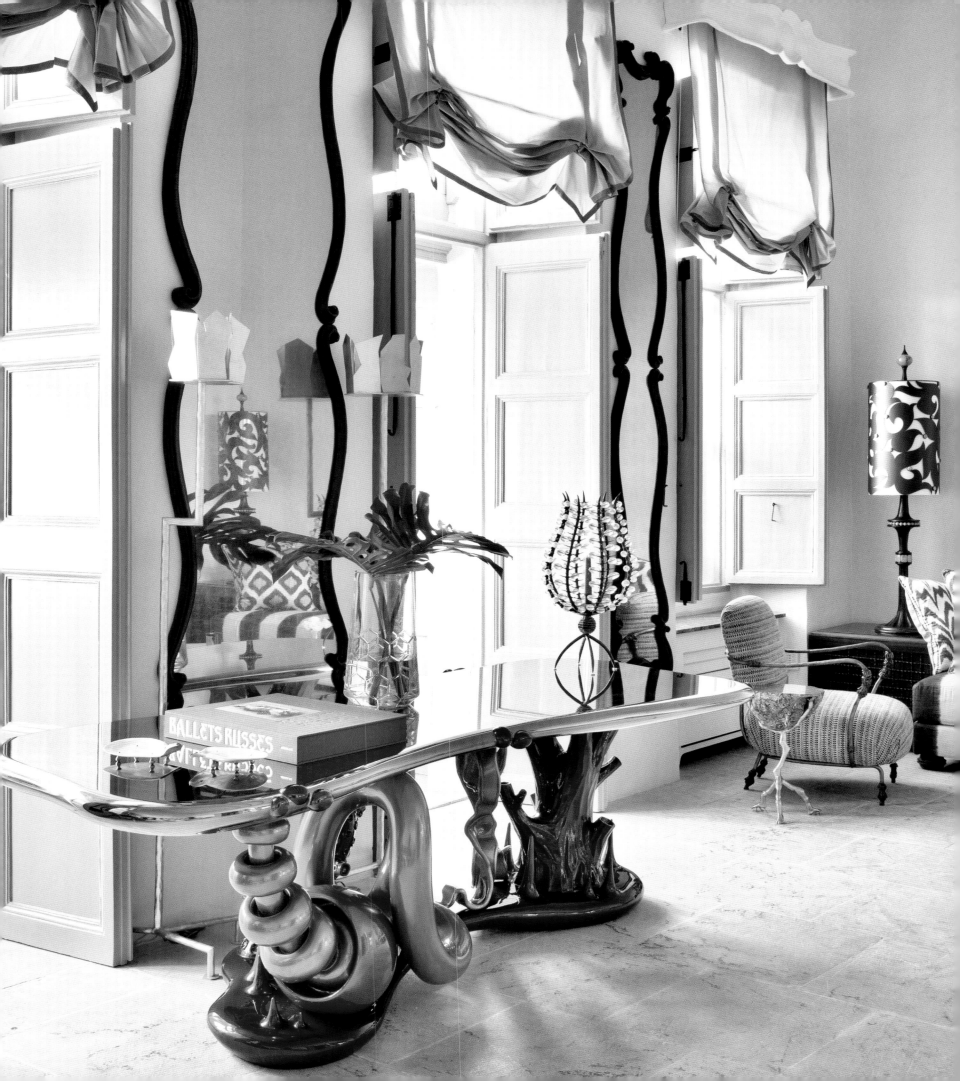

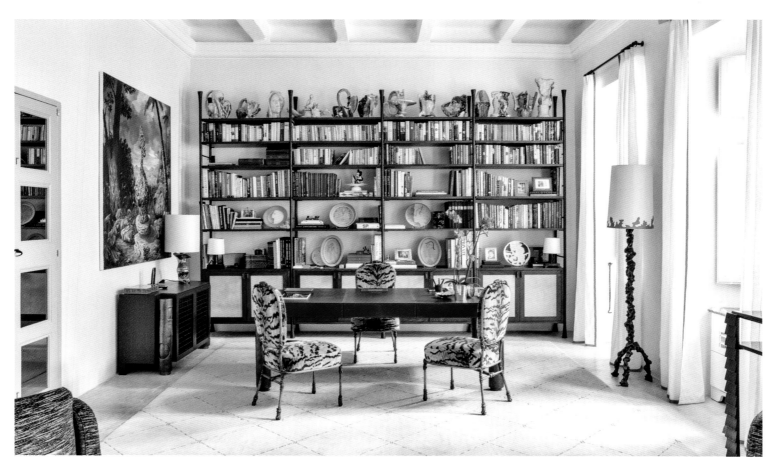

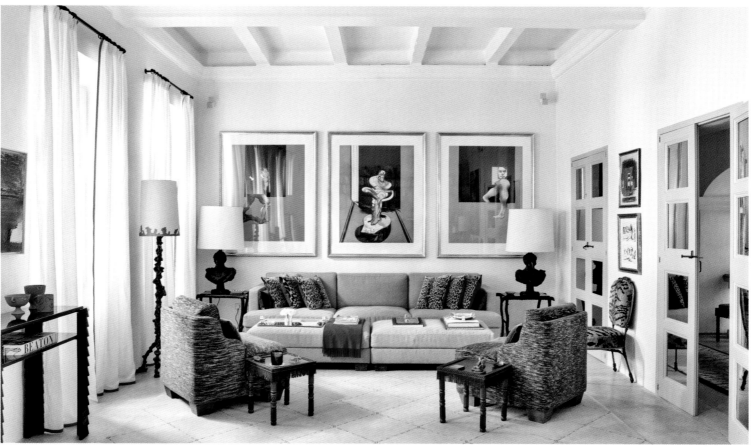

*THE STUDY: A collection of ceramics sits across the top of the bookcase.
"Fringe" side tables, "Congo" chairs and "Grotto" standard lamps, Mattia
Bonetti, 2014, stand beneath, from left to right; "Study from a Human Body",
"Sitting Figure" and "Untitled", limited edition prints, Francis Bacon, and
"Emperor" table lamps sit on "Trianon" side tables, Mattia Bonetti, 1999,
alongside two "Philippo" armchairs, Francis Sultana.*

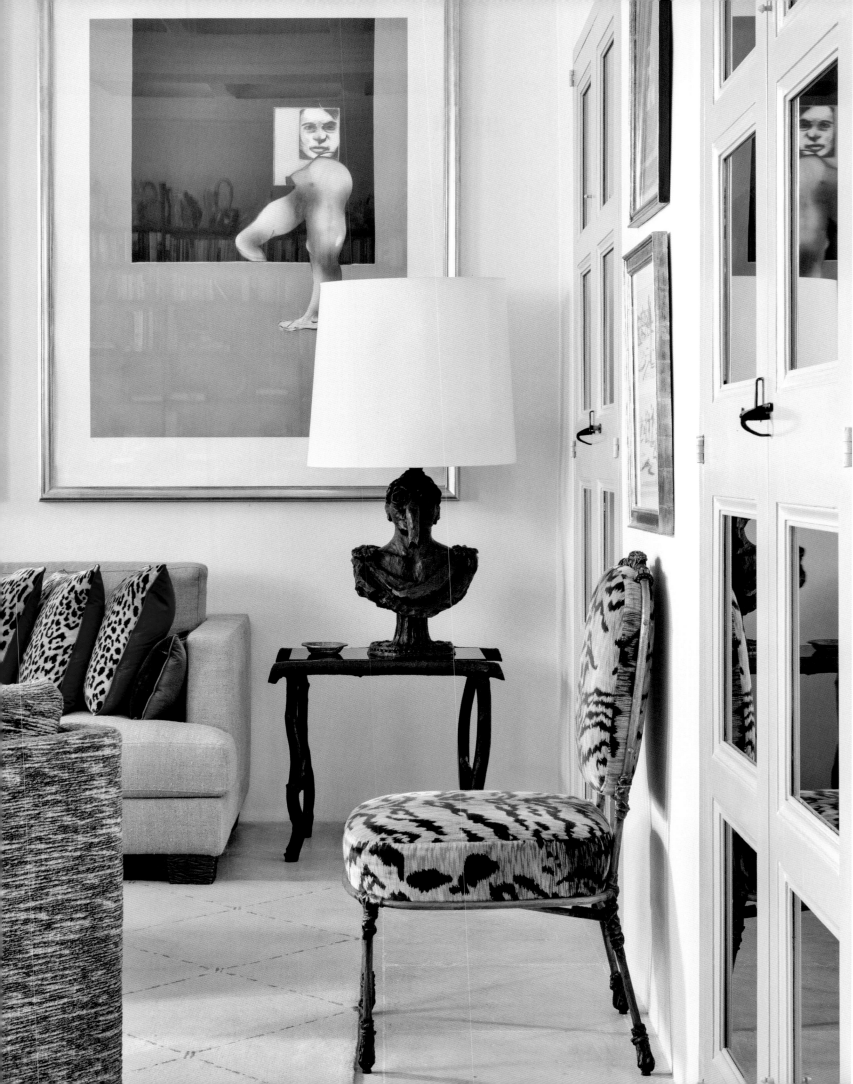

BEATON

OPPOSITE: "Untitled", Carroll Dunham, 2017, is displayed above a collection of Jean
Cocteau ceramics on "Rihanna" console, Francis Sultana, 2015.
ABOVE: "Merveilleuse" patinated bronze table lamp, Mattia Bonetti, 2012, with three
pastels to left and "Lufthansa" oil on linoleum, 1991, to right, all Aldo Mondino.

*THE TERRACE: "Twig" sofas and table by Francis Sultana stand before the fireplace he designed, made by Oriel Harwood, in the indoor/outdoor terrace. Mirror is also by Oriel Harwood; "Atlas" planter, Garouste & Bonetti, 1996.*

# "Trends only follow after an individual has made a statement."

DAVID GILL

Best efforts were made to verify all photography and art credits. Any oversight was unintentional and should be brought to the publisher's attention so that it can be corrected in a future printing.

**CONTENTS**
PAGE 4: David Gill in front of *Pig*, Paul McCarthy; Photo ©Kevin Davies

**FOREWORD**
PAGE 6: *King Bonk chairs*, Fredrikson Stallard; Photo ©Thomas Brown

**INTRODUCTION**
PAGE 8: *Monumental Vases*, Grillo Demo; *David Gill*; Photo ©Simon Upton / Interior Archive
PAGE 9 (left): *Diego Giacometti*, Photo ©Michel Sima / Bridgeman Images / DACS
(right): *Eugene Berman*, Photo ©AKG Images / Mondadori Portfolio; (bottom): *Coffee table with "Oreiller Chinois" lamp*, Photo ©Jean Collas / courtesy of Comité Jean Michel Frank
PAGE 10 (top left): *David Gill's Lexham Gardens Interior*, Photo ©Christoph Kircherer; (bottom left): *Antiquité bouclée, Jeunesse d'éternité*, Jean Cocteau / Jean Cocteau Estate / DACS; Photo ©Richard Davies; (bottom right): *Chérie*, Line Vautrin / Line Vautrin Estate / DACS; Photo ©David Gill Gallery
PAGE 11: *David Gill's Lexham Gardens Interior*; Photo ©Richard Davies
PAGE 12: *Nelson Woo's Hong Kong Interior*; Photo ©Guillaume de Laubier
PAGE 13: *Picabia*, Paul McCarthy; *David Gill*; Photo ©Ricardo Labougle

**FULHAM ROAD, CHELSEA**
PAGE 14: *Pandora Box*, Mattia Bonetti; *David Gill*; Photo courtesy of Mattia Bonetti
PAGE 15: *Business Card*, Illustration Pierre Le Tan; Photo ©David Gill Gallery
PAGE 16: *Catalogue*, Illustrations Pierre Le Tan; Photo ©David Gill Gallery
PAGE 17 (top left): Jean Cocteau / Jean Cocteau Estate / DACS; Photo ©David Gill Gallery; (bottom left): *Petit Faune*, Jean Cocteau; Photo ©Serge Caussé / Musée Jean Cocteau Collection; (right): *Invitation*, Illustrations Pierre Le Tan; Photo ©David Gill Gallery
PAGE 18: *Catalogue*, Illustrations Pierre Le Tan; Photo ©David Gill Gallery; (middle): *Gold Amphora*, Line Vautrin / Line Vautrin Estate / DACS; Photo ©David Gill Gallery; (bottom): *Poudrier Feuille*, Line Vautrin / Line Vautrin Estate / DACS; Photo ©David Gill Gallery
PAGE 19: *Line Vautrin Exhibition, Fulham Road*, Line Vautrin / Line Vautrin Estate / DACS; Photo ©Steve Dalton
PAGE 20: *Catalogue*, Illustrations Pierre Le Tan; Photo ©David Gill Gallery
PAGE 21: *Prince Imperial Chair*, Garouste & Bonetti; Photo ©David Gill Gallery
PAGE 22: Illustrations: *Boite Pandora / Bougeoir No 5 / Autumn Leaves Sofa / Pois Table*, Garouste & Bonetti, ©Mattia Bonetti; Photos: *Fauteuil Chair / Kris Side Table / Carre Mirror*, Garouste & Bonetti, Photo ©Barbara Stoeltie
PAGE 23: *Mattia Bonetti and Elisabeth Garouste*, Photo ©Jean-Erick Pasquier / Gamma-Rapho / Getty Images
PAGE 24: *Grand Canal Chair / Pois Table / Tripod Candlesticks / Carre Mirror*, Garouste & Bonetti, Photo ©Barbara Stoeltie
PAGE 25 (top left): *Inspirale Espirale Firedogs*, Garouste & Bonetti, Photo ©Barbara Stoeltie; (top right): *India Guéridon Side Table*, Garouste & Bonetti, Photo ©Barbara Stoeltie; (bottom left): *Pandora Box / Autumn Leaves Rug*, Garouste & Bonetti, Photo ©Barbara Stoeltie; (bottom right): *No 5 Candelabra / Cabinet de Terre*, Garouste & Bonetti, Photo ©Barbara Stoeltie
PAGE 26 (top right): *No. 60 Bookshelf*, Donald Judd, Donald Judd Foundation / DACS / Doris Lehni Quarella /Antonio Monaci; (top right): *No. 45 Chair*, Donald Judd, Donald Judd Foundation / DACS / Doris Lehni Quarella /Antonio Monaci; (top right): *No. 56 Desk*, Donald Judd, Donald Judd Foundation / DACS / Doris Lehni Quarella /Antonio Monaci; Photos ©Phillips Auctioneers
PAGE 27 (top): *Fulham Road Interior*, Photo ©David Gill Gallery; (left): *Fulham Road Interior*, Photo ©Oberto Gili / Condé Nast; (bottom): *Pompeii Chandelier*, Patrice Butler, Photo ©Patrice Butler
PAGE 28: Painting: *L'Architetto e L'Imperatore*, Aldo Mondino; *David Gill*;

Photo ©Henry Bourne
PAGE 29: *Lord Biron*, Aldo Mondino; Photo ©Fabrizio Garghetti, courtesy Archivio Aldo Mondino
PAGE 30 (top): *The Grayson Perry Trophy awarded to a Person with Good Taste*, Grayson Perry, courtesy the Victoria Miro Gallery; Photo ©David Gill Gallery; (left): *Grayson Perry / Claire*, Photo ©David Montgomery / Getty Images; (right): *My Heroes*, Grayson Perry, courtesy the Victoria Miro Gallery; Photo ©David Gill Gallery
PAGE 31: *Chair*, Nicholas Alvis Vega; Photo ©David Gill Gallery
PAGE 32: *Oriel Harwood*, Photo ©Armin Weisheit
PAGE 33: *Oriel Harwood Exhibition, Fulham Road*, Photo ©David Gill Gallery
PAGE 34 (top left): *Leaf Mirror*, Oriel Harwood; (top right): *Snake Cup and Saucer / Dragon Cup and Saucer*, Oriel Harwood; (bottom right): *Cloud Candlestick / Flaming Orb Candlestick / Minotaur Candlestick*, Oriel Harwood; (bottom left): *Shell Wall Sconce*, Oriel Harwood; Photos ©David Gill Gallery
PAGE 35 (top left): *Poseidon Candelabra*, Oriel Harwood; Photo ©David Gill Gallery; (top right): *Voluta Candelabra* Oriel Harwood; Photo ©Oriel Harwood; (right): *Wings Head*, Oriel Harwood; Photo ©David Gill Gallery; (centre): *Coral Grotto Wall Appliqué*, Oriel Harwood; Photo ©David Gill Gallery; (bottom left): *Voluta Gilt Metal Table*, Oriel Harwood; Photo ©Oriel Harwood
PAGE 36: *Silver Candlestick*, Richard Vallis / *Coral Ceramic Head / Cup and Saucer*, Oriel Harwood / *Posh Urn*, Grayson Perry, courtesy the Victoria Miro Gallery; Photo ©Guillaume de Laubier
PAGE 37: *Textiles and Soft Furnishings*, Ulrika Liljedahl; Photo ©Ulrika Liljedahl

**LOUGHBOROUGH STREET**
PAGE 38: *Yah Hoo Town Bunkhouse*, Paul McCarthy, courtesy of Hauser & Wirth; *David Gill*; Photo ©David Gill Gallery
PAGE 40: *Painting*, Albert Oehlen; *Dune Table*; *Dune 01-07, Shelves*, Zaha Hadid; *Flowers in the Air Cabinet*, 1994, Garouste & Bonetti; *Bergère 2, Chair*, Fredrikson Stallard; Photo ©Hemis / Alamy Stock Photo
PAGE 41 (top): *Loughborough Street Opening Card*, Photo ©David Gill Gallery; (bottom): *Cupboard / Table / Bookcases*, Jean Prouvé; *Stools*, Charlotte Perriand; *Seat*, Ernest Boiceau; Photo ©David Gill Gallery
PAGE 42 (top left): *Turandot Side Tables*, Garouste & Bonetti; *Slit Coffee Tables*, Fredrikson Stallard; *Untitled*, Franz West; *Seventeen Haunts*, Gilbert and George; Photos ©David Gill Gallery; (top right): *Flower Tables*, Mattia Bonetti; *Date Painting*, Ugo Rondinone; Photo ©David Gill Gallery; (centre left): *St Petersburg Chest of Drawers*, Garouste & Bonetti; *Oval Mirror*, Garouste & Bonetti Bonetti; Photo ©David Gill Gallery; (guests, below left): *Nicky Haslam, David Gill; Patrice Butler; David Gill and Guests*; Photos David Gill Gallery; (right): *St Petersburg chest of drawers*, Mattia Bonetti; *Oval Mirror*, Garouste & Bonetti; *Vases*, Grillo Demo; *Bambino with Falling Jasmine*, Grillo Demo; *Leaf Mirror*, Oriel Harwood; *Wall Lamp*, Serge Mouille / DACS; *David Gill*; Photo ©Clive Frost / *FT How To Spend It Magazine*
PAGE 43 (left): *Naturale, Transparente, Artificiale*, Gino Marotta; Photo ©David Gill Gallery; (right): *Fakir Cabinet*, Mattia Bonetti; Photo ©Mattia Bonetti
PAGE 44: *Yah Hoo Town Bunkhouse*, Paul McCarthy, courtesy of Hauser & Wirth; Photo ©David Gill Gallery
PAGE 45: *Yah Hoo Town Bunkhouse*, Paul McCarthy, courtesy of Hauser & Wirth; Photo ©David Gill Gallery
PAGE 46: *Sketchbook*, Jaime Hayon; Photo ©Hayon Studio
PAGE 47: *Mediterranean Digital Baroque, Installation*, Jaime Hayon; Photo ©Hayon Studio
PAGE 48: *Mediterranean Digital Baroque*, Jaime Hayon; Photo ©Hayon Studio
PAGE 49: *Mediterranean Digital Baroque*, Jaime Hayon; Photo ©Hayon Studio
PAGE 50 : *Jack (prototype)*; *Tower*, Tom Dixon; Photo ©David Gill Gallery
PAGE 51 (top row): *T-section Sideboard; Bench*; (bottom row): *Hexagonal Chest; Bench*, Tom Dixon; Photo ©David Gill Gallery
PAGE 52 (top): *Curtains; Cushions; Almond Blossom Mosaic Table; Bambino with Falling Jasmine (series)*, Grillo Demo; Photo ©David Gill Gallery; (bottom): *Butterflies Cabinet*, Grillo Demo; Photo ©David Gill Gallery
PAGE 53 (right): *Bambino with Falling Jasmine*, Grillo Demo; (left): *Silver Jasmine Paperweight*, Grillo Demo
PAGE 54 (top): *Almond Blossom Mosaic Table*, Grillo Demo; *Jasmine Blossom*

*Mosaic (detail)*, Grillo Demo; Photo ©Martin Parr / Magnum; (bottom): *Madonna, (painting detail)*, Grillo Demo; Photo ©Martin Parr / Magnum
PAGE 55 (top and right): *Monumental Vases (details)*, Grillo Demo; (bottom left): *Jasmine Vases*, Grillo Demo
PAGE 56 (top): *Monumental Vases, Black and Turquoise*, Grillo Demo; (bottom): *Monumental Vases, Black and Turquoise, work in progress (details)*, Grillo Demo; Photo ©Martin Parr / Magnum
PAGE 57: *Monumental Vases, Red and Turquoise (details)*, Grillo Demo
PAGE 58: *Untitled (art)*, Richard Prince, courtesy of Gagosian Gallery; *Block Head (sculpture)*, Paul McCarthy; *Vases*, Grillo Demo; *Vases*, Grayson Perry, courtesy the Victoria Miro Gallery; *Plates*, Jean Cocteau / Jean Cocteau Estate / DACS; *Silver Box*, Luigi Scialanga; *Chaise Brisée*, Garouste & Bonetti; *Armchair*, Emilio Terry; Photo ©Ricardo Labougle
PAGE 59 (top): *Dennis*, Photo ©David Gill Gallery; (bottom): *Untitled (art)*, Christopher Wool; *Untitled (art)*, Berlinde de Bruckyere; *Untitled (art)*, Richard Prince, courtesy of Gagosian Gallery; *Twilight of the Idols (Virgin Mary)*, Kendell Geers; *The Fountain of Youth*, 2003, Barnaby Barford; Photo ©Ricardo Labougle
PAGE 60: *Plates*, Jean Cocteau / Jean Cocteau Estate / DACS; *This Is Where He Keeps The Heads*, 2006, Barnaby Barford; Photo ©Ricardo Labougle
PAGE 61: *The Fountain of Youth*, 2003, Barnaby Barford; Photo ©David Gill Gallery
PAGE 62: *Cut Out Sofa*, Mattia Bonetti; *Polyhedral Side Tables*, Mattia Bonetti; *Vases*, Grillo Demo; Photo ©Ricardo Labougle
PAGE 63: *Plates*, Jean Cocteau / Jean Cocteau Estate / DACS; *Untitled (art)*, Richard Prince, courtesy of Gagosian Gallery; *Untitled (art)*, Christopher Wool, courtesy of Luhring Augustine; *Untitled (art)*, Chantal Joffe; *Pinocchio*, Paul McCarthy, courtesy of Hauser & Wirth; *Petra Table Lamp*, Garouste & Bonetti; *Cut Out Butterflies*, Grillo Demo; *Monogold ™ Coffee Table*, Yves Klein; *Ring Coffee Table*, Mattia Bonetti; *Chaise Brisée*, Garouste & Bonetti; *Armchair*, Emilio Terry; Photos Ricardo Labougle, Simon Upton / Interior Archive (bottom left)
PAGE 64 (top left): *Chair*, unknown; *Turandot Side Table*, Mattia Bonetti, 1991; Photo ©Ricardo Labougle; (top right): *Alfred Drayton & Robertson Hare, 1938 (photo)*, Angus McBean / Houghton Library, Harvard University; *Luchino Visconti, Paris, 1937 (photo)*, Horst P Horst / Art & Commerce; Photo ©Ricardo Labougle; (bottom left): *Bookcase*, Syrie Maugham; *Plate*, Grayson Perry, courtesy the Victoria Miro Gallery; *Spaghetti Table Lamp*, Garouste & Bonetti; *Untitled (art)*, Richard Prince, courtesy of Gagosian Gallery; Photo ©Simon Upton / Interior Archive; (bottom right): *Venetian Magician's Chest*, Richard Snyder; *Antique German Chairs*, Gerhard Schliepstein; *Falling Jasmine Plate*, Grillo Demo; *Head Vase*, Oriel Harwood; Photo ©Ricardo Labougle
PAGE 65: *Venetian Magician's Chest*, Richard Snyder; *Antique German Chairs*, Gerhard Schliepstein; *Falling Jasmine Plate*, Grillo Demo; *Bullet Hole (art)*, Nate Lowman; *Ceramics (on table)*, Giacinto Cerone; *Fakir Cabinet*, Mattia Bonetti; *Cushions*, Ulrika Liljedahl; *Christina Daybed*, Francis Sultana; Photo ©Ricardo Labougle
PAGE 66: *Vase*, Grillo Demo; *Plate*, Jean Cocteau / Jean Cocteau Estate / DACS; *Balinese Door Lock*, painted by Grillo Demo; Photo ©Ricardo Labougle
PAGE 67: *Antique Relic*, Spanish; *Scuplture*, Dallas & Texas; Photo ©Ricardo Labougle
PAGES 68–69: *Venetian Magician's Chest*, Richard Snyder; *Antique German Chairs*, Gerhard Schliepstein; *Vase*, Grillo Demo; *Ceramics (on table)*, Giacinto Cerone; *Plate*, Jean Cocteau / Jean Cocteau Estate / DACS; *Pinnochio*, Paul McCarthy, courtesy of Hauser & Wirth; *Ring Coffee Table*, Mattia Bonetti; *Pirate Drawing*, Paul McCarthy, courtesy of Hauser & Wirth; *Untitled (art)*, Chantal Joffe; *Performance*, 1998, Vanessa Beecroft; *Untitled (art)*, Mike Kelly; *Untitled (sculpture)* Chapman Brothers Photo ©Graham Wood
PAGE 70: *Wall Lamp*, Serge Mouille / DACS; *Chairs*, Jean Prouve; *Table*, Le Corbusier; *Ceramic (on worktop)*, Giacinto Cerone; Photo ©Simon Upton / Interior Archive
PAGE 71: *Wall Lamp*, Serge Mouille / DACS; *Chairs*, Jean Prouve; *Table*, Le Corbusier; *Head Vase*, Oriel Harwood; Photo ©Ricardo Labougle
PAGE 72: *Mirror*, Oriel Harwood; *Gunship Grey Statue*, Don Brown; *Untitled (art)*, Giacinto Cerone; Photo ©Ricardo Labougle
PAGE 73 (top): *Semen*, Francesco Clemente; *Three Graces Table Lamps*,

Garouste & Bonetti; *Antique Side Tables*, T H Rossjohn-Gibbings; Photo ©Ricardo Labougle; (bottom): *Date Painting*, Ugo Rondinone; *Gunship Grey Statue*, Don Brown; Photo ©Ricardo Labougle

**KING STREET, ST JAMES'S**
PAGE 74: *David Gill*; Photo ©Solina Guedroitz
PAGE 75: *David Gill Gallery*; Photo ©Matthew Farrand / David Gill Gallery
PAGES 76–77: *Edward Scissorhands Side Tables*; *Basoli Circular Dining Table*; Campana Brothers; all pieces edited by Giustini / Stagetti Roma; *Stripes (art)*, Daniel Buren; Photo ©Campana Brothers
PAGES 78–79: *Shield Sofa*; *Grotto Candelabras*; *Paragon Coffee Table*; *Atlantis Mirror*; *Descartes Desk*; *Congo Chair*; *Metropolis Torchére*; *Fringe Side Table*, Mattia Bonetti; Photo ©Tomas Rydin / David Gill Gallery
PAGES 80–81: *Meretricious, Untitled 5*; *Meretricious Untitled 12 and 13*; *Meretricious Untitled 25*, Jorge Pardo; Photo ©David Gill Gallery

**SELECTED DESIGNER-ARTISTS**
PAGE 82: *Happy Birthday Cabinet*, Mattia Bonetti; Waterfall, 2006, Rosemarie Trockel; *David Gill*; Photo ©Steve Double
PAGES 84–85: *Me Want Now Exhibition/Barnaby Barford*, Photo ©Martin Slivka
PAGE 86 (top row): *Well If Julia Can*, Barnaby Barford; (bottom): *Ooohh You're Gorgeous You Are*, Barnaby Barford; Photos ©Martin Slivka
PAGE 87 (top): *It's OK, He's Rich*, Barnaby Barford; (bottom row): *Pssst, It's Bullshit*; *What's Wrong With The Fokin Beatles*; Barnaby Barford; Photos ©Martin Slivka
PAGE 88 (top): *What Do You Mean You're LATE*, Barnaby Barford; (bottom row): *Oh Mummy Please Can We Keep It*; *Viva La Luche Libre*; Barnaby Barford; Photos ©Martin Slivka
PAGE 89: *Struggling Will Only Make It Worse*, Barnaby Barford; Photo ©Martin Slivka
PAGE 90–91 (top): *Park Life*, Barnaby Barford; (bottom row) *Stick That On You Tube*, Barnaby Barford; *Come On Alan You Little Bitch*; *Mary Had A Little Lamb*; Barnaby Barford; Photos ©Matthew Donaldson
PAGE 92 (top): *BOOM!*, Barnaby Barford; (bottom): *The Strongest Man In The World*, Barnaby Barford; Photos ©Matthew Donaldson
PAGE 93 (top): *Sorry*, Barnaby Barford; (bottom): *If You Play Your Cards Right*, Barnaby Barford; Photos ©Matthew Donaldson
PAGE 94: *Show Me The Money*; *You Scream, I Scream, We All Scream For Ice Cream*; Barnaby Barford; Photos ©Matthew Donaldson
PAGE 95: *Secret To A Happy Marriage*; *Lawfully Wedded Wife*; Barnaby Barford; Photos ©Matthew Donaldson
PAGE 96 (top): *Sloth*; *Avarice*; *Pride*; Barnaby Barford; (centre) *Gluttony*; *Wrath*; *Envy*; Barnaby Barford; (bottom): *(detail)*, Barnaby Barford; Photos ©Paul Plews
PAGE 97: *Mirror, Mirror* (in reflection, *Lust*), Barnaby Barford; Photo ©Paul Plews
PAGE 98: *The Bear (detail)*, Barnaby Barford, Photo ©Martin Slivka
PAGE 99: (left): *Baby Elephant during construction*, Barnaby Barford; (right): *Me Want Now Installation*; *Reality*; Barnaby Barford; Photos ©Martin Slivka
PAGE 100: *Mattia Bonetti*; Photo ©Jude Edgington / Camera Press
PAGE 101: *Mattia Bonetti*; Photo ©Mattia Bonetti
PAGE 102 (left): *Strata Cabinet*, Mattia Bonetti; (right) *Polyhedral Chest of Drawers*; *Fakir Cabinet (detail)*; Mattia Bonetti; Photo ©Mattia Bonetti
PAGE 103: *Cut Out Sofa*; *Polyhedral Side Tables*; Illustrations ©Mattia Bonetti / Photo ©Ricardo Labougle
PAGE 104 (top): *Abyss Table*, Mattia Bonetti; Photo ©Mattia Bonetti; (bottom row): *Abyss Table*, Illustration ©Mattia Bonetti; *Abyss Table*; *Muse Light*; *Strata Cabinet*; *Turandot Side Tables*; *Beggars Bench*; Mattia Bonetti; Photo ©David Gill Gallery
PAGE 105: *Abyss Table*, Mattia Bonetti; Photo ©Mattia Bonetti
PAGE 106: *Alu Console*; *Yo-Yo Coffee Table*; Mattia Bonetti; Photo ©Mattia Bonetti
PAGE 107 (top): *Happy Birthday Cabinet*; *Bubble Gum Side Table*; Mattia Bonetti; (bottom): *Toast Side Table*; *Cloud Sofa*; Mattia Bonetti; Photos Mattia Bonetti
PAGE 108 (top): *Big Jim Armchair / Ottoman*, Mattia Bonetti; (bottom): *Benin Coffee Table*; *Endless Ribbon Console*; Mattia Bonetti; Illustration / Photo ©Mattia Bonetti
PAGE 109 (top): *Incroyables Table Lamp*; *Monolith Chest*, Mattia Bonetti; Illustration / Photo ©Mattia Bonetti; (bottom): *DW4 / DW5 Coffee Tables*, Mattia Bonetti; Photo ©Martin Slivka

PAGE 110: *Shield Armchair*; *Shield Sofa*; *Grotto Candelabras*; *Fringe Side Table*; Mattia Bonetti; Illustrations ©Mattia Bonetti; Photo ©Tomas Rydin
PAGE 111: *Metropolis Torchére*; *Strata Armchairs / Ottoman*; *Taurus Side Table*; *Buckle Armchair*; Mattia Bonetti; Illustrations ©Mattia Bonetti; Photos ©Martin Slivka
PAGE 112 (top): *Buckle Armchair*; *Palermo Chairs*; Mattia Bonetti; Photo ©Mattia Bonetti; (bottom): *Cylinder Sofa*, Mattia Bonetti; Photo ©Martin Slivka
PAGE 113: *Jungle Torchére*, Mattia Bonetti; Illustration / Photo ©Mattia Bonetti
*Surface Side Table*, Mattia Bonetti; Illustration ©Mattia Bonetti/
Photo ©Martin Slivka
PAGES 114–15: *Design Sketches*, ©Mattia Bonetti
PAGES 116–17: *Humberto & Fernando Campana, Sao Paulo, Brazil, 2016*,
Photo ©Miguel Schincariol / AFP / Getty Images
PAGE 118: *Humberto Side Tables*; *Ouro Preto Floor Lamp*; *Anhanguera Sofa*;
Campana Brothers; all pieces edited by Giustini / Stagetti Roma
PAGE 119: *Lacrime di Coccodrillo Candlestick*; *Lupa Chair*; Campana Brothers;
all pieces edited by Giustini / Stagetti Roma
PAGES 120–21: *Aleijadinho Candlesticks*; *Angra Coffee Table*; *Tarquinio Sofa*;
*Pamphilj Chandelier*; Campana Brothers; all pieces edited by Giustini /
Stagetti Roma
PAGES 122–23: *Lina Armchairs*; *Humberto Side Table*; *Tritone Candlestick*;
Campana Brothers; all pieces edited by Giustini / Stagetti Roma
PAGE 124: *Basoli Consoles*; *Alligator Toy*; *White Tiger Toy*; Campana Brothers;
all pieces edited by Giustini / Stagetti Roma
PAGE 125: *Basoli Circular Dining Table*, Campana Brothers; all pieces edited
by Giustini / Stagetti Roma; *Stripes (art)*, Daniel Buren
PAGE 126: *Ionic*, David Chipperfield; *David Chipperfield & David Gill*;
Photo ©David Gill Gallery
PAGE 127: *Ionic Installation*, David Chipperfield; Photo ©David Gill Gallery
PAGE 128: *Patrik Fredrikson & Ian Stallard*, Photo ©Mark Cocksedge
PAGE 129: *#1(Log) Coffee Table*; *#2(Log) Side Table*; Fredrikson Stallard;
Photo ©Thomas Brown
PAGE 130 (top): *Bergère 2 Chair*; *Bergère 2 Chair*; Fredrikson Stallard; (bottom)
*Aluminium Series Slit Coffee Table*, Fredrikson Stallard; Photos ©Thomas Brown
PAGE 131: *Bergère 2 Chair*; *Bergère 2 Chair*; Fredrikson Stallard;
Photo ©Fredrikson Stallard
PAGE 132: *Rubber - Red (detail)*, Fredrikson Stallard; Photo ©Thomas Brown
PAGE 133: *Pyrenees Sofa*; *Rubber Coffee Tables*; Fredrikson Stallard; Photo
©Thomas Brown; *Rubber - Gold Side Tables*, Fredrikson Stallard;
Photo ©Peter Geunzel
PAGE 134 (top): *Unit #3 Feather Side Tables*, Fredrikson Stallard; Photos
©Stephane Briolant; (bottom) *Unit #3 Feather Coffee Table*, Fredrikson Stallard;
Photo ©Peter Geunzel
PAGE 135: *King Bonk Armchair / Stool*, Fredrikson Stallard;
Photo ©Thomas Brown
PAGE 136: *Lynx*, Fredrikson Stallard; Photo ©Thomas Brown
PAGE 137 (top): *Lynx*; *Daytona*; *Phoenix*; Fredrikson Stallard; (bottom):
*Cadillac*; *Aviator 1*; *Acid Queen*; *Pink Corvette*; *Silver Spirit 2*; Fredrikson Stallard;
Photos ©Thomas Brown
PAGE 138 (top): *Gold Crush Side Table*; *Silver Crush Side Table*; Fredrikson Stallard;
(bottom): *Gold Crush Coffee Table*, Fredrikson Stallard; Photos ©Stephane
Briolant
PAGE 139: *Silver Crush Coffee Table (detail)*, Fredrikson Stallard; Photo
©Stephane Briolant
PAGE 140: *Gravity Guéridon*; *Polaris Coffee Table*; *Gravity Coffee Table*; Fredrikson
Stallard; Photo ©Fredrikson Stallard
PAGE 141: *Pantheon Mirror*; *Species III Armchair*; *Atlas II Coffee Table*; Fredrikson
Stallard; Photo ©Fredrikson Stallard
PAGE 142: *Antarctica Bronze I, II & III Side Tables*, Fredrikson Stallard; Photo
©Dan Korkelia; *Hudson Console*; *Untitled Stool*; Fredrikson Stallard
PAGE 143 (top left): *Pantheon Mirror*, Fredrikson Stallard; Photo ©Dan Korkelia;
(right): *Untitled Standard Lamp*; *Scriptus Shelves*; *Crush Silver Desk*; *Hudson
(Diptych) Console*; *Untitled (4-Leg) Chair*; *Tokyo II Coffee Table*; Fredrikson Stallard;
(bottom): *Scriptus II Mirror (detail)*, Fredrikson Stallard;
Photos ©Fredrikson Stallard
PAGE 144: *Zaha Hadid*; Photo ©Steve Double / Camera Press

PAGE 145: *Karl Lagerfield & Zaha Hadid*; Photo ©Zaha Hadid Architects
PAGE 146: *Dune Formations*, Zaha Hadid; Photo ©Zaha Hadid Architects
PAGE 147: *Dune A - G Shelves*; *Dune 01–07 Shelves*; *Mercuric Stools*; *Zephyr Sofa*;
Zaha Hadid; Photo ©David Gill Gallery
PAGES 148–49: *Liquid Glacial Stools*; *Liquid Glacial Dining Table*; *Liquid Glacial
Dining Table* (detail), Zaha Hadid; Photos ©David Gill Gallery
PAGES 150–51: *UltraStellar Coffee Table*; *UltraStellar Chairs*; Zaha Hadid;
Photos © Martin Slivka
PAGE 152: *UltraStellar Double Seat Bench (prototype detail)*; *UltraStellar Three-
Seat Bench*; *UltraStellar Grey Chair*; Zaha Hadid; Photos © Martin Slivka
PAGE 153: *UltraStellar Red Chair*, Zaha Hadid; Photo ©Martin Slivka
PAGE 154: *Michele Oka Doner*; Photo ©Jordan Doner
PAGE 155: *Michele Oka Doner*, (studio details) Photos ©Michele Oka Doner
PAGE 156 (top): *Underwater City Epergne*; *Seated at Shaman's Table Place Card
Holders*; *Bark Lightning Champagne Bucket*; *Palm Vases*; Michele Oka Doner;
(bottom): *Burning Bush Candelabras*, 1995–2013, Michele Oka Doner;
Photos ©Michele Oka Doner
PAGE 157: *Ice Ring Bench*; *Radiant Table*; *Ocean Reef Glass Bowl*, Michele Oka
Doner; Photo ©Michele Oka Doner
PAGE 158: *Spirograph II*; *Bark Lightning Champagne Bucket*; Michele Oka Doner;
Photos ©Michele Oka Doner
PAGE 159 (top): *Ice Ring Bench*; *Radiant Table*; *Ocean Reef Glass Bowl*; *Palm Vases*;
(left): *Radiant Table*; (right): *Radiant Table*; *Ocean Reef Glass
Bowl (detail)*, all Michele Oka Doner; Photos ©Michele Oka Doner
PAGE 160–61: *Ice Ring Bench*; *Radiant Table*; *Ocean Reef Glass Bowl*; *Palm Vases*;
*Fertile Reflection Mirror*; *Radiant Coffee Table*; *Pollinator Sconce*; *Golden Reflection
Table Lamp*; *Burning Bush Candelabra*, Michele Oka Doner;
Photo ©Martin Slivka
PAGE 162 (top): *Altar II Candelabra*, Michele Oka Doner; (bottom): *End of Feast
I Platter*; *Burning Tara Candelabra*, Michele Oka Doner;
Photos ©Michele Oka Doner
PAGE 163 (top row): *Adam From Roots, 2 of 4*; *Primal, 6 of 8*; *Restless, 2 of 8*;
(bottom): *Totem, 2 of 8*; *Totem with Crown, 4 of 8*; Michele Oka Doner;
Photos ©Michele Oka Doner
PAGE 164: *Jorge Pardo*; Photo ©Matt Harbicht
PAGE 165: *Meretricious Installations*, Jorge Pardo; Photo ©David Gill Gallery
PAGE 166 (top): *Meretricious Untitled 8 (table)*; *Meretricious Untitled 24 (mirror)*;
*Meretricious Untitled 25 (chandelier, left)*; *Meretricious Untitled 23 (chandelier,
right)*; (bottom): *Meretricious Untitled 3 (cabinet, left)*; *Meretricious Untitled 5
(cabinet, centre)*; *Meretricious Untitled 1 (cabinet, right)*; Jorge Pardo;
Photos ©David Gill Gallery
PAGE 167 (top): *Meretricious Untitled 9-22 (mirrors)*; (bottom): *Meretricious
Untitled 6 (cabinet, left)*; *Meretricious Untitled 2 (cabinet, right)*; Jorge Pardo;
Photos ©David Gill Gallery
PAGE 168: *Gaetano Pesce*; Photo ©Mark C. O'Flaherty / Camera Press
PAGE 169: *Pond Table*; *Lagoon Table*, Gaetano Pesce; Photo ©David Gill Gallery
PAGE 170: *River Table*; *Pond Table (detail)*, Gaetano Pesce;
Photo ©David Gill Gallery
PAGE 171: *What it is to be Human Chandelier*; *Ocean Table*, 2010, Gaetano Pesce;
Photo ©David Gill Gallery
PAGE 172: *José Yaque*; Photo ©David Gill Gallery
PAGE 173: (left): *Mina a Cielo Abierto V*; (right): *Margarita I*, 2016, José Yaque;
Photos ©David Gill Gallery
PAGE 174 (top): *Magnesita I*; *Magnesita III*, 2016, José Yaque;
(bottom) *Falla en el Horizonte V*, 2016, José Yaque; Photos ©David Gill Gallery
PAGE 175: *Cancrinita I*, 2016, José Yaque; Photo ©David Gill Gallery
PAGE 176: *Tierre Madre Installation*; *Tierra Santa (detail)*; José Yaque;
Photos ©David Gill Gallery
PAGE 177: *Suelo Autóctono III*, José Yaque; Photos ©David Gill Gallery

**DESIGN-ART: A PRIVATE HOUSE PROJECT**
All Photos © Armin Weisheit
PAGE 178: *Ram*, François-Xavier Lalanne; *Treet Bench*, Claude Lalanne ©
ADAGP, Paris and DACS, London 2018
PAGE 179: *Wall Lights*, André Dubreuil

PAGE 180: *Table & Chairs*; Claude Lalanne © ADAGP, Paris and DACS, London 2018
PAGE 181: *Bench*; Claude Lalanne © ADAGP, Paris and DACS, London 2018; (bottom): *Side Tables*, André Dubreuil
PAGE 182: *Cow*, François-Xavier Lalanne; © ADAGP, Paris and DACS, London 2018
PAGE 183: *Moon Rise*, Ugo Rondinone
PAGE 184–85: (left): *Tree*, Donald Baechler, 1988; (centre): *Woman on Rocks*, 1999; (right): *Homage to Darwin*, Saint Clair Cemin, 1986
PAGE 186: *Choupette*, Claude Lalanne; © ADAGP, Paris and DACS, London 2018
PAGE 187: *Untitled Sculpture*, Andro Wekua, c. 2007
PAGE 188–9: *Choupette* (small), Claude Lalanne © ADAGP, Paris and DACS, London 2018; *Table*, Mattia Bonetti; *I Am My Own God (vase)*, Grayson Perry, courtesy the Victoria Miro Gallery; *Wall Sconces*, André Dubreuil
PAGES 190–1: *Choupette*, Claude Lalanne © ADAGP, Paris and DACS, London 2018; *Table*; *Bookcase*, Mattia Bonetti; *Chandelier*, André Dubreuil
PAGES 192: *Chest of Drawers*, Mattia Bonetti; *Mirror*, André Dubreuil; *Grave Goods Vase*, Grayson Perry
PAGES 193: *Bedroom Furniture*, Mattia Bonetti; *Good* and *Evil* (paintings), Barbara Kruger; *Bedside Lamp*, André Dubreuil;
PAGES 194–5: (left): *Untitled (portrait)*, Andy Warhol; (centre): *We Don't have Problems With The Rolling Stones, Because We Buy Their Guitars*, Martin Kippenberger; (right): *Untitled (art)*, Richard Prince
PAGES 196–7: *Young Woman with Pearl Necklace (sculpture)*, George Condo; *Console*, André Dubreuil; *Do Az I Do (art)*, Edward Ruscha
PAGE 198: *Chest of Drawers*, Mattia Bonetti; *Lights*; André Dubreuil
PAGE 199: *Vase*, Grayson Perry, courtesy the Victoria Miro Gallery; *Side Table* (left), Mattia Bonetti; *Side Table* (right), André Dubreuil
PAGE 200: *Mirror; Console*, Mattia Bonetti; *Singe (Monkey)*, Claude Lalanne © ADAGP, Paris and DACS, London 2018; *Échassier (Wader) Lamp*, c.1999, François-Xavier Lalanne © ADAGP, Paris and DACS, London 2018
PAGE 201: *Untitled (portrait)*, Francesco Clemente; *Console* and *Chandeliers*, André Dubreuil
PAGES 202: *Bedroom Furniture; Bedside Lights, Mattia Bonetti, 2007*
PAGES 203: *Bed,* Mattia Bonetti, 2007; *Grue (Crane) Lights*, 1991, François-Xavier Lalanne © ADAGP, Paris and DACS, London 2018

## DAVID GILL AT HOME : ALBANY

PAGE 204: *Untitled (sculpture)*; Franz West; *Untitled (art)*; Josh Smith; *Ceramics*; Jean Cocteau / Jean Cocteau Estate / DACS; *Vase*; Grayson Perry, courtesy the Victoria Miro Gallery; *David Gill*; Photo ©Henry Bourne
PAGE 205: *Seville Torchére*, Garouste & Bonetti; Photo ©James Macdonald
PAGES 206–7: *Eggs*; *Boxes*; Line Vautrin / Line Vautrin Estate / DACS; *Incroyables Table Lamp*; *Homage to Henry Moore Fire Dogs*, Mattia Bonetti; *Tinkerbellend*, Dinos & Jake Chapman; *Belgravia Table Lamp*; *Petit Trianon Side Table*; *Ring Coffee Table*; Garouste & Bonetti; *Pinocchio*; *Pirate Drawing*, Paul McCarthy, courtesy of Hauser & Wirth; *Armchair*, Emilio Terry; *Sofas*, Francis Sultana; *Untitled*, Richard Prince; *Untitled (Brown Brown Rub Mask)*, Mark Grotjahn; Photo ©James Macdonald
PAGES 208–9: *Salome Dining Table*; *Boy Candlestick*; *Girl Candlestick*, Garouste & Bonetti; *Silver Vases*, Richard Vallis; *Vase*, Constance Spry; *Vases*, Grayson Perry, courtesy the Victoria Miro Gallery; *Candelabra*, André Dubreuil; *Untitled (art)*, Michelangelo Pistoletto, 2014; *Infinity Nets (art)*, Yayoi Kuzama; Photos ©James Macdonald
PAGE 210 (top): *Emperor Table Lamp*, Garouste & Bonetti; *Rubber - Gold Side Table*, Fredrikson Stallard; *Sofas*, Eugene Printz; *Cattail Melting in the Snow (art)*, Ida Ekblad; Photo ©James Macdonald; (below): *Untitled (sculpture)*, Franz West; *Belgravia Table Lamp*, Garouste & Bonetti; *Ceramics*, Jean Cocteau / Jean Cocteau Estate / DACS; *Vase*, Grayson Perry, courtesy the Victoria Miro Gallery; *Untitled (art)*, Michelangelo Pistoletto; Photo ©James Macdonald
PAGE 211: *Belgravia Table Lamp*, Garouste & Bonetti; *Cherub Table*, Vintage; *Vase*, Grayson Perry, courtesy the Victoria Miro Gallery; *Untitled (art)*, Josh Smith; Photo ©David Gill Gallery
PAGE 212: *Flower Side Table*; *Chewing Gum Side Table*, Mattia Bonetti; *Ottoman Brisée*, Garouste & Bonetti; *King Bonk Armchair / Ottoman*, Fredrikson Stallard; *Vase*; *Ottoman Brisée*, Garouste & Bonetti; *Dune 01-07 Shelf*, Zaha Hadid; *Come On You Lightweight, Down It*, Barnaby Barford; *Infinity Nets (art)*, Yayoi

Kuzama; *Untitled (art)*, Christopher Wool, courtesy of Luhring Augustine; *Piccadilly Circus Tea Party Pink*, Paul McCarthy, courtesy of Hauser & Wirth; Photo ©James Macdonald
PAGE 213: *Strata Cabinet*; *Grotto Lamp*, Mattia Bonetti; *Him (art)*, Steven Shearer; *Untitled (art)*, Michelangelo Pistoletto; Photo ©James Macdonald
PAGE 214: *Come On You Lightweight, Down It*, Barnaby Barford; Photo ©James Macdonald
PAGE 215: *Pirate Drawing*; Paul McCarthy, courtesy of Hauser & Wirth; *Shit! Now I'm Going To Be Really Late*, Barnaby Barford; *Vase*, Grayson Perry; *Alu Console*, Mattia Bonetti; Photo ©Henry Bourne

## DAVID GILL AT HOME : VALLETTA

PAGE 216: *Atlantis Console*, Mattia Bonetti; *Mirror*; *Chandelier*, André Dubreuil; *Hurricane Lamps*, Francis Sultana; Photo ©James Macdonald
PAGE 217: *Hallway*; Photo ©James Macdonald
PAGE 218: *Atlantis Console*, Mattia Bonetti; *Mirror*, André Dubreuil; Photo ©James Macdonald
PAGE 219: *My Madinah. In Pursuit of My Ermitage*, Jason Rhoades; *Rising Sun*, Eva Rothschild; Photo ©James Macdonald
PAGES 220–21: *Venetian Chest of Drawers*, Mattia Bonetti; *Vase*, Grayson Perry, courtesy the Victoria Miro Gallery; *Antique German Chairs*, Gerhard Schliepstein; Photo ©James Macdonald
PAGE 222: *Michael Jackson Red*, Paul McCarthy, courtesy of Hauser & Wirth; *Introvert Sun*, Olafur Eliasson; Photo ©James Macdonald
PAGE 223: *Ceiling Art*, Daniel Buren; *Congo Armchairs*; *Table Lamps*, Mattia Bonetti; Photo ©James Macdonald
PAGE 224: *Congo Armchair*; *Table Lamp*, Mattia Bonetti; Photo ©James Macdonald
PAGE 225: *Candelabra*, André Dubreuil; *Abyss Table*; *Congo Armchair*; *Table Lamps*, Mattia Bonetti; *Mirrors*, Oriel Harwood; Photo ©James Macdonald
PAGES 226–27: *Salome Dining Table*, Garouste & Bonetti; *Palm Dining Chairs*, Mattia Bonetti; *Wall Bosses*; *Blue Coral Candelabras*, Oriel Harwood; Photo ©James Macdonald
PAGES 228–29: *Prints: Study from a Human Body* (left); *Sitting Figure* (centre); *Untitled* (right), Francis Bacon © The Estate of Francis Bacon. All rights reserved. DACS 2018; *Grotto Standard Lamps*; *Congo Armchair*; *Fringe Side Tables*; *Emperor Table Lamps*; *Trianon Side Tables*, Mattia Bonetti; *Mirrors*, Oriel Harwood; *Philippo Armchairs*, Francis Sultana; Photo ©James Macdonald
PAGE 230: *Untitled (art)*, Carroll Dunham, 2017; *Ceramics*; Jean Cocteau / Jean Cocteau Estate / DACS; *Rihanna Console*, Francis Sultana; Photo ©James Macdonald
PAGE 231: *Lufthansa; Three Pastels (art)*, Aldo Mondino; *Merveilleuse lamp*; Mattia Bonetti; Photo ©James Macdonald
PAGE 232–33: *Mirror*, Oriel Harwood; *Twig Sofas; Table,* Francis Sultana; *Atlas Planter*; Garouste & Bonetti; Photo ©James Macdonald
PAGE 235: *David Gill / Francis Sultana*; Photo ©Chris Floyd

## ACKNOWLEDGEMENTS

Thank you to Francis Sultana, without whose love and support this book, and much more, would not have been possible.

Special thanks to: Sarah Mathew, for her tireless efforts throughout this project; the whole team at David Gill Gallery, especially Daniel Malarkey, Zara Barouche and Rachel Brown; Pauline Karpidas, for her support over the years; Jacques Grange and Frank de Biasi.

All the artists, photographers and friends, whose works are featured in, and are the heart of this book, especially: the late Zaha Hadid; Mattia Bonetti; Michele Oka Doner; Oriel Harwood; Ulrika Liljedahl; Grayson Perry and the Victoria Miro Gallery; Ian Stallard; Patrik Fredrikson; Barnaby Barford; Gaetano Pesce; Humberto and Fernando Campana; José Yaque; David Chipperfield; Jorge Pardo; Jaime Hayon and Hayon Studio; Tom Dixon; the Donald Judd Foundation; Patrice Butler; Richard Vallis; Elisabeth Garouste; Aldo Mondino; Grillo Demo; Paul McCarthy and Hauser & Wirth; Nicholas Alvis Vega; Richard Snyder; Gino Marotta; Franz West; Ugo Rondinone; Luigi Scialanga; Gilbert & George; Christopher Wool; Berlinde de Bruckyere; Richard Prince and Gagosian Gallery; Kendell Geers; Chantal Joffe; Christopher Wool and Luhring Augustine; Nate Lowman; Giacinto Cerone; Dallas & Texas; Vanessa Beecroft; Mike Kelly; Don Brown; Francesco Clemente; Daniel Buren; Claude Lalanne; André Dubreuil; Edward Ruscha; Barbara Kruger; Josh Smith; Dinos & Jake Chapman; Mark Grotjahn; Yayoi Kusama; Ida Ekblad; Michelangelo Pistoletto; Steven Shearer; Jason Rhoades; Eva Rothschild; Olafur Eliasson; Carroll Dunham; Pierre Le Tan; Keith Davies; Thomas Brown; Simon Upton and Interior Archive; Christoph Kircherer; Richard Davies; Guillaume de Laubier; Ricardo Labougle; Steve Dalton; Barbara Stoeltie; Oberto Gili; Henry Bourne; Armin Weisheit; Clive Frost; Martin Parr; Graham Wood; Solina Guedroitz; Matthew Farrand; Tomas Rydin; Martin Slivka; Matthew Donaldson; Paul Plews; Jude Edgington; Mark Cocksedge; Peter Geunzel; Stephane Briolant; Dan Korkelia; Jordan Doner; James Macdonald; Chris Floyd.

I would also like to thank the editorial, design and publishing team, including Meredith Etherington-Smith, Beatrice Vincenzini, Francesco Venturi, David Shannon, Roger Barnard, Anna-Marie Manley and Vivien Hamley for making this project a beautiful reality.

First published in 2018 by **The Vendome Press**
Vendome is a registered trademark of The Vendome Press, LLC

**NEW YORK**
Suite 2043,
244 Fifth Avenue,
New York, NY 10011
www.vendomepress.com

**LONDON**
63 Edith Grove,
London,
SW10 0LB, UK
www.vendomepress.co.uk

**Publishers:**
Beatrice Vincenzini, Mark Magowan & Francesco Venturi

**Copyright in the work:**
© 2018 The Vendome Press LLC and Co & Bear Productions (UK) Ltd

**Text Copyright:**
© 2018 David Gill Gallery

Distributed in North America by Abrams Books
Distributed in the rest of the world by Thames & Hudson

ISBN: 978–0–86565–344–3
1 3 5 7 9 10 8 6 4 2

**Editor:** Anna-Marie Manley
**Picture Researcher:** Vivien Hamley
**Designer:** Roger Barnard

**Library of Congress Cataloging-in-Publication Data available upon request.**

**Printed in Italy**